FOLK ORIGINS OF INDIAN ART

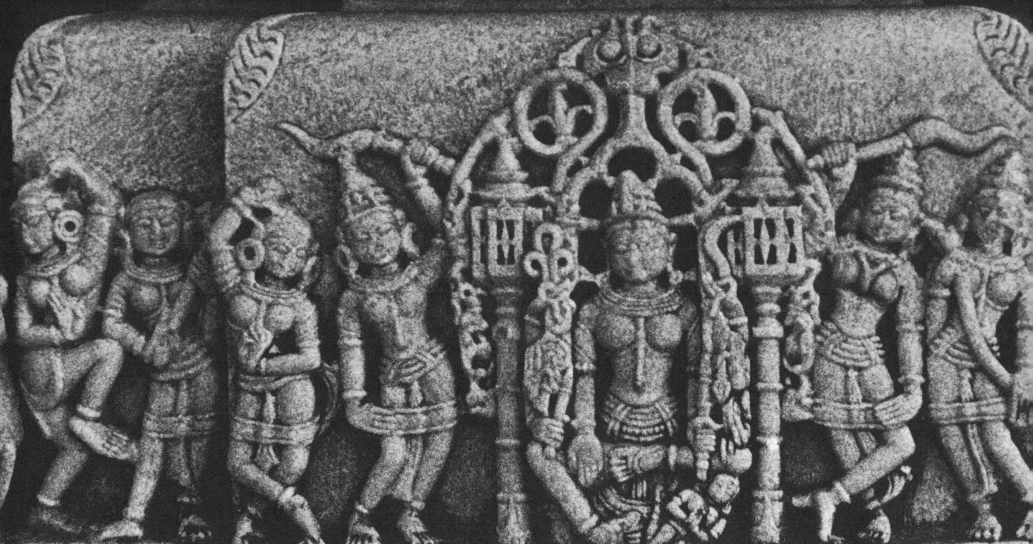

FOLK ORIGINS
OF INDIAN ART

Curt Maury

COLUMBIA UNIVERSITY PRESS

NEW YORK AND LONDON 1969

Copyright © 1969 Columbia University Press

SBN: 231-03198-x

Library of Congress Catalog Card Number: 75-94909

Printed in the United States of America

CONTENTS

FOLK ORIGINS OF INDIAN ART

INTRODUCTION

Ever since the Christian West first beheld her distant and then legendary world, India has confronted it with a bewildering enigma and an inexhaustible source of marvel and fascination. Her cultural gestalt, in its ideational ramifications and phenomenal expressions, has defined and largely preserved India as a land of wonder, of mystery that has deepened even as it seemed to unfold. The intellectual intolerance and doctrinal preconceptions of traders, missionaries, administrators, and curiosity seekers exacerbated their traditional and religiously fostered ignorance of the non-Christian world to further confound the apparent contradictions. For here was unmistakable evidence of an ancient and highly developed civilization; yet its beliefs and customs, its conceptual and creedal perspectives, seemed not merely alien to and incompatible with their own, but inconceivable within the European's frame of reference. Indeed, so bizarre and preposterous did they seem that for a long time only a few individuals considered their comprehension worth a serious effort. Their attempts, however tentative, haphazard, inadequate, and defective in analysis or

conclusion, provided the initial impetus to a slowly intensifying endeavor toward a more balanced and valid appreciation of the phenomenon that is the culture of India.

Most of the original explorations concentrated on the Islamic and Buddhist components of Indian art and thought. Though the Mohammedan was an infidel, his theism was akin to that of the Christian. Moreover, the political alliance of the British with the Moslem power of the Moghuls tended to favor this partiality the more as the art and architecture of Moslem India, drawing via Iran and Central Asia on the achievements of the larger Islamic domain, proved relatively familiar to the Occidental and conceptually and esthetically geared to his sensibilities. The teachings of the Buddha also captured the newcomers' mounting attention and elicited an extent of preoccupation acutely disproportionate to their actual influence and popular following in the India of their own day. Here again the ostensible affinities of the Enlightened One's doctrines with those of Christ, though often resting on expedient imputation and misinterpretation, provided a ready point of departure for the explorer and a compass to guide him across expanses of the mind, unknown but not entirely uncharted. Buddhist art and architecture, too, managed to strike a faintly familiar chord. The few still extant stupas might, it is true, impress those steeped in Europe's tectonic traditions as structural oddities. But their semiglobular shapes would, in their geometric simplicity, allude to the well known. The iconic designs adorning the gates and railings, however unfamiliar or even disconcerting in some specific aspects, would in their hieratically accented compositions evoke memories of the not so different figurations of European cathedrals. The Greco-Roman influence dominating the esthetics of so much of later Buddhist sculpture was bound to facilitate popular acceptance in the West and to carry added appeal to its classically oriented scholars.

Although Hinduism enjoyed the allegiance of the vast majority of India's people and had accounted for the overwhelming share of her cultural product, it long remained the stepchild of Western consideration and, when at last made its object, suffered from a hesitant, perfunctory, and usually negative approach. This disregard, at best springing from uneasy indifference but more often accompanied by overt distaste, is not so unaccountable as at first glance it might appear. Given the European's confidence in the implicit superiority of Occidental and Christian ethos, it emerges as a congruous, even cogent manifestation of his attitude. Here was no common link of professed monotheism such as had founded a bridge of understanding, however precarious, to the Moslem sphere. Here was no doctrine rejecting the world of the senses and the flesh in favor of a spiritual Absolute to offer the illusion of cherished analogies; no trace of Greco-Roman classicism to endow the artifacts with a comforting gloss of the long-accustomed and popularly sanctioned. Instead, Hinduism presented a vastness of perception and conception, of macrocosmic vision and microcosmic expression, finally extraneous to the outsider's experience; a nightmare vastness unfolding in ever more alarming varieties of notional and corporeal imageries.

With its apparent polytheism, its acceptance of many equally valid faces of truth, its cyclical view of time and creation, its nondualism and consequent tolerance of variant creeds, its affirmation of this life as an opportunity for experience rather than a punitive exile, its exaltation of the eternally feminine and of sensual gratification; with its encompassing emphasis on the cosmic rather than the celestial, and its anthropocentric rather than theocentric orientation, Hinduism seemed to confront the European with a perspective of existence not merely foreign but essentially antithetic to his own. Its premises baffled, perturbed, and frightened him, perhaps because, long anathematized and cast from his consciousness, they might not have been so safely defunct as he had thought and wished them to be. Moreover, the complexities inherent in the syncretic character of this religious and social, metaphysical and pragmatic, philosophical and ritualistic system posed a seemingly forbidding problem. Its competing components of Vedic and indigenous origin introduced concepts often mutually exclusive and frequently still unresolved yet inextricably welded. Its profusion of mythological assimilation and doctrinal accommodation, scriptural contradiction

and sectarian particularization, its equivoques of nomenclature and symbolism, exegesis and imagery, long loomed prohibitive to Western inquiry.

On the other hand, in time these very difficulties came to act as a challenge. Since about the middle of the past century, missionaries and colonial administrators and a random crew of adventurers began explorations of Hindu scriptures and legends, traditions and rituals, art and iconography. The authors of these treatises and critiques paved the way for the ever more knowledgeable and disciplined, conscientious and objective, efforts which soon followed. The examination of Hinduism in all its civilizational and cultural aspects passed into the hands of scholars. The initial discovery of Sanskrit links to the idioms of the West had undoubtedly contributed its share of stimulation; Indology had become an ever-broadening field of endeavor.

The past several decades have witnessed a significant expansion of popular interest as well as academic study, a trend persuasively reflected by the accelerating pace of publications of both specialized and general appeal. Translations have encompassed a steadily widening range of India's sacred and vernacular texts. Her myths and philosophies have been subjected to penetrating critique. The historical influences and the traditional impacts bearing on her evolution have been analyzed in considerable depth. Above all, her religious and artistic heritage has increasingly moved into the focus of inquiry. For, however diversified in application and emphasis, all studies of Hinduism have necessarily taken their departure from one of these twin bases, often from both of them. India's religious inspiration has been recognized as the fountainhead of her culture and the key to its understanding, and her artistic bequest as that inspiration's sublimation, self-expression, and ultimate evidence.

The voluminous efforts of Indologists have produced a body of valuable knowledge, of often brilliant deduction and sometimes keen insight. They have moved within the range of apprehension a spectrum of thought and experience until not long ago unintelligible to Western sensibilities, and have rendered attractive what was once unacceptable, engrossing what for-

merly seemed objectionable. They have succeeded in actuating the non-Indian's awareness of another way of contemplating truth, and in encouraging his appreciation of a different approach to conveying its realizations through the idiom of imagery.

Yet, cumulatively, these scholarly accounts have suffered from their one-sided focalization. While rendering by and large an accurate account of Hinduism's canonical lore, they have been remiss in considering its living tradition; while exploring its theoretical beliefs, they have tended to lose sight of its actual exercise. Preoccupation with its high-religion elements has not been accompanied by equal attention to its popular strains. Conditioned by his training as much as his technical limitations, the Indologist's almost total reliance on scriptural and literary sources, and on the exegeses offered by Brahmanical authorities, made the prejudicially weighted character of his material inevitable. Priests and their academic spokesmen are not objective exponents or willing critics of their own religion. Moreover, religious speculation has evoked a readier response from the intellectually preconditioned Western scholar than has religious experience; philosophical argument, a more sympathetic reception than mystical realization. His basic inclination has been toward the Vedic heritage, presenting as it does a frame of reference more familiar to his classical training. Similarly, his propensity toward an esthetic and art-historical evaluation of the artistic product prompted him toward the more conventional forms of Hinduism's iconographic reflections, which he has necessarily correlated with and appraised in terms of his knowledge of high-religion mythology and symbology. This approach has of itself minimized his interpretative effort in behalf of those iconic forms which testify to the impact of heterodox inspiration. Perhaps the true scope of the latter's abundance might never have become quite apparent to him. The virtual confinement of his examination to selected groups of famous and artistically accomplished sanctuaries and his concomitant disregard of folk iconography may well have been impelled in part by the relative inaccessibility of much of India's countryside, which provides the bulk of its most significant evidence.

Only of late have efforts been made to redress the long-standing imbalance of emphasis and replace the deceptively homogeneous but substantially distorted picture of India's religious ethos and cultural evolution with a more objective assessment. These efforts have been advanced almost exclusively by anthropologists, whose detailed studies of village and tribal societies have shed a great deal of light on the interrelationships of high religion and folk religion. Robert Redfield's concept of the folk-urban continuum gave impetus to the idea of the Great Tradition and the Little Tradition, proposed by him and Milton Singer and elaborated by McKim Marriott's discernment of the interacting processes of universalization and parochialization.[1] Field workers have opened new horizons to a search for the authentic, historical, and conceptual roots synthesized in the complex structure of competing stresses that is known by the comprehensive designation of Hinduism. By recording the beliefs and practices of common worshipers as distinct from the precepts and explanations of official interpreters, they have extended our awareness of the interrelationship between the indigenous and the Aryan-Vedic perspectives, wedded to each other by the force of socio-historical necessity, and of the ensuing contradictions within what has seemed a monolith of creedal and philosophical premises.

The concept of the folk roots of Hinduism, therefore, is not a novel one to students of village India. To a large extent their findings support the contentions of this book and, though arrived at by entirely different methods, corroborate its conclusions.

The present work, concentrating as it does on iconographic, mythological, and linguistic evidence, endeavors to provide a fuller exploration of the non-Vedic, non-Aryan components of Hinduism, to probe the import of indigenous India's religious heritage, and to further a more discerning apprehension of its experiential and notional premises. It hopes to suggest a more adequate appreciation of the extent to which the Hindu synthesis has been indebted to this autochthonous tradition for its popular acceptance and country-wide proliferation. In the process it attempts to sketch, however tentatively, the outlines of a perspective of existence which, immemorial in its inception, continues as the dominant influence in India's religious and secular life to this day.

Given the chronological remoteness of the evolution of this perspective, and the erosion of its authentic contours in the course of untold centuries, this study must occasionally tread precarious grounds. Every so often its conclusions must depend on purely interpretative efforts, mostly of nontraditional reference, at times even of conjectural character. Admittedly, this may court a margin of error; but, then, the validity of any thesis does not rest on the final correctness of each of its incidental details; rather, its crucible is the intrinsic rationality and coherence of its total context. Moreover, the incertitudes inherent in subjectively interpretative and conjectural contentions may be proportionally minimized by the soundness and pertinence of the documentary evidence from which they have taken their departures.

The substantiating material offered by this book is novel, not in type but in selection and emphasis, in juxtaposition and correlation. No attempt is made to adduce new or heretofore inaccessible clues. Rather, effort is directed toward pursuing those available all along, yet left unpursued, toward tapping iconographical and symbological, mythological and etymological, evidence exploited before but haphazardly and insufficiently. Thus, this study uses the familiar tools but applies them in a different and, hopefully, creative way to gain fresh insight and knowledge from the perennial sources.

To derive the fullest benefit from these sources, it proposes to forgo the habitual reliance on textual source material, which has produced an image of Hinduism obviously unsupported by the iconic actuality. Theological doctrines and their academic exegeses provide excellent material for critical analysis, but are a notably poor guide to greater insight into the human condition. To paraphrase a familiar dictum, religion is too precious a human experience and too elementary a human need to be trusted to the interpretation of priests and philosophers. A constant, living interaction between man and his universe, religion's true contour emerges only as it is removed from the sphere of esoteric cogitation in favor of exoteric expression; as it is

observed in its operative manifestation, reflecting the continuous and direct dialogue of men with that which they perceive as the vast mystery inaccessibly beyond themselves. The present effort, therefore, endeavors to explore the countenance of the Divine by the witness of its living evidences in folk imagery and folk symbology, popular cult and semantic evolution;[2] to explore it in terms of the immediate monuments to indigenous India's own vision and definition of it.

These monuments attain a special force and clarity where the superimposition of canonical Hinduism has exerted a proportionally weaker impact. This circumstance accounts for the nearly exclusive selection of central India's unfamiliar countryside as the wellspring of the present work's documentation. Certainly, the evidence of a heterodox tradition is present everywhere. The old religion has left its imprints on the great sanctuaries of the famous pilgrimage centers. Yet, it is in the now half-forgotten backwoods temples of ancient grandeur and prominence, in the back country's artless shrines, its strange icons, and unconventional rites, that these imprints assume their most persuasive conspicuousness, attain their most vivid impact as testimonials to a perception of the Divine, not as an exalted abstraction but as a living experience, an inalienable inner reality. It is here that the cumulation of "live" material is most pronounced, providing the widest scope for effective exploitation.

Though this circumstance might be deemed of itself sufficient to favor this book's concentration on central India's countryside and its largely unfamiliar creations, other considerations have been incidental to this choice. By the very origin of its examples, the illustrative material in this volume should more equitably adjust the prevailing impression conveyed by repetitive reference in other publications to a restricted array of famous sacred sites. Its bulk is derived from sites not shown or discussed in other published works; the remainder are drawn from sanctuaries which, like those at Udayapur, Modhera, Ranakpur, and Khiching, have been cited in literature but accorded no more than perfunctory attention. This selection is designed to demonstrate the universality of India's artistic accomplishment and its underlying religious inspiration. Though many of these forgotten shrines abound in imageries of a beauty and sophistication comparable to those found in temples of universal acclaim and in museum collections, the inroads of time and neglect, of course, often have denied them perfect preservation. Yet even remnants may betray the imaginative sweep and artistic competence of their conception and, at times, an eloquence of meaning superior to their unravaged and well-publicized counterparts.

To be sure, many of these backwoods images display crude craftsmanship and bizarre shapes. Though almost totally ignored by the surveys of Indian art, they are fully as integral a part of the subcontinent's religious expression as are the polished and more conventional specimens of its iconography. In them the heritage of the indigenous tradition, less controlled by the amending influences of the high religion, achieves its authentic expression. However unprepossessing and even unappreciable esthetically at times, they constitute the primary and most valuable source for any study of India's cultural evolution. Consequently, this volume proposes, not the purely artistic merit, stylistic development, or formal properties of the illustrative items, but the scope of their import as the criterion for their presentation.

Almost any segment of India's sprawling countryside would provide ample material to document the thesis of this book and advance it toward substantially identical conclusions. If the subcontinent's central region has been singled out, this delimitation was prompted by several interrelated factors. Although not in any respect different from other areas in its basic accents, central India offers a greater concentration of significant evidence. Being less thoroughly assimilated to the canonical creed, it has preserved a more vigorous recollection of the indigenous religious heritage. The artistic and iconographic creations of this least traveled and least investigated segment of the country are bound to contribute to a wider appreciation of India's traditions. By their novelty as much as by their intrinsic significance, they may fill in a vast, yet heretofore blank, expanse on her cultural map.

The area referred to is not distinguished by any inherent homogeneity, but by its somewhat arbitrary boundaries, which might have been extended or

contracted without diminishing the appropriateness of its designation as central India. As applied in the present context, the term defines the broad belt stretching from east to west between roughly the 18th and 25th parallels. It comprises the states of Orissa, Madhya Pradesh, and Gujarat, as well as the southern regions of Rajasthan and the northern ones of Maharashtra and Andhra, those zones of immemorial habitation watered by the great sacred streams, the Mahānadī, Narmadā, and Godavarī and their tributaries. Nevertheless, special attention has been accorded to inland Orissa and the eastern half of Madhya Pradesh, which parts have been exposed to exploration even more sparingly than other territories of central India, even though the cogencies of geography and the known facts of history would point to their preeminence as earlier centers of culture. The sites mentioned are pinpointed on the map.

The circumscribed scope of this volume has not only argued for geographical delimitation, it has also imposed definite restrictions on its structural and topical composition. Many subjects, though entirely germane to its theme and often of considerable interest to the development of its thesis, could not be given the attention proper to their importance. Some have found mention only in cursory textual references or brief footnotes. Others, because their ramifications would lead to speculations only tangential to the context, have not been touched upon. Among other articles of comparable fascination and import, such omissions extend to the interrelationship of Shiva's son Skanda with the southern Subrahmanya and the Tamil Murugan, or the problems raised by the mythic traditions of those primordial divinities, Daksha and Kashyapa. Other subjects considered in a manner obviously incommensurate with their prominence include the manifold anthropomorphic and zoomorphic aspects of the great gods Vishnu and Shiva and some of the equally numerous manifestations of the Goddess. Such fragmentary treatments seemed acceptable in view of the Western student's greater familiarity with, and the more readily available information on, these topics. Their more extended discussion was waived in favor of a more thorough presentation of items which are further removed from general knowledge

and access and at the same time carry superior pertinence to the main theme.

The most obvious, and at the same time most vital, subject left undiscussed is the broad spectrum of questions concerning the religious notions and practices of tribal peoples, the characters and functions of their deities, the mystic properties of the clan goddesses, and their roles within the social structure. Certainly, steeped in tribal lore as India's indigenous tradition is, answers to these questions are fundamental to its proper study. Yet, at once too complex and too important for perfunctory reference, this topic would prove unfeasible for valid consideration within the frame of the present essay. Its presentation rates a full study specifically devoted to the traditions of tribal religion.

In this exploration of a field as broad and complex as the folk origins of Hinduism, choices of emphasis and subjective preferences are inevitable, Obviously, similar discretion proves necessary in presenting the illustrative material. Such selectivity should reduce neither the validity nor the value of the findings but, it is hoped, act as a stimulant to the investigation and clarification of those areas that have not found their full, due consideration. The list of related reading in the Bibliography suggests some sources, general and specific, which may aid such pursuits. However limited quantitatively, the pictorial material itself may serve as a repository of significant iconographic detail and may prompt elaboration or amendment of the hypotheses and conclusions expounded in the present context.

These illustrative samples, all the author's originals, have been of special subjective value in the formulation of this study. This property has accrued to them from their *in situ* origin, from their perception as part of each sacred precinct's iconic gestalt. For, no matter how beautiful or perfect, even symbolically eloquent an individual sculpture or carved panel, divorced from its natural context it forgoes some of its magic and mystique, and to a proportionate extent its experiential impact, and thus its interpretative value. It is from its interrelation with all the components of the temple precinct's aura that it derives its special significance and suggestiveness: from the other imageries with which it shares the sacred compound, but equally from

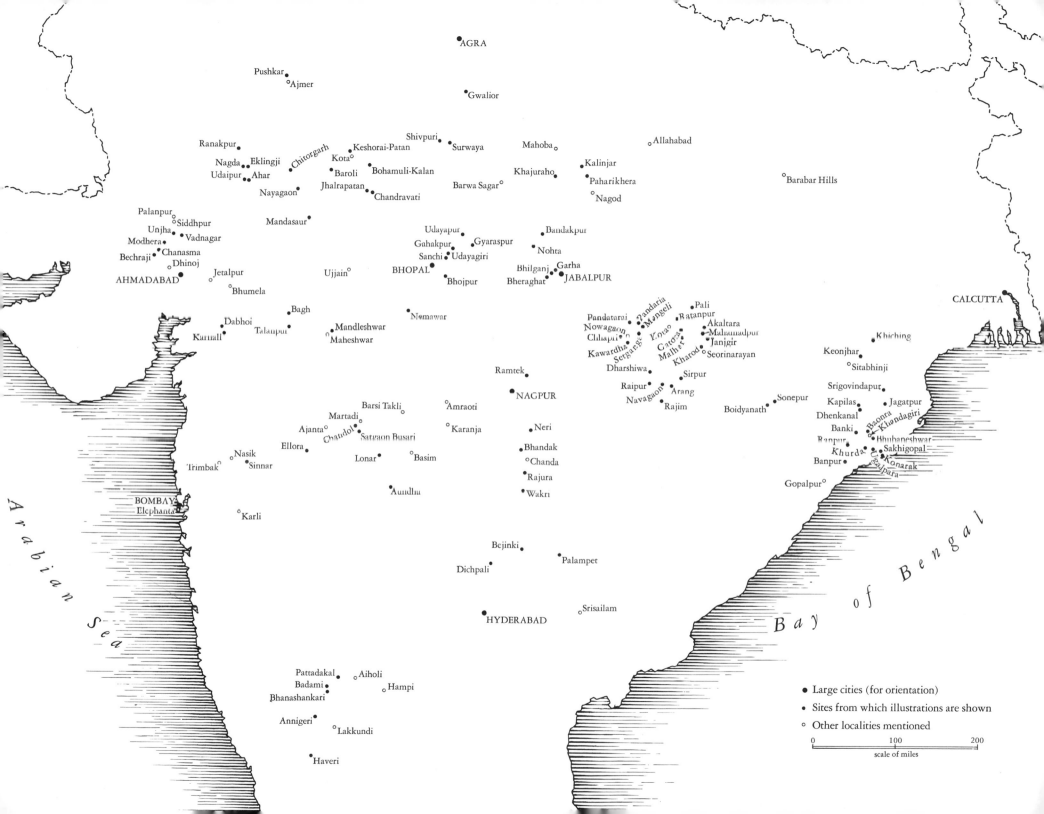

AGRA

Pushkar
○Ajmer

Gwalior

Ranakpur Shivpuri
Eklingji Chitorgarh Keshorai-Patan Surwaya Mahoba○ ○Allahabad
Nagda Eklingji Kota○ Kalinjar
Udaipur Ahar Baroli Bohamuli-Kalan Khajuraho Paharikhera ○Barabar Hills
 Nayagaon Jhalrapatan Barwa Sagar○ ○Nagod
 Chandravati

Palanpur Mandasaur Bandakpur
Unjha ○Siddhpur Udayapur
Modhera Vadnagar Gahakpur Gyaraspur Nohta
Bechraji Chanasma Sanchi Udayagiri Bhilganj Garha
 Dhinoj BHOPAL Bheraghat JABALPUR
AHMADABAD ○Jetalpur Ujjain○ Bhojpur
 Bhumela CALCUTTA

 Bagh Nemawar Pandaria
Dabhoi Pandatarai Mandaria Mengeli Pali
Karnall Talanpur Mandleshwar Nowagaon Y.tao Ratanpur Akaltara Khiching
 Maheshwar Chhapri○ Setganga Gatora Mahamadpur Janjgir Keonjhar
 Kawardha Malhar Kharod Seorinarayan ○Sitabhinji
 Dharshiwa Sirpur Srigovindapur
 Ramtek Raipur Sirpur Kapilas Jagatpur
 NAGPUR Navagaon Arang Boidyanath Sonepur Dhenkanal
 Barsi Takli ○Amraoti Rajim Banki Baonra Khandagiri
Martadi Banpur Bhubaneshwar
Ajanta Chandor Satgaon Busari ○Karanja Neri Sakhigopal
Ellora Lonar Basim Bhandak Khurda Konarak
Nasik Lonar ○Chanda Banpur Jajalpara
Trimbak Sinnar Aundha Rajura Gopalpur
 Wakri

BOMBAY
Elephanta
 ○Karli

 Bejinki
 Dichpali Palampet

 HYDERABAD ○Srisailam

 Pattadakal ○Aiholi
 Badami Hampi
Bhanashankari
Annigeri ○Lakkundi

 Haveri

● Large cities (for orientation)
• Sites from which illustrations are shown
○ Other localities mentioned

0 100 200
scale of miles

Arabian Sea

Bay of Bengal

the structure of the temple itself and the main object of adoration within it; from the hallowed pond nearby; the small idol shrines dotting the courtyard, and the venerable trees interspersing its expanse; the old man squatting in the shade of a pillar, lost in contemplation; the young women mumbling devotions as they strew flowers over the likeness of their favorite divinity; even the vast stillness of the landscape and the luminous blue of the sky above—from all these, as they blend to endow each single image with a meaning beyond its own existence.

Surely, no photograph could ever hope to convey this subtle interplay. Neither the photographer's skill nor the technical potential of his tools is adequate to the task. The illustrations presented here cannot claim any exceptional endowments, but beyond each of them perseveres the memory of an actual experience, of a total impact which has given rise to extensions of interpretation that might otherwise have proved elusive. If this study succeeds in communicating some of the resultant realizations, its efforts will be more than justified.

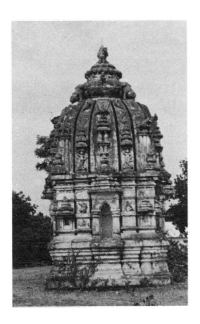

ONE

BACK-COUNTRY WORSHIP

Everywhere in the back country of India the hours after sunrise see villagers walking along the rough roads and narrow footpaths, or across fields made desolate by unrelenting heat. A majority of them are women, moving with unhurried grace, carrying freshly cut blossoms and small bronze urns filled with water. They are on their way to perform their devotions to the powers that shape and govern their lives.

Some of them turn toward the great temple which, sometimes half ruined yet still awesome in its majesty, bespeaks a glory now centuries past. They ascend the broad stairway and pass the lofty gate, proceed through its lovely arches and along sculpted pillars, its walls carved with a countless host of celestials, pause perhaps to glance at the superb upward sweep of the shikhara. The temple may be dedicated to Vishnu, Lord of the Universe, or to Shiva, the Cosmic Dancer, personalization of the Absolute. It may be the seat of Kālī, the All-Encompassing One, presiding over the altar in one of her numberless aspects, under one of her numberless names. Silently the visitors pour water over the

images, strew over them the blossoms they have brought. Their lips move in soundless murmurs, addressing the specific deity yet invoking a power far more ancient, far more immediate to their emotional actuality, a power that, dominating the lives and beliefs of untold generations, has shaped the living creed of the countryside.

It is the presence of this power which all the villagers seek as they make their way through the dawn of the back country. But not all seek it in the great temple. Many continue their quiet procession past its precincts, unmindful of the exquisiteness of its art work, unstirred by the grandeur of its contour and the message of its ancient sacredness. Their goal may be an inconspicuous shrine, often no larger than a small chamber, hidden among the huts of a hamlet or beyond the fringe of the settlement. It may be an artless structure somewhere in the woods or on top of a rocky hill; perhaps the single, tiny domicile of some divinity sheltering but a single idol, or a cluster of more elaborate ones alongside a lotus-covered pond. It could be a small array of icons casually grouped in an open field; sometimes one lone image, its contours raised on a stone slab, propped against a rock or leaning against the embankment of a dried-up brook; a divine effigy in the shade of an ageless tree, by an abandoned well, next to a sacred tank; or some symbolic figures representing rather than depicting the deity, rising on a low platform within a dilapidated enclosure.

There the devotees sprinkle their offering in a ritual gesture of washing the divine body, deposit their flowers in worshipful reverence, for here, too, is where their gods live, under whatever names, whatever guises, the gods of the old religion. This is where they have always lived, where they have most truly preserved their distinct identities and their ancient meanings; out here in the vastness of nature, blistered by the sun and swept by the monsoon rains, rather than in the dimness of some magnificent domed sanctuary.

Immemorial projections of the Divine, the old gods have never died. Often they have yielded their primacy to the mightier deities of a conquering creed, reconciling themselves to a coexistence within the orthodox pantheon, paying for their admission with their acquiescence in an inferior rank. Some of them, too powerful to be subdued yet not powerful enough to assert their independent dominion, would retain their eminence, as but diverse aspects of the reigning lords of the Beyond. Others might have had to accede to more drastic reductions in status, to subsist as minor spirit forces on the periphery of the supernatural domain. Many more would suffer debasement to some order of demon beings, not rarely of hideous countenance and vicious temperament, destructive to man and oppugnant to the new celestial establishment. Many others would live on in benign aspect, their original identification hidden behind the mask of a canonical deity.

Yet, whatever assimilations these gods of old have undergone, whatever guises they have assumed, whatever corruptions of their substance they may have endured, they have never relinquished their hold on popular imagination and allegiance. Even in the urban centers priding themselves in their emancipation from the traditional ways, some of them, donning a cloak of orthodox respectability, remain objects of general reverence. They preside over shrines specially dedicated to them, and their images grace the house altars in every Hindu home. Throughout the countryside they continue, far more numerously and overtly, to be the effective representatives of the divine presence, the primary targets of refuge and entreaty, the essential dispensers of consolation and hope and guidance. The archaic rites with which they used to be honored may have fallen into discard; the primal legends once woven about their deeds may be long forgotten. The specifics of their characters and functions, even of their authentic names, may be lost, their identities no longer clearly distinguishable. Their vehicle, the old religion itself, may well have ceased to be perceived in its total compass; and its ethos, which they personify, may continue unacknowledged as an operative, formative impulse. Yet the facets of custom, the gestures of devotion reaffirm their enduring presence. It is their primordial world of mystery and wonder, of arcane forces animating and imbuing every stone and tree, every particle of nature, to which those villagers offer their homage as they wend their way past the great temple toward the humble shrine or the lonely

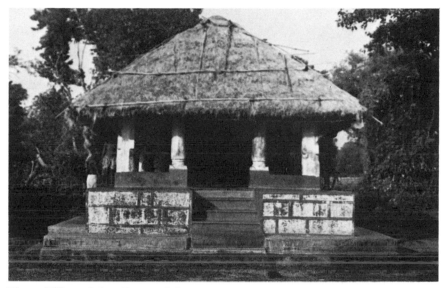

Fig. 1. *Village shrine. Baonra, Orissa.*

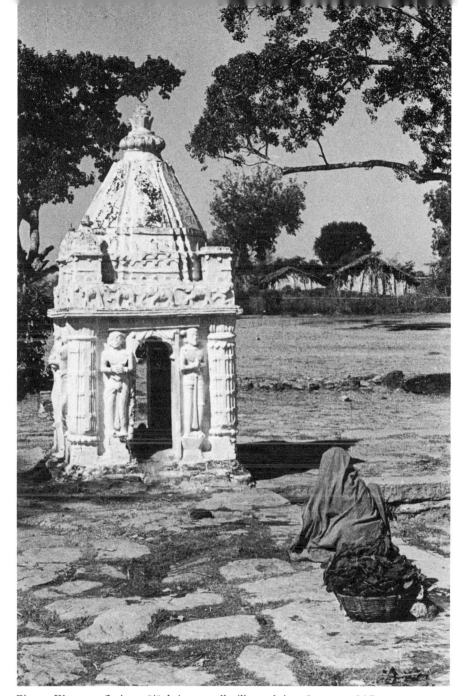

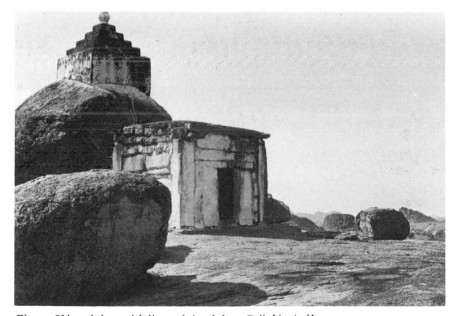

Fig. 2. *Shiva shrine, with linga shrine below. Bejinki, Andhra.*

Fig. 3. *Woman offering pūjā before small village shrine. Setganga, M.P.*

image in the field, and even as they worship in the name of some canonically confirmed deity.

Dimmer though much of its memory has become, not all awareness of this heritage has been lost. Language itself still reverberates with its echoes. One can hardly adduce a whim of casual nomenclature when the great temple is colloquially called *deva mandir*, or Dwelling of God, while the village shrine is popularly referred to as *purāna mandir*, literally Dwelling of Ancient Lore. These designations seem to suggest a deliberate juxtaposition, contrasting the priests' deities to the people's own; the new religion to the old tradition; two supernatural spheres, one of ostensible glory and power, the other of hidden substance and meaning. However blurred by the passage of time and ambiguous from age-long adulteration, however ill-defined and recondite, this meaning still appears to retain some precious reality for the worshiper. Certainly, there is little else the purāna mandir can offer to its visitors. A simple country chapel, usually of undistinguished exterior, it often can be distinguished from similarly unassuming structures only by a scraggy pennant fluttering from its roof or shading its doorway. Even the most elaborate among them, a few divine figures clumsily molded from the plaster covering the outside walls or placed above the entrance, can scarcely boast of esthetic attraction. Murky and thick with incense fumes, the crumbly, bare interiors can hardly enhance the worshiper's sense of relief from the crushing burdens of his daily existence. But there is the soundless quietude, evocative of ineffable mystery. And there is the divine image. Barely visible in the dark hollow of the altar niche, often crudely formed by untutored hands and devoid of artistic merit, it embodies all meaning, all reality, to the devotee. At once terrifyingly awesome and sublimely beautiful to him, this vague, sometimes weird and occasionally unidentifiable shape radiates the magic of a world beyond and its transcendence, of which for moments he becomes part. His perceptions intensified by this communion, his sensibilities attuned and linked to those of the generations of his ancestors, he may fleetingly glimpse his own place within

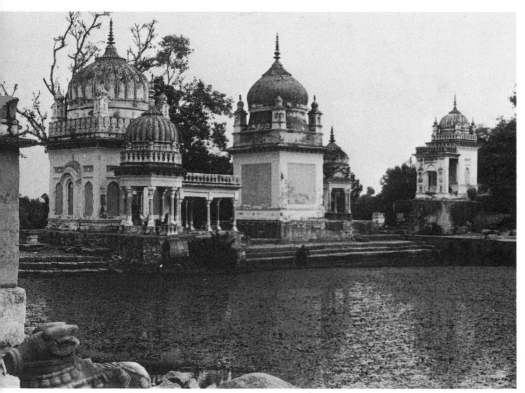

Fig. 4. Temples around a tank. Garha, M.P.

the eternal round of life. Here, in the purāna mandir, is the Ancient Lore incarnate in the divine presence of the effigy.

Those who favor one or the other of the open-air altars for their devotions are seeking, and become part of, the identical experience. Here, exposed to the shifting rays of the sun, changing its countenance with the interplays of light and shadow, the image may seem even more alive, more profound in its mystique. The surrounding countryside, itself evocative in the grandeur of its immense silence, would endow it with a dimension of infinity. Nature herself becomes the purāna mandir, a boundless abode of the Divine enchanted with the wonders of perennial growth and regeneration, with the ultimate magic of perpetual transformation. It may well be here that the old religion achieves its most persuasive potency, here that it receives its greatest tributes. Certainly, those motionless figures every where in the back country, those multitudes of communicants absorbed in their dialogue with the Divine, are eloquent in their testimony; and, where they have left, the traces of recent *pūjā* offer silent witness. The water from the little bronze jugs may have already evaporated. But there, still, are the flowers clinging to the object of homage. Later the wind may blow them away. But next morning others will take their place.

These open-air altars may be encountered everywhere—in a field or in a clearing, next to the central village well or in front of a township's gate, at a crossroad or on a hilltop, close to a river's fording point or on a tiny island in the middle of a lake. More than a few are placed near a great temple, frequently even within its walled-in precincts, as though to assert the antithesis and unvanquished rivalry of their inspiration and to offer an alternative to the visitor.

As diverse as their locations are the geneses of these holy places. Some, ostensibly, are the remains of rough tabernacles that have wasted away. Others may mark an event of presumed supernatural intervention. Many had their beginnings as sites of votive offerings. Many more, particularly those near gates and wells and crossroads, were patently set up to honor a

Fig. 5. Field altar. Haveri, Mysore.

Fig. 6. Roadside altar of local female divinity. Bhubaneshwar, Orissa.

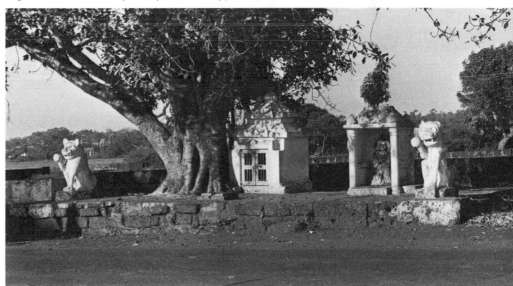

guardian deity, embodiment of apotropaic power. Quite a few seem to have been erected as tokens of personal piety. Most of them, however, owe their origins to the preexisting sacredness of the spot which they have come to occupy—an ageless tree, a gushing spring, an oddly shaped stone, a jagged crevice or a cavern in the rock, an isolated grove, a lotus-covered pond, each an embodiment of creative energy, a manifestation of a divinity of the old religion, and habitation of the supernatural.

Whatever their specific inspiration or incidental location, these simple memorials are the objects of popular adoration. Even those villagers who, in taking their supplications to the great temple, profess their dedication to

Fig. 7. Open-air altar, with image of Sūrya; facing it, linga in yoni. Garha, M.P.

Fig. 8. Chabutra, with lion and nāga. Bhojpur, M.P.

the august deities of the authoritative faith, rarely omit a brief devotion when they pass one of the ubiquitous roadside altars or the solemn ruin of a purāna mandir. And even beneath the overawing loftiness of the dome, amid the splendor of the ornate pillars and intricately carved arches of the great temple, even before the divine effigy and the sacred symbols confronting them from the altar with the authority of the present, they experience the divine presence in terms of their primordial heritage.

The new gods may possess all the power and glory and everlasting truth. Still, the Ancient Lore retains its mystique, the crude images exercise their spell of magic and mystery. In the gods of old, too, are power and truth, different and obscure now, but no less everlasting.

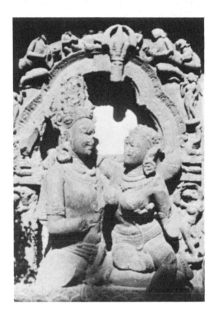

TWO

ANTHROPOMORPHIC
MASKS OF THE GOD

As ubiquitous in their representation as they are encompassing in their inspiration, the gods of the Ancient Lore are by no means confined to the backwoods. Their multiform countenances are inalienably part of the great temple's iconography. Often inconspicuously, almost discreetly, blending into its figurative composition, often, again, assuming ostensibly orthodox guises, and in either case interpreted in terms of Hindu legend and tradition, their true nature has escaped identification. But, if in the great temple they have remained the mute heralds of a profound commitment, the guardians of an immemorial secret, in the villages of the countryside they show themselves openly, assertively, persistently, in a kaleidoscopic multiplicity of shapes and postures. Here they evoke a supernatural world at once immediate and remote, vivid and obscure, fascinating and alien. They seem to reveal themselves, yet prove forever unfathomable, for, while their contours are palpable, their identities remain elusive and, with them, their original characters.

Fig. 9. Head of a yaksha. Navagaon, M.P.

Fig. 10. Folk divinity. Dharshiwa, M.P.

Familiar though these deities of old are to the villager, exploration of their identities can expect little help from him. He knows them intimately in all their propensities, their promises and terrors; but, flowing from his own unique relationship with them, his knowledge is defined by his subjective experience. His neighbor may, and often does, venture a different interpretation. Even the pūjāri[1] may not be certain of their names, and their legends appear vague and often contradictory. Frequently the same image may be known by four or five appellations and may find as many diverse exegeses. Thus, a highly polished figure at Keshorai Patan was variously explained as a rishi, an unspecified incarnation of Vishnu, a yaksha, and an ancestor of the ruler of nearby Kota. Similarly, an image at Kawardha was variously described as a likeness of the local maharajah's ancestor and his wife, as Vishnu and Lakshmī, and as a mysteriously nameless holy man of long ago who had attained semidivine exaltation. Such ambiguities haunt countless other sacred effigies. At Navagaon the sculpted figure was proposed to represent Shiva, an unspecified local deity, a yaksha, and an originally secular but divinely exalted hero who had become that village's special guardian. At Malhar a strange torso armed with a club evoked the same kind of many-pronged argument. Other icons, like that at Mahamadpur, seem even more enigmatic and equivocal. The birdlike emblem sprouting from the cranial apex seems incongruous with a countenance whose vermilion markings might suggest Shiva,[2] though its disembodied contour carries no trace of Shiva's features. It cannot even be certainly identified as male, the less so as it is placed near a small shrine to Mahāmmai, the local aspect of the goddess. It left the pūjāri as incapable of elucidation as his counterparts faced with the odd, often bizarre images at Dharshiwa, Karnali, Chhapri, Bhojpur, Ratanpur, and Bagh, among so many more. All he would repeat was that this figure was "deva"—a divine being, a god.

In the final analysis, this generalization might well have been the most pertinent and inclusive explanation. The forthright admission of ignorance, the refusal of further specification or elaboration, expressed a realization that all particulars of designation and identification were but externalities

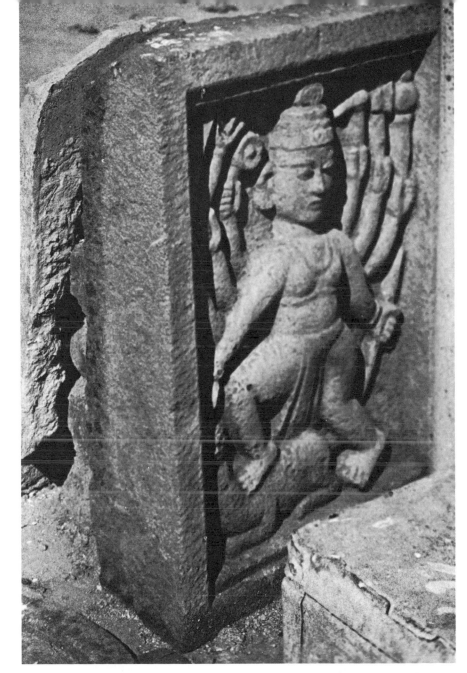

Fig. 11. Local divinity, assimilated to Durgā. Kubeshvara temple, Karnali, Gujarat.

irrelevant to the intrinsic character of the icon, its sacred and magical, supernatural and mystical immanence. The mysterious countenance was "deva." Transcending the transient partialities of doctrinal definition and differentiation, this statement spurned religious departmentalization; and, implicitly recognizing the incidental aspects of the Divine as illusory, it submerged the apparent diversities in the common essence. Whether Shiva or yaksha, symbol of some elemental force or apotheosized sage, male or female, this image was, like all other images, but an emblematic actualization of the Power Beyond. The specifics of form and the contingencies of

nomenclature were no more than varying emphases of the same human experience, conditioned by the trivialities of time and locale, and meaningless before the infinitude and all-presence of that Power. In defining that recondite design at Mahamadpur as "deva," the pūjāri produced the only substantive identification: one applying equally to the multitudes of icons throughout India; for they all are visualizations of the Divine in Being, and their names or legends, postures or attributes, however dissimilar and contrasting in their multiformity, are essentially immaterial.

This realization is evidently shared by the people of the countryside. In-

Fig. 12. Local divinity, with face carved on his body. Mahādeo temple, Bhojpur, M.P.

Fig. 13. Local divinity with face carved on his body. Mahākāleshvara temple, Bagh, M.P.

tellectually it may be ill-defined, its outlines and implications may be less conscious, but experientially it has been apprehended and internalized. An integral part of their religious heritage, the concept of divine oneness, has remained their fundamental inspiration, as attested by the analogies of ritual reverence and reflected by the unfailing mirror of idiomatic usage. The latter, especially, exposes the diversities of the local gods as apparent rather than substantial, as variant aspects rather than separate entities of the supernatural essence.

This fact becomes fully manifest only as one tours the backwoods of India. Here almost every little town, every village, every hamlet, honors its own special deity defined by distinct, even unique features, and credited with specific powers and assigned specific dominions. Yet, even where their traditional names are still unforgotten, it is not by them that these deities are most commonly invoked, and in many places those ancient appellations seem to have become altogether unfamiliar to the everyday usage of the community. So much indeed have some of them fallen into disuse that even the pūjāri himself refers to his god as "Balaji."

Transcending the differences of dialect and custom and regional idiosyncrasy, the name "Balaji" bespeaks the unity of the religious experience. Local designations and iconic shapes are but the ephemeral emphases of the transcendent Essence that has one name only. Throughout the countryside, across the broad belt of the central and northern Deccan, "Balaji" identifies the male divinity, regardless of his peculiar character or legend, aspect or function, often regardless even of his appearances in the various guises of the orthodox godhead.[3] He is at once the majestic figure at 9 10 Navagaon and the scurrilously gnomelike one at Dharshiwa, the enigmatic 12 V one at Bhojpur and the bizarre one at Ratanpur. Presiding over sites hundreds of miles apart are a thousand supramundane countenances in a thousand places across the map of India, a thousand masks of the Divine presenting themselves in their endless diversity of posture and attribute—here 14 kneeling, with a phallic staff pressed to the body; there sitting, a club in

Fig. 14. Club-armed Balaji. Sakhigopāla temple, Sakhigopāl, Orissa.

the clenched hand; standing, terrifying in a monstrous stare; freakishly VI three-legged, in the throes of an ecstatic dance. Or, again, triumphant in 15 conquest, elation on the semizooidal face; agonizing with a spectral leer, 16 epitome of preter-human savagery; gloating over a trampled victim, violence IV bursting from ten arms and five snoutlike faces; stolidly remote, ineffable with self-conscious power; placidly affable, features faint with a suggestion of benevolence; motionless, watchful, with torch and dagger, guarding the gate; martially mustached, shattering the enemy hosts by the force of a giant tread and the blow of a merciless cudgel; self-satisfied and self-possessed amid the accouterments of exaltation, incongruously calm and calming as a severed head dangles from one of four hands; exultant in victory, glorying in his adorers' worshipful submission. A thousand masks of the Divine, and all are Balaji. The pūjāri at Mahamadpur might well have so designated that enigmatic countenance on the stone slab also. But, perhaps uncertain of its sexual identity, the designation "deva" seemed more neutral, more noncommittal to him. Even so, one villager, less cautious than his priest and evidently judging the image to be male, did in fact call it Balaji. Nor would the pūjāri object, for this appellation is appropriate to the male divinity everywhere.

Fig. 15. Dancing Balaji. Balahotra temple, Srīgovindapur, Orissa.

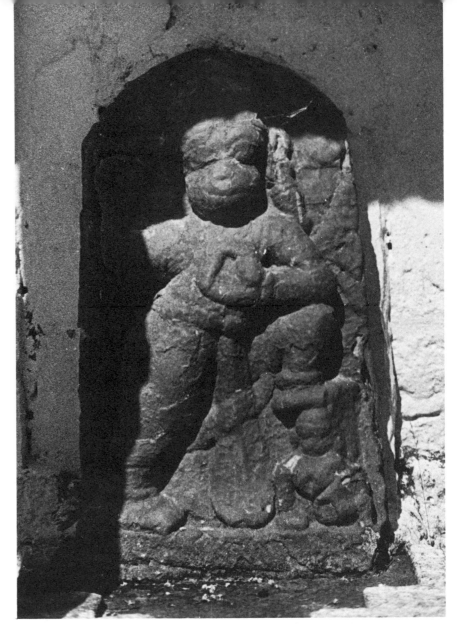

Fig. 16. Maroti-type Balaji. Ramchandra temple, Ramtek, Maharashtra.

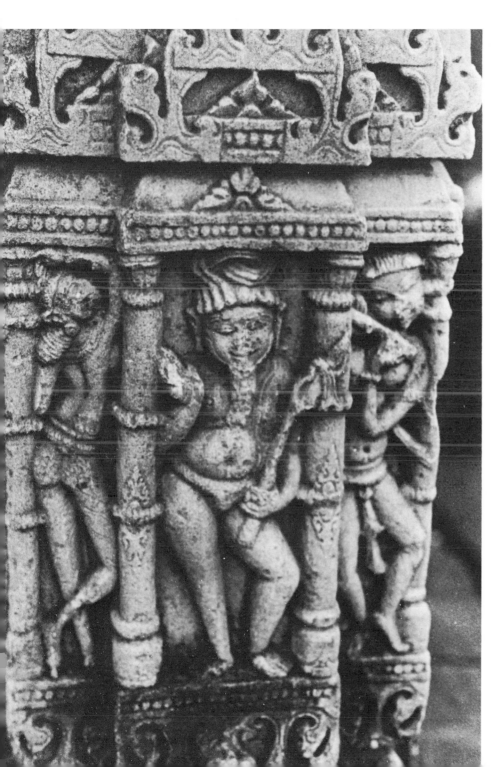

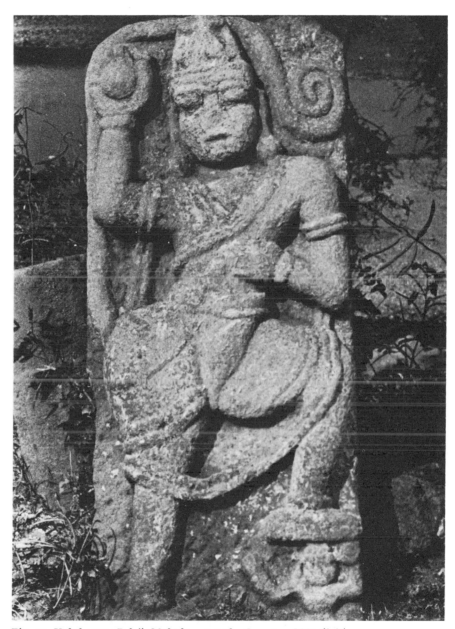

Fig. 17. Yakṣa-type Balaji. Mahādeva temple, Surwāya, M.P. (left)

Fig. 18. Maroti. Someshvara temple, Rajura, Maharashtra. (above)

21

Fig. 19. Mask of Balaji; trishūla; and stylized lion on temple wall. Sakhigopāla temple, Sakhigopal, Orissa.

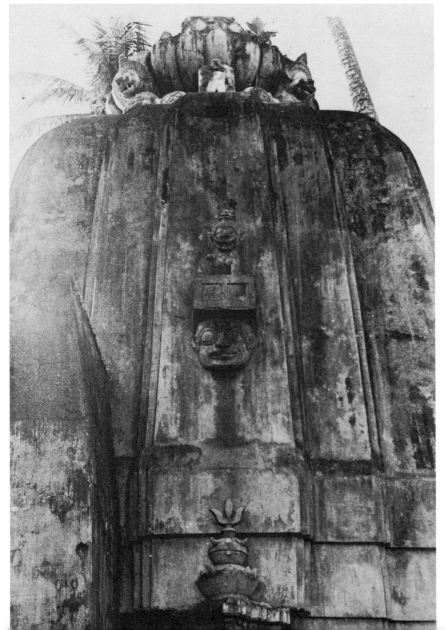

It is its role as the vehicle of India's most ancient and most authentic tradition, that of the One Transcendent Essence of which the divinities are but ephemeral masks, which makes this appellation so universally applicable. And this role is implied in the semantics of the term. For "Balaji" does not represent a proper name or, strictly speaking, an invocative formula, but an epithet which time and usage have converted into a title. Composed of the Sanskrit *bala*, signifying "might, power, strength, vigor," and the suffix *ji*, which combines the ideas of "beloved" and "revered," it is an honorific remarkably recalling the Syrian-Canaanite one of El, the "Strong One," which was later adopted by the Hebrew lord in a plural form, *elohim*. Thus connotatively analogous to the Judeo-Christian designation, "the Almighty," it provides a true rendering of the concept of a singular power encompassing all possible capacities, characteristics, and manifestations of the Divine.

It seems, therefore, hardly surprising if throughout the backwoods of India not only many purāna mandirs but even larger and more elaborate temples should be found dedicated to the divinity under that generic title; for it denotes *any* male deity, even where iconography and symbology might present him as some familiar denizen of the supramundane sphere. Whether he appears, as at Surwāya, in an aspect ostensibly portraying the likeness of a yaksha; whether, as at Raipur, his absurdly grotesque form is confused with that of Dugdhadharī, the eternal provider;[4] whether he may present himself with the characterizing tail of Maroti;[5] whether, as at Nagod, his image may be officially revered as that of Shankara; whether the telltale emblem of the trident or even the attributes of both trident and bull[6] might bespeak his identification with Shiva; or whether he is depicted in the three-headed (*trimūrti*) aspect of that god's *maheshvara* manifestation[7]—whatever his official identity, he is, at least concurrently, addressed as "Balaji."

Though this title is frequently applied to the deities of the Hindu pantheon, and by far most commonly to Shiva, the iconographic evidence can leave no doubt that it originally pertained to the divinity of the local non-Hindu tradition. Clearly, "Balaji" has been a characteristic appellation

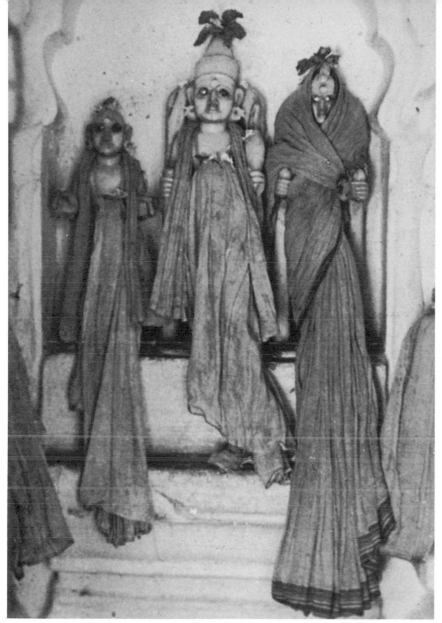

Fig. 20. *Triad of folk divinities on an altar. Brideshvara Mahādeo temple, Ratanpur, M.P.*

of the folk deity, a collective designation of the immemorial representative of the supernatural power. Though its universality and inclusiveness encouraged its extension not only to old-religion divinities but also eventually to members of the Hindu pantheon, the antecedents of its usage seem well confirmed by the effigies identified as Balaji. Whatever associations with the orthodox celestials their attendant symbols and attributes may appear to establish or their specific configurations may seem to suggest, they invariably carry the imprint of folk imagery. Their contours and miens reflect the locally qualified, yet typical, visualizations of the non-Hindu, often

Fig. 21. *Jagannath mask. Jagannātha temple, Arang, M.P.*

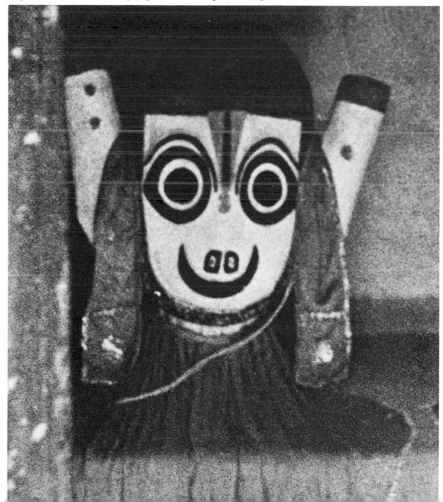

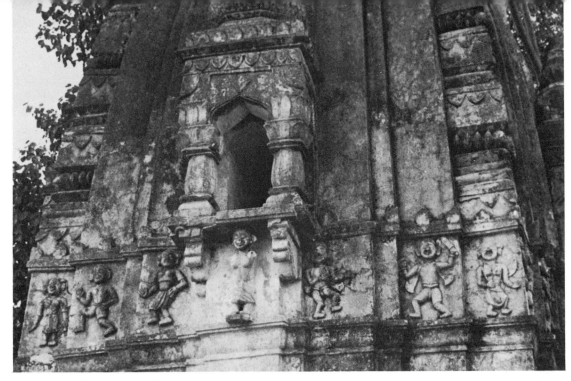

Fig. 22. *Local goddess surrounded by folk deities. Shankara temple, Gatora, M.P.*

Fig. 23. *Shankara dancing amid group of supernaturals. Shankara temple, Wakri, Andhra*

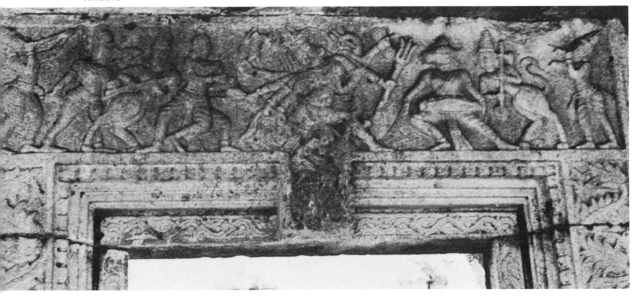

Fig. 24. *Procession of supernatural beings. Fresco, Bharunai temple, Khurd. Orissa.*

pre-Hindu, divinity, visualizations testifying to an entirely different dimension of metaphysical experience and conception, and bespeaking the stubborn power of heterodox inspiration and belief which asserts itself even within the precincts of the authoritative faith. That sightless mask,
19 with the protruding tongue, gazing from the temple dedicated to Vishnu's aspect as Krishna-Sakhigopāla, the companion and friendly shepherd of mankind, could not have sprung from the world that originated Vishnu. That utterly bizarre figure with the little cap perched on the nearly feature-
v less face, reinforcing its scary primitivity, may be identified by the symbolic trident as the rightful occupant of the alter niche in the temple of Shankara but his contour and countenance are as alien to Shiva's accepted image as are those of the more sophisticated, trident-and-bull-defined deities presiding over other temples. All of these images are the likenesses of local gods assimilated into the reigning cult, the odd and scurrilous, freakish and ambiguous shapes of the Divine across the Indian countryside.

Their assimilation has always been fragile, and in terms of its purpose it has been generally ineffective, for in its very quaintness or monstrousness the heteromorphism of these icons overrides and finally negates the apparent testimonies of symbol and affiliation. In retaining their traditional aspects, these folk divinities have retained also their roles as the authentic vehicles of the old religion and, as the evidences of pūjā attest everywhere, it is in these roles that they are primarily recognized and revered by the people of the countryside.

In fact, the perseverance of the old religion has made assimilation a two-way street. Not infrequently, the gods of the authoritative creed are found assuming the characteristics, donning the masks, and affecting the attributes of the folk deity. The main altar niche in the Jageshvara-Mahādeo temple at Bhandakpur, for instance, reveals an array of divine images, ostensibly representing Krishna, Shiva, and Durgā as a trinity in the background, with another likeness of Shiva rising in the foreground. The figures are well defined by their standard attributes. Krishna has his flute, both Shiva icons carry the trident, and Durgā is accompanied by her lion. Yet, except for Krishna's, whose posture is characteristic and traditional, none of these images displays the accustomed and conventional features of the Hindu deity. In their different ways they exhibit the disturbingly remote, unworldly and nonhuman, strangely ghostlike countenances of the folk divinity. Originally, it seems, their depictions had been conceived in the patterns of the canonical deities, but at some point the emotional force of an older inspiration superseded the original purpose and imposed its own vision of the Divine.[8] This process is by no means unique. It must likewise be postulated, for instance, for the divine trinity in the Brideshvara-Mahādeo temple at Ratanpur, which assumes a variant but no less typical aspect of folk imagery. 20 Here the prevalent, masklike quality peculiar to its creations emerges even more forcefully to intensify the haunting eeriness of those figures whose garments and floral crowns recall a special holiday's puja. Similarly, in the Rādhākrishna temple at Baonra the sacred enclosure presents the likenesses of the divine lovers to whom the sanctuary is dedicated. But, except for the identifying emblematic flute, this image of Krishna has nothing in common with its orthodox counterparts; nor does the likeness of Rādhā bear any resemblance to her customary portraitures. Once again, folk tradition has intervened to invest the celestial pair with a touch of unrealness which chills the childlike, almost playful grace of their carefully garbed forms. Once more the masklike quality of the icons is inescapably vivid. They seem like puppets moving on invisible wires across a shadowy stage.

This mode of representation reaches its ultimate denouement in such creations as the disembodied masks, at once whimsically affable and weirdly spectral, which tenant the altar of the Jagannath temples throughout 21 Orissa and Eastern Madhya Pradesh. No less persistently and ubiquitously it recurs in the less startling but cumulatively impressive variant of the stone-carved *kīrtimukha*, the stylized and patternized "demon-face" which has come to form an integral constituent of temple iconography.[9] To varying extents it has imposed itself on the bulk of folkloric imagery, endowing its creations with that subtle yet distinctive aura of irreconcilable remote-

ness. Yet, though equal in essential significance, neither these icons nor the kīrtimukhas could match the impact of the Jagannath masks, before whose enigmatic drollness the divine presence becomes nonreality—intangible, incomprehensible, mysterious, a mystical equation of nonentity. This bewildering effect may well have been intended; perhaps not consciously but rather as the inevitable corollary of a metaphysical concept, part of an ancient heritage internalized by successions of countless generations.

The full compass of this concept can today be only conjectured. But, if the testimony of folk iconography is read correctly, it would seem to comprise a perception of cosmic structure in which the divine sphere is interposed between the antithetic spheres of transcendent reality and mundane realization. Not part of either, the gods are but puppets on the stage of universal being, intermediaries of the cosmic drama, its interpreters in terms of man's cognitive limitations. They are neither the creatures nor the heralds of that ultimate truth which remains forever an unfathomable and unimaginable mystery, but its distorting and deceptive disguises in which man may find reflected his illusion of truth.

The masklike aspect of the deity presents the symbolizing objectification of a cosmic perspective which germinally contains the notion of the eternal duality—the absolute and *māyā*, reality and world-illusion—a notion that emerges as the center of all Indian philosophy and metaphysical speculation. The fact that its depictive reflections are peculiar to the iconography of folk religion would seem to suggest that its inspiration originated in the ideational complex of non-Hindu, perhaps pre-Hindu, society.[10]

It is this conception of the deities as creatures of māyā, in varying shades of subtlety attaching to so many of the folk images to endow them with the quality of the nonreal, that accounts for their often bizarre and fantastic shapes, their abstruse and frightening countenances. Defined as chimeras of sensate delusion, these divine presences become mirrors, not of reality but of man's self; interpretations not of the transcendent but of his own world; revelations not of the eternally unrevealable but of his own nature. Outward projections of his aspirations and his dilemmas, their representations may take any form dictated by his confused and beguiling, anxious and sanguine dreams. Icons like those at Bhojpur, Mungeli, Chhapri, Dharshiwa, Ratanpur, and Raipur portray entities belonging to an extramundane rather than supramundane, extracelestial rather than infracelestial, dimension. Often a temple wall may display entire sections peopled by such phantasmagoric beings. The strongly zooidal suggestions of some of these designs approach the improbable, as on the lintel of the Shankara temple at Wakri, while the humanoid aspect predominates in such constellations as the array of remote, seated forms between the two flanking enigmatic masks at Kapilas, or the graphic rendition on the temple wall at Khurda.

Many of these otherworldly personifications have come to be known by diverse generic designations. As mere components of larger configurations, many others have lost their once specific identities, now being perceived collectively only as "celestial hosts." Yet, singly, each might fittingly be addressed as Balaji, for each looks back on an individual existence as a particularization of the old religion's all-inclusive Power, a role that may claim the title of Almighty. Each of them once was a local deity, a yaksha.

The designation "yaksha" is still applied to some of these deities, but in what seems an arbitrarily limiting fashion, as though pertinent only to a special species of pretermundane being. However, the generally accepted definition of the yaksha as a "class of demigods, attendants of Kubera," seems to be contradicted by the semantic implications of the term itself. Even disregarding the always present possibility that the appellation may have been adopted from the native language, and considering only its Sanskrit etymologies, it would appear that its putative derivation from *yaksh*, "hasten forward," is, in spite of the weight of official approbation, the least likely because the least reasonable. Nothing in the yaksha's iconography confirms, or even suggests, his character as a "speeder." Some of his depictions, it is true, show him in various types of motion, but the vast majority present him in stationary postures. Moreover, his female counterpart, the *yakshī* or *yakshinī*, appears almost always in more or less static

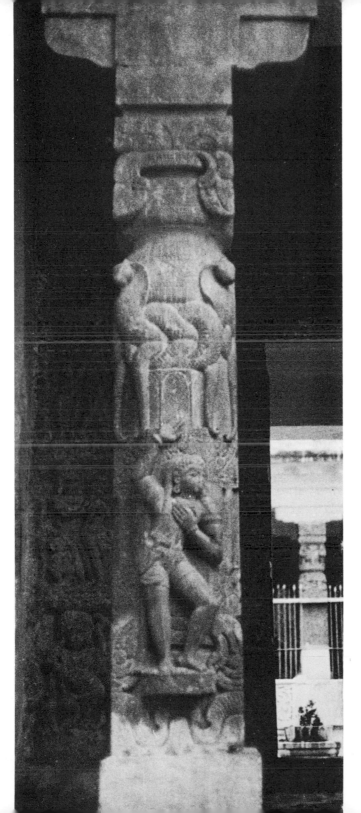

poses which confute any idea of "speeder." Nor does terminology substantiate the yaksha's classification as a "gnome or fairy."[11] On the other hand, either of two other alternative etymologies provides plausible interpretations. One is proposed by the term *yakshin*, "living," which would bestow to the yaksha the meaning of "living presence" or, perhaps by extension, "eternally living presence," thus emphasizing the essential quality of the Divine. The other may be found in a possible derivation from the aoristic base of the verb *ya*, "to worship, to sacrifice to," which would describe the yaksha as "one to whom worship had been rendered and sacrifice proffered," thus implying his authentic status as an object of devotion and cult, but one belonging to the indigenous past rather than to the Hindu present.

Both of these etymologies define, in their different but complementary ways, the yakshas as old-religion divinities. Moreover, they accord with the finding of Coomaraswamy's penetrating examination of the yaksha figure[12] to the effect that "the designation Yaksha was originally practically synonymous with Deva or Devatā, and no essential distinction can be made between Yakshas and Devas." This identification as devas would, of course, make plausible the yakshas' characterization as gnomes or fairies, supernatural creatures that everywhere represent the collectives of diminished transcendent forces. It would also accord with their interpretation as "local tutelary deities, who are the lusty guardians of the treasures of the earth."[13] Though it needs to be qualified, Basham's conclusion seems most pertinent. "Before the Christian era," he says, "their cult was widespread, but they lost their significance as the great gods of Hinduism became more widely worshipped."[14] In fact, their significance was not lost but merely reinterpreted; and their cult was not discontinued in favor of that of the Hindu gods, but just largely restricted to the vast rural hinterland where it kept flourishing alongside, and often in preference to, the orthodox dedications. Basham acknowledges this by stating that they (the yakshas) are "worshiped by the country people."[14] So they have always been. They remain the traditional divinities of the countryside, essentially changeless, retaining their primeval character as agricultural gods. Hence their frequent, if rather

Fig. 25. Yakṣa beneath intertwining serpents. Rājīvalochana temple, Rājīm, M.P.

27

loose, designation as "earth spirits," which hardly does justice to their true exaltation and importance as the once all-powerful local protectors of life itself. Thus, Zimmer's reference to their function as "guardians of the treasures of the earth" must be understood in terms of the original rather than the subsequently acquired, mythopoeic meaning. Those treasures were not, as later supposed, jewels and precious stones in the depth of the earth, but the treasure of perennial regeneration and growth and nutriment hidden in the earth over which these ancient deities presided.

Consequently, the yaksha figure may assume any shape or posture. Divinity comprises all aspects. Variants of depiction merely reflect local and temporal specializations of viewpoint and esthetics. In early representations, such as the familiar specimens of Sanchi and Bharhut, the yaksha's muscle-bound immobility seems intended to suggest his superhuman status and grandeur. Many later ones still echo this design, persisting in a similar rigidity of stance, though the raw strength of the bodies is no longer so imposing. Others repeat the huge physique of the Buddhist models, but a twist of motion may endow the figure's latent power with a dimension of captivating immediacy. Collectively they confirm Coomaraswamy's conclusion that "early Yaksha iconography has formed the foundation of later Hindu and Buddhist iconography."[15]

Generally the yaksha presents the countenance of the local folk deity,[16] often claiming reverence as Balaji; but, quite frequently, he has come to be identified with the divine figures of more orthodox persuasions. He assumes Shaivite or Vaishnavite features, and posing as a divinely exalted ancestor is one of his favorite disguises. This process of assimilation is most common when he appears in the role of the *dvarapāla*, the guardian of the gate, a role that, enacted by him in the times of Sanchi, has become his preeminent and traditional function.

Few peculiarities of Indian iconography demonstrate the survival of the old-religion deity and the perpetuation of his hold on the popular mind as implicity as does the yaksha's assignment as dvarapāla. The sanctuary may celebrate the sublime Buddha or extol the supreme lords of the universe,

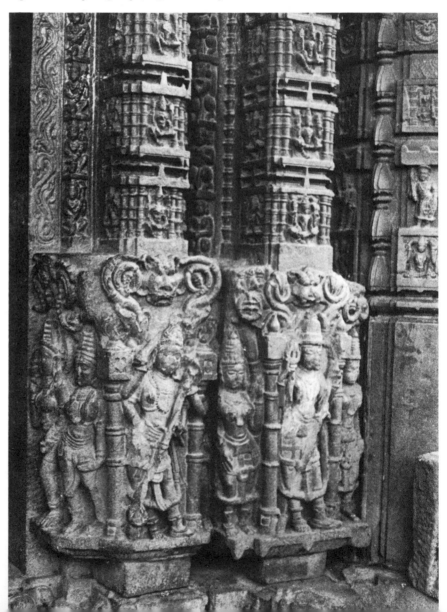

Fig. 26. Dvarapāla group. Nāganātha temple, Aundha, Maharashtra.

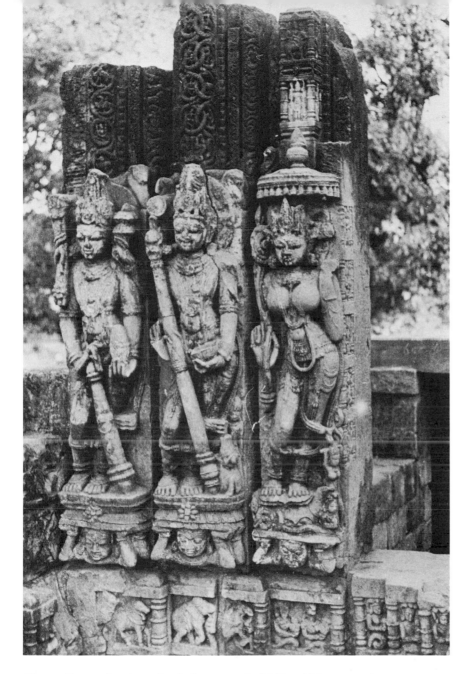

Fig. 27. Dvarapāla group. Pātāleshvara temple, Malhar, M.P.

Shiva and Vishnu; it may house the altars of the Jaina saviors or of the Adorable One, Krishna; yet its safety from the assaults of evil demons and irreverent spirits is entrusted to those gods of old. To them, rather than to the nominal masters of the sacred precincts, is imputed the true and effective power that will protect the abode of the reigning divinity. They may have been demoted to mere subalterns, serving the celestial ruler who commands all official devotion; they may have been reduced to retainers who affect his special emblems as indicants of the ostensible source of their derived power as, fierce with their clubs and lances, their swords and long staffs, they stand sentinel at the gate. Yet, in their apparently humble positions they are the essential sustainers of the divine world, indispensable to its preservation. This curious, left-handed exaltation presents a singularly Indian phenomenon, inexplicable except by way of recognizing the old-religion deity's persistent actuality to the Indian experience. The yaksha's role as dvarapāla proves that, however his external dignity may have been abased, his internal authority has remained undiminished.

This is why, for the grandiose temple and the unassuming country shrine alike, the yaksha is the prerequisite guardian of the gate. In fact, many of the isolated figures now receiving devotion on their own account may have started their careers as dvarapālas. Separated from their original locations by the inroads of time and weather, they have come to assume their separate existences. It is for this reason that they are so often found near or within the temple precincts, as for instance, the previously mentioned Balaji likenesses in Chhapri or Mungeli or Navagaon. Many more yaksha dvarapālas IV VI 9 have retained their stations and, as the flowers strewn about them so frequently attest, have continued as the objects of discrete and personal pūjā.

Most often it is not the single yaksha who watches over the sacred precincts, but a group of guardians almost always including, and frequently 26 featuring, the female likeness of the old-religion divinity.[17] At many gates the Shaivite, staff-armed figures are joined by female counterparts in dancing poses. At others, as in Malhar, the juxtaposed groups consist of two males and one female each, the latter being placed next to the entrance. At Barwa 27

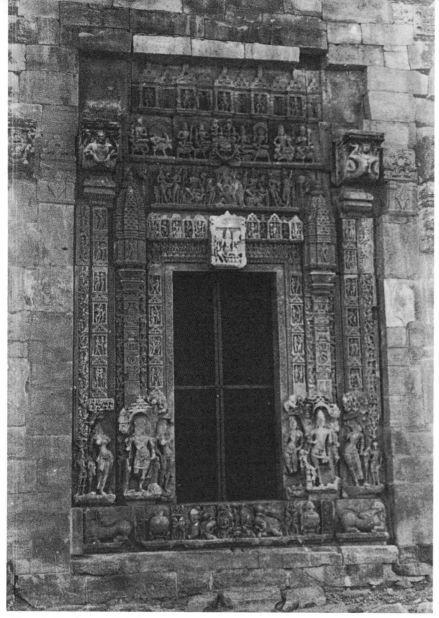

Fig. 28. Entrance to Jārakā Mātā temple, Barwa Sagar, U.P.

Fig. 29. Yakshīs as dvarapālīs. Mahālakshmī temple, Chandol, Maharashtra.

28 Sagar this ratio is reversed, the male appearing between two females in seductive poses. Elsewhere foursomes of guardians are evenly balanced, but once more with the females next to the sanctuary's access, while at Aundha the guardian contingents are extended to hexads, in which the females

26 preponderate. Even the simplest shrines, though otherwise bare of imagery,

29 still offer the traces of the dvarapāla presence, with exclusively female guardian groups by no means an exceptional feature.

This emphatic inclusion of the female presence is not the least of the indications pointing to the old-religion origin and nature of the yaksha dvarapāla. Aside from the predominance of the feminine which it reflects, a predominance fundamental to folk tradition,[18] it also implies that it is not to the power of any specific deity but the encompassing Power in all its aspects to which the ultimate protection of the temple is committed. As has been noted, this concept of divine oneness is characteristic of the native non-Aryan rather than the Aryan-inspired religious perspective.

The god of backwoods India is still the yaksha, and in his likeness the people of the countryside have continued to shape their images of the Divine. As often as the aboriginal deity has assumed the symbolic paraphernalia of the orthodox, it has in turn imposed its own features on the canonical divinities. Beautifully polished in their intricate elaborations, their every posture and attribute strictly circumscribed, the canonical portraitures of Vishnu and Shiva and Brahma, and of other members of the official pantheon, grace the walls and pillared halls of the temples. Admired for their artistic merits, these countenances have preoccupied the scholar's interest, and their reproductions have preempted the publications of India's iconography. But their equally numerous counterparts presented in the likeness of the ageless folk divinity have not enjoyed similar familiarity.

Yet the folk divinities counterpoise the canonical divinities everywhere; by no means only amid the sometimes crude imageries of the simple village shrines, but also side by side with the more conspicuous depictions of the orthodoxy in the great sanctuaries of Hinduism. As a random example, the Someshvara temple at Karnali, renowned as a focus of pilgrimage, reveals

Fig. 30. Vishnu Trivikrama. Setganga temple, Setganga, M.P.

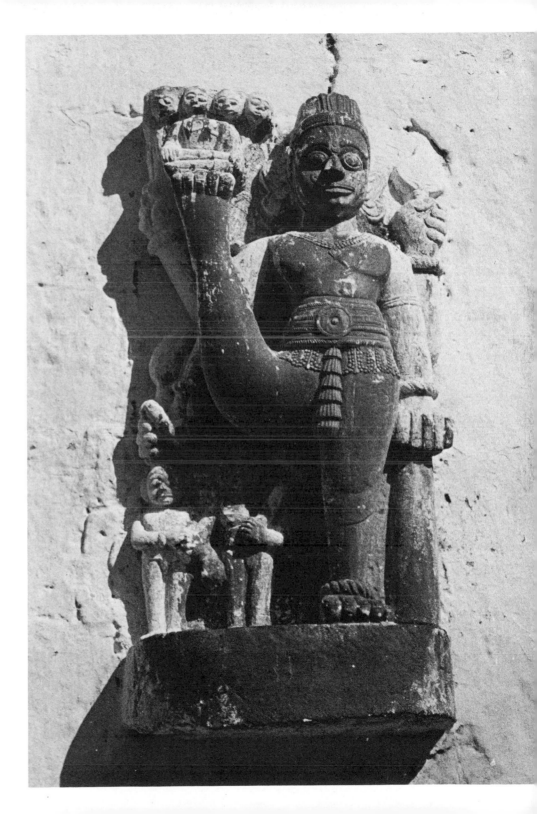

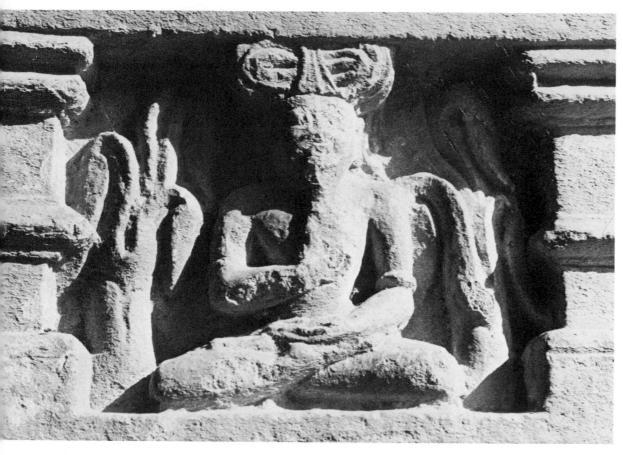

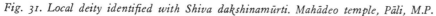

Fig. 31. *Local deity identified with Shiva dakshinamūrti. Mahādeo temple, Pāli, M.P.*

Fig. 32. *Shiva and Pārvatī. Kubeshvara temple, Karnali, Gujarat.*

amid its otherwise traditional sculptings the seated figure of Vishnu, fully identified by its standard attributes yet with the features and physique of the folk deity. At Banpur, another famous center of pilgrims' devotion, the elephant-borne god is depicted with similar characteristics. The traditional configuration of Vishnu and Lakshmī in the Vithala temple at Hampi reflects in shape and mien the impact of heterodox influence. At Mandsaur,

again, his role as dvarapāla affirms the yaksha aspects of the Hindu deity as Harihara, the lord in his manifestation as Vishnu and Shiva combined.[19] At Setganga, only his legendary posture as he takes the last of his three universe-encompassing strides identifies Vishnu *trivikrama*,[20] for his countenance is typically that of the yaksha. Moreover, the singular symbolization of his supernality by having the four heads take the place of the toes

30 echoes the old-religion rather than the orthodox concept of the Divine, even though these heads, ostensibly those of Brahma, pretend to express this concept in terms of orthodox symbolism. The indigenous inspiration of this image seems the more plausible as the story of Vishnu's three steps appears to have its roots in non-Hindu myth.[21] This design of the fourfold Brahma heads, though uncommon in its specific application at Setganga, returns to signify the identical idea of transcendent nature, as at Rajim, where it appears on the chest of a yaksha-featured Vishnu.

The latter representation depicts its sacred subject with the overpowering muscularity of the yaksha's characteristic physique, which so often bespeaks the folk-divinity nature of the Hindu godhead. This trait, however, is more commonly found in the Shiva image; after all, it is this god, among all the figures of the orthodox pantheon, who is by far most consistently identified with the local deity.[22] Many of Shiva's artistically most exquisite, otherwise traditional portraits still retain the prototypal contours of the yaksha likeness established by the models of Sanchi and other Buddhist sanctuaries. Yet other Shiva likenesses reveal his identification with the local deity even more explicitly. At Pāli, for instance, he appears among the conventional depictions of the Mahādeo temple with features so expressly those of a yaksha that he would be unidentifiable except for a curiously plantlike

31 stylization of his trident and for his characteristic teaching posture. In the Kubeshvara temple at Karnali he is presented in the traditional constellation with his *shakti*,[23] but with a countenance wholly untraditional. Its traits

32 and expression are those of the local deity. At times, too, that strange masklike quality, that surrealist puppet aspect which so often characterizes the folk divinity, is transmitted to his likenesses to make him a creature of a dream world, of that intangible sphere of māyā where even the all-inclusive vision of the Divine is but illusion; where even Shiva Maheshvara, the Great Lord, becomes only a chimera spawned by man's mind, part of the same infinite expanse of nonreality that has given shape to so many

33 effigies, such as that of Vishnu at Shivpuri.

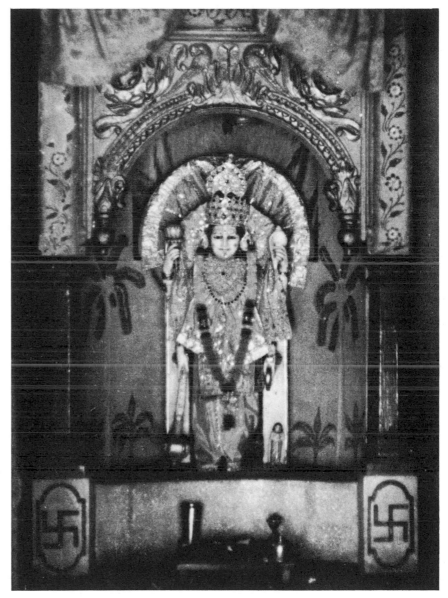

Fig. 33. Vishnu. Mahāmāyā-Siddhīshvarī temple, Shivpuri, M.P.

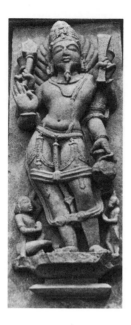

THREE

THE CANONICAL GOD

Few Hindu icons have remained unaffected by the native perspective of the Divine. Almost invariably some traces of this interaction persist, however minute, and discernible only to careful scrutiny. Everywhere the ancient traditions have amended and qualified the countenances of the Hindu gods. At times obviously, more often subtly, they have imposed themselves on the lesser and the supernal exponents of the orthodox pantheon alike, and even on its surviving Vedic members. Among many examples one might recall the image of Sūrya at Konārak. Here the herculean likeness of the old sun god repeats the prototypal physique of the early yaksha figure.[1]

These effects of folk tradition on Hindu iconography are indeed incisive and conclusive. Even so, they seem vastly overshadowed by the imageries explicitly originating in and shaped by the heritage of the old religion. For, though the syncretistic character of Hinduism as a fusion of Indo-Aryan and indigenous concepts has long been appreciated and consistently noted, the extent of the latter's share in its religio-mythic formulations

and their representational equivalents reveals itself as far more substantial than might appear from the generally cursory references. Many, if not a majority, of the preeminent manifestations of the Hindu deity have their roots in the transcendental perspective of non-Aryan India. They owe their very existence to her specific experience and primal vision of the Divine. However their extant imageries may conform to the prevailing, canonically sanctioned esthetics, however their features and postures may reflect the approved and established patterns, they are but the official creed's refurbished stylizations of an essentially alien inspiration. This fact is most forcefully demonstrated by the iconography of those dual protagonists of Hinduism's male shape of the Divine, Vishnu and Shiva, who in their sublime aspects incorporate the very essence of this inspiration; and it is significantly, if circumstantially, corroborated by the observation that it is precisely in the back country, the prime repository of native tradition, that these aspects assume a more decisive, often dominant prominence.

While a complete exploration of these divinities and their manifestations would reach beyond the context of this study, their importance for the religious and iconographic expression of the Indian countryside demands at least a summary consideration.

Vishnu's legends have, of course, long established his nature as a composite deity, and some authors have, if only by implication, recognized the multiple accretions of native lore to his original character as a new version of the Indo-Aryan solar creator god.[2] Initially a subordinate Vedic deity associated with Indra and the Ādityas, he gradually gained prominence only as the prestige and popularity of his similar predecessors declined, together with the Vedic religion, under the resurgence of native religious concepts and cult patterns. Vishnu's affinity with those older solar gods of the Aryans became one of appearance rather than substance. His name, it is true, still recalls his original nature; it means "Energizer, Stimulator" and represents an epithet commonly applied to the sun, but his ascendancy itself was based on his non-Vedic character. Retaining but the formal traits of the traditional Indo-European creator god,[3] Vishnu came to serve as a convenient shell of Aryan godhead to be filled with the contents of more meaningful beliefs and experiential cognitions, some universal among the indigenous peoples, more often of broadly regional importance. From western India (apparently including parts of present-day Rajasthan and perhaps Gujarat), he assimilated the very ancient cult of Vasudeva, by which title he is still being revered, though most often in his incarnation as Krishna. From another area, probably the region of the Vindhyas, he syncretized to his own cult that of a great deity, Nārāyana, and in this manifestation he has continued to receive widespread worship. Throughout the country many major sanctuaries have been dedicated to Vishnu's role as Nārāyana,[4] which, as "the human vehicle of the Divine," appears to emphasize the immanence of godhead in inherent contrast to the Aryan-Vedic, and generally Indo-European, concept of the generic dissimilitude of gods and men. Other native divinities of lesser eventual, though not necessarily lesser original, prominence have also been received into the cultic and mythic compound that is Vishnu. Thus the preeminent recurrence in Orissa of his worship as Jagannātha, "Protector of the World," might suggest that this title, too, may have been inherited from a preexistent Aryan deity in the process of the latter's identification with the great lord of Hindu tradition. The peculiarly regional character of the preference for this divine aspect tends to support this possibility.

Yet more significant are the god's avatārs. These "incarnations" are not merely vehicles of the old-religion heritage; whether anthropomorphic or zoomorphic,[5] they represent the unmistakable reembodiments of old-religion deities in canonically sanctioned disguises. The many clues offered by legend and nomenclature, and especially by iconography, make these disguises even more transparent than may seem at first glance. From their evidences, Basham's appreciation that "popular divinities were in one way or another identified with him [Vishnu],"[6] long shared by students in the field, may need a change of emphasis. Rather than being identified with Vishnu, these gods of old have retained their own distinct and independent

identities, with no common denominator save their native origins and the fortuitous incorporation of their individual legends in a collection of myths tortuously grouped around a central figure of orthodox legitimation.[7] These legends have, of course, been severely altered, but enough remains of their original versions to point to their non-Vedic geneses. Incidents and etymologies substantiate their true descents, and the imageries which give them their visual expressions provide the final clues.

Even the cursory consideration feasible within the present context should prove persuasive enough. The old-religion inspiration of the vāmana (dwarf) avatār has been noted, as has the yaksha physique typical of the abundant likenesses of "Vishnu of the Three Strides." This inspiration is even more obvious in the case of the famous Rāma avatār. In spite of its nearly complete and largely successful reinterpretation in terms of the Brahmanical viewpoint, some details of its story still carry the implications of its indigenous source. The Rāma of the epic that has made his figure so familiar is the conventional warrior-hero of Indo-European legend, the apostle and defender of the patriarchal system and ethos, whose "virtues" earn him canonization and ultimate apotheosis. Yet, as with so many of his mythic counterparts everywhere, the effective popular acceptance of this exaltation seems to have depended less on his newly refurbished character than on the lingering memories of his antecedents as a deity of the old religion with a cult apparently prevalent in the central and southern Deccan[8] but probably of wider import. His very name, Rāma, describes him as the "Dark-hued One," apostrophizing his native origin in apparent contradistinction to the lighter-skinned Aryans. His non-Vedic past has been remarkably reemphasized by his iconography, as he is usually depicted as a dark-colored figure. His legendary alliance with the "monkey" tribe led by Hanūman[9] paraphrases once more his authentic role as a divinity, a yaksha, of some aboriginal people. Because of the analogous nomenclature alone, a similar history must be postulated for Vishnu's far less familiar incarnation as Parashurāma, "Rāma with the Ax." This comparatively less prominent avatār may have originated in the cult of another, perhaps local,

native divinity important enough to prompt his adoption into the orthodox system.

By far the most extensively and devotedly revered among the anthropomorphic avatārs of Vishnu is that of Krishna. Beyond the fact that in popular dedication, scriptural reference, and iconographic presentation his legend and worship outshine those of all the rest, including even Rāma, he is the great god's one incarnate manifestation who has established himself in full independence as the focus of a sectarian cult. His final shape and character are the composite result of many diverse traditions and influences which deserve more intensive exploration than seems feasible within the scope of this book. However, all evidence appears to agree that the most powerful factors of Krishna's lore derive from his antecedents as an indigenous deity. In fact, these antecedents may be the same as Rāma's. Not only does his appellation carry the identical meaning of "The Dark One" or "The Black One," implying his native origin, but in fact he has been believed to be a later incarnation of Rāma himself. Certainly, an ageless divinity of western India, Vasudeva,[10] had been early associated with him, and he still carries this name as his eponym. Moreover, he unmistakably shares the prototypal features of the ancient Tamil Mayon, "The Black One," a god of cowherds who plays the flute and dallies with the milkmaids. His popular epithets of Gopāla and Govinda, both connoting "cowherd," recall his assumption and assimilation of Mayon's primary role and function. The many-faceted Krishna myth may well contain some contributory elements of early Aryan lore developed outside of India, but its essentially native inspiration could hardly have found any clearer expression or any more weighty witness than the story of its protagonist's clash with and victory over Indra. Here Krishna, the dark-hued god of the dark-hued, cowherding indigenes, is opposed to the warlord-god of the fair-skinned warrior tribesmen from the north. This confrontation at Mount Govardhana not only pits the divinities of two competing creeds against each other and so defines the terms of a historic, religious struggle; it also explains the aston-

ishing but inevitable ascendancy of the native god whose magic had proved more potent, so that he had to be recognized as a major divine power and accepted as such into the orthodox framework.

No doubt the "Black One's" integration into the company of the Aryan gods must have at first met with the greatest resistance which only gradually crumbled before overwhelming popular pressure. This opposition would not be directed only against his indigenous origin as such, but particularly also against his explicit and persuasive symbolization of the indigenous ethos and its underlying religious and social perspective. His supportive association with the Pāndavas, which defines him as their tribal divinity, carries with it his implicit approval also of the marital arrangement involving that quintet of brothers who all share Draupadī as their common spouse, an approval by extension applying to a system of fraternal polyandry which seems alien to Indo-European prepossessions in general. Again, Krishna's gospel of immanent rather than transcendent divinity, the fundamental thesis eventually expounded in the Bhagavad Gītā, must have been not merely foreign but repugnant to Indo-European conceptions of godhead generally and to Aryan ideology in particular.

Like the revealing story of the confrontation at Mount Govardhana, these items of legend and philosophy are among the few that have survived the jealous intrusions of the Brahmanical theologians. Their consummate editing has purged the Krishna myth of many indicative incidents, and their equivocal interpretations have blunted the points of still others. But all their efforts at orthodox rehabilitation of the Krishna tradition have failed to expunge from the people's affections the memory of the ancient beloved lord of the pastures and forests. On the contrary, the image of the earthily charming, intimately humane, and excitingly erotic, otherworldly companion of man that had captivated the dedications of native India has been ever more vividly recaptured in the course of the passing centuries. It is this image of godhead that, because of its superior humanity and promise, has proved so infinitely more attractive as a focus of worship than the grim warriors, severe lawgivers, and ineffable priest-kings of the Aryans' celes-tial domain; that, especially in the back country, has emerged as the cultically as well as iconographically most important aspect of Vishnu. Scores of shrines are exclusively dedicated to its worship. Its representations are commonplace on any temple consecrated to Vishnu in whatever identity or aspect and are often present even in sanctuaries celebrating some other form of the Divine.

In these representations, Krishna's guise as an avatār is flimsy, his connection with Vishnu perfunctory. Overwhelmingly they depict him in precisely those poses that are at most obvious variance with the Brahmanical conception of deity: as the joyous leader of rural celebrations, playing his flute for the gopīs' dance or for the greater glory of his adored divine mistress, Lakshmī; as the prankish youth who, having hidden the wraps of the bathing cow-maidens, is sitting in a tree to gaze in good-humored and distinctly sensual delight on their pretended embarrassment;[11] or, again, as the flirtatious lover of his favorite, Rādhā, who sometimes gently teases her, sometimes draws her close in a dance as a prelude to an hour of amorous abandonment. But scarcely ever do they portray him in the pursuit of any of his later exploits as a hero and king with which busy theological invention has credited him, or in the company of Rukminī, his legal consort according to the proper priestly rites. Significantly, even on his altars his likeness is joined by Rādhā, his female alter ego from his days as a deity of the native cult, rather than Rukminī, his official spouse; just as it is the former rather than the latter who receives adoration as a semidivinity. For Rādhā belongs to the Krishna of the indigenous tradition who, erotic and winsome, relaxed and affable, the authentic helper and understanding friend of man, remains the subject of the icons because he has remained the subject of worship and devotion. In him, Vishnu appears in the aspect and identity closest to the here and now of mankind and its immediate experience of the Divine.

If India's continued attachment to the heritage of the old religion is reflected in her emphasis on the worship and depiction of Vishnu's avatārs

rather than on his canonical identity as the supernal lord, it is even more forcefully attested by the back country's propensity toward Shaivite cult and imagery. Here it is not the previously noted· predominance of Shiva's presence as such that proves most indicative, but again the unmistakable accent on certain specific manifestations of this presence.

Shiva, of course, has no avatārs. Though numerous myths and legends have been related to his central figure and account for many of his aspects, his evolution toward sublime divinity has not been syncretic. Unlike Vishnu, he has no Aryan past nor even any Vedic association. His roots and antecedents are exclusively indigenous. He was no alien god who could extend his sway only by identifying himself with the local deities and permitting their cults to persist under the precarious veneer of orthodox legitimacy which his name lent to them. Though perhaps at the outset himself but a deity of specialized function, he has for ages been the great god of native India, masculine manifestation of the Divine whose essence encompassed all the regional and sectarian aspects. As such, he has been the prototypal exponent and vehicle of non-Aryan conceptuality and ethos, the personification of the old religion's perspective of Being. This of course amply explains the flagrant hostility and contemptuous rejection which he originally encountered at the hands of the Vedic priests. This antagonism is reflected in several myths, but it should suffice to recall the one recorded in the *Kālikā Purāna*, which describes the gods' deliberate refusal to invite him to participate in Daksha's Great Sacrifice on the grounds that he was a mendicant ascetic and thus ceremonially impure.[12] To put it another way, he was pursuing the practices of indigenous cult and worship and consequently was not merely unworthy of, but abominable to, the company of the Vedic celestials.

Shiva remained exiled from the world of the Aryan gods. Yet it was not

Fig. 34. Krishna playing to the dance of the gopīs. Shankara temple, Wakri, Andhra.

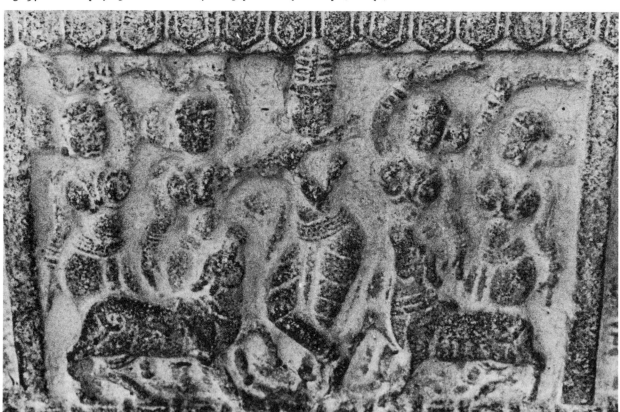

his power that atrophied, but theirs. While the cults of Indra and Agni, Mitra and Varuna gradually declined, his steadily gained in intensity and importance. While even Brahma's prestige ebbed to the point of virtual otiosity,[13] Shiva's continued in an uninterrupted ascendancy which made him the focal divinity of the emerging Hindu synthesis. Once again he was recognized as the one he had always been, the sublime lord, now frankly asserting the triumph of the old religion as he counterpoised Vishnu, whose Brahmanical antecedents were being used to disguise and belie it.

For all the attempts to purge him of his old-religion character and associations, and to adapt him to the sensibilities of the new orthodox establishment, Shiva has largely preserved his ancient identity. Though frequently enough his portrayals are patterned after the canonical image of supernal exaltation, the bulk of his iconography retains his authentic aspects, the vividness of countenance and contour which is so characteristic of, and apposite to the folk divinity's essential inspiration. Though perhaps more consistently so in the shrines of the countryside, these likenesses of the old-religion Shiva predominate everywhere. In their multiformity they tell the story of his origins and trace the distinct outlines of the conceptions that shaped his evolution.

Shiva's attested presence as a great deity 2500 years ago, and presumably much earlier, has long been recognized. The familiar ithyphallic figure on the Mohenjo-Daro seal,[14] seated in yogic posture in the midst of surrounding animals,[15] has been generally held to represent his antecedent form. Of course, his name was not Shiva then. If he was known by a proper name, it will remain forever lost unless, some day, the Indus Valley script is deciphered. At any rate, "Shiva" is no more a proper name than "Balaji." Like the latter, it is an epithet, a euphemistic appellation applied by the Aryans to a divinity of whom, not comprehending the totality of his nature, they perceived only the fearsome aspect as the lord of destructive storms. Identifying him with a form of their own fire god, Agni, they at first called him Rudra, "the Roaring One," until, in their desire to propitiate him, and perhaps aided by a dawning realization of other, quite different properties

he displayed, they began to call him the Gracious, Beneficent, Auspicious One; that is, "Shiva." A universal and all-inclusive epithet of the godhead, the designation became common usage, at times to be regionally replaced by the synonymous one of "Shankara."[16]

But the great lord of indigenous India was the Gracious One as surely as the Roaring One; the destroyer as well as the regenerator; the ascetic no less than the lover. He comprised all divine potentialities, for he personified the old religion's vision of divine oneness. Thus the various aspects of Shiva's images signify not different identities of the Divine, but diverse emphases within the infinite scope of its oneness. Often they still carry the imprint of the origins which had left Shiva so irreconcilably alien, even repugnant, to the society of the Vedic gods. In them still the old religion lives on, expressing itself in terms of the characteristics anticipated by the divinity of Mohenjo-Daro.

The ancient godhead's posture of yogic absorption, for instance, finds its replica in numerous bronzes and carvings of Shiva, some of them, as at Pāli, portraying him with the features of the folk deity. Such folk-tradition echoes of Shiva's inherited role as the supreme yogi, importantly emphasized also in Purānic legend, tend to reinforce the argument for an indigenous origin of the concept and cult of yoga.

Nor has his role as *pashupati*, Lord of the Beasts, been forgotten. Occasional folk-style images suggest it by way of associating the divine figure with that of an animal. More definitely, however, it is recalled by the many representations of Shiva *dakshinamūrti*, the god as the benevolent teacher of man, which show him with an animal springing from the fingers of one of his left hands.[17]

Although the ithyphallic emphasis of the pashupati figure has not been paralleled by any *direct* counterparts, it is remembered by the phallic symbols so inseparably associated with Shiva's conventional as well as folk images. Whether assuming the obvious form of the *linga*, or appearing as such universal attributes as the club or the staff, they are the equivalent indicants of the erotic nature so convincingly exhibited by his Mohenjo-

31

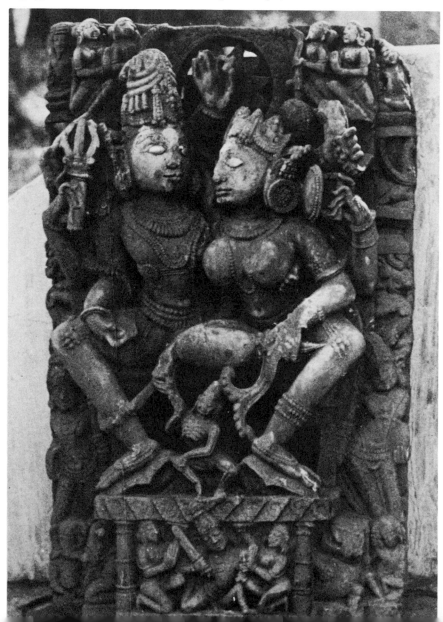

Fig. 35. *Shiva and Pārvatī. Boramdeo temple, Chhapri, M.P.*

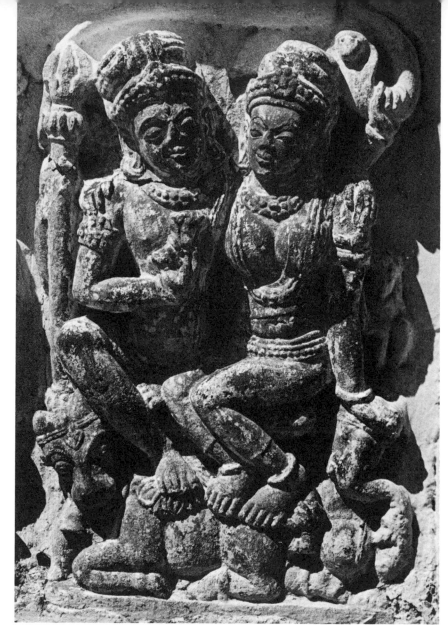

Fig. 36. *Shiva and Pārvatī. Stele, Sirpur, M.P.*

Daro prototype as an essential of old-religion concept and cult.[18] More subtly if not less effectively, Shiva's erotic character has found its reflection in his ever-present depictions in amorous and intimate poses with his goddess, Pārvatī, attaining its sublime apotheosis in his appearance and cult as Lingarāja, Lord of the Linga, and in its iconic symbolizations by the Shivalinga, the Chaturmukha linga, and the esoteric *lingodbhava*.[19]

There is more than a suggestion that Shiva's characteristic emblem, the *trishūla*, that trident so reminiscent of Poseidon's, might be but a variation of the pashupati's strange crown, formed by what has been identified as a pair of horns flanking an elaborate headdress. However, this design may symbolize a quite different, profoundly meaningful concept. Its likely evolution into the all-important Buddhist concept of the *triratna*, the three jewels of the fundamental principles,[20] should surely encourage a reevaluation of the actual imagery and a search for some more discerning interpretation. At any rate, certainly the trishūla is of primeval origin. Its frequent connections with the folk divinity, some specimens of which have been previously noted, would seem to imply its indigenous inception. And its emblematic appearance in the hand of the goddess would not only reinforce this probability but also suggest a symbolic import which to date seems to have been insufficiently considered.[21]

It seems likely that Shiva's *trimūrti* aspect, which he assumes in his manifestation as Maheshvara, the Great Lord, derives from the same concept of a threefold manifestation, a threefold power of the Divine, and should perhaps be understood as the representational equivalent of the idea rendered in emblematic form by the trishūla. Its familiar projection in the Maheshvara Cave at Elephanta,[22] though certainly the most beautiful and accomplished as well as most famous specimen of the type, is by no means so singular as its exclusive treatment in publications might make it appear. Likenesses of Shiva in trimūrti are consistently encountered as sublime specializations of the god in both Hindu and counterpart folk imagery. Their appearances in the popular perspective in particular testify to the antiquity of this vision of divinity and to its roots in the traditions of the old religion.

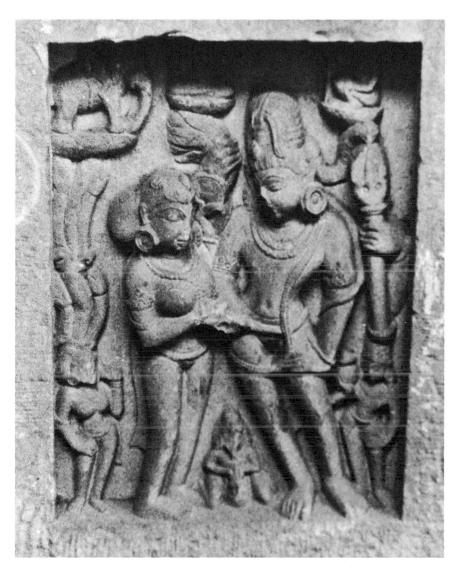

Fig. 37. Shiva and Pārvatī. Teli-ka-mandir, Gwalior, M.P.

41

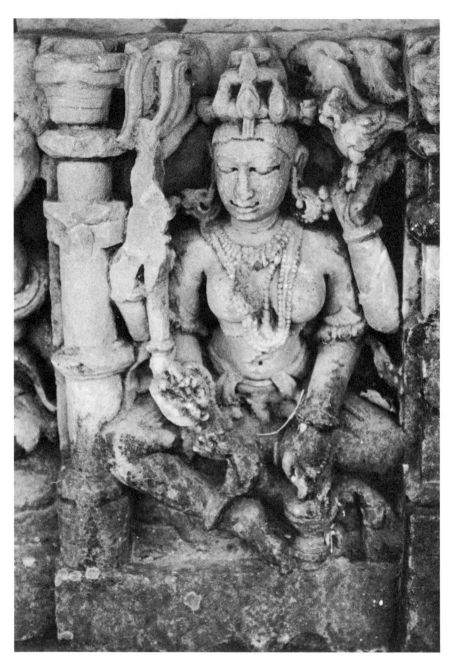

Fig. 38. Chandī. Nīlkanteshvara temple, Udayapur, M.P.

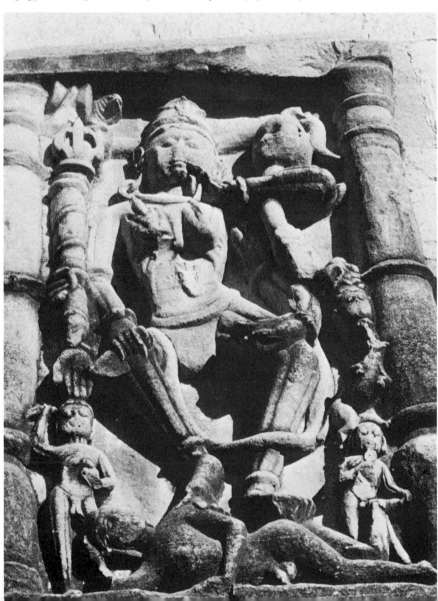

Fig. 39. Kālī-Yogeshvarī. Yogeshvarī temple, Nayagaon, Rajasthan.

Fig. 40. Local goddess in trimūrti. Mahāmmai temple, Dharshiwa, M.P.

So, even more pointedly, do the trimūrti likenesses of the Goddess which, rather than presenting analogies of the Maheshvara manifestation of Shiva, seem to be latter-day embodiments of the original triple deity.[23] This ageless identification of the triune essence with the female deity is also circumstantially demonstrated by the Vedic god Agni, who, esoterically linked to the indigenous Lotus Goddess,[24] comes to reflect her threefold nature in his own iconography. The trimūrti aspect of Agni is thus fully equivalent to that of Shiva Maheshvara; the god in trimūrti appears to have inherited both his sublimity and his countenance from Maheshvarī, the preexistent Great Goddess.[25]

But specifics of aspect or posture directly tracing back to the pashupati of Mohenjo-Daro by no means constitute the only reminders of Shiva's pre-Aryan, non-Aryan past. His appearances as Natarāja, King of the Dancers, equally bespeak the antiquity of his tradition, whose indigenous inspiration might be inferred from the fact alone that the idea and image of the dancing god are entirely foreign to Indo-European theophany, myth,

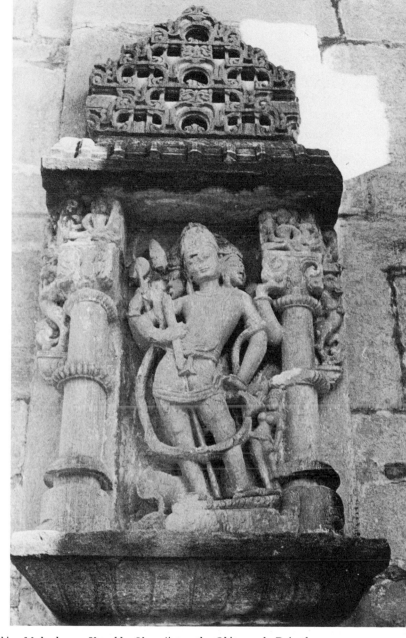

Fig. 41. Shiva Maheshvara. Kumbha Shyanji temple, Chitorgarh, Rajasthan.

and cult. Such rare exceptions as Bacchus-Dionysus are proved imports from non-Indo-European domains at a later period. Whether appearing in *ghora-mūrti*, his "terrible and violent aspect," or as Bhairava, the "Frightful One," the Dancer of the Cremation Grounds, swirling with the most violent rhythms of the *tandava*; or revealing himself, in the more measured sublimity of *nritya-mūrti*, in his "aspect as the Cosmic Dancer," the ecstatic character of this Shiva is as incompatible with the Aryans' lawgiving and order-decreeing creator god as it is germane to the indigenous personification of the Divine, as alien to the patriarchal lord of ritual and sacrifice as it is connate with the deity of the mystic vision.[26] Certainly, then, Shiva Natarāja is a creature of the old religion. In fact, his appearance might even be linked to the pashupati image. It may well represent the inward ecstasy of the latter's yogic absorption transcribed into external motion. More definitely, it may be associated with the ageless vision of the Tamil god, Murugan. The Natarāja's affinities with that aboriginal mountain and forest deity who was worshiped in orgiastic dances in which he joined as the supernal participant are unmistakable; particularly as Murugan was symbolized by a spear, the common equivalent of the phallic club or staff which accompanies Shiva as his attribute. Traditionally Murugan is identified with Karttikeya-Skanda rather than with Shiva himself; but, in terms of the language of myth, this presents merely a confirmation of Shiva's identity with the Tamil folk deity, for Karttikeya-Skanda is considered Shiva's son, that is, his special manifestation. It would certainly not be too farfetched to regard Murugan as an older, non-Hinduized version of Shiva, particularly in the latter's identity as the divine dancer. In view of all this, it should hardly seem surprising if folk divinities are so frequently found in analogous dancing postures, as attested by such images as that at Srīgovindapur, and especially by the dithyrambic Shankara figure on the lintel of the temple at Wakri. Like their numerous counterparts elsewhere, these effigies recall the ancient divinity of the native tradition, whose dancing aspect manifested one of his essential properties.

Shiva's identity with that divinity is intimated by other details of his

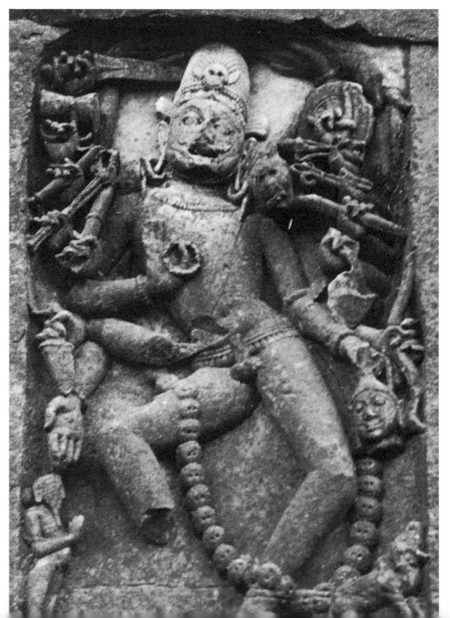

Fig. 42. Bhairava. Rock-carved image, Kalinjar, M.P.

44

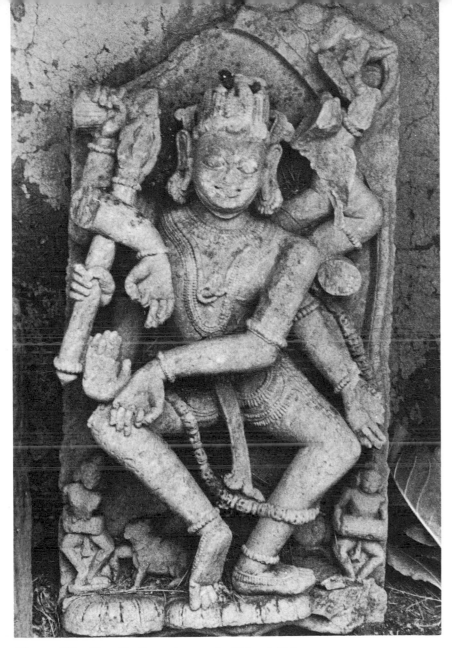

Fig. 43. Shiva Natarāja. Boramdeo temple, Chhapri, M.P.

attributes and iconography. There is, for example, his epithet Nīlakantha, the "Black-throated One." Though there is virtually no iconic presentation of Shiva Nīlakantha, an imposing number of prominent sanctuaries, such as those at Udayapur and Kalinjar, are specifically dedicated to him. Undoubtedly, then, this byname must have carried considerable significance. Indeed, an apocryphal myth endeavors to emphasize this significance by explaining the epithet as one commemorating the god's salutary intervention when he swallowed poison fumes to prompt the further churning of the sea for the purpose of raising from its bottom the elixir of immortality. But would it seem too extreme to presume that the byname of "black throat," rather than alluding to the poison's coloring his throat black, might have related to Shiva's preexistence as the dark-hued deity of the non-Aryan, dark-skinned people of native India?

His aspect as Nandīsha, Lord of the Bull, quite surely traces back to those long lost but still remembered days, too. The bull, of course, has appeared as the divine animal and zoic equivalent of the godhead throughout vast areas to the west of India, and his cult has characterized a whole era of early history. Yet the factors which consigned him to oblivion in other regions did not come into play in India. Here the bull has remained the practically inseparable companion and preeminent symbol of Shiva; in fact, his zoomorphic identity. This is implicit in the animal's very name, Nandi, a term of several meanings, one of which is that of "son," always indicating a specialized manifestation of the "parental" deity. It is for this reason that Nandi's effigy is encountered also independently of Shiva's image as its full equivalent. Frequently a small separate shrine within the Shiva temple's compound is dedicated to him. Occasionally, as at Khajuraho, he may even command a temple of his own. However, most often he serves as an identifying and qualifying attribute of Shiva and of the folk gods who appear as local aspects of the old religion's all-inclusive deity invoked as the Gracious and Beneficent One. In this role the bull assumes certain patterned poses. Oddly human-faced, he may crouch beneath the feet of Shiva 36 and his goddess, or carry on his back the sitting figures of the divine couple. 32

He may appear at the god's side or, again, as his mount. But invariably his presence announces Shiva's aspect as Nandīsha, the ancient bull god who may quite possibly have been introduced into India from Mesopotamia[27] but whose assimilation to Indian cult and worship must, at any rate, have antedated the advent of the Aryans.

Though less conspicuous than that as Nandīsha, Shiva's aspect as Nāgeshvara or Nāganātha, Lord of the Serpent, carries more profound significance. In fact, so important and broad are the historical and cultic ramifications of the godhead's serpentine manifestation that they warrant specific exploration in a separate context.[28] Here it must suffice to note that, precisely because of its intrinsic implications, orthodox iconography has played down Shiva's serpentine identity as completely as popular tradition and devotional allegiance would permit. In the backwoods country, however, the imageries reveal a more candid reference, and many shrines honor it in special dedication. But everywhere the emblematic attributes have remained to recall the serpentine character of the deity and, by their persistent emphasis, to maintain its tradition against all orthodox efforts at obliteration. There still is the cobra coiling up Shiva's arm to raise its hooded head from his hand. There it is, strangely human-faced, its winding shape above his head as he amorously consorts with his goddess. There it is, prominently displayed like a heraldic banner, as he receives the impassioned devotions in his role as Nāgarāja, King of the Serpent-Beings; or, again, more discreetly, circling his arm in the form of a serpentine bracelet; and, reaffirming his old-religion antecedents, representing the indispensable attribute of the deity's likeness as Nateshvara, the Cosmic Dancer.

If the beginnings of Shiva Nāgeshvara are but dimly discernible through the twilight of distant antiquity, those of Shiva Ardhanārī, the great god's manifestation in a shape half-male, half-female, lie hidden in the darkness of time's very depth. Though some authorities consider the androgynous deity to be of comparatively recent inception, the weight of evidence, mythological as well as iconographic, appears to assign this vision of the Divine to a period of prehistory as yet undefined in its remoteness. The same evidence also seems to indicate some connection between the hermaphroditic and the female godhead, but the precise links in this relationship remain speculative. Not so the immemorial antecedents of Shiva Ardhanārī; they seem firmly substantiated. They can, however, not be ascribed exclusively to indigenous conception. Though some of Shiva Ardhanārī's portraitures seem reminiscent of the yaksha figure and others may cast him in the likeness of the folk divinity, these images are balanced by others of more conventional aspect and configuration not suggestive of old-religion origins. More importantly, there is the Indo-Aryan lore of the hermaphroditic Kāma, personification of the associative principle that created cosmic order from cosmic chaos.[29] Analogous to that of the Greek Proto-Eros, the tradition of this primordial Kāma affirms the concept of the bisexual divinity as part of the Indo-European heritage; in fact, it seems to have been part of a universal heritage. In the figure of Shiva Ardhanārī, then, the shared Aryan and indigenous notions may have fused to produce a likeness of the Divine whose enigma remains unsolved.

However, a similar process of fusing traditions may not be postulated for the important, if strangely ignored, manifestation of Shiva in five-faced aspect. Though not infrequent, and recurrently shared with local folk divinities, this aspect seems to lack even a legend to explain it. True, a myth does describe how the four-headed Brahma, to display his superiority over the likewise four-headed Shiva, grew a fifth head; and how thereupon Shiva angrily cut off this presumptuous adjunct to restore divine coequality.[30] But this story is not followed up by an account of how Shiva himself came by his fifth head, though it seems that in the long run his assumption of this symbol was inevitable, since coequality no longer reflected the actual relationships within the supramundane power structure.[31] Whatever the means by which this acquisition was accomplished, the five-headed deity is, unmistakably, Shiva. An image at Pattadakal, for instance, which shows the god seated in a pose of regal sovereignty with his goddess by his side, reveals the characteristic trishūla in back of his right shoulder. Other depictions of Shiva *panchamukha* (five-faced) are similarly symbolized. Yet,

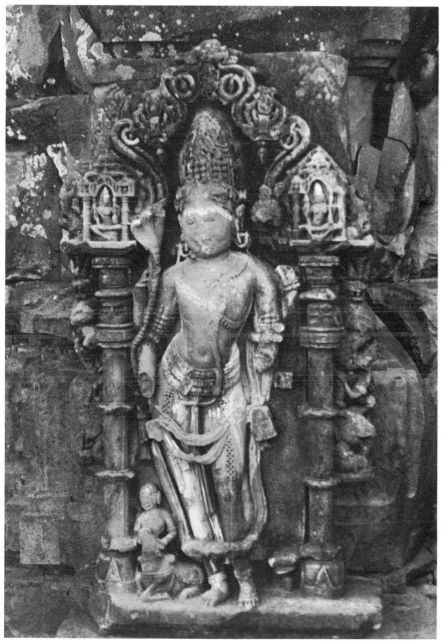

Fig. 44. Shiva Nāgeshvara. Mahādeo temple, Bhojpur, M.P.

even if this emblematic identification were not available, other considerations could not fail to confirm the old-religion component of this divine manifestation. The five-headed aspect belongs to the inheritance of Nīla-kantha, the dark god of the dark people of indigenous India, whether he assumes the identity of the universal Shiva or that of some parochial god known by his local designation. Its aboriginal inception is implicit in the reference of the number five to the symbolism of the female deity, the numerical equivalent of the Goddess in her manifestation as Māyā. Preserved across the ages, one of her epithets has been Panchānanī, the Five-faced One.[32] It is this very link which endows the five-headed Shiva and his local folk equivalents with their special significance. Their shapes present the primordial goddess in masculine manifestation.

There are many secondary anthropomorphic aspects of Shiva and Vishnu and their fellow gods of the Hindu pantheon, some of them inspired by reconditioned Vedic lore, most of them creatures of the old religion reinterpreted in terms of the new religion's preconceptions. They all find their iconographic expressions. But their description and discussion would only reiterate or paraphrase the testimony offered by the more prominent imageries. The infinitely varied countenances of the godhead are, after all, merely infinite specializations of the divine essence. Greater insight into ancient India's conception of these specializations, rather than preoccupation with their phenomenal details, is the concern of this study. A brief consideration, therefore, of the nonrepresentational, symbolic presences of the Divine should prove of greater value here as an aid to such fuller understanding.

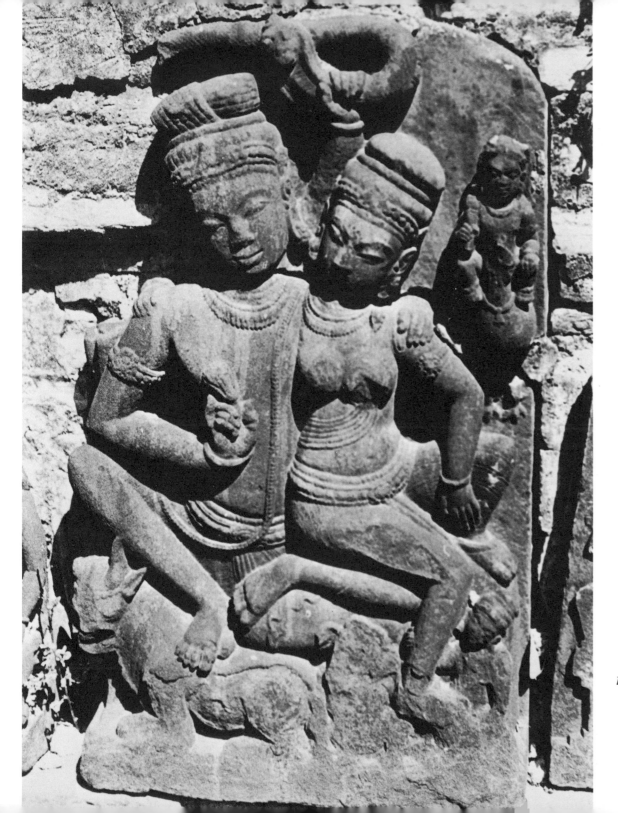

Fig. 45. Shiva and Pārvatī. Lakshmana temple, Sirpur, M.P.

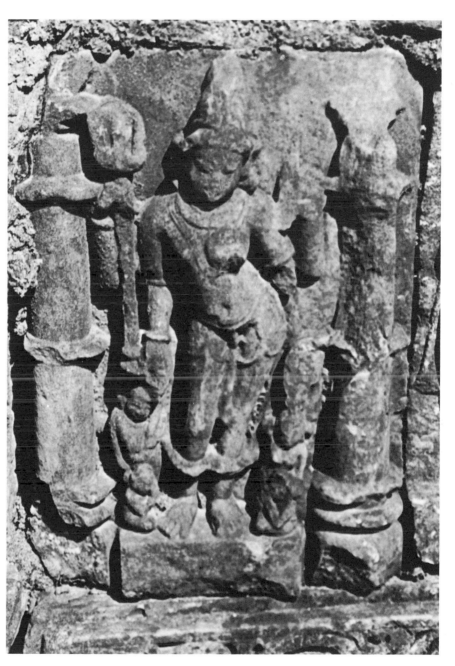

Fig. 46. Shiva Nāgarāja. Nandi temple, Khajuraho, M.P.

Fig. 47. Shiva Ardhanārī. Kandarīya-Mahādeo temple, Khajuraho, M.P.

FOUR

THE SYMBOLIC PRESENCE OF THE GOD

Of all the hylomorphic equivalents of the Indian deity, the linga is by far the most ubiquitously prominent as well as the most connotatively significant. Agreeing with other authorities, Heinrich Zimmer avers that statistically it outnumbers all the other types of Indian sacred images.[1] Considering the staggering profusion of such images, this condition in itself indicates an intensity of impact far transcending that conveyed by the phallic emblem elsewhere.

Reaching back into remote prehistory, the representation of the male organ is universal. Whichever of its variant forms it might take, everywhere its symbolism has been sacred and its worship extensive. Like all other peoples, certainly the Indo-Aryans, too, knew and revered their own equivalent version of this timeless icon, particularly since, within their male-centered warrior world, it must have stood for its most prized ideal, masculine prowess and potency. Yet, clearly, it is not from them that India's worship of the linga was derived. This is irrefutably demonstrated by the fact that the emblem was not associ-

Fig. 48. Giant linga in yoni. Mahādeo temple, Bhojpur, M.P.

ated with any of the Vedic deities, nor with Brahma, nor with the brahmani-cally inspired Vishnu, but exclusively with Shiva, the dark god of the dark people and successor to the pre-Aryan pashupati of Indus Valley days. As for other domains, so for India, archaeology has established the presence of the phallic icon for at least that era,[2] and the evidence suggests that even then it must have been the heir to an incalculable past. Not only are its indigenous roots thus fully attested, but its worship and especial sacred-ness as well.

This singular sacredness may have accrued to it from its relationship to, and its combined appearance with, the *yoni*, the analogous representation of the female organ, a connection whose implications are considered subse-quently.[3] More basically, it derives from a metaphysically inclusive inter-pretation of the phallic emblem, apparently peculiar to indigenous India. To the Indian communicant the linga is not merely a symbol of masculine capacity, of fertility and reproduction. While it comprises and conveys these meanings, its sacredness does not flow from its function as an objecti-fied analogue of the deity's creative energies, but from its nature as the essential shape of the deity himself. It is neither an equivalent of, nor a substitute for the godhead. It is the very presence of the godhead.

This unique concept finds its definitive expression in Hindu theology, which, in contradistinction to all representations of Shiva, regards the linga as the god's "fundamental form" (*mūlavigraha*).[4] It finds its ultimate illustration in the linga's appearances as the sole and exclusive cult object of many sanctuaries. The huge domed hall of the Mahādeo temple at Bhojpur, for instance, is bare except for the giant phallic shape rising from the immense circular contour of the female emblem. A similarly enormous 48 linga in the yoni within a stone-walled enclosure at Hampi announces in overpowering solitude the presence of the god. Everywhere, but particu-larly in the back country, the linga is encountered as a free-standing focus of devotion to which pūjā is rendered in exactly the same manner as to the representations of the deity. It may be placed in the courtyard of a temple, VIII or in an inconspicuous shelter alongside the road. It may appear as the IX

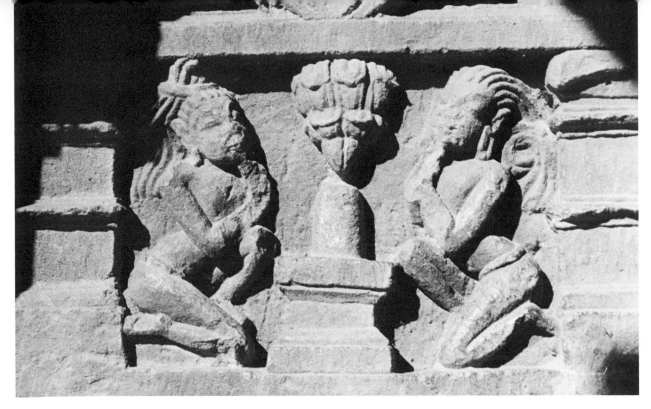

Fig. 49. *Two rishis worshiping linga. Panel, Mahādeo temple, Pali, M.P.*

Fig. 50. *Mukha linga. Kalinjar, M.P.*

single object of an open-air shrine or, again, as part of its configuration of idols. Thus at Garha its isolated shape confronts the image of Sūrya as though to contrapose the presence of the native deity to that of the Vedic sun god. At Arang, in a shrine-like niche within the precincts of the temple of Shiva-Bhūteshvara, Lord of Demons, it assumes the center between two images, one a simian-featured folk divinity, the other a bust of a local deity, identified with Shiva-Bhūteshvara. In a nearby roadside shrine two imposing linga forms, one a polished and conventional version, the other a cruder folk-style specimen, seem to dominate the likeness of Shiva and Pārvatī with which they are grouped, while at Karnali a miniature linga still effectively reaffirms the identity of the divine couple. Time and again, everywhere, the linga reveals the traces of recent flower offerings, and a moist spot at its base often recalls the ritual washing which has been applied to it in a gesture of devotion due to any embodiment of the Divine.

This dedication to the linga finds frequent direct depiction, as at Pāli where a sculpted panel on the wall of the Mahādeo temple shows two holy men engrossed in its worship. Their utter entrancement, mirrored by their faces and even their postures, seems to suggest something more than just the usual reverence before an image of their god. But then, as emphasized before, the linga is not just an equivalent; it is the divine presence, objectified.

This fact is even more forcefully expressed by the icon of the *mukha linga*, a phallic emblem revealing the head of Shiva. While it suggests an origin in indigenous vision and imagery, the four-faced (*chaturmukha*) *linga* seems to owe its genesis to an oblique reaction to the influence of Hindu mythopoeia, whose image of the four-headed Brahma served as the model. Such indication of control over the cardinal points of the universe illustrated the god's absolute supernality. A Shaivite equivalent, the chaturmukha linga thus claims for the old religion's god the same absoluteness in terms of orthodox symbolism. In fact, it claims an even superior sublimity; the grouping of Shiva's four countenances around the phallic axis asserts his transcendent presence.

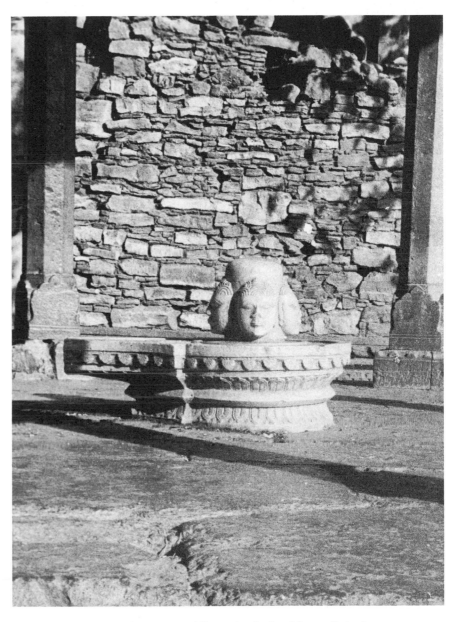

Fig. 51. Chaturmukha linga. Rugnāthji temple, Keshorai Patan, Rajasthan.

53

Yet the ultimate in linga symbolism is offered by the rare icon of the godhead's revelation in the phallus. It presents sacredness objectified. A beautifully subtle myth treating of the lingodbhava (the origin of the linga) does not merely explain the meaning of this image but explicitly proclaims Shiva as the "force supreme of the universe"[5] and the source of both Brahma and Vishnu, whose powers and even very existences he contains within his being. It is this cosmic inclusiveness of Shiva's godhead which is illustrated by the archetypal linga, limitless in its extension, the axis of the universe, displaying the all-powerful figure of the deity within, as its front opens to reveal him as its essence. In this image the old religion celebrates the vindication of its fundamental concept of divine oneness.

The unique impact of the linga would in itself establish its paramountcy among the nonrepresentational icons of the male deity. By the sheer prodigiousness of its recurrence it dwarfs all the rest, even the emblematic trishūla, in prominence. Appearing for the most part as attributes of the various gods or as objects of local and specialized worship, though, each of the other symbols likewise carries with it the imprint of a remote past and profound inspiration. But their abundance and diversity precludes their specific consideration within the scope of this study. Even some of the more intriguing ones, such as the replicas of Shiva's footprint, or the more common ones, such as Vishnu's iron club (kaumodakī) and discus (sudarshana), can here only be mentioned in passing, though their exploration would yield rewards in additional insight.[6] Others, now commonly associated with the male deity also but originally privy to a world of quite different presumptions, are considered in more pertinent contexts.

Because of their diversity and generally local reference, those notable nonrepresentational equivalents of the Divine, the sacred tree or rock, and the magic design, also can find only cursory mention here. Their continued, conspicuously prominent veneration in the countryside grows from immemorial traditions of primarily indigenous inspiration which may antedate all other forms of worship or even of acknowledgment of a Divine

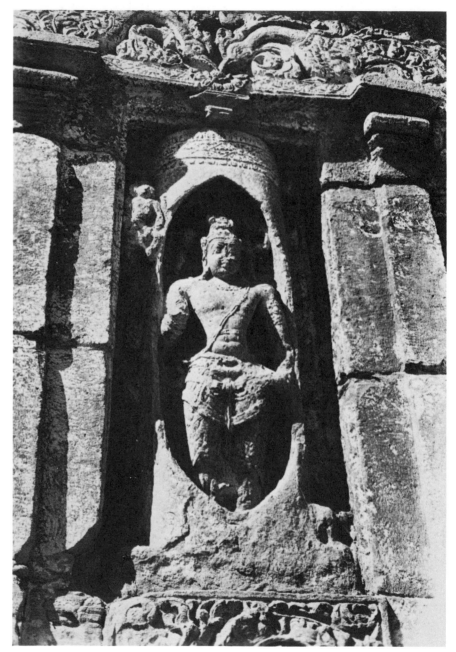

Fig. 52. Lingodbhāva. Virūpāksha temple, Pattadakal, Mysore.

Fig. 53. Satī stone. Chhapri, M.P.

Fig. 54. Satī stone. Chhapri, M.P.

Presence. The fundamental patterns of animism, fetishism, and magism remain in unmistakable evidence, though they have at times been fused with other folk-religion and even orthodox elements. One example, which finds numerous parallels, is offered by the enormous ageless tree near Rājim, in whose roots an array of small images has been lodged to provide the pretense for the cultic activities of which it is the focus. It is not these idols but the tree itself that is the repository of the sacred; other trees, exempt from imagery, have been the subjects of like worship. Similarly, it is the stone by the roadside near Srīgovindapur to which the actual immanence of supernatural power has been imputed; its natural shape has been artificially retouched to emphasize the contour of a miniature elephant whose body enshrines a tiny linga, and whose trunk has been daubed with red pigment. Throughout the back country many rocks, large and small, marked only by splashes or stripes of vermilion, are accorded analogous reverence. Similar markings also announce the sanctity of various spots, along a river's banks, in a cavern, on a curiously shaped boulder, to make them centers of popular adoration.

From time immemorial these creatures of nature have served as the habitat of the supernatural. In them the divinities of the forests and hills and streams still live on, immediate presences to the backwoods communicant. They may be auspicious to him, or noxious. Often they are both, at different times and under different circumstances. Whether by way of propitiation or exorcism, man has always aspired to the control of these unpredictable forces. His magical exercises are the concomitants of life in a magical universe. In essence his prayers have always been conjuring formulas, and his religious symbols evocative or apotropaic charms. In India, these primordial magic designs are of preponderantly, though not exclusively, indigenous inception. While even in the back country many of them must have passed into oblivion, many others have survived. Though relevant to the present study, their full examination would prove too intricate and digressive to be attempted here. Such examples as the *yantra* and *mandala* form, in the Jaina Balatkar at Karanja, or the mysterious and

Fig. 55. Kīrtimukha. Pillar, Kālasiddheshvara temple, Chandravatī, Rajasthan.

56

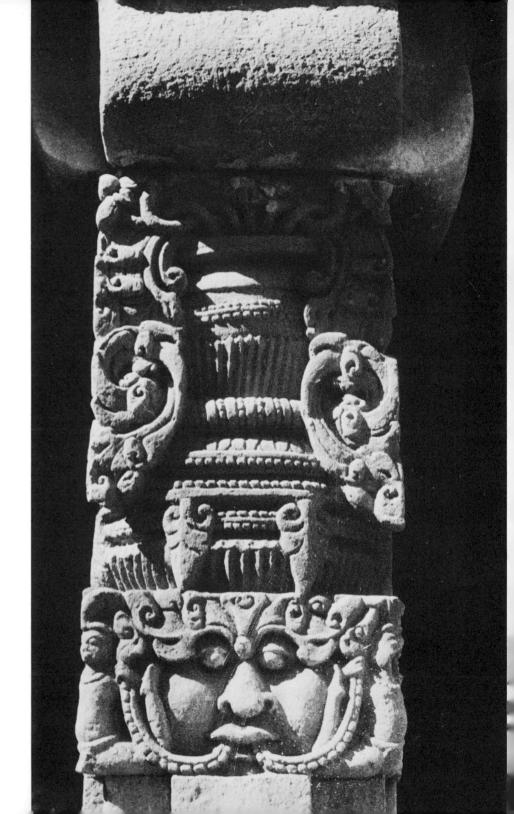

Fig. 56. Maithuna. Daitya Sudāna, Lonar, Maharashtra.

Fig. 57. Kimnara couple among apsarases. Mihira temple, Chitorgarh, Rajasthan.

unexplained array of triangles and other figurations on the wood block marking the entrance to the cavern shrine at Sītābhinji, and repeated on the naked walls of the rock and on the pennantlike pieces of ragged cloth which constitute the sole decor of this sanctuary, find their numerous counterparts everywhere. So does the sign of the open hand, palm turned outward, another relic of ancient magical conceptions, emblematically ap-

53 54 pearing on the Satī stones[7] but also on the enclosures of sanctuaries and on private dwellings.

Of all Indian magical designs the one most familiar and consistently featured is, of course, the swastika. Contrary to the widely held belief, engendered by ignorance of facts or by deliberate misinformation, neither its origin nor its affiliation is geographically or societally determined, least of all racially defined. No doubt the Indo-Aryans knew it and held it in utmost reverence, associating it with the sacred power, long before their advent in India. But there is no evidence that they were the first to introduce it into their new place of sojourn. Whatever role it may have played in indigenous cult and symbolism, this mystical design has remained associated preponderantly with the Vedic deities and their eventual Hindu successors, Brahma and Vishnu. Often it appears woven into the ornamen-

33 tal decor of their sanctuaries or, as at Shivpuri, adorning the altar of the god, often even being instrumental in his identification. Its occasional attribution to effigies of Ganesha, a divinity associated with the cult of Shiva, seems to be imitative and induced by the apparent analogy of its imputed significance and the elephant god's specific functions.[8]

Yet there are, though not too frequently, possible intimations of the swastika's native antecedents, such as its appearance on the bodies of the two elephants that from their uplifted trunks pour water over Lakshmī, the gentle goddess of the lotus. The linking of the magic sign here with the primal goddess[9] may itself offer a clue; that her local folk-divinity likeness should have been chosen for this symbolic display only adds to the suggestion.

It would hardly seem too extravagant to presume that these so differ-

Fig. 58. Māla Devī. Māla Devī temple, Gyaraspur, M.P.

ently connected swastikas might convey diverse, perhaps incongruous, meanings, none of them necessarily consistent with the symbol's original esoteric connotation. A primal, abstract representation of interrelating metaphysical forces, it is basically a cross, though one of very special aspect; thus its exegesis must take its departure from the presumptive significance of that design while taking into consideration its specific elaborations. The diversity of delineatory patterns, evolved in different areas and at different times, admit a variety of fascinating, equally possible interpretations, whose ramifications are too involved to make their discussion feasible here. Suffice it to note that the swastika's orthodox definition as an "auspicious mark," token of "good fortune, well-being, success," is far too superficial and temporal to do justice to its essential symbolism. Similarly, its more recent use as a sort of good-luck charm or, as its frequent appearances at the thresholds and gates of dwellings and official buildings intimate, as an apotropaic emblem, represents a debasement of the mystic experience it originally transcribed, and a corruption of its sacred character.

Among the still extant representational devices of magic the *kīrti-mukha* assumes, by sheer ubiquity, a prominence whose true extent has remained inadequately reflected by descriptive or interpretative attention. Though donning anthropomorphic or zoomorphic contours, this icon should be more properly regarded as essentially an occult design, a symbol of apotropaic powers formed into a mystic mask.

Kīrtimukha means "Face of Glory." The designation is an obvious euphemism for what unmistakably is, by its very aspect as well as its mythical definition,[10] a demon face. The design, though adopted as a common element of temple iconography, is clearly of indigenous origin and inspiration. This fact is inferred by the exegetic legend which, however edited and adapted by Hindu theology, shows its intrinsic connection with the mythologies of Shiva and the Goddess, the primeval deities of non-Aryan India. It is further emphasized by the kīrtimukha's favored allocation to Shaivite shrines, on which it recurs almost like a signature of their

Fig. 59. *The goddess on the tortoise. Māla Devī temple, Gyaraspur, M.P.*

59

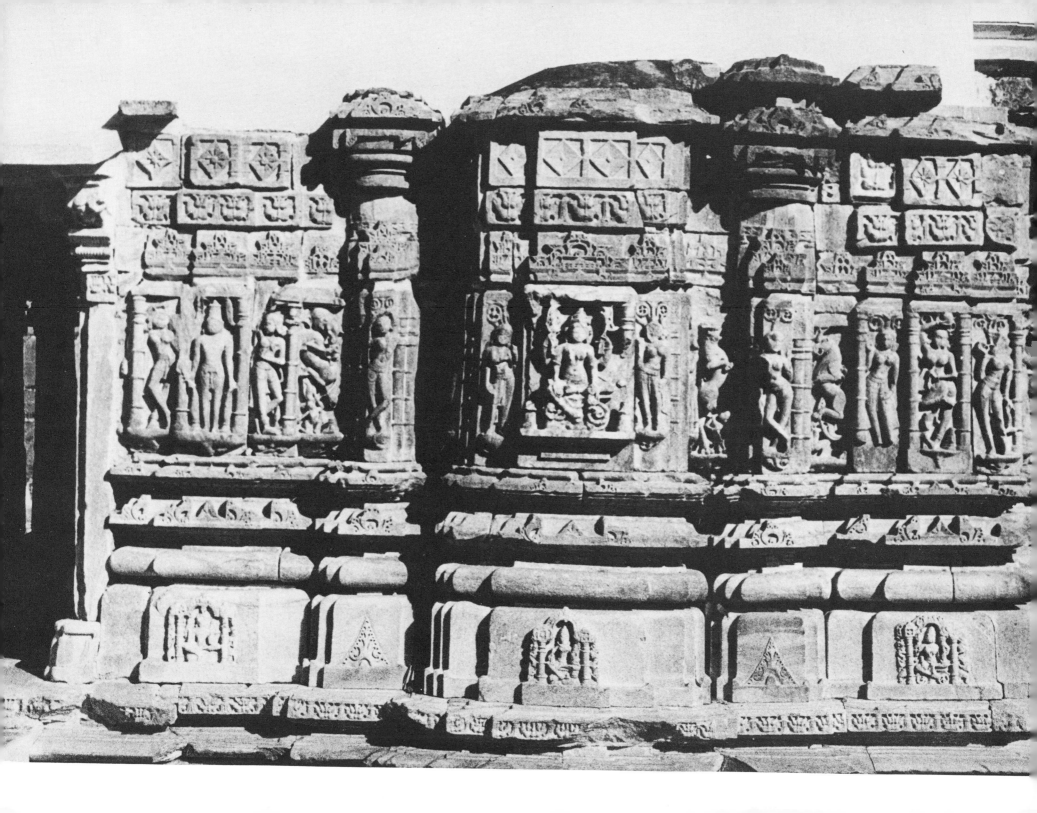

divine owner. Most eloquently, however, it is demonstrated by the mythic mask's esoteric name, Vanaspati, which identifies it with the "Lord-Spirit of the Woods, Patron of the Wilderness, King of Vegetation,"[11] a personification of the divine presence typical of the native Indian concept and vision. Even so, the specifics of its pattern and placement within the total complex of temple decor tend to suggest that this demon-face may have begun as a magic design of protective character which only later evolved into the Face of Glory.

The kīrtimukha appears as a demon mask, but as a curiously good-natured, almost benign one. Its occasionally serious but always complacent expression conveys the same reassurance that emanates from its more often bizarre, sometimes even humorous countenances, a reassurance indeed recalling the prototypal disposition of the ancient Vanaspati, the friend and benefactor, teacher and protector, of the backwoodsmen. Nor is this auspicious character lost when the kīrtimukha assumes its preponderant zoomorphic aspect, that of the stylized lion's head, which finds its putative explanation in a mythical story but might claim a far more meaningful reason for its being. This leonine countenance, always placid and often droll, is almost perversely nonfrightening. Whether appearing singly or in triad, or again in multiplicities often arrayed in friezes girding the temple walls, it invariably exudes an air of amiable comfort and grandfatherly geniality. Even behind the lion mask there is the gnarled smile of the Old Man of the Woods who mitigates the dangers of the jungle and keeps the hamlets safe from the perilous forces issuing from its darkness. It seems quite congruous that he should have appropriated some earlier design of apotropaic magic, to transform it into an aspect somewhat grotesque but in character a true likeness of himself.

Fig. 60. The Goddess, surrounded by vyalis and surasundarīs. Adinātha temple, Ahar, Rajasthan.

ZOOMORPHIC MASKS
OF THE GOD

The evolution of the kīrtimukha image must challenge our curiosity. Why should it affect a zooidal appearance, and in particular one of lionesque contour yet so conspicuously lacking in lionesque character? Had Vanaspati been envisioned in the shape of a lion and, if so, why? Or, perhaps, had a different tradition superimposed itself on this design; and, if so, what was this tradition, and what might have been its inspiration and purpose?

The answers to these questions, indispensable to any study of Indian religion and especially that shaped by the folk heritage, are neither simple, nor satisfactory if attempted on the specific terms of the kīrtimukha design. To become meaningful, they must be related to the inclusive context of the zoomorphic vision of the Divine, of which that stylized lion's mask represents but one among many aspects.

To ancient man the transcendent presence, all-encompassing and all-expressive, might manifest itself in any mode, appear in any shape, assume any gesture. There was not one single object within his perception that might not reveal it. Each particle of the universe

was a specialization of its power, its will, its mystery. Every phenomenon of nature was its vehicle, every event its evidence, every fragment of matter its habitat.[1]

Inevitably, the animal, imbued with life of an order ostensibly similar to that of human experience, would be immediately suggestive of divine immanence. All around man the world was teeming with its myriad forms, so intimately familiar yet so awesomely strange. Pursuing their activities in patterns of an inscrutable logic, the creatures of the wild seemed impelled by magic. Often superior to man in size and strength, swiftness or cunning, they would be objects equally of his fear and his admiration. Constant perils to his physical existence, yet, as potential nutriment, also sustainers of it, they would seem endowed with superhuman powers, living projections of a supranatural presence in all its benign and dooming attributes. They were the manifestations of a Power Beyond, whose favor had to be entreated, and whose wrath placated, by spellbinding ceremonies centered on the specific animal embodiment it had chosen as its vehicle.

Theriotheistic cults are a characteristic of early worship everywhere. Their special preeminence in ancient India is affirmed by the theriolatrous imagery which forms such a large part of the iconographic heritage. Especially throughout the back country, the theriomorphic image of the godhead, in its multiform figurations, continues as a prominent object of popular reverence, a primary repository of the old religion and an instrument of its most uninhibited expression. In fact, the plethora and diversity of its appearances are such that they limit this study to a survey of only the more conspicuous among the zoomorphic masks of the male divinity.

Any such survey must inevitably begin with the elephantine Ganesha. His droll, potbellied effigies are encountered everywhere, on temples and town gates, in any conceivable place of sacred or even secular importance. His image is a common feature of field altars, indeed of any group of idols. Again, it may constitute the sole subject of reverence. Portraying him seated or standing, in curiously giddy dancing postures, or conjoined with his

Fig. 61. Ganesha. Jageshvara Mahādeo temple, Bhandakpur, M.P.

5 II
61
XIII

63

62 human-featured "spouse," his portrayals are encountered everywhere. A house altar without his presence would be exceptional; here his figure is frequently central to the array of divine likenesses, emphasizing it as the favored cult object. His cheap paper-print depictions look from the walls of tea stalls and stores and even government offices. Small statues in shallow niches above the doorways, they adorn many private dwellings.

Undoubtedly, this signal profusion of Ganesha worship and imagery was enhanced by the elephant god's acceptance as a full-fledged member of the orthodox pantheon. Occurring rather late,[2] its integration seems to have entailed no important diminution of his ancient status. The apocryphal legends endeavoring to explain such features as his one broken tusk or his association with the rat would becloud and eventually supersede the memories of his actual antecedents.[3] His canonical designation as a son of Shiva and Pārvatī would permit him to be revered freely and openly without taint of lingering heterodoxy. So complete, in fact, is his Hinduization that at one time he emerged as the supreme deity of a fervently orthodox sect.[4] Yet this doctrinal sanction has scarcely attenuated his eminence as a focus of popular devotion and cult, for it has allowed him to retain his traditional attributes. He has remained the remover of obstacles, the helper of men in their trials, the dispenser of wealth and health and good fortune. Moreover, by imputing to him the special protectorship over literature and education, Hindu hierology has defined him as the patron of cultural enterprise in general and, thus, of the values assumed to lead man and his society to a higher plane of self-perfection. His immense popularity, however, finds its source not in this lofty assignment but in the timeless meaning of his presence to the lives of the Indian people. The epitome of benevolence and beneficence, he offers refuge and promise, celestial succor unencumbered by the ominousness so often attaching to the darker sides 61 of other deities. His affable, almost debonair countenance, the amusedly understanding, slyly indulgent wink of his eyes, the calming nonchalance XIII of his gesture, the fun-loving graciousness which surrounds his very presence—all convey a sense of comfort, reassurance, tolerance of human

Fig. 62. Ganesha and his Shakti. Bhadravatī temple, Chandravatī, Rajasthan.

foibles and even transgression, of encompassing safety and warmth and confidence.

It hardly seems mere coincidence that the most genial features of the god's likeness predominate in the representations of the countryside. There is a subtle innuendo of iconography which differentiates the folk-cult Ganesha from his orthodox counterpart. He is not the one configured with Shiva and Pārvatī as part of the divine family group, overshadowed by the sublimity of his parents, a small and inconspicuous adjunct to their presence. Nor is he the one so often enthroned side by side with this celestial pair, or with an apotheosized ancestor couple; not that stiffly self-important, elephant-faced patriarch affecting demeanor designed to bestow on him an aura of exaltation, though often resulting merely in bedeviling his good nature with a look of incongruous pompousness. His back-country images preponderantly depict his authentic prototype, a figure relaxed, cheery, exempt from the ceremonial rules of divine comportment which, after all, are the concern of the celestial dignitaries who govern mankind, not of a deity living among the folk as a friend.

Ganesha has always lived among the folk, and always as a friend. For untold generations he has been their ever-willing protector, the villagers' individual and collective guide and guardian, a kind of apotheosized familiar sharing their daily lives with them. This is how they, too, have in turn always perceived and experienced him, how they have reflected him in their imageries, as a being of whimsical wisdom and impish amiability, an intimate of their troubles and their hopes. It is here, in the countryside, that his likenesses most often show him in that half-humorous dancing stance, swaying as though inebriated with some fanciful ecstasy; here that they most vividly suggest his indolent and undisturbable, gluttonous and self-indulgent temperament, which makes his divinity so earthy. It is here, too, that he most frequently makes his appearance with the nonelephantine female manifestation of his essence in informal twosomes of mutual affection. It is here that Ganesha's iconography most palpably preserves his character as a deity of the old religion.

All the efforts to ensure his orthodox rehabilitation have failed to obscure his identity as a latter-day version of the pre-Aryan elephant god.[5] On the contrary, they have served only to emphasize the popular eminence which had compelled his integration into the canonical pantheon. His Hinduization has proved to be a purely theological exercise. For all the fanciful exegeses of his theriomorphic aspect and other peculiarities of his appearance, for all the exaltation implicit in the new celestial genealogy and hierarchical dignity bestowed on him, he has remained the one he seems to have always been. Unimpressed by his gratuitous promotion, he has pursued the role of the supernatural companion of man, the divine commoner, a distinction he may have claimed even in the days that saw his beginning.

Those days belong to a very remote past. Just how remote, no one can safely assert; but theriotheism being typically a feature of very early religious perception and expression, a period certainly antedating the Aryan invasion of India suggests itself. Moreover, the specific elephantine vision of the godhead would of itself seem to postulate an inception well prior to that era.

This is inferentially attested by the remarkable association of the elephant with the Vedic other-world, in particular, his conspicuous assignment as Indra's mount and the supernatural prominence attributed by Vedic lore to his celestial prototype, Airāvata.[6] Evidently, alien to the Aryans' original habitat and unfamiliar to them before their descent into India, the elephant could not have been part of their authentic legend. In the dawning days of their mythology there could have been no Airāvata to carry their king of gods into battle. Such accounts, then, could not be credited except as adaptations of indigenous tradition. But, given the conservatism of institutional religion, such a radical innovation could not be simply attributed to the newcomers' astonishment or even dread of the strange animal's awesome size and strength. Only the presumption of the elephant's preestablished sacred character and the deeply rooted practice of his worship can adequately account for his assimilation into the frame-

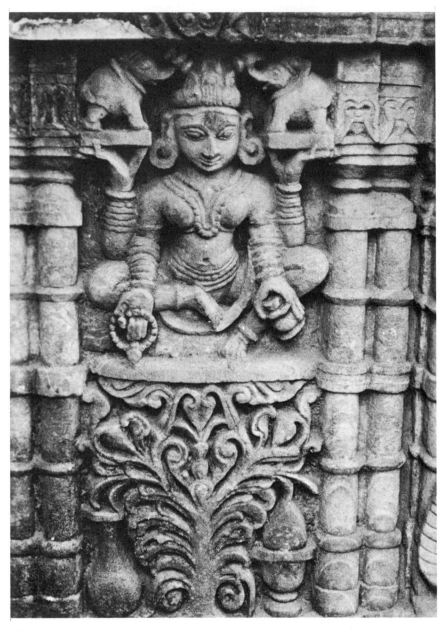

Fig. 63. Gaja-Lakshmī. Alakeshvara temple, Vadnagar, Gujarat.

work of Aryan belief. Airāvata as Indra's imposing, if incongruous, mount represents the Vedic orthodoxy's compromise with indigenous India's ideological and emotional commitment to the cult of the elephant god.

A commitment to any theistic concept so powerful as to enforce such a compromise must premise an extended period of evolution and consolidation. If the cult of the elephant god was so consequential at the point of the Aryan advent, then its inception must be attributed, not to the era immediately prior, the terminal phase of the Indus Valley culture, but to the obscure days of its beginnings, and perhaps those beyond them.

And, indeed, the sacred character of the elephant is suggested for a period well before the fall of the Indus cities, by seals ascribed to the third millennium,[7] displaying him in a manner and setting analogous to the contemporary depictions of other hallowed subjects. Also, the configurations of Gaja-Lakshmī[8] point to his early association with the pri- 63 mordial Lotus Goddess and, therefore, to his timeless identification with the divine sphere. Thus, the antiquity of elephant worship in India seems beyond any doubt. Clearly indigenous to the subcontinent, the elephant must have presented a predominant feature of ancient India's scenery. His giant physique and fabulous strength, his majestic gait and apparent invulnerability, may have of themselves indicated supernatural endowment, while his generally placid, unaggressive temperament may have tended to invest him with an aura of friendly protectiveness. Effective master of the jungle, he would suggest himself to the dwellers at its fringes as the power assuring their security from its ever-lurking perils. His imputed wisdom would promise them guidance toward greater prosperity and fulfillment. Undoubtedly, these twin aspects of apotropaic and ameliorative efficacy formed the essential attributes of his divine exaltation and the subject of the primal spellbinding incantations and cultic celebrations. They still find their reflections in the iconography of Ganesha. His standing likenesses, quizzically ponderous, suggest the teacher and guide; his seated ones, with 61 their comforting geniality, the protector and sustainer; his dancing ones, XIII in their awkward whimsy, the leader in enchanted self-abandon and bliss-

ful rapture. The last pose may well recall ritual trance, not surprisingly, since such a state appears as an accessory, even a prerequisite, of ancient cult. In fact, this liturgic ecstasy may well have constituted the salient element of the primeval rites in honor of the elephant god. His capacity as its actuator may well have been a primary source of his popularity and of the affectionate dedication he has always enjoyed. Quite possibly, even his very divinity may have had its origin in this role.

A study of the Gaja-Lakshmī image in its traditional design, as well as in a unique variant of its aspect, appears to yield the clearest clue to the elephant god's earliest identity. The conventional configuration of this icon, the lotus goddess between the two elephants, has been noted earlier. But while the central figure of the female divinity has evoked much interpretative comment, not so the presence of the attending elephants, nor their specific activity. Yet their water-pouring performance must have some meaningful function, one recalled perhaps by the analogous washing ritual that has persisted as an implicit feature of everyday pūjā. These elephants, then, may be dispensing the ceremonial honors due to the deity. Not being part of any general assemblage of worshipers, they would seem to be especially selected for this task. They may well portray the likenesses of elephant-masked priests officiating at the devotions.[9] The singular image from Palampet tends to confirm this suggestion and elaborate it, for here 64 the central shape of the goddess is replaced by an elephantine figure which assumes her precise posture between the attendant twin elephants. In fact, this figure reveals the traditional contour of Ganesha himself. Might the inference of this deviative design not permit the conjecture that the elephant god may have begun his career as a priest of the goddess whose liturgy he performed in the ceremonial mask of an elephant? In this function he would indeed be the dispenser of divine wisdom and grace, guidance and protection; moreover, it would implicitly groom him as the leader, even the actuator, of the ritual ecstasies which probably were intrinsic to the mysteries and the mystique of those sacred rites. In this role he would come to be regarded as the vehicle of the Transcendent Essence and the equivalent of the godhead herself. Eventually, he himself would be held to be of divine nature, at last to be apotheosized as the goddess' special manifestation to whom the homage and celebrations due her would now be dedicated.

This hypothesis seems to receive vigorous support from the semantic evidence presented by the elephant god's current appellation, "Ganesha."

Fig. 64. Ganesha between elephants. Panel, Mahādeo temple, Palampet, Andhra.

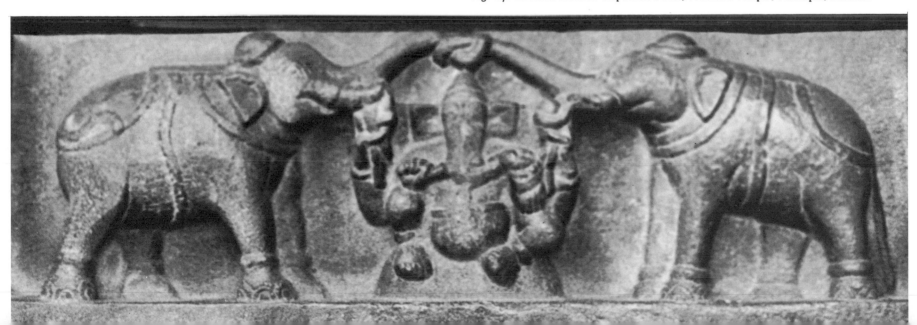

Fig. 65. Gana. Capital figure; Shiva temple, Neri, Maharashtra.

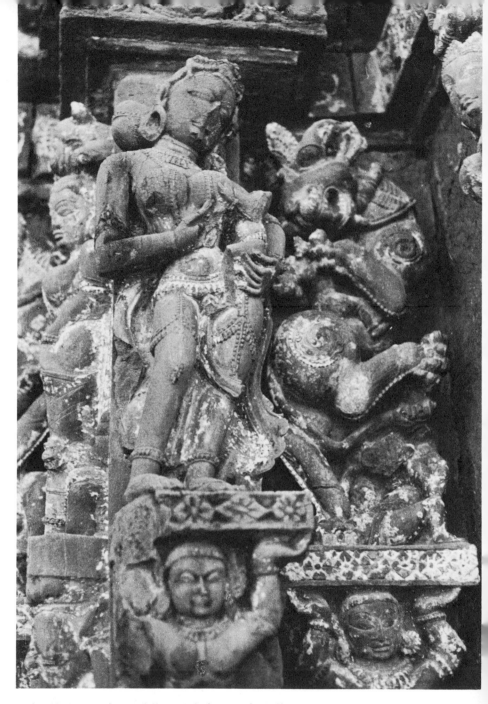

Fig. 66. Surasundarī and lion. Mahādeo temple, Pali, M.P.

An epithet formed by a composite term, it defines him as the Lord (*īsha*) of the Hosts (*gana*), curiously reminiscent of Jehovah's identical title yet of essentially contrasting significance. Ganesha's hosts are not the armies of celestial and mundane militants in the cause of His Law, but the dwarfish and paunchy, jolly and sometimes prurient multitudes of Shiva's extramundane servants, assigned by him to the special care and command of his elephant-headed son. Single representations of those ungainly beings serve as conventional features of temple decor, supporting, much like male misshapen counterparts of the caryatids, pillar capitals and pedestals on their uplifted arms, or enlivening the surfaces of columns and the depths of

65 66

niches. More conspicuously, however, they appear as the entourage of Shiva, in groups in his direct attendance, or crowding entire friezes of his temples

with the carved processions of their bizarre, sensuously animate, dancing forms. These characteristic and consistent depictions of their frolicking, dancelike poses, which have been ascribed to "drunken" states,[10] may well contain a clue to the ganas' actual identity. May these creatures not, in terms of a later age's unsympathetic recollection, portray the entranced worshipers of the ancient folk cult? May the "drunken" abandon of their gamboling gyrations not perhaps reflect inebriation indeed, but with the delights of their visionary and rapturous, perhaps drug-induced metaphysical experience? May even their freakishly distorted shapes not merely present a hostile orthodoxy's view of the "hosts" of communicants celebrating their vision of the divine in the repugnant ways of the ancient rival religion?

There are no counterindications to embarrass such a presumption. Indeed, it seems significant that the gana have been assigned to the auspices of the deity who would eventually emerge as the sublime focus of a Tantric cult[11] featuring rites with markedly dithyrambic overtones. Thus, true to his appellation, the ancient elephant god figured once more as the leader of his ecstatic communicants, the immemorial Lord of the Hosts.

These hosts would look to him for encouragement and relief, for boons and good fortune, but, given the precariousness of survival amid the grimness of their habitat, perhaps most of all for protection from danger. This emphasis on his apotropaic capacity may well account for Ganesha's icono-

graphic association with the rat, an apparently incongruous constellation never adequately explained.[12] In view of the role of the cobra within the early Indians' environment, one of the most important attributes of the protective divinity must have been his ability to guard them against this ever-present, deadly peril. What, then, would be more plausible than that the elephant god should choose as his tool that natural enemy and killer of the snake, the mongoose? Functionally related to his specific power and character, this animal may well have been his original companion and perhaps corecipient of the ritual devotions. It may have been its image

Fig. 67. Surasundarī and elephant-destroying vyāli. Vishnu temple, Janjgir, M.P.

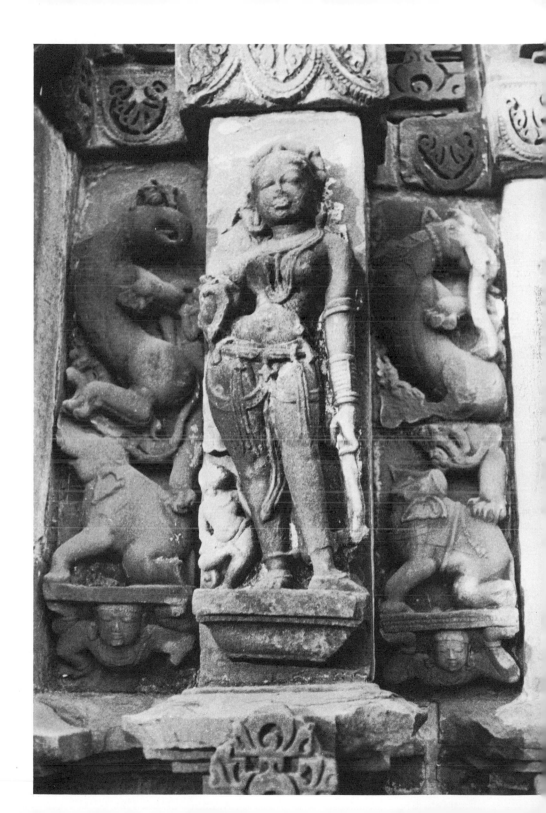

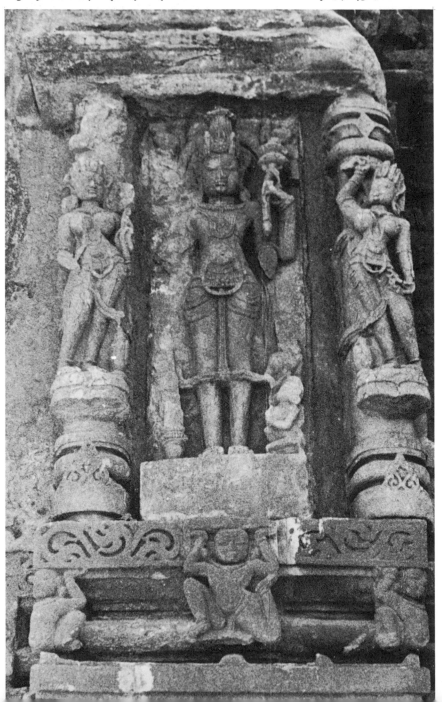

Fig. 69. Vishnu flanked by Lakshmī and Sarasvatī. Vishnu temple, Janjgir, M.P.

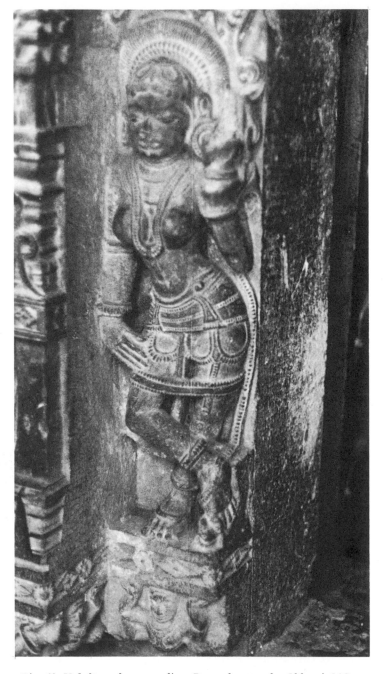

Fig. 68. Yakshī as door guardian. Boramdeo temple, Chhapri, M.P.

which had been iconically linked with his but, owing to a superficial similarity of contour, was eventually misread for that of a rat.

It is not difficult to appreciate that the distant memories of his antecedents and the promises of his nature and function should have combined to make the old elephant god one of the most enduring repositories and vehicles of surviving folk religion. He may now be said to be the son of Shiva and answer to the name of Ganesha as he assumes his place in the Hindu pantheon. But to the people of the countryside he is still what he had been to their remotest ancestors—the apotheosized hierarch of the Goddess, embodiment of strength and wisdom, guardian of their lives and guide of their fortunes.

The water and flowers of the *pūjā* lavished on his countless images are eloquent in their silent witness.

The elephantine countenance is merely one among the many zoic masks of the Divine still recalled from India's past by folk religion. Varying local conditions and the complexities of psychic need would engender divergent perceptions of the supernatural and associate them with diverse forms of the native fauna. Conspicuous among these theriomorphic embodiments, rivaling, and often even surpassing the elephantine one in continued cultic and iconic prominence, is that of the monkey god.

Like Ganesha's images, and often conjoined with them, his effigies appear everywhere throughout the country, and particularly as the featured idols of field tabernacles and sundry hallowed spots. Like the old elephant god, he too has been assimilated into the orthodox pantheon. Under the name of Hanūman[13] he has assumed a place in the extended mythology of Vishnu. Thus solemnized, his likenesses dot the great temples and local shrines and assume their places on countless house altars. Like Ganesha, he receives the homage of the observant Hindu. Yet, like the elephant god, he has never relinquished his claim to his true dominion, the back country where his preeminence owes nothing to orthodox sanction but flows from the force of an unbroken tradition.

Otherwise, though, there is little affinity between these two zoic shapes of the Divine. Only their roots in, and their perpetuation as parts of, the old religion prove analogous. In fact, the countryside's monkey god emerges as a deity of quite contrary character, and its devotions and offerings, though as generous as those rendered to the elephant god, are actuated by very disparate sentiments. However blurred by the palliative euphemisms of adoring liturgies, it is fear that lingers as the basic impulse of its reverence. In the larger, emancipated centers the refurbished personality and apocryphal mythology supplied to the monkey god have succeeded in providing a comfortable rationalization. Here Hanūman appears as the faithful friend and ally of Vishnu's avatar, Rāma, exalted to divine rank as the reward for his pious loyalty. There can be little doubt that the distant past saw him as a widely worshiped, monkey-shaped divinity of indigenous tribal peoples in central India and especially the Deccan, and possibly as their totem animal; it seems equally obvious that racial and cultural denigration played midwife to his orthodox legend also, for in his person the ruling, light-skinned Aryan "elite" equated the dark-hued subject natives with monkeys. For this reason, to this day the Hanūman legend of the Rāmāyana remains resented throughout the Tamil

Fig. 70. Frolicking ganas. Frieze, Cave temple II, Badami, Mysore.

country, the more so as the more exalted antecedents of the ancient monkey god have not been entirely lost to popular recollection.

These memories are completely ignored by orthodox iconography. There it is the superimposed character of the monkey god as Rāma's adoring intimate and adulating servant that finds consistent and exclusive portrayal. In its representations Hanūman is shown standing or kneeling, often attired in a tiaralike headdress signifying his supramundane eminence, at other times in his naked simian likeness, prototypally with his hands folded upon his chest, in humble homage and servile attendance upon the superordinated Vaishnavite deity. In these depictions he is thoroughly converted, a pious allegory rather than an effective transcendental force, a canonical cipher bare of any evocative capacity. Not a spark of his ancient inspiration is rekindled, even in the shrines dedicated in his special honor; their mystique is eroded and the devotions are barren, formal routine.

Figurations of the Hinduized monkey god numerously recur also throughout the back country, but here they are balanced and rivaled by a more authentic vision of his presence, a vision still beholding the wild, almost savage deity, the honored as well as dreaded object of native tribal cult. For here the fear of his powers has never moved far from man's awareness. The ornately costumed, genuflecting, and obeisant Hanūman may still receive some of the villagers' murmured litanies and some of their offerings, brought to satisfy the conventions of orthodoxy. But here also is that other, restive figure: a hairy shape with long provocative tail, a sinewy fist frequently clenched around a heavy cudgel; a contour surging with the intimation of dangerous imminence, the breath of the untamed wilderness about it, an aura of irresistible will and force, and of latent violence. Even when he appears in immobile posture, his enormous eyes still stare with potential aggression.

This is the monkey god, awing the back-country people as the embodiment of their objectified anxieties, gripping them with a sense of indeterminate peril, over whose images most of the water is poured, most of the blossoms of the morning pūjā are lavished. This is *their* monkey god

and their ancestors', subject of a homage born of the age-old fear that is part of their heritage, a fear as elementary an impulse of primal religion as its twin, hope. Creatures of an insecure environment, their perception of nature as the precarious playground of arbitrary and hostile forces engenders in them the ominous vision of a deity as the transcendent personification of terror. Frightened man creates a frightening god as his divine archetype. Though the passage of time has mitigated much of his fierceness, the monkey god's folkloric image still suggests his origin as a theriomorphic aspect of that fearsome deity.

Iconography is not alone in encouraging such a conclusion. The etymological inferences of the monkey god's appellations add their own persuasiveness.

Like its elephantine counterpart, the simian countenance of the Divine is of indigenous genesis. In all likelihood it antedated the advent of the Aryan. At any rate, being alien to his original habitat, it would seem incongruous as a vision of his godhead; therefore "Hanūman," a word of Sanskrit derivation, could scarcely have been the monkey god's original name, but most likely presented a more or less literal rendering of a preexisting, native appellation's substantive meaning. The authoritative form of this Sanskrit transcription is Hanūmat, signifying "He Who Possesses Strong Jaws." But strong jaws hardly constitute the monkey's most characteristic or descriptive attribute, and thus would not seem apt to signify a deity perceived in his likeness. On the other hand, the root *han*, fundamental to all the variants of the monkey god's appellation, denoted the idea of violent and lethal destruction. Some form of this etymon, older than that of Hanūmat, and simply meaning "Destroyer," might well have been the original Sanskrit equivalent of the native term, which in time fell into disuse and was replaced by an inappropriate but similar-sounding and more familiar term.

Certainly, this divinity's countryside depictions would not discredit the appositeness of the "Destroyer" epithet. But there is still more etymological evidence to substantiate it.

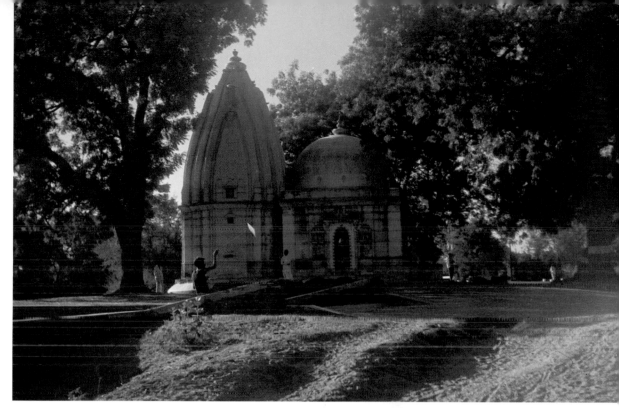

Plate I. Mahādeo shrine. Bhumela, Gujarat.

Plate II. Field altar. Bhilganj, M.P.

Plate III. Local divinity. Mahāmmai temple, Mahamadpur, M.P.

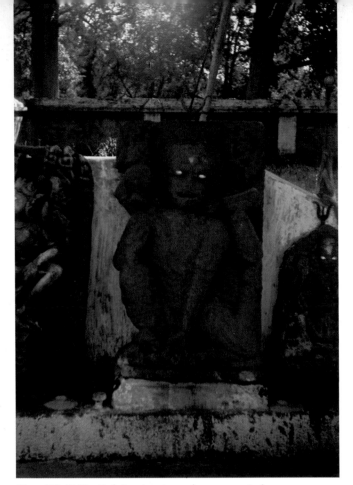

Plate IV. Folk divinity in demonic aspect. Stele, Boramdeo temple, Chhapri, M.P.

Plate V. Local divinity identified with Shiva. Shankara temple, Ratanpur, M.P.

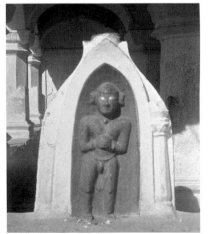

Plate VI. Balaji. Shiva-Bharu temple, Mungeli, M.P.

Plate VII. Countenance of Dugdhadharī, Dugdhadharī temple, Raipur, M.P.

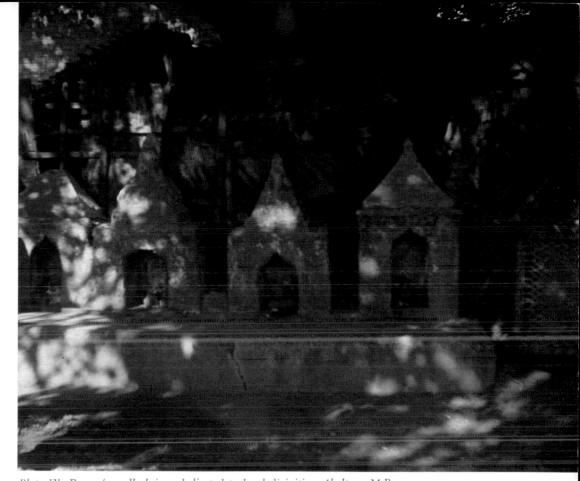

Plate IX. Row of small shrines dedicated to local divinities. Akaltara, M.P.

Plate VIII. Linga and trishūla. Shītalā-Bhūteshvara temple, Raipur, M.P.

Plate. X. The footprints of Shiva. Mahādeo temple, Bechraji, Gujarat.

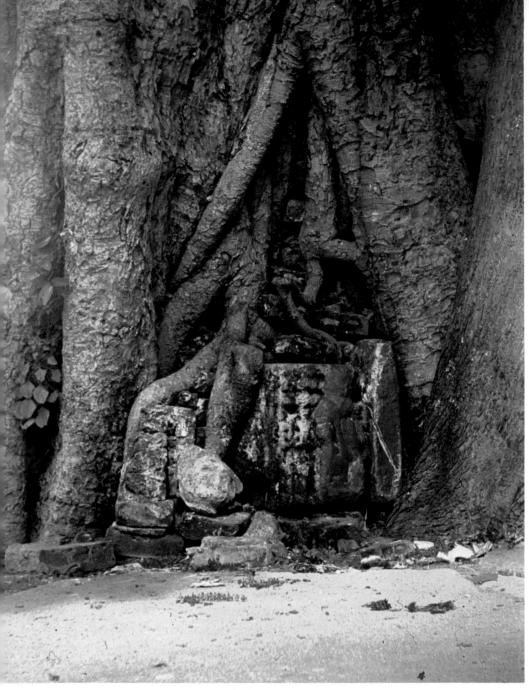

Plate XII. Roadside idol. Srīgovindapur, Orissa.

Plate XI. Altar of local divinity in roots of Banyan tree. Rājim, M.P.

Plate XIII. Dancing Ganesha. Stele, Bhandak, Maharashtra.

Throughout much of the central and western Deccan, the fearsome aspect of the monkey god is identified as Maroti. The name Hanūman is still in circulation but is used mostly in reference to the docile servant of Vishnu-Rāma. That fierce, leaping embodiment of dynamic tension is commonly known as Maroti, and his many back-country shrines are dedicated to him in this designation.

Maroti's existence has remained unacknowledged by the sacred texts. He persists strictly outside of the scheme of the canonical hierarchies. His scope and function are not definite, varying somewhat from region to

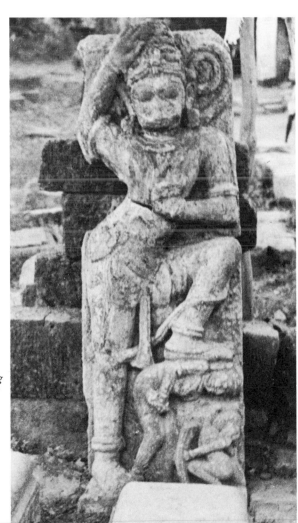

Fig. 71. Maroti conquering foe. Pātāleshvara temple, Malhar, M.P.

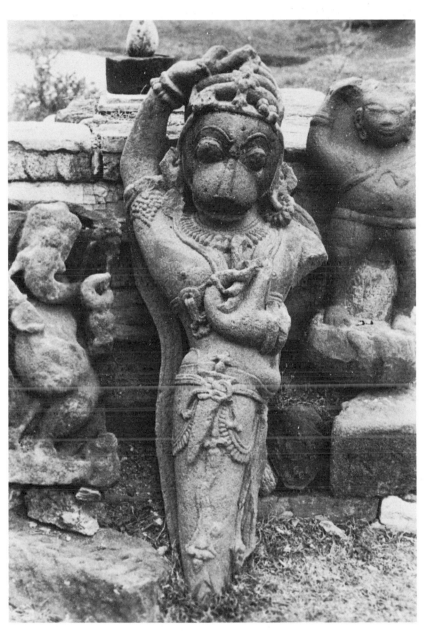

Fig. 72. Maroti. (See also Plate II.) Field altar, Bhilganj, M.P.

region, sometimes from village to village. Generally associated with Shaivite folk cult, and often identified as one of the local deities invoked as Balaji, he is regarded as a deity in his own right. Some of the more sanguine villagers may equate him with Hanūman, but many pūjāris will insist that he is, in fact, the father of Hanūman. Though unsupported by

Fig. 73. Guardian lions. Chandrashekar temple, Kapilas, Orissa.

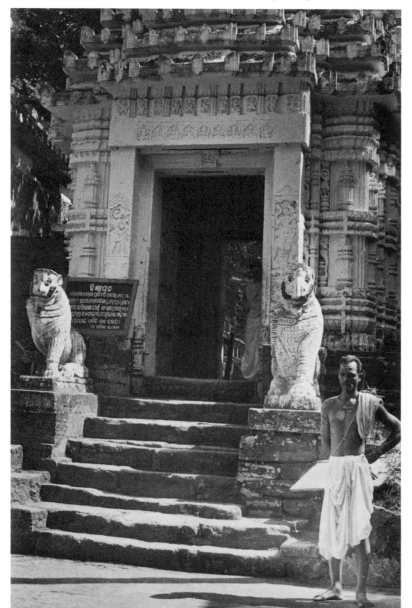

any authoritative source, and contradictory in that Hanūman is affiliated with the Vaishnavite cult and Maroti with the Shaivite, this genealogy is of considerable interest. Evidently inspired by residual memories of folk tradition, it defines Maroti as the preexisting and superordinated divinity, and Hanūman as but his specialized manifestation. These complexities of identification are paralleled by those of iconography. Some images present Maroti in the full array of his simian features; others may mitigate these by minimizing the characteristic hairiness or eliminating the tail, sometimes even modifying the facial contours to simulate a near-human look. Yet the varying proportions of theriomorphism or anthropomorphism hardly affect that aura of aggression, violence, perilousness. Unchanged beneath his incidental masks, the elementary character of the ancient monkey god still persists.

72
XIV

This character seems to echo in the designation "Maroti." In the absence of any scriptural authentication or reference in the Sanskrit vocabulary, only its current version can serve as a source for semantic interpretation. Fortunately, idiomatic evolution and vernacular modifications have

Fig. 74. Lion pentad. Festival chariot, Bhanashankari, Mysore.

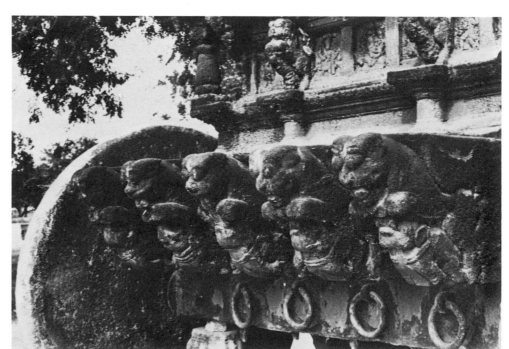

not obscured its etymological associations. The term "Maroti" presents a slightly variant derivative of the Sanskrit designation, "Marut," applied to the impetuous and destructive storm gods of Vedic lore. Erstwhile plural manifestations, companions of the awesome Rudra, The Roaring One, they eventually came to achieve collective embodiment in the single deity who now perpetuates, in both his appellation and his portrayals, the vivid memory of their terrifying presences. This identification of Maroti with the Maruts is corroborated also by the orthodoxy's apocryphal mythology of the monkey god. Here Hanūman, his Hinduized equivalent, is declared to be the son, that is, the special aspect or manifestation, of Vāyu, the Vedic god of the wind. Analogous to that of the pūjāri, this genealogy once more emphasizes Maroti's antecedent as a storm god, a role further supported by the testimony of grammar: used in its plural form, the term "Vāyu" assumes the meaning of "The Maruts."

Maroti thus emerges as a simian aspect of pre-Aryan India's storm god, a zoomorphic specialization of Rudra. The latter's name most likely presents a Sanskrit equivalent for an older native name of the great indigenous divinity who in time reasserts his ancient power as Shiva. These semantic relationships incidentally explain Maroti's aforementioned frequent associations with Shaivite cult. They are paraphrases of the recollections preserving the authentic identity and character of the primeval deity.

Belonging to an age emotionally and conceptually so remote from our own, the equation of storm god and simian countenance remains recondite. But whatever its impetus and rationale, in its time it must have been profoundly significant to persist so tenaciously millennia later and mold another era's images of Maroti, whose zooidal shapes, fraught with potential violence, still recall him as the linear descendant of the ancient Roarer, Rudra, and as the personification of a residual terror which, though intellectually often amorphous, remains experientially acute to the communicants of the back country.

This insidious but relentless anguish, passed on from generation to generation, has found its reflection in the monkey god's quite common

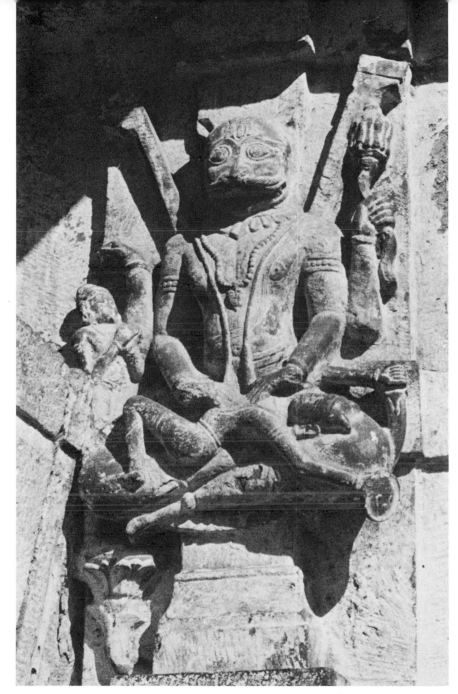

Fig. 75. Vishnu Narasimha. Rāmchandra temple, Mandasaur, M.P.

75

appearance in an apotropaic role. Not only the humble and benevolent Hanūman of Hindu cult but the fierce Maroti, too, guards the habitations of gods and men: hopefully, his powers will be employed to turn away the very forces he himself commands. Thus it is as man's protector that he now receives the gifts of pūjā, offered not from love but fear, intended not to celebrate but placate the fury of the elements personified in his effigy.

The elephantine and the simian are merely the two most prominent among the many animal masks of the male divinity known to the Indian countryside. Myths and legends suggest that perhaps a majority of the fauna may have been envisioned as vehicles of the supernatural presence. Many of them have left no trace in latter-day cults. Still, a substantial segment of this anciently far broader spectrum of theriotheistic worship survives, mostly on local levels of specialized reference and limited iconography. These animal-featured village deities, some adored as sublime, some feared as demonic,[14] but all cryptically meaningful to the communicants, command considerable and effective authority within their particular environments. Their collective and individual importance deserves a far more specific exploration than can be attempted in the present context. Here discussion must remain confined to those manifestations only that have managed to transcend the circumscribed spheres of the villages' private traditions and attract more general recognition.

Such broadly based perpetuation has most often resulted from the native zoomorphic divinity's infiltration of, and eventual assimilation into, the Hindu pantheon. Though frequently this would involve abdication of their separate identities, in their fusion with the canonical deity they would invest the latter with substantial elements of popular imagination and tradition. Even where apparently diminished to a merely attributive role, the essential character of the folk god survives in the guise of the officially acceptable image.

Some of the zooidal countenances of the godhead, though, have pre-

Fig. 76. Vishnu Narasimha. Lakshmīnāryān temple, Rājim, M.P.

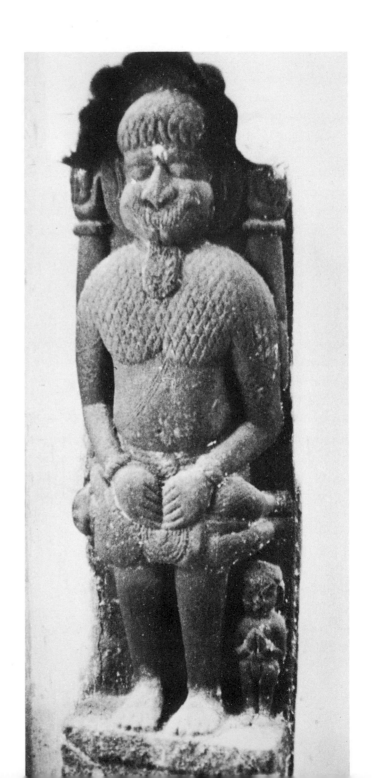

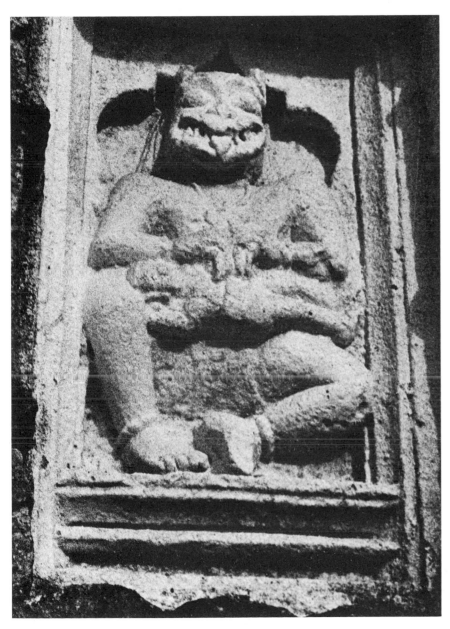

Fig. 77. Vishnu Narasimha. Someshvara temple, Rajura, Maharashtra.

served much of their original independence. We have already noted that the divine bull, Nandi, though frequently just an attribute of Shiva, may also appear apart from the god's likeness to command worship and cultic recognition on his own. So also may the divine lion, whose symbolic mask has been assumed from the cult of the Goddess[15] by those of Vishnu as well as Shiva. However, unlike Nandi, the leonine image rarely receives direct worship, nor does it preside over shrines in its special dedication. It is an indicant rather than an equivalent of the transcendent presence. In this function its appearances are profuse. At Sirpur, for instance, it occupies a niche in the wall of the Vaishnavite Lakshmana temple. At Kapilas its twin specimens serve as gate guardians of the Shaivite Chandra- 73 shekhar temple. At Visnagar, its majestic likenesses assume the same function, while, at Aundha, leonine countenances watch over the group of dvarapālas as though to reinforce their apotropaic magic. And a row 26 of five lion heads,[10] carved from the wood of a festival chariot, signifies the sublimity of the indwelling Benevolent Manifestation, Bhanashankara. 74

Most of the zooidal masks of the Divine have not maintained such separate existences but, even as the majority of taurine and leonine forms, they appear as attributes or *vahanas* of the Hindu gods.[17] Too numerous and diverse for a full account, only a few examples can find mention here. Thus, the tiny deer or doe that springs from the finger of Shiva in his dakshinamūrti aspect may well have served as a zooidal specialization of the Divine and enjoyed a cult of its own in the days of the pashupati. Analogous antecedents might be assumed for the peacock, which has come to appear as the mount of Shiva *vīnādhara*, the Lute-Holding One, as well as that of his "son" Karttikeya, whose identification with the aboriginal Tamil Murugan[18] must of itself suggest the ancient native roots of a peacock-featured divinity. Above all there is, of course, the serpent likeness, so intimately related to all the deities of the Hindu pantheon. It has already been encountered in its connections with Shiva's Nateshvara manifestation and as the essential attribute of his appearance as Nāgarāja. The similarly prominent roles assumed in its associations with Vishnu and

Krishna under such various aspects as those of Ananta-Sesha, Vāsuki, or Kālīya are generally familiar. However, the apposite imageries are not merely illustrative of certain mythical incidents in these gods' biographies. In every case the serpent's archetypal, esoteric, and cultic preeminence[19] has made its presence the ultimate cause of the icon's enduring symbolism. For this presence bespeaks the continuity of the old religion in the guise of the new.

This continuity is similarly maintained by the timeless deities of theriotheistic cults who, sanctioned by the ruling theology and artfully reequipped with new legendaries by Hindu mythopoeism, appear as the four zoomorphic avatars of Vishnu: the lion, the boar, the fish, and the tortoise.

The leonine avatār, Narasimha, the frequency of whose depictions ranks close to that even of the Rāma and Krishna incarnations, is encountered everywhere, and several variant versions of his image on the same temple are by no means uncommon. He presides over numerous shrines dedicated to his specific worship, and for a time figured as the chief divinity of a Hindu sect.[20] Occasionally his effigy may be found as an isolated object of cultic reverence, such as the demonically grotesque, giant-sized one at Hampi. The basic pattern of the image portrays Narasimha in his main mythic role, as a human-bodied but lion-faced shape towering in his in-
75 vincibility as he disembowels the prostrate diminutive form of the demon Hiranyakashipu. At times the triumphant snarl degenerates into a super-cilious smirk, as on the bizarrely near-human visage of his likeness at
76 Rājim, which indicates his lion identity symbolically only by way of a stylized mane. This Narasimha presents some of the features of the leonine folk divinity, features yet more starkly emphasized in such terrifying images
77 as that at Rajura which, except for the helpless figure of the demonic foe, no longer recalls any semblance of Vishnu but reveals the true countenance of the lion god of folk imagery. And, not rarely, the imagery of the old lion deity discards even the last pretense of his connection with the Hindu

deity to recall its folk-religion origin. The antiquity of the actuating therio-theistic cult seems implicitly attested by its prodigious recurrence through-out central India where the lion, extinct for centuries, could not have served as a model in more recent times.[21]

A no less venerable indigenous tradition also accounts for the iconogra-phy of the *varāhāvatāra*, Vishnu's incarnation as boar. Like those of his leonine counterpart, his depictions may occur in diverse presentations in the same sanctuary. His presence, too, is celebrated by some specially dedicated shrines, the most remarkable of which is the Varāha temple at Khajuraho, housing as its sole cult object the giant monolith of the boar that, standing massively in the center of the shrine, exhibits the carvings of hundreds and hundreds of supramundane figures in arrays covering every inch of his body and legs. This effigy may well have been intended as an equivalent of Vishnu himself by the pious Chandella kings who inspired its creation and their sculptors who carried it out, but its true impetus might be traced to different, if perhaps unconscious, roots. The boar avatar has long been recognized as descended from the native boar god cult of eastern Malwa,[22] a worship that appears to have spread well beyond the confines of that region, as the cumulative recurrences of the *varāha* icon throughout eastern Madhya Pradesh and western Orissa would indicate. The beginnings of this boar cult must be postulated for a distant past, when its original focus may have been a female rather than a male divinity, as may be inferred from such images as that of the boar-headed yoginī in the Chaunsath Yoginī temple at Bheraghat.[23]
78
The antiquity and indigenous antecedents of the varāha image are re-flected everywhere. Many of its specimens, creations of folk tradition, ap-pear side by side with its more conventional depictions illustrating the pertinent Hindu legend. The latter present the god as a human-bodied giant with a boar head, in the act of rescuing the earth goddess by raising her
79 youthful form high above the all-engulfing waters of the cosmic ocean. The boar god's folk images consistently and significantly disregard this mythical deed. Though his likeness may appear still with the characteristic emblems

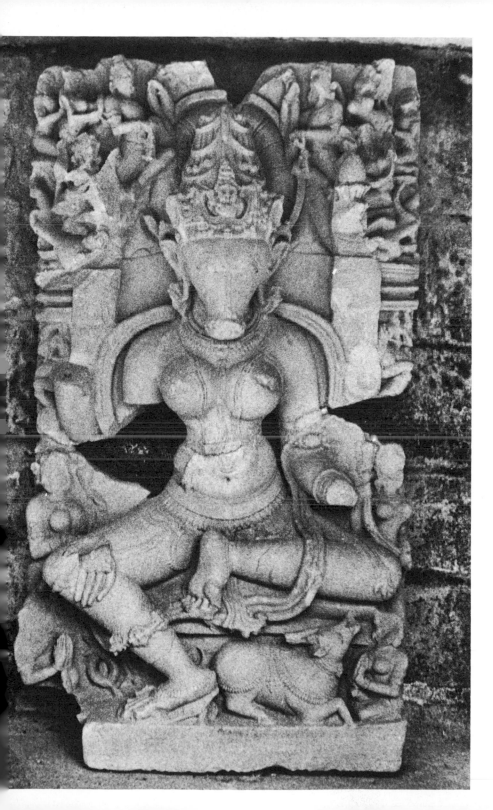

Fig. 78. Boar-headed Yoginī. Chaunsath Yoginī temple, Bheraghat, M.P.

of Vishnu, it is unassociated with the earth goddess, presenting an anthropomorphic form with a zoomorphic countenance, sometimes wearing the boar's tusks atop its head like horns. In the old temple at Bohamuli Kalān this boar-headed figure dons the crown and scepter of the universal divine sovereign as he stands, ignorant of the earth goddess' distress, flanked by two fantastic animal shapes. At Pandatarai he appears in a similarly folk- 80 inspired but stormily aggressive pose. And, perhaps most reminiscent of 81 his age-old cultic role, occasionally his dancing likeness reveals itself, bizarre in its exaggerated contour, like a throwback to the most ancient days of his worship.

Analogies from other cultures would assign the inception of Vishnu's fish and tortoise avatars[24] to even earlier times. Both of these animal forms appear as focuses of primordial cults in many areas of the world, and Indian mythology recalls these avatars as the god's earliest manifestations.

Vishnu's piscine incarnation is ascribed to the era of a primeval great flood and associated with the appearance of the first man. This legend is an obvious Aryan-Vedic adaptation of far more ancient lore: the evidence from other culture areas affirms that the rituals and symbolisms of the sacred fish or sea beast are intrinsically linked with the worship of the female godhead, which relates the *matsyāvatāra's* genesis to the indigenous rather than Indo-Aryan tradition. Moreover, even in its sparsity the iconography of this divine incarnation reinforces this inference. Thus at Vadnagar the typical design of the piscine Vishnu reveals an anthropomorphic but fish-tailed 82 likeness paralleling the portrayals of the Nixies and Mermaids, the Tritons and Nereids, the Naiads and Rusalkas of other peoples' legends. All of these aquatic supernaturals are female or, like the Tritons, intimately associated with the female divinity and her cult.[25] Even more explicit testimony is offered by an untypical and perhaps singular image at Pandatarai. Here Vishnu is presented in fully piscine shape, with his anthropomorphic contour floating above it; and the giant fish is flanked by a pair of serpentine 83 creatures who, as subsequent consideration will confirm,[26] are essentially linked to the cult of the female divinity. Thus it appears that the incarna-

79

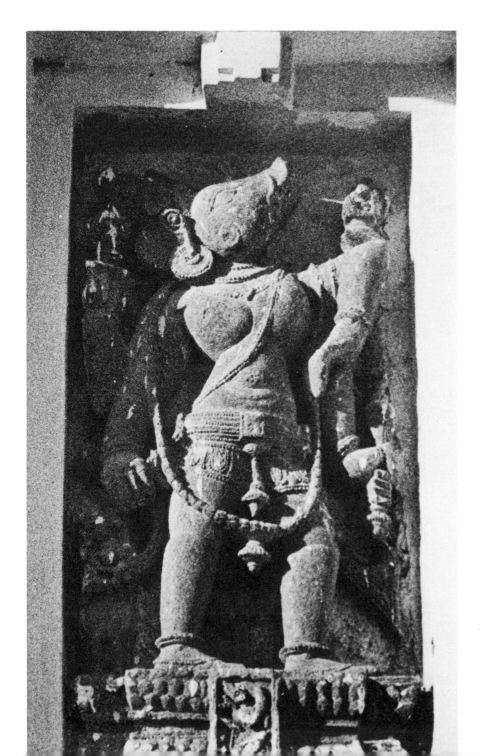

tion of the fish must be presumed to present, like that of the tortoise, "a piece of very early folklore" whose "identification with Vishnu is comparatively late,"[27] most likely having been prompted by the force of its surviving tradition and cultic expression.

The timelessness of the *kūrmāvatāra*'s antecedents is attested by the legends of many diverse cultures, which stress the importance of the divine tortoise in their respective cosmologies. Some tradition of tortoise apotheosis may well have been familiar to the Indo-Aryans, but the preponderant evidence argues against tortoise-Vishnu's origin from that source. The very tardiness of his introduction into the Hindu legend seems of itself indicative. More importantly, the prominent and perhaps central involvement of the lotus goddess, Lakshmī, in the basic kūrmaāvatāra legend[28] once more suggests some intimate connection with the cult of the female divinity, one so alien to the people of the Vedas that it could hardly have been recalled by a myth of their own fabrication. Thus, again, the probabilities point to a native theriotheistic worship, apparently continuing into comparatively late times, as the source of Vishnu's tortoise manifestation. However, though assimilated into the Hindu scheme, its tradition has left virtually no cultic and few iconographic traces. Only an occasional depiction records this vision of the Divine; but its original import seems circumstantially affirmed by the tortoise icon's appearances as an independent equivalent of godhead unrelated to Vishnu's cult or mythology, as at Karnali, where inside the Shaivite Kubeshvara temple it joins the bull, Nandi, in a dual symbolization of the transcendent presence.

Though not counted among his avatārs, the bird Garuda embodies another prominent zoomorphic aspect of Vishnu. Most often, this celestial creature assumes a partly human appearance and, not rarely, even a fully human shape with only a pair of wings indicating his avian character. The question of Garuda's evolution has by no means been finally settled. Too much has been presumed, too little explored. His assignment to Vishnu as his vāhana, and his standard depictions that show him kneeling as he carries on his shoulders the god's figure in solitary exaltation or joined by Saras-

84

Fig. 79. Vishnu Varāhāvatāra, rescuing the Earth Goddess. Jagannātha temple, Ranpur, Orissa.

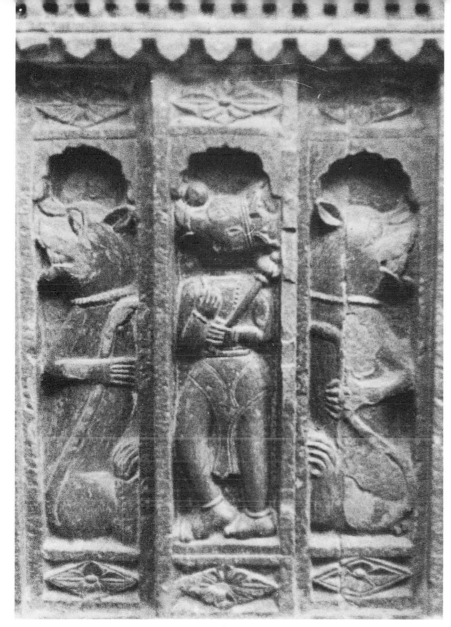

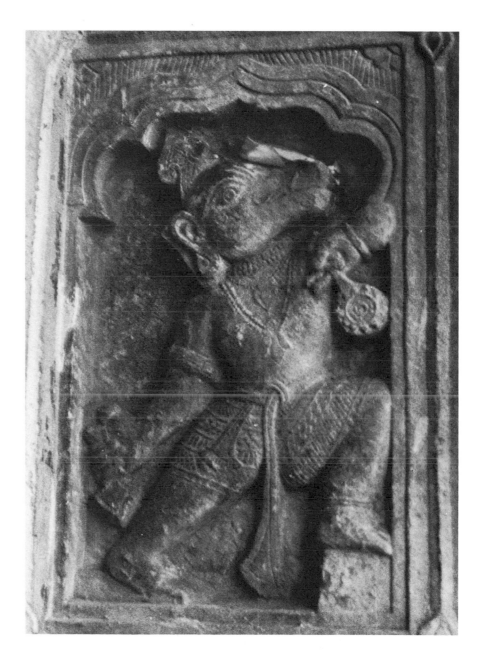

Fig. 80. *Vishnu Varāhāvatāra between zoic figures. Dasavatāra temple, Bohamuli Kalān, Rajasthan.*

Fig. 81. *Vishnu Varāhāvatāra. Bala temple, Pandatarai, M.P.*

vatī,[29] have encouraged the presumption of his exclusive association with Aryan-Vedic conceptions; the more so as, presenting an ostensible Indian analogue of the familiar and ubiquitous solar bird who appears as the symbol and representative of the high god in male-oriented cultures and as the irreconcilable foe of the serpent,[30] he seems implicitly identified with Indo-Aryan lore and religious ideology. Yet Garuda's genesis cannot be ascribed solely to this source. His antecedents are too complex, his attributes too ambiguous, his legend and depiction too contradictory. For instance, when in his zoomorphic aspect, he exhibits the attributes not of the eagle or falcon or griffin, the prototypal solar birds, but of the vulture, a denizen not of the northern climates whence the Aryans came but of the tropical ones to which they descended. Again, when in his anthropomorphic aspect, he often appears independent of his divine lord as a divinity in his own right. In this role, moreover, he tends to manifest not only his disposition as the
85 triumphant conqueror of the serpent but also his ithyphallic nature, which is entirely uncharacteristic of, if not alien to, the Vedic deity. Even his very appellation, Garuda, is not free of strange incongruity. Literally meaning "Water Swallower," it has been held to refer to his task, as personified solar power, of drying up the moisture of the ground.[31] But in a tropical country parched by heat and thirsting for the relieving and fructifying waters, this hardly constitutes a function as beneficial as would seem congruous with his identification with the divine "preserver," Vishnu. Only much further study in depth may be able to resolve these inconsistencies. But their very existence suggests that important native conceptions may have been synthesized with the Indo-Aryan tradition to modify the Hindu countenance of the solar bird.

The theriotheistic cults of the old religion have survived not only in the animal masks of the great gods of the new; they have left their imprints on the wondrous multitudes of the Indian other-world. The supernatural sphere is teeming with all manner of zooidal beings, each recalling some remote vision of the divine presence. Sometimes perhaps of merely local and ephemeral import, their explanatory legends, as far as they may exist,

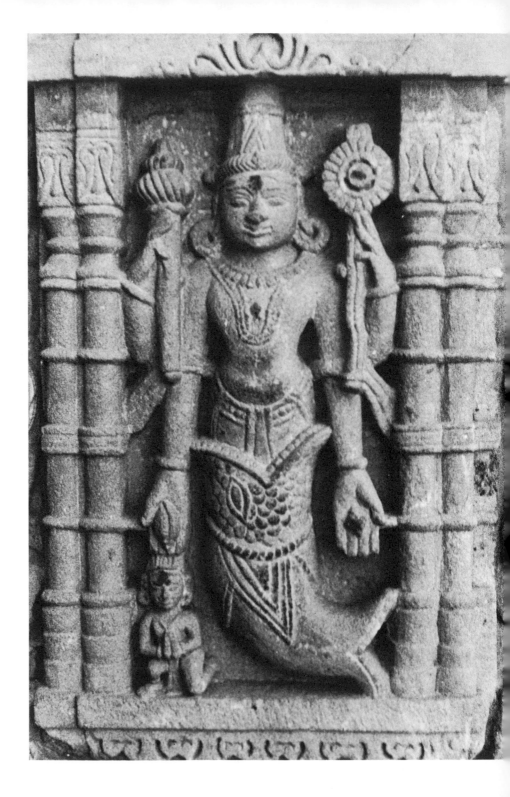

Fig. 82. Vishnu Matsyāvatāra. Alakeshvara temple, Vadnagar, Gujarat.

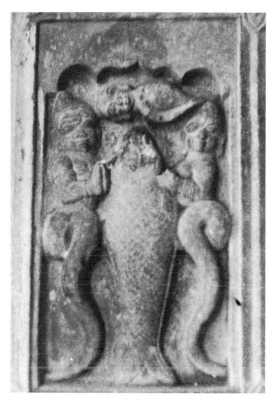

Fig. 83. *Vishnu Matsyāvatāra, flanked by serpentine beings. Bala temple, Pandatarai, M.P.*

are as strange and tortuous as their shapes are bizarre. Some have been canonically legitimized; others have somehow surreptitiously acceded to the Hindu Beyond. There, creatures born of an essentially alien vision, they now sport in the company of the great divinities, their countenances winsome or unsightly, carrying the accents of the celestial or the demonic. For the most part they remain anonymous, except for local, generally equivocal, terms of identification.

Only one special group of such half-human, half-animal apparitions is distinguished by a more broadly recognized classification. Their designation, *kimnara*, literally "what kind of a human being?" is obviously apt, but hardly enlightening. But even this title proves uncertain and inconclusive. Some authors describe the kimnara as a celestial being, half man, half horse; others apply the designation to another celestial type, half man, half bird.[32] However, other specimens, similarly half humanoid, half zooidal, seem not to have been included in the kimnara category. To a few of those supernatural characters some special function has been imputed, as, for instance, that of the heavenly musicians to the kimnaras. Most of them, however, are undefined presences on the walls and pillars of the temples, each a recondite reminder of some earlier or even persevering cultic activity.

Full consideration, or even enumeration, of the prodigious varieties of these zooidal forms would prove prohibitive within the scope of this study. Here but a few of their typical appearances may be presented in passing, as examples.

The fanciful couple in quasi-dancing pose, occupying the center panel on the Mihira temple at Chitorgarh, for instance, may be identified as representative of the birdlike kimnara type, even though there is no indication of their role as musicians of the other-world.[33] A similar pair, shown in affectionate embrace, appear on a pillar at Raj Samand. A fully zooidal pair, of apparently elephantine aspect and depicted in what seems to be a somewhat grotesque dancing pose, may convey the memories of an ancient religious fancy. At Neri another semizooidal couple are flanking an unidentifiable idol, but here the animal attribute is complex, for the birdlike lower bodies

86 and legs combine with long, demonstratively exhibited tails. Kimnaras, too? No clue to the identification of these bizarre creatures has been offered. At Wakri, more conventional kimnaras appear as participants of the dithyrambic

23 scene. Here assuming their function as music makers, they are joined by yet another musician, a drummer, of semizooidal aspect, with a boar's or possibly bull's head on his human figure. This being, too, remains anonymous and unexplained, as do the many composite humanoid-zooidal shapes commonly encountered everywhere. True, a pūjāri might identify them as ''Balajis,'' but this would be merely another way of saying that these were divine beings of great power.

Not even such perfunctory identifications, much less any clarifying or interpretative suggestions, are offered to explain the many more or less

87 zooidal creatures that, like the one at Keonjhar, emerge unexpectedly everywhere to intermingle, virtually disregarded, with the profusion of celestial images crowding the temples. Yet their presences could be neither idle nor accidental. They must be actuated by some tradition, however obscure, however undefined, however repressed. Even the most creative imagination relies on an impetus; the freest association requires some point of departure. No matter how bizarre or fantastic, such figures must have a history; one sometimes related to such as the bull-headed *asuras* who join the gods in the

88 act of churning the sea; sometimes, again, one quite different in origin or even in significance.

Whatever their specific histories or evolutions, whether identifiable or not, the zooidal likenesses of the Divine find their common denominator in the indigenous theriotheistic cults whose recollections still form a powerful substratum of India's folk tradition. They still are waiting to be accorded the attention and study commensurate with their importance, an importance defined primarily not by the sheer plethora of their extant iconographies, but by their geneses as integrals of the old religion.

It is within the framework of the latter that the zoomorphic imagery of India must be explored and interpreted, if it is ever to be fully comprehended. But, then, this is true also of the anthropomorphic representations

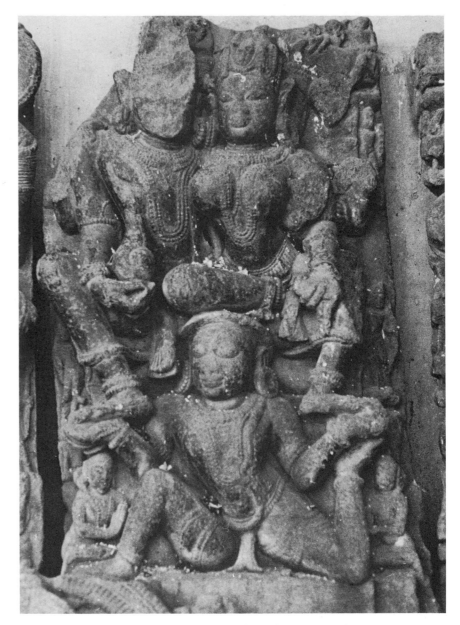

Fig. 84. Vishnu and Lakshmī born by Garuda. Stele, Gatora, M.P.

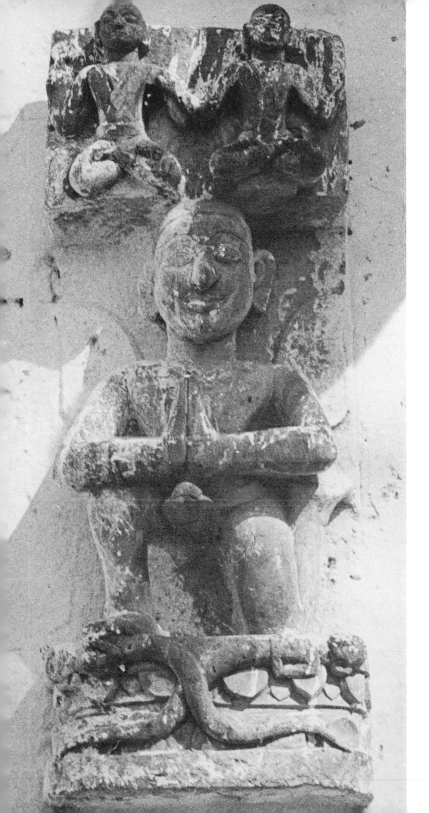

Fig. 85. *Phallic Garuda, conqueror of serpents. Setganga temple, Setganga, M.P.*

Fig. 86. *Kimnaras. Shiva temple, Neri, Maharashtra.*

of the male deity, whether reflecting the conceptions of the Hindu orthodoxy or those of the heterodox folk traditions. In fact, it is true of all of India's iconography. For all the specific amendments and obfuscations, accent shiftings and interpolations, attenuations and corruptions inflicted on its products by time and deliberate policy, closer examination will yet reveal their collective inspiration flowing from a remote world whose essential perception of existence and vision of the Divine, intrinsically alien to our own, have never quite passed out of man's emotional actuality.

Fig. 87. Zoomorphic divinity. Wall figure, Jagannātha temple, Keonjhar, Orissa.

Fig. 88. The Churning of the Sea. Panel, Alakeshvara temple, Vadnagar, Gujarat.

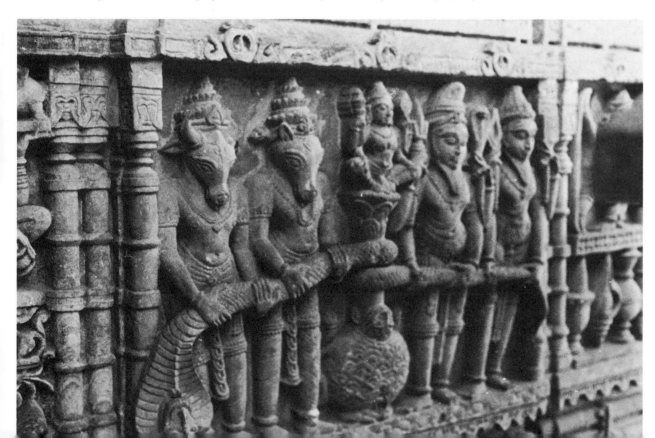

THE REALM
OF THE GODDESS

The world in which the old religion took its form and from which living folk religion has drawn its fundamental inspiration is remote in human time but not in human consciousness, alien to modern man's acquired conceptual, but privy to his intrinsic emotional, apprehension. Its perspective has controlled the psychic actualities of succeeding generations, and its heritage has been universal. The focal characteristic of that ancient world was its equation of nature with the feminine essence, its interpretation of cosmic phenomena and life processes in terms of the prototypally female psychical and physiological properties, and in consequence its personification of the transcendent mystery of Being in the image of the Divine Woman. In the most acute sense it constituted what Sibylle von Cles-Reden has called the Realm of the Great Goddess.[1] This realm seems to have extended wherever earlier humanity found its domiciles, to mold man's perspective and determine the basic principles of his religious sensibility and social organization. For millennia the Divine Feminine was man's absolute sovereign. Eventually, in different

regions at different periods, her dominion suffered supersession by new, dissimilarly oriented systems. Yet nowhere has her hold over the minds of men been wholly superseded, least of all in India.

Given the complexities of the Goddess's world, the compass of its experience and cultural expression, a full discussion even of its Indian segment would exceed the limitations and the purposes of this study. However, such has been its impact that a survey of its more prominent traces should suffice to permit insight into that primal world's particularities, its fundamental ethos and conceptions, which have remained the inalienable heritage of the Indian people, providing the infrastructure of their religious tradition and framing the contours of their worship and their temples.

The prodigious dedication throughout the subcontinent, and particularly its central regions, of shrines in honor of the Goddess would in itself attest to her perennial paramountcy as a source and focus of religious inspiration. However, the female deity's true significance in the texture of Indian life might be more accurately reflected by the total compass of her configurations, especially within the sanctuaries devoted to the great male divinities of the ruling religion. Whether in temples consecrated to Shiva, as at 89 90 9 Aundha and Khiching, Bhandakpur, Khajuraho and Nemawar; or to 92 93 Vishnu, as at Sirpur and Keonjhar; or again, as at Vadnagar, to Alakesh- 94 95 vara-Kubera, Lord of the Spirits; it is her effigy that is displayed in the most 63 prominent, often the very central positions. Even in the shrines of the still more strictly male-oriented Jaina persuasion, such as the Shravaka at Cha- 96 nasma, it occupies locations of exalted and controlling distinction.

These examples might be augmented indefinitely. There is not one great temple in India, nor a country shrine, that would not exalt the Goddess. Yet it is not conspicuousness alone that defines her cardinal significance; the multiplicity of her representations is equally conclusive. Many of the central Indian sanctuaries display walls girded by dozens of her ever-variant countenances. If, then, the female divinity can assert her sublimity in the

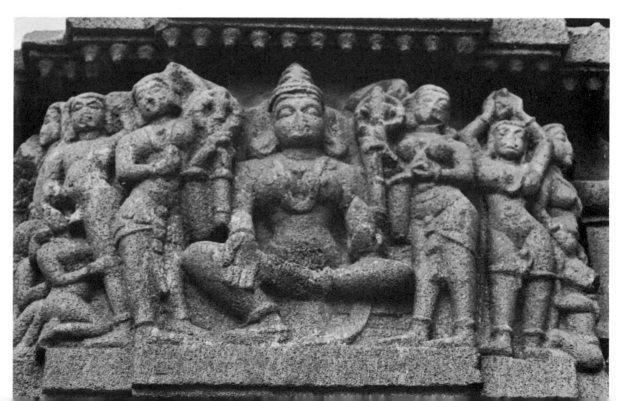

Fig. 89. Chandī, surrounded by surasundarīs. Nāganātha temple, Aundha, Maharashtra.

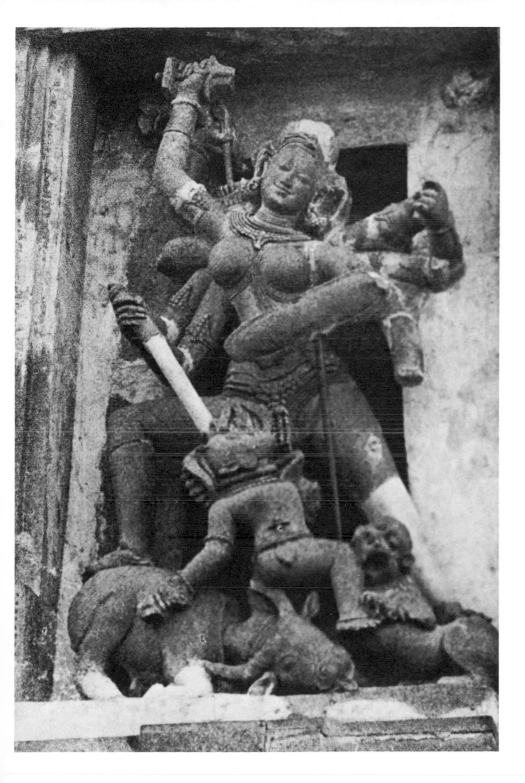

Fig. 90. *Durgā Mahishāsura-mardinī. Shiva temple, Khiching, Orissa.*

Fig. 91. *Shītalā with miniature attendants. Jageshvara Mahādeo temple, Bhandakpur, M.P.*

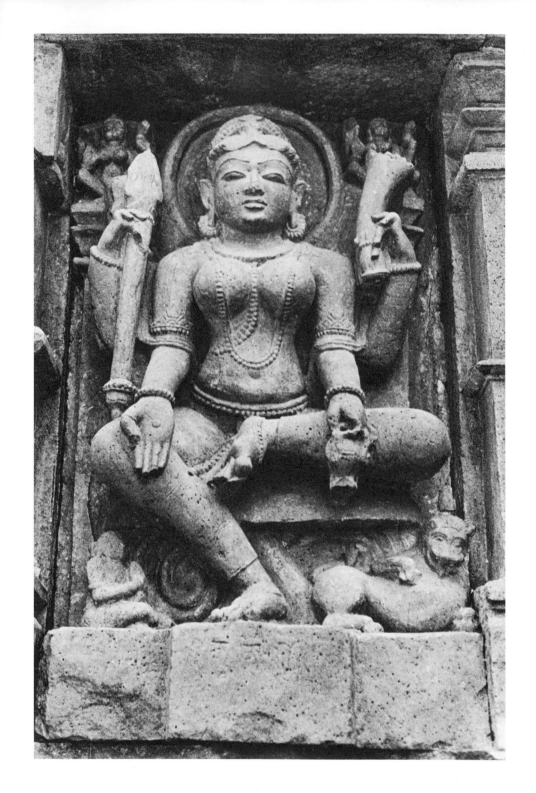

Fig. 92. *Gaurī. Lakshmana temple, Khajuraho, M.P. (left)*

Fig. 93. *Bhairavī. Shiva temple, Nemawar, M.P. (above)*

Fig. 94. The Lotus Goddess. Stele, Sirpur, M.P.

Fig. 95. Durgā Mahishāsura-mārdinī. Jagannātha temple, Keonjhar, Orissa.

precincts dominated by the ethos of an uncompromisingly male-centered Brahmanical theology, her presence seems bound to obtain to even superior exaltation in sanctuaries committed to her own auspices. These are far more numerous than a survey of current reference works might suggest. Predominantly located in the distant towns and villages, in the disregarded backwoods settlements, they have naturally escaped proper appreciation. In the great places of pilgrimage, controlled by the canonical creed intent on imposing its concepts and forms of devotion, most of the shrines would of necessity honor the preeminence of Hinduism's male divinities.

And yet, even here the ageless impulse of the indigenous tradition has never been wholly thwarted. The ascendancy of Tantrism, with its steadily surging revival and eventual reestablishment of Goddess worship,[2] has

Fig. 96. Durgā Mahishāsura-mārdinī, flanked by surasundarīs. Shravaka temple, Chanasma, Gujarat. (below)

92

Fig. 97. Folk image of local goddess, identified with Lakshmī. Shrine of Gūdavāsinī, Ugalpara, Orissa. (right)

added its momentum to promote the construction of sanctuaries and street altars celebrating the female power even in the foremost centers of orthodox cult. The old Chandella capital of Khajuraho, for instance, also features the great temple of Devījagadambī, the Goddess Mother of the Universe, as well as the smaller shrines of Pārvatī and Lakshmī and an early one of Chaunsath Yoginī exalting the Goddess in her sixty-four revealed forms.[3] At Shivpurī, the city of Shiva, the most popular shrine has remained that of Mahāmāyā-Siddhīshvarī, the Mistress of Magic; at Konārak the precincts of Sūrya, the Sun God, enclose also the temple of Chhāyā Devī, the Beautiful Goddess. At Ellora, for centuries a principal center of Buddhist and Jaina as well as Hindu consecration, an important sanctuary glorifies Ahalyā, spouse of the Compassionate One. At Sonepur, once a regional focus of Vaishnavite homage, some of the most elaborate among the dozens of extant shrines are dedicated to the goddess in her several manifestations.[4] At Bhubaneshwar, the ancient temple city sacred to the Lord of the Universe, one of the most splendid tabernacles is dedicated to Gaurī, and, surrounded by the mighty edifices professing the transcendence of the male deities, there is, almost incongruously, a street altar presenting the likeness of Devī molded by the unmistakable tradition of folk imagery.

But it is the towns and villages beyond the highways of orthodox penetration that remain the heartland of the Goddess' realm. Here, less inhibited in its exercise, popular devotion to the female godhead finds its truer reflection in the wider incidence of shrines to her worship and their primacy in the communities' religious life. At Chanda the main temple honors Mahankālī; at Barsi Takli, Kālikā Devī; at Dabhoi, Kālī Mā. At Amraoti it is presided over by Ambikā; at Palanpur and Chandravatī, by Ambā Bhavānī. At Raipur it celebrates Dugdhadharī; at Ratanpur and Mahamadpur it exalts Mahāmmai, who in the latter sanctuary assumes the identity of the snake goddess, Manasā. At Ugalpara the village temple is devoted to Gūdavāsinī, the Mysterious Dweller, appearing in the folk-style likeness of the lotus goddess, Lakshmī; at Unjha, again, to Homīya Mātā, Mother of Sacrifice; at Maheshwar, to Ālaya Mātā, Mother of the Dwelling; while at

Fig. 98. *Homīya Mātā. Homīya Mātā temple, Unjha, Gujarat.*

Barwa Sagar it is consecrated to Jārakā Mātā, the Mother as Lover and Paramour, recalling the interdependence of these fundamental aspects of the Divine Feminine.[5] At Arang the principal tabernacle exalts the goddess Mahāmāyā, the Great Mistress of Mundane Illusion; at Salabhata, as Chandī Devī, the Shining Goddess. At Kota, the hilltop sanctuary worships her manifestation as Lakshmīdevī; the ancient ruined one at Gahakpur, that as Mangalādevī, the Auspicious Goddess.[6] At Dhinoj her presence is glorified as Vyagreshvarī, the Preeminent One; at Mahoba, as Mānya Devī, the Goddess Deserving of Supreme Respect; at Trimbak, as Udari, Shiva's Spouse;[7] at Banki, as Charchikā-Chāmundā, the Anointed One Who Devours Life; at Banpur, as Bhagavatī, the Fortunate and Blessed One; and at Kharod, as Samarī Devī, the Goddess of the Congregated Multitude. XVI At Chandol the main shrine of the village is devoted simply to Devī, the Goddess; in the nearby hamlet of Martadi, to Martadī Devī, following a pattern typical of smaller communities where the female divinity assumes explicit patronage of the settlement as its acknowledged supernal mistress. In many localities her primordial and intrinsic character as Nature 58 Personified is recalled.[8] Thus, at Gyaraspur she is adored as Māla Devī, Goddess of the Fields; at Khurda, as Bharanī, the Fruit-Bearing One; at Nayagaon, as Yogeshvarī, Mistress of Magic Arts; at Jetalpur, as Bho- 39 geshvarī, Mistress of Delight and Joy and Ecstasy; and, in an identity of similar import, as Modeshvarī, at Modhera where the altar of the inconspicuous but popularly celebrated village shrine displays the folk-style image of the goddess riding, armed with a cudgel, on the back of a wolf. 99

Again, these examples might be expanded at random. The emphases of worship rendered to the Divine Feminine are inexhaustible in their variety. As reflections of her encompassing nature, her countenances are infinite, her presences as many-faceted as man's perception can reach. To this day she remains the godhead of native India, repository and vehicle of the people's unsquandered heritage flowing from the prehistoric distance, personification of their sometimes dimmed but never forgotten realization.

SEVEN

THE VEDIC GODDESS

While India's adoration of the Feminine has its roots in that common experience and interpretation of Being, that universal perspective which defined the Realm of the Goddess, her specific cultic elaborations, symbolism, and theophanies are of autochthonous inception. These singularities of worship have molded an ethos which, antedating the Indus Valley and contemporaneous civilizations of the subcontinent, and of remote antiquity at the time of the Indo-Aryan advent, has remained her people's guiding if unconscious impulse, and whose inalienable hold over the native mind has been the primary factor in the religious and cultural syncretism known as Hinduism. This amalgamation of heterogeneous indigenous and Aryan conceptions culminated in the introduction of the female deity into the exclusive male company of the Vedic pantheon, an event whose revolutionary dimension and impact seem to have been all too effectively obscured by the ostensible presence of Vedic goddesses. Yet, though vouched for by scriptural references and, in some cases, eventually reaffirmed by iconic representation, these divinities had no functional actuality and no emotional reality.

Even a cursory exploration reveals their merely nominal existence, even though some of them indeed trace back to the remote past. Surely, at some early stage the Aryans, like all their fellow Indo-European tribal groups, had been denizens of the Realm of the Great Goddess and had shared the basic conceptions which were its universal denominator. But by the time of their descent into India, that era had receded into the wastes of deliberately fostered oblivion. Only here and there a twist of etymological inference or an internal inconsistency in the mythic accounts unwittingly betrays antecedents that a more recent ideology had exorcised from Aryan consciousness. The creed of that male-centered, patriarchally organized, king-and-priest-led warrior society could not tolerate the coexistence of precursory beliefs; its pantheon of divine autocrats and ritual-obsessed patriarchs, of apotheosized heroes and personified abstractions, would not be likely to survive the competition. Even so, the distant memories of the old religion appear to have continued to haunt the Aryan tribesmen. As always and everywhere, its experiential verity and its mystique had proved too powerful for total extinction. Evidently some recollection of the primordial Mistress of Man persevered even into the Vedic age, though, victimized by the depredations of the reigning persuasion, her original attributes and meaning had long become unrecognizable. The loaded interpretations of a hostile, myth-making and worship-controlling priesthood would often pervert them into their very antithesis.

The metamorphosis of Danu serves as a ready example. Evidently regarded by the prepatriarchal Indo-Europeans as a primary manifestation of the Divine Feminine,[1] in her original role she was, as her appellation suggests, the Giving One, the Bestower, personification of the life-sustaining forces of nature. Undoubtedly, she assumed a similar preeminence also for the ancestors of the Vedic Aryans. The antiquity of her sacred tradition among them is affirmed by the later legend that makes her the wife of Kashyapa, the primeval Tortoise Man. Precisely this singular exaltation seems to have prompted the even more savage, more radical destruction of her image. When cultic attenuation, the withdrawal or interdiction of ritual worship, proved inadequate to the purpose, demonization, the mythopoeic transformation of a divine into an antigodly force, was applied as a more effective tool. Danu the goddess was pronounced the mother of the Dānavas, a race of fiends haunting the world as the irreconcilable foes of the gods. But as a generation of *female* Dānavas might yet have perpetuated some recollection of feminine sublimity, it is by an ungainly host of *male* demons that the great Danu has come to be represented in the canonical texts. She herself rarely appears in them; but, however perfunctory the reference, it defines her in her new character as the incorporation of the evil and degradation now imputed to the feminine archetype.

Other female divinities of the prepatriarchal Aryan past have suffered closely analogous reinterpretations. Among the most prominent of them is Diti, another legendary wife of Kashyapa, who became the mother of another race of demons and antigods, the Daityas, like the Dānavas locked in eternal combat with the forces of the Divine. Some authorities have concluded that this goddess never commanded any actual tradition but owed her origins to an etymological construction evolved in antithesis to the primordial Aditi, the goddess Infinity. However, the very fact that Brahmanical theology felt constrained to effect her demonization would of itself suggest the authentic preexistence of this goddess. Contraposed to Aditi, Infinity Personified, it establishes "Diti" as Finiteness Incarnate, conceptually akin to Māyā, the creatrix and dispenser of mundane illusion.[2] Brahmanical idealism, forever opposing the sense-bound deception of this world to the transcendent Reality of the divine sphere, would inevitably equate the goddess Finiteness first with the ungodly, and then with the antigodly, principle. In fact, the confrontation of Diti and Aditi enhances the likeliness of their coeval origins as complementary aspects of the prepatriarchal Aryan's Woman Divine, respectively presiding over the terrestrial and cosmic planes of existence and activity.

Aditi herself survives as a "mysterious and tenuous figure,"[3] a mere cipher of exaltation. For all the transcendence implicit in her epithet, "Mother of the Gods," her adoration is confined to some extravagant lip

service from a few Vedic hymns. Perhaps very early reduced to but a symbol for a cosmic concept, she may, precisely because of her ineffectualness, have been permitted to continue in her theoretical sublimity. Long alienated from man's direct experience, she posed no further threat of becoming a vehicle for any resurrection of the anathematized past.

Other specializations of the prehistoric Indo-European goddess appear to have undergone similar evolutions under the reign of the Aryan patriarchate, to endure into Vedic times, mostly as personifications of natural forces, processes, and phenomena—such as Ushas, the goddess of Dawn,[4] Rātrī, the goddess of Night, or Prithivī, the goddess of Earth.[5] Usually the goddess Aranyanī too is counted among these nature-representing divinities. Though identified by a Sanskrit name, she seems not to have had any Indo-European, Aryan past. Significantly, the one Vedic hymn celebrating her is of very late date, and the terms in which it refers to her feminine character and beauty are unusual for Vedic texts. Most importantly, the designation Aranyanī itself may imply meanings different from those commonly inferred. The Sanskrit word aranya does indeed translate as "wilderness, forest," fostering the presumption of this goddess's identity as the Lady of the Forest. However, aranya also, and in its primary sense, means "distance, foreign country." Perhaps, then, her appellation identifies this divinity as the "Strange, Alien One," suggesting her antecedents as an indigenous deity who in late Vedic times, because of her popular preeminence, was adopted into the orthodox pantheon as the "alien" goddess of the non-Aryan, native people.

Whatever devotional and cultic actuality these female divinities might once have enjoyed had long ceased. Divested of their evocative powers, they lingered on as subjects of some exalting poetry, but devoid of any apparent popular following or even awareness of their very existence. As an alternative to the processes of demonization and cultic attenuation, a more insidious transformation, the reembodiment of female sublimity in a male figure, proved a viable method of religious conversion. Its effectiveness seems well exemplified by the primal Mistress of the Fire, who was to emerge as Agni, the celestial Master of Sacred Magic and high priest of the gods.[6] Still, in the case of Sāvitrī, the ancient bestower of the vivifying cosmic juice[7] associated with the lunar power, her supreme sacredness appears to have called for a more circuitous device of obliteration. Permitted to retain her female form, she was reappointed as the "wife" of her own masculinized aspect, Savitri. In accord with patriarchal Aryan preconception, this "Energizer" of the Universe implicitly assumed all her powers, including control of the lunar elixir of life, now reinterpreted as solar energy. Thus, while he now commanded all ritual and devotional attention, the primal goddess continued as the typical subaltern and dependent Brahmanical wife, a shadow without substance.

An even more discreet scheme to efface the prestige and popular image of the female deity was applied with signal success to Vāch, another aspect of the ancient Indo-European goddess, whose sparing citations in the verses of late Vedic literature hardly convey her primeval eminence.[8] Identified by her name as the goddess Speech, scriptural characterization has designated her the patron divinity of learning and the arts. An apotheosized abstraction of man's intellectual endeavors, not dissimilar from the original Greek concept of Logos, her presence is commensurably intangible and nonevocative. But the etymological evidence bespeaks very different, far more sublime antecedents. As a name, Vāch, an Indo-European term cognate with the Latin vox, designates the personified voice of the godhead, the humanly perceptible revelation of the Divine Presence, and thus the subject of the ultimate mystic experience.[9] In this aspect, then, the female divinity must have assumed a station of sacred transcendence analogous to that of the great deities appearing throughout the Indo-European world under names root-related to that of Vāch, such as the Slavic Bog,[10] the Iranian Vohu-Mano,[11] the Roman Vacuna,[12] and possibly even the Phrygian Bacchus. When, perhaps resuscitated by the example of native India's goddess worship, the long dormant tradition of Vāch gained new impetus to disturb the religious establishment of the late Vedic period, the inevitable repression followed, not the pattern of masculinization favored by the Slavs

and Iranians and Phrygians, but the process later successfully exploited by the Romans. Just as the latter would reduce Vacuna to inconspicuousness by turning her into a mere appendage of the great Mars of the battlefields, the Brahmans achieved their purpose by assigning Vāch to their ascendant solar god, Vishnu, as his wife. In further refinement of this device, they contrived to identify her with the indigenous lotus goddess in her specific aspect as mistress of the sacred river, Sarasvatī. However, though allowed to retain the guardianship over learning and the arts which she had assumed from Vāch, Sarasvatī's sovereignty over these spheres remained titular only. In her canonically circumscribed role as Vishnu's wife she would be divested of all independent influence.[13] Always in reverent attendance upon her lord and master, content with the leavings of the glory and adoration offered to his grandeur, her shadowlike insignificance is eloquently recalled by the configurations of her miniature shape in humbly worshiping posture at the side of his overpowering form. Even where, in analogy with the typical Shiva-Pārvatī constellation, the divine couple is shown sharing the cosmic throne, the disproportion of their relative sizes and emblems of dignity is designed to contrast the god's sublimity to the goddess' inferior nature.

Yet, while this scheme largely succeeded in minimizing the exaltation of Vāch, it proved less adequate for a similar reduction of Sarasvatī's. Even the demonstrative tokens of her diminishment failed to wholly obscure her authentic eminence, to which the canonical sanction inherent in her association with Vishnu may itself have imparted new impetus. The pressure of the residual indigenous dedication to the mistress of the lotus obliged further accommodation; even Brahma, the creator high-god himself, had to substantiate his popular legitimation through conjunction with the goddess. Thus Sarasvatī, an Indian counterpart of Greece's Pallas Athene and Rome's Minerva, appears also as a "wife" of Brahma, brought forth from his mind as one of the fivefold emanations variously identified as Sātarupa, Sāvitrī, Gāyatrī, Brahmanī, and Sarasvatī, which collectively subsume the archetype of Woman.[14] The subtlety of this legend presenting her generation as a

manifestation of Brahma's creative energy implicitly redefines Sarasvatī's status in terms of Brahmanism's conception of the female role and function: as a secondary and subordinate adjunct to the male deity's supernality, an accessory to his sublime essence, from which every modicum of her own supernality would be derived.

Ostensibly, then, Sarasvatī joins the ranks of those typical Vedic goddesses who appear as *shaktis*, as materializations of the male gods' female energies. Lacking any tradition in Vedic thought, this concept seems to have emerged as a concession to native esotericism, but one that astutely perverted the original vision of female power[15] and in its application to the consorts

Fig. 100. Vishnu with Sarasvatī and Lakshmī. Stele, Kawardha, M.P.

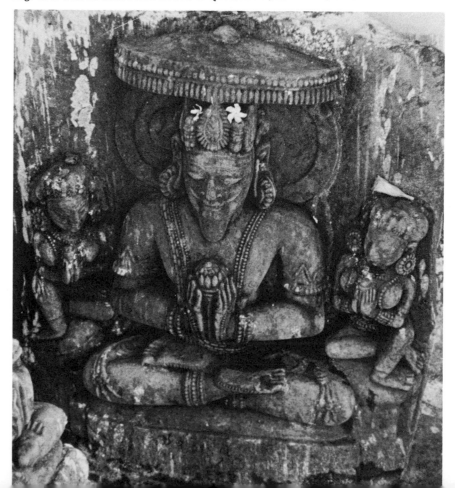

of the old Vedic gods attained its own caricature. Figures such as Brahmaṇī and Indrāṇī, Varuṇī and Agnāyī, present contrivances of theological sophism. Creatures of expediency, they are "goddesses" without any functional existence, devoid of any roots in mythical or devotional reality, or even an identity of their own. They are canonically certified nonentities, and all the efforts of the Brahmans have failed to endow them with more than token exaltation. Even their appellations are mere grammatical abstractions, feminine adaptations of the male gods' names.

It seems cogent that, though these shakti-goddesses figure as the occasional subjects of speculative poetry and priestly invocation, their intrinsic lack of evocative capacity should be faithfully mirrored by the paucity and inspirational poverty of their imageries. To this, the central regions of India offer the most eloquent witness. Throughout their reaches, the likenesses of these goddesses have found no more than scattered, incidental portrayals. Of Indrāṇī there are a few depictions casting her in the pose of stiff and lifeless majesty so characteristically exemplified by the familiar effigy in the Indra Sabha Cave at Ellora;[16] some also of Brahmaṇī, likewise predominantly subjects of Jaina iconography, rendered in similar accents of aloof grandeur. But no certainly identifiable images of Sāvitrī, Varuṇī, or Agnāyī are known; nor of Sūryā who, in some legends called Sūrya's daughter, and in others his wife, may well look back on antecedents as an Indo-European sun goddess who eventually emerged as the shakti of her own masculinized self.[17] No effigies anywhere can be positively associated with any of the lesser gods' female emanations.

The only Vedic shakti who has received consistent iconographic attention is Sarasvatī. The actual evidence as well as rational deduction would suggest, though, that this distinction has accrued not to her canonical presence as Vishnu's or Brahma's consort but to her unforgotten identity as an aspect of the native lotus goddess. All attempts to ensure proper representation of the female divinity's subordinate and nonevocative role have failed to finally obliterate the intimations of her authentic character as the **Lady Divine of the Lotus Ponds.**

They have failed, but not for lack of effort. Whether occupying the cosmic throne surrounded by adoring worshipers, or claiming it in lonely grandeur as celestial queen, or, again, stepping from the mysterious hollow of a niche, her image betrays the inroads of orthodox bias. In deference to popular preconceptions of female ideality it may show her as a beautifully featured, stunningly proportioned woman; but superimposed on this splendor is a stiffness of contour and an impassiveness of mien, designed to void the impact of these female endowments.[18] Upon her smile a shiver of frigidity is grafted, every detail of her features is calculated to subvert her physical fascination by the waste of psychical vapidity, to make her likeness analogous to Brahmaṇī's or Indrāṇī's. Impressive but not attractive, exalted but not lovable, sexually favored but erotically irrelevant, hers is a female form from which female nature has been abstracted, a perfection unrelated to human need and longing and aspiration. To minimize further whatever traces of feminine enchantment might be left, she has been equipped with the emblems sternly recalling her Brahmanical character as the mistress of learning and the arts and as the serving wife of the high god: the book of Vedic wisdom, assumed from Vāch, and the pretty flower which, incongruously, she retains even though her lord and master is no longer present to cherish this gesture of conjugal devotion.

Neither these trappings of anachronistic symbolism nor her pretensions of celestial supernality appear to have enhanced the impact of Sarasvatī's canonical identity even for the devotees of the conventional faith. The few sanctuaries expressly dedicated to her witness scant cultic activity, attracting only passing pilgrims on their way to other hallowed destinations. And even to them the goddess' image seems to be little more than an object of perfunctory piety and routine reverence, of lip service to a name, not of devotion to the substance of the Divine.

Yet, if they but allowed themselves to recognize it, even these carefully defeminized, canonically sterilized likenesses of Sarasvatī still preserve a memory of her uncorrupted nature. There are the symbolic tokens of her original identity, that swanlike bird, animal of the female deity in her

primarily erotic character,[19] and the emblematic lotus, its stylized petals forming the seat of her throne, or its back, or its canopy, or again appearing in the guise of an ornament near her effigy.[20] Above all, triumphant over every effort to efface it, there is that glow of her erstwhile captivation. However distantly, it still animates many of her portrayals; touches them, however faintly, with scintillas of preterhuman grace and charm and passion.

Some of Sarasvati's likenesses have harnessed these scattered glimmers of feminine mystique. The conventional pilgrim, bound to his doctrinal preconceptions, may prove insensible to their innuendo and impervious to their meaning. The back-country communicant, still attuned to the echoes of an ageless past, seems to perceive the one and to realize the other. Perhaps, in some measure, his response is induced by the subliminal suggestion of the ever-present lotus figuration, actuating associations long dormant, retracing esoteric connotations long blurred, rekindling embers of belief never quite extinguished. More basically his adoration of Sarasvati springs from a circumstance of vast if unconscious irony—his misidentification of her effigy as that of Lakshmi.

Fig. 101. Brahmanī, surrounded by Apsarases. Jain temple, Ranakpur, Rajasthan.

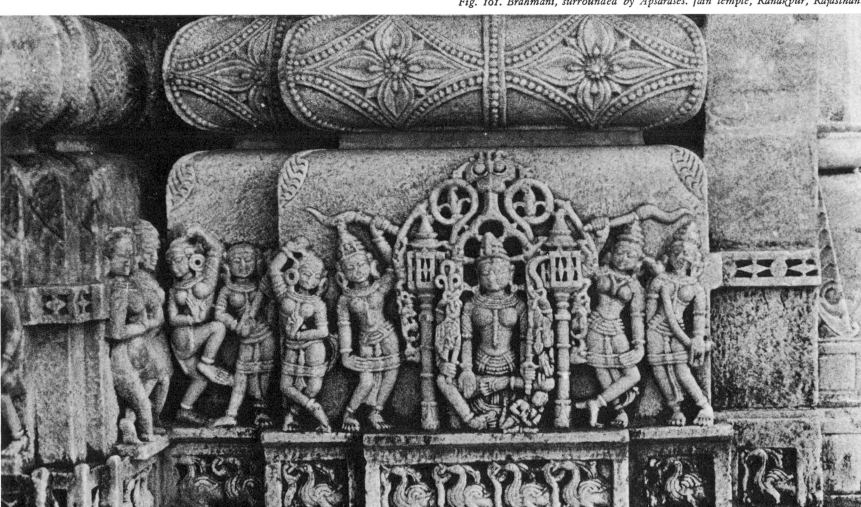

EIGHT

THE LOTUS GODDESS

Among the countless local and regional identities of the lotus goddess, that most peculiarly Indian aspect of the female divinity, Lakshmī, is the one most generally recognized and worshiped. In the cities as in the countryside she is part of the people's everyday life, integral to their physical environment and their psychical reality. In her, men find their reassurance and promise; from her, women draw their consolation and happiness. The pūjā lavished on her images betokens as much sheer gratitude for her beatifying presence as due reverence for her divine nature, for this presence encompasses all the concurrent meanings of her appellation. She is the embodiment of beauty and splendor, of dignity and glory, of good fortune and wealth, of graciousness and prosperity.[1] Yet, beyond these manifested attributes there is an essence of far subtler sublimity, remembered by the festival of nine days which terminates on the tenth with a joyous, frequently ecstatic celebration of her renewal, rendered by the beat of drums and the gyrations of dancers as the renewal of life itself.[2]

XVII

All of India's back country is the dominion of Lakshmī, the goddess of the lotus.

Religious purists may insist on distinguishing her from Sarasvatī, and in solemn discourses define their diverse characters and functions. Pundits may point to their differential attributes and cite some sacred texts which even claim a state of enmity between these two goddess figures, explaining that wealth and learning, beauty and wisdom are rarely combined.[3] To the rest of the people, however, such doctrinal dialectics remain irrelevant. They behold the emblem of the lotus; beside it all other attributes seem merely incidental. The Vedic scrolls and the flower of wifely devotion in Sarasvatī's hands count for no more than accessories peculiar to one particular manifestation of the lotus goddess, of her they call Lakshmī. After all, she assumes so many aspects, so many names. The manifold of her temporal masks cannot deceive them: Sarasvatī, too, is just one of them. She, too, is Lakshmī and, as often as not, the village elders, even the pūjāri himself, will so identify her image.

Theologically, to be sure, they are in error. Theosophically, their insight is authoritative: there always has been only one goddess of the lotus, incorporation of the Feminine Essence.

She accompanies every mile traveled through central India, every visit to a temple. Not a few of these are consecrated to her special worship. Idolizing her in one of her infinite guises, often celebrating her local role and function, a village shrine may shelter but her solitary image, sometimes of strange aspect and title. Her likenesses are omnipresent on the walls and pillars, lintels and niches of sanctuaries, regardless of the deity of their specific dedication. To include in the iconography of the lotus goddess only such of her representations as may be identified by emblematic attribute or recognized designation would be to produce a far too narrow and thus distorting view of her preeminence in India's religious experience and tradition. Her actual import must be measured by the endless variety of her locally envisioned and locally named, pluralized and semidivine shapes; by all her equivalent manifestations, even where no attendant lotus symbols might spell out her actual presence.

This presence is pervasive. Though through the ages many particulariza-tions of the lotus goddess must have faded into oblivion, even her extant imagery encompasses a bewildering diversity of forms, ranging from the creations of most refined artistry to the often artless and sometimes crude handiwork of local conception. Some are identified by appellations of wide familiarity; many more by titles of obscure, parochial usage. Yet these contrasting externalities of specific aspect and nomenclature dissolve before the intrinsic concordance of their common inspiration. Inseparably linked to their primal archetype, they all share the fascination of enchanting feminity, of erotic propensity and delight, each but one incidental materialization, one ephemeral mask of a cosmic experience embodied by the Mistress of the Lotus, one of the multiform reflections of her multifold being.

Her images may show her as Dignity and Glory, as at Khajuraho where she appears enthroned, an ornate figure elaborately conceived, in a temple dedicated in her name; or, again, as Beauty and Graciousness, as at Ugal-para where, assuming the charming poise and folksy attire of the Oriyan country girl, her figure rises from the simple round of a lotus pedestal. 97 They may portray the ethereal serenity of her lotus-framed visage, the mysterious eroticism of her half-smile, displaying the sacred flower; the sensuous suggestion of her charms culminating in provocative luxuriousness 102 103 as she strides upon the wide-open calyx of the lotus. They may display her 105 as Good Fortune and Wealth, as the Auspicious One; or as the special XVI protectress of a locality. They may define her as Prosperity and Abundance, 63 whether in the identity of Gaja-Lakshmī, the elephant-flanked mistress of bouty and regeneration; or in the improbably grotesque one of Dugdhadharī, the Milk-Bearing One, provider of life's sustenance, local version of VII her aspect as Annapūrnā. They may design her in myriad nuances of pose and mien, myriad accents of emphases and meaning. Yet, in their diversity they are all the countenances of Lakshmī, defining, in their aggregate, her very nature.

It is by this appellation that the lotus goddess seems to have been known since the early days of the Aryan conquest. In the apocryphal addendum to

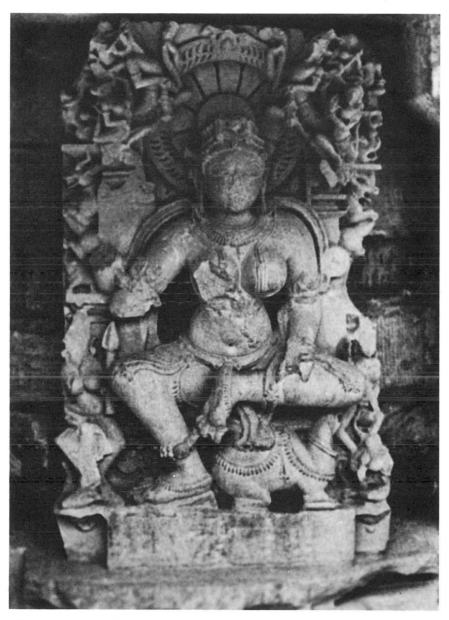

Fig. 102. Yoginī with lotus halo. Chaunsath Yoginī temple, Bheraghat, M.P.

the Rig-veda, the *Shrī-sukta*, she may be addressed as Padminī and Padmasambhavā, as Padmākshī or Padmānanā, as Padma-ūrū and Padmeshthitā and Padmahastā;[4] but these were poetical apostrophes, elaborate references to her lotus nature, some vaguely esoteric, others again frankly descriptive,[5] with no application or actuality outside the hallowed text. Across the country, people may worship her under such titles as Jaganmātri or Samarī Devī, Māla Devī or Nārāyanī, Vyagreshvarī or Mānya Devī, Ālaya Mātā, or simply Mātā; but these are merely epithets accenting locally favored facets of her divinity, vagaries of nomenclature transcended by her identification as Lakshmī, the one universally accepted and traditionally used.

The ascendancy of this designation over such older ones as Padmā or Kamalā or Kumudinī,[6] which characterized the goddess as the theomorphic personification of the sacred flower, of itself affirms its selection as the one most immediately evocative of the divinity's function. The etymology of the name Lakshmī contains no reference to her connection, formally or esthetically, with the lotus. Nor do its dictionary meanings[7] prove radical. Ostensibly descended from the term *laksh*, "to observe, perceive, apprehend," its connotation suggests itself as "She Who Is Perceived." But divinity perceived is divinity revealed. "Lakshmī," then, may well represent a designation, in its original implication now no longer understood, defining the goddess as "the one who reveals the nature of the lotus." If so, this appellation would expose all the meanings commonly imputed to it as later accretions that, by misinterpretation and misdirection, have invariably depreciated its all-inclusive import.

If the primordial goddess indeed was, as the Indo-Aryans perceived, the one "who reveals the nature of the lotus," her revelation failed its beholders. Flowing from the alien ethos of a conquered and despised people, its message was interpreted to fit the new order's own preconceptions. The properties of the goddess were envisioned in terms of a different and inherently incompatible perspective. Thus, the divinity's essential faculty of eternal regeneration, so vividly recalled by the icon of Gaja-Lakshmī, was

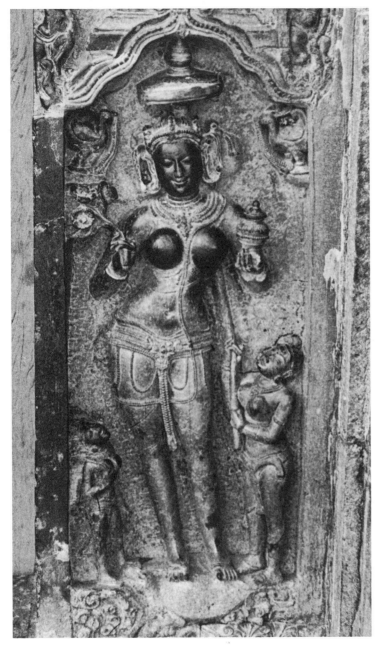

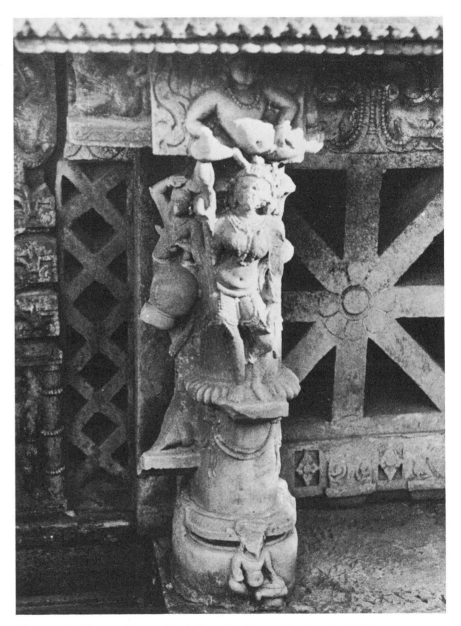

Fig. 103. Lakshmī. Shiva temple, Khiching, Orissa.

Fig. 104. Goddess on lotus pedestal. Rāmchandra temple, Surwāya, M.P.

Plate XIV. Maroti. Chandravatī, Rajasthan.

Plate XV. Mahāmmai. Mahāmmai temple, Mahamadpur, M.P.

Plate XVI. The goddess. Samarī
Devī temple, Kharod, M.P.

Plate XVII. Lakshmī Pūjā. Dhenkanal, Orissa.

Plate XVIII. Section of wall. Boramdeo temple, Chhapri, M.P.

Plate XIX. Dancing and musicmaking celestials.
Nilkantheshvara temple, Udayapur, M.P.

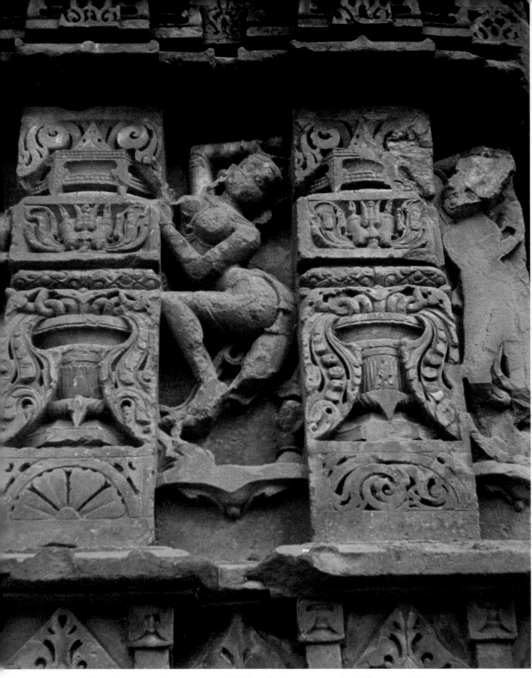

Plate XX. Dancing Apsaras. Nīlkantheshvara temple, Udayapur, M.P.

Plate XXI. Surasundarīs circling pillar. Baroli, Rajasthan.

revaluated in terms of temporal comfort. Facile minds would redefine the notion of infinite life-sustaining and life-perpetuating energy as a promise of physical abundance, and a more cynical materialism would proceed to refer it to the boons of wealth and worldly prosperity. Prey to similar conceptual dilution, Auspiciousness[8] was recast in the snug aspect of good fortune; and, yet further profanized, in the cruder one of bounty-bestowing Chance. In fact, Lakshmī has been identified with Chalā, the Goddess of Fortune, India's fickle Lady Luck,[9] counterpart of Rome's Fortuna.[10] Her gentle powers reformulated by the prepossessions of the princely and priestly, warlike and hierarchically organized Aryan society, she would emerge as Dignity and Glory, personified, bestowing *kīrti*, fame, and *riddhi*, success.[11] Her charm and enchantment, mystery and magic, the fascination and erotic intrinsicality of the Feminine, would be appreciated in terms of pure externality, as physical beauty and self-sufficient splendor.

Though identified so prominently with capacities of the profane sphere, Lakshmī nevertheless has managed to escape her reduction to metaphysical inconsequence and cultic ineffectuality, to a decorative cipher of the Divine. Though popularly acknowledged, her association with the mundane vanities seems to have assumed little relevancy to the worshipers' actual experience. The tradition of the lotus goddess retained too much vitality to permit extraneous accretions to obscure or distort her archetypal image; and the ever-present figurations of her floral emblem, undiminished in the mystique of their symbolism, would continue to recall her essential nature even where her worldly aspects as Lakshmī might occasionally elicit recognition and ritual attention. For who would not pay his respects to Dignity and Glory, render his homage to Beauty and Splendor; who would not seek the promises of Prosperity and Wealth, try to solicit Good Fortune or bribe Dame Luck with suitable prayers? Yet, even while offered their perfunctory tributes, these forms of the lotus goddess appear to have been apprehended as but the ephemeral masks of her authentic countenance.

Across the millennia that countenance has never been forgotten, nor has its symbolic equivalent yielded its mystic preeminence. Joined to her

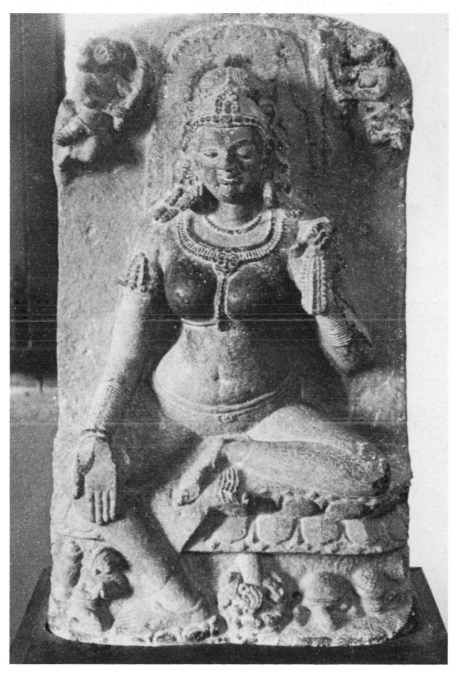

Fig. 105. Lotus goddess. Stele, Khiching, Orissa.

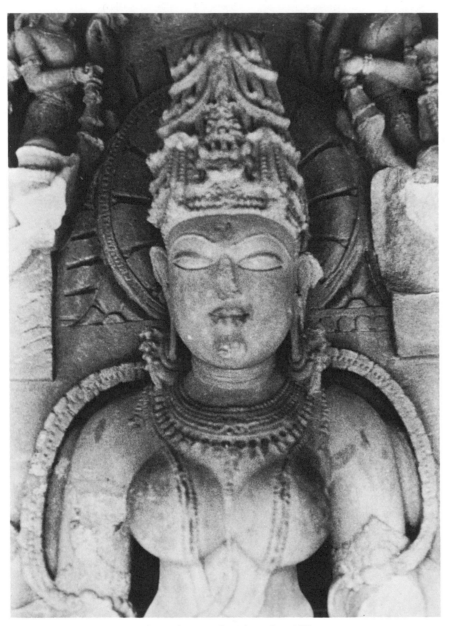

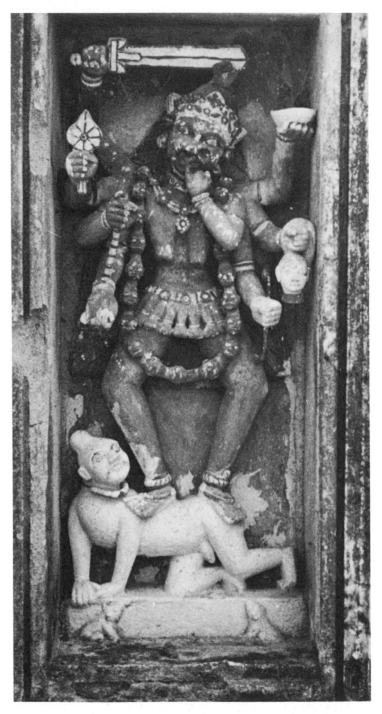

Fig. 106. Gaurī. Chaunsath Yoginī temple, Bheraghat, M.P.

Fig. 107. Kālī-Chāmundā dancing on a conquered demon. Samlai temple. Sonepur, Orissa.

Fig. 108. Surasundarīs. Porch, Nīlkantheshvara temple, Udayapur, M.P. (right)

97 102 own effigies to reinforce their testimony, or associated with those of other
58 106 deities to record their substantive inspiration,[12] the sacred design of the
107 lotus appears in innumerable recurrences. Unattached, often stylized or
79 101 woven into ornamental patterns, from temple walls and pillars, friezes
104 108 and windows and ceilings, from processional chariots and field altars, even
7 109 from the façades of secular dwellings, it announces the transcendence of
the Feminine. Its message becomes palpable in the corporeal form.

The figure of the goddess, anthropomorph of the Cosmic, transforms abstraction into actuality, principle into impact, idea into experience. In a diversity of flagrant display or subtle insinuation, it discloses the regenerative and erotic immanence, the elementary mystique of Woman, that has been the primordial source of her divine exaltation.

The effigies of the lotus goddess are still acute with this sensuous magnetism, with the promise of self-realization[13] perennially nurtured by a psychic imperative. Orthodox influence has succeeded in no more than mitigating, perhaps here and there blunting, their franker exhibitions, by way of conventionalizing their externalities. But nowhere has it been able to suppress their suggestive force, not even when they depict Lakshmī in her canonical role as Vishnu's "other" wife.

For Lakshmī, too, has been "canonized" as a member of the Hindu pantheon. In fact, notwithstanding the eventual theological contradistinctions, Sarasvatī appears to have been but a specialized, probably local manifestation of the great goddess of the lotus, who was addressed as Shrī, the Exalted One, even before she became known as Lakshmī, the One Who Reveals.[14] But while Sarasvatī proved more tractable to orthodox conversion[15] and, through identification with Vāch and assumption of the latter's functions and insignia, emerged as a Brahmanical divinity, the inclusive figure of the lotus goddess resisted such self-obliterating assimilation. Even as theologians proclaimed and official iconography depicted her as Vishnu's "other" bride, Shrī-Lakshmī retained her own undiminished identity, her own symbol, her own indelible characteristics. She never compromised the physical properties or psychical propensities of her nature.

As a diminutive shape flanking her "husband's" dominant figure, she may 100 frequently be captive to the doctrinally favored posture; far more consistently, however, she asserts her female charms, often even imparting some of this sensuous winsomeness to the counterpart form of Sarasvatī. In her 69 portrayals as Vishnu's sole consort, this erotic immanence appears in yet sharper focus. Unlike Sarasvatī, she does not buttress the remote and rigid majesty of her divine master's throne but, tender with amorous self-bestowal and seductive encouragement, shares her divine lover's privacy in intimate conversation.[16]
84
But, then, it is not really Vishnu who relinquishes his transcendent grandeur in exchange for the tempting immediacy of the wistful and ardent goddess. It is Nārāyana, the consort of Mahālakshmī[17] in the days when he had not yet been despoiled of his primal character by his imposed identification with the solar creator god. It is still the ancient native deity of the Vindhyas and his lotus-defined goddess whose memories linger on in many backwoods icons, to draw their likenesses in the accents of an older, more authentic inspiration.

That inspiration is the heritage which underlies the manifestations of folk religion and has shaped many of Hinduism's metaphysical and cultic concepts. Though the remoteness of time and the alien viewpoints of an essentially disparate perspective of life must foreclose any final assessment of that heritage, the surviving evidence of iconography and symbology presents the opportunity of a valid, if limited, reconstruction.

Though the memories of many locally specialized and even essential aspects of the lotus goddess must have fallen prey to time, collectively her extant imageries provide a fair clue to the Feminine's archetypal visualization. But, because of the contrasting dissimilitudes of her individual portrayals, this clue has been largely disregarded. It does, indeed, seem bewildering to define the common theme linking the pretermundane loveliness of her likenesses and the unprepossessing earthiness of many more; 94 10 the queenly containment of some of her effigies, and the smiling intimacy 110 and inviting poses of others; the easy grace of her appearance at Gyaraspur 105 5

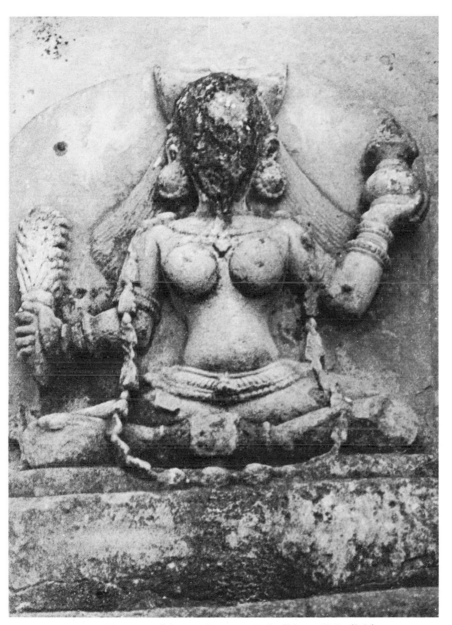

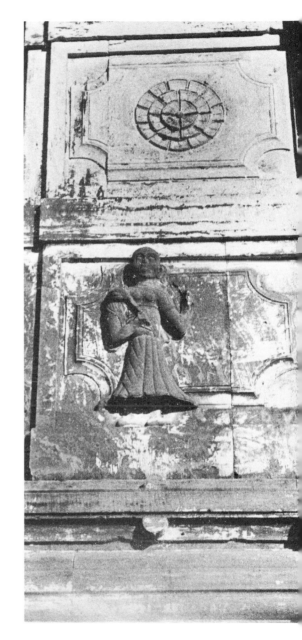

Fig. 109. *Lotus emblem carved in wooden post. Paharikhera, M.P. (left)*

Fig. 110. *Annapūrnā. Subaranameru temple, Sonepur, Orissa. (above)*

Fig. 111. *Local divinity as lotus goddess. Jain temple, Talanpur, M.P. (right)*

and the masklike stiffness of that at Talanpur; the quiescent poise of her depiction in a maternal role and the erotic animation stirring so many others. Reconciliation of these ostensible contradictions tends to pose all the more difficulty as they negate any correlation with artistic skill and sophistication, the inroads of changing tastes and styles, or the differences of orthodox and folk traditions. Yet this impasse is resolved once the observer divests himself of his conditioned passion for compartmentalizing his impressions and his responses, and appreciates that diversity itself may constitute the contour of the infinite. The very incongruities of the goddess's appearances might suggest the answer: external disparity may have been perceived as the cogent equation of her multifold immanence, of the myriad manifest and occult properties that unite in and compose the allness of her nature.

This nature finds its definition in the inclusive symbol of the lotus. Esoteric yet ingeniously transparent, this mystic design, figurative equivalent of the Woman Transcendent, provides the key to any apprehension of the ethos which has continued as the *basso ostinato* of India's religious life.

Though itself of ancient inception, the lotus emblem appears to have been an elaboration of a preexistent, simpler design: a floral figuration of the circle, always and everywhere the elementary ideograph of the female organs, subsumed in India by the term *yoni*. This role as the fundamental allegory of female sexuality has endowed the flower with its aura of sacred mystery and imparted to its diagrammatic abstraction a dimension of the Cosmic. Whether in hylic or emblematic form, the lotus has come to present the ultimate equation of female being and female magic: its petals enclose the enigma of generation and regeneration, its center is the omphalos of the universe, the source and substance of life itself.

As its theomorphic embodiment, the lotus goddess personifies these intrinsicalities of the Feminine Essence, incarnates the connotations encompassed by the term yoni. A word of multiple significations, it defines woman's sexual functions and manifestations as indivisibly interrelated, as the various interacting aspects of the same process. In its meaning of

Fig. 112. Nāyikā nursing infant. Jagannātha temple, Keonjhar, Orissa.

"womb," it emphasizes her reproductive and protective, in that of "vulva" her libidinal and erotic, potentialities; in its sense of "receptacle," her receptive and responsive, in that of "repository," her internalizing and assimilative, capacities. Just as all these meanings are simultaneously conveyed by the vocable, so they are envisioned as concurrent in the substantive experience of woman, her sexual self-realization. It is this vision of total female being, of woman as vehicle of the yoni, which Lakshmī "reveals." For the world which first beheld her apprehended woman in terms not of differentiated physical and psychical propensities but of a psychophysical gestalt, an existential integer of infinite potentialities. This all inclusiveness of the Feminine's latent capacities is woman's everlasting fascination, and the decisive factor of her apotheosis. It is the quintessence of the lotus goddess' arcanum, mystically transcribed by the emblem of the lotus-yoni and mirrored by the countless multiformities of her imageries.

Her perception as the divine equivalent of Woman made the lotus goddess the prototypal godhead of India's pre-Aryan past. She represented the transcendent extension of the yoni, the supramundane analogue of the Feminine's erotic and sexual powers. In rendering this analogue in anthropomorphic aspect, in bringing the metaphysical abstraction within the immediate compass of human sensibility, she became Lakshmī, the revealer of the lotus' nature. If this revelation seems so bewildering not only in its diversities but also in the complexities of each of its manifestations, its enigma is implicit in the infinite potentialities of the yoni and of the female gestalt which subsumes them. For, regardless of their respective emphases, each likeness of the lotus goddess endeavors to incorporate all the meanings of the yoni. Just as her depictions as mother[18] retain the suggestions of the erotic, the magic, and the mystic, so her seductive poses recall her maternal and conjugal, receptive and assimilative potentialities. For, as womb and vulva are functionally interdependent components of the yoni, so are motherhood and erotic experience functionally interdependent phases of sexual womanhood; before becoming a mother, woman must have been a lover; yet the desire that will make her a lover has been

Fig. 113. Nāyikā giving birth. Panel, Wedding shrine, Chhapri, M.P.

impelled by her imperative of maternal self-realization. Nor could assimilation take place without prior receptiveness; yet the latter would be lacking were it not for the need to enrich selfness through the accretion of otherness to internalize the external.

Interpreted by the universalizing abstraction of the lotus symbol, the potentialities of the yoni attain new dimensions of import, far surpassing its terminological definition. "Womb" now signifies capacities beyond the merely regenerative, physically renewing ones; "vulva" now implies more than a focus of the bodily delight and instinctual gratification that are the enabling preliminaries to reproductive effectuation. The connotations of "receptacle" and "repository" assume a new depth of metaphysical and occult realization. The properties of female being acquire the experiential and conceptual scope of the Feminine Principle. It is the latter that becomes manifest in the icons of the lotus goddess, its ultimate embodiment.

This universality of female character and function, inherent in each image of the lotus goddess, is most poignantly emphasized by the iconography of central India. Even as she may be depicted in the apparent role of the birth-giving, or nursing, or child-rearing mother, behind these incidental masks stand the countenances of Bharanī, the one who bears life; of Annapūrnā or Dugdhadharī, who sustain it by dispensing the rice and milk on which it must feed; of Ālaya Mātā, who maintains the total family by protecting its dwelling; of Māla Devī, who guards the fields, its means of material provision; of Mangalā Devī, the Auspicious One, who offers shelter and refuge, consolation and encouragement; of Samarī Devī, who safeguards the continued existence of all folk in this world, which, as Bhavānī Mātā, she has produced. Yet beyond those countenances there is the placid, knowing smile of Kāmākshī, the Love-Eyed One, who has experienced the delights of the lover that are the threshold of motherhood, transforming each of her likenesses into a microcosmic equation of the indivisibly interdependent erotic and maternal principles which have traced its macrocosmic contour.

It is in this sense that the lotus goddess' epithet, Jaganmātri, Mother of the World, must be understood. Some of her images present its direct iconic interpretation; as at Gyaraspur, where she appears seated on a lotus throne borne on the back of a tortoise, the zooidal archsymbol of cosmic creation, as the theomorphic incorporation of the cosmic yoni from which the universe has issued forth. This primordial vision finds its semantic corroboration in the Sanskrit term, *jagatī,* synonymously connoting "female being, earth, world." Here, its echo still reverberating in the Vedic language, the authentic conception of the Feminine as the originating source of the phenomenal universe persists to belie the Vedic myth of the supernal male deity and his arrogation to himself of a creative power essentially extrinsic to his potentials and capacities.

The terminological equation of "female being" and "earth" tends to define the goddess Earth, whom Vishnu varahāvatāra rescued from the bottom of the sea, as a specialization of the lotus goddess. This identification seems to be further supported by the central incident of Vishnu's tortoise incarnation when his exploit of the churning of the sea raises Lakshmī herself from the depth of the ocean.[19] Similarly, the several Earth goddesses of Indian lore, such as Prithivī or Sinīvalī, might be recognized as elemental aspects of the deified maternal principle, particularly as the implications of the term jagatī identify the lotus goddess with Nature herself, the matrix of all that is sensually perceived and experienced.

This equation of Feminine Essence and Nature is in most languages reflected not only semantically but grammatically as well. Their respective terms signifying "nature" are invariably of feminine gender,[20] indicating that in her apotheosis Nature was envisioned as female. India's goddess Nature had her universal analogies. As the corporeal manifestation of the maternal principle, her presence, cultic and iconographic, signified not alone the primordially generative but also the eternally regenerative capacities. Hers were not only the magical powers of production and reproduction, but also the mysterious compulsions of desire and passion, of erotic attraction and quest and gratification, that are the primum mobile of all vital processes.

Regarded, not as the creatrix or sovereign ruler of nature, but as nature personified, the lotus goddess implicitly assumed the aspect of every one of nature's phenomena. The material universe was imbued with her essence. She indwelled earth itself and all living creatures that roamed it, every plant that grew from it, every spring and stream that fertilized it. Every cave that gave shelter was her domicile, every rock and stone a hallowed monument to her all-immanence. In the vastness of its diurnal blue and its nocturnal quietude the sky itself was the living mirror of her beauty, the luminaries and stars the habitats and dispensers of her powers, the elements but the reflections of her moods. Every particle of life was sacred: it was part of Nature, part of her own being.

In the venerative patterns and imageries of central India the traditions of this encompassing vision are still abundantly, if sometimes only inferentially, evident; too abundantly, in fact, for any full discussion here. Environmental and psychological factors have, of course, conditioned the emphases respectively accorded to the diverse particularizations of the lotus goddess. Some of them, as the stellar and elemental ones,[21] have gradually come to suffer devotional attrition. Even her ancient eminence as sky goddess is recalled only by scattered and obscure references. Other of her manifestations, most prominently those as the mistress of the waters and of vegetation, have preserved their momentum.

As the mythic, cultic, and iconographic evidence everywhere affirms, the identification of the female divinity with the waters is fundamental and universal. But in India its accent has been further intensified. From time immemorial, all constituents of the aquatic sphere, rivers, lakes, ponds, springs, and wells alike, have been sanctified by her implicit inbeing, which has made them primary objects of worship and ritual activity. As the repositories as well as effectuators of sacred power, they have provided the impetus for the most hallowed places of pilgrimage. The purifying sanctity of the Ganges at Varanasi has become proverbial, but it presents merely the most familiar of untold counterparts. It is closely rivaled by the analogous import of the Godavarī at Nasik, the Sarasvatī at Siddhpur, the Yamunā

Fig. 114. Gaṅgā. Rāmeshvara Cave (#21), Ellora, Maharashtra.

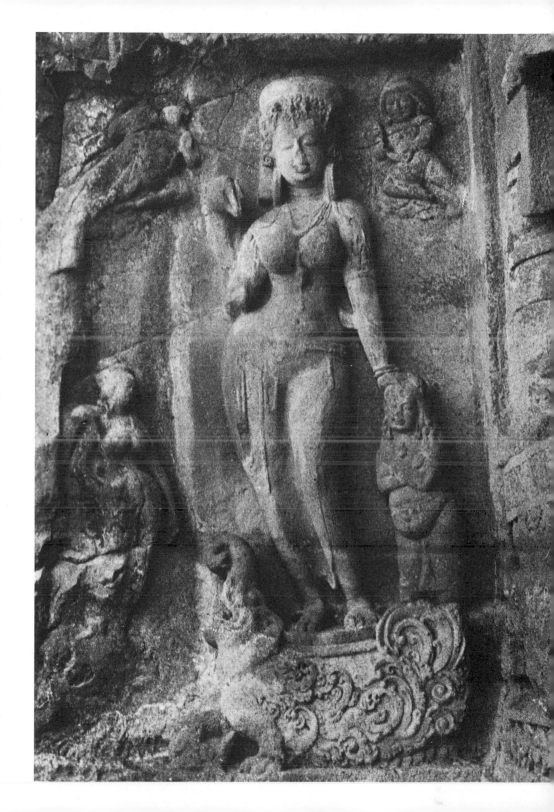

Fig. 115. *The goddess of the Mahānadī.*
Rāmchandra Dewal, Rājim, M.P.

Fig. 116. *Vriksha devatā.*
Rājīvalochana temple, Rājim, M.P.

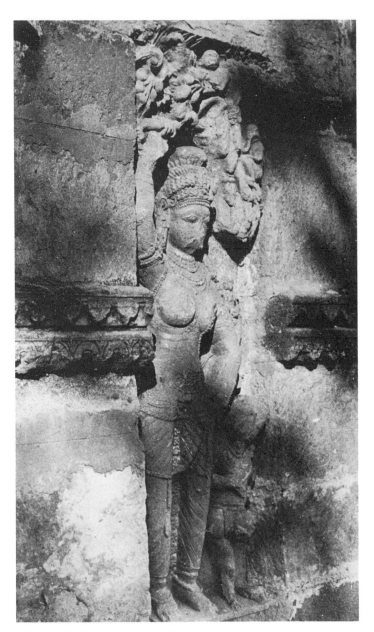

Fig. 117. *Vriksha devatā. Kanthi Dewal, Ratanpur, M.P.*

at its confluence with the Ganges near Allahabad, the Siprā at Ujjain, the Krishna at Srisailam, Lake Pushkar near Ajmer, or Lake Bindusagar, which is surrounded by the temples of Bhubaneshwar. Though these centers of worship have in time been appropriated by the cults of the Hindu deities, their sanctity unmistakably derives from the mystical powers of the water which, as language itself continues to attest, have never ceased to be recognized as the immediate manifestations of the primal goddess of pre-Hindu, pre-Aryan days. For one, the almost unexceptional feminine gender characterizing their names points to the fundamental female personification of rivers and lakes, of ponds and springs. For another, some of them, like Pushkar Lake,[22] carry direct reference to the lotus goddess; or an implied one, like the mythical Siprā Lake, which is symbolically determined by its abundance of lotuses. The identification especially of rivers with the female divinity has been even more direct. The Ganges is idolized in the form of the goddess Gangā; the Yamunā, in the likeness of the goddess of the same name, invariably portrayed as youthful, erotically insinuating prototypes of feminity. Undoubtedly, such had also been the original aspect of Sarasvatī in her ancient role as both the Lady of the Lotus Ponds and the divine personification of the river Sarasvatī. Throughout central India, counterparts of these great goddesses, known by topical names and celebrated by folk imagery, personify the fertilizing, life-sustaining powers of local streams and ponds, springs, and wells. While for the most part, like Gangā and Yamunā, they may lack emblematic signification as aspects of the lotus goddess, their very identities as specializations of nature personified would so define them. Moreover, the double role of Sarasvatī, at once as mistress of the waters and of the lotus, would seem to attest this intrinsic association.

If less spectacular, the worship of the goddess as the divine incorporation of vegetal growth is no less intense in its dedication or common in its exercise. The forest may not rival the great river's sacramental prominence, but the numberless hallowed trees remain the vehicles of her power. The fields may not attract throngs of pilgrims, but the *panchavati* groves, those clusters of five sacred trees at the outskirts of backwoods villages, call the local worshipers to their moments of homage. Every flower, every fruit or grain is imbued with her magic. Every one of the branches, so commonly placed above the entrances to shrines, symbolically announces her presence. Throughout the countryside the gnarled roots or cavities of an age-old banyan may shelter a hallowed effigy or offer its giant trunk as the backdrop for some folkloric idol. Even failing such overt tokens, its sanctity is inherent, accruing to it as an abode of the goddess, a manifestation of her regenerative energies.

The prominence of her iconography conveys the true measure of the reverence in which the mistress of the plants is held. In great temples and backwoods shrines alike, her images present her in a plethora of identities, sometimes generic, sometimes peculiar to the specific worshiping community. Typically, the mistress of the plants is a yakshī, a local revelation of nature personified, sustainer and protectress of the individual village or hamlet. Her tradition reaches back into the primeval days of India's indigenous past, when her cult must have been paramount within the settings of small isolated clusters of human habitation. Though the often accepted interpretation of the well-known Harappa seal,[23] identifying the self-displaying divinity as a tree goddess, seems questionable on several counts,[24] all evidence suggests that in her role as the mistress of vegetation the female deity had been the subject of depiction during, and probably well prior to, the early second millennium B.C.[25] At any rate, a very protracted cultic as well as iconographic evolution must have provided the means for the high level of artistic accomplishment demonstrated by the first-century A.D. plaque from Basarh, which shows the female deity upon a lotus pedestal amid framing branches and giant, phallic flower buds;[26] or by the comparable sophistication of her depictions on the oldest extant monuments of worship in India, the Buddhist stupas, built around the beginning of the Christian era. At Bharhut several first-century B.C. pillar reliefs, each with an inscription identifying its subject as a yakshī, portray her in the prototypal if stylized poses and configurations of the tree goddess.[27] More

refined in technique, and significantly freer in expression, is the captivating realism of her first-century A.D. effigy balancing on the transversal of the gateway at Sanchi;[28] returning to the archetypal vision of the mistress of the plants, it is rendered in the explicit accents of erotic feminity to set the pattern for all her succeeding effigies.

Though, unlike her earlier counterparts at Bharhut, at Sanchi this divinity remains undefined by any qualifying legend, she has been generally identified as yakshi[29] or, alternatively, a *vrikshakā*, a term synonymous with *vriksha devatā*, "tree goddess," and *vana devatā*, "forest goddess." Exploiting a classical analogy, these titles have been rendered as "dryad"[30] and applied as generic designations. While the later images of such divinities have abandoned the archaic stiffness of their precursors at Bharhut, for the most part the eroticism of their designs, though always emphatic, favors a more subdued expression than that encountered at Sanchi. Their pervasive seductiveness is conveyed by suggestion rather than flagrant display; by the loveliness of an enigmatic smile, at once knowing and inviting passion; by the sinuous twist of a nubile body languid with the fancies of desire and the dreams of gratification. Translating the Feminine's erotic potential into the idiom of stone-carved materiality, these medieval likenesses of vrikshakās and vana devatās recapture the primal vision of the lotus goddess whose particularizations they represent.

Given the intrinsic and primary identification of the lotus goddess with the productive and life-sustaining potence of telluric matter, the ostensible sparsity, even near absence, of imagery presenting her in her identity as earth goddess might seem indeed astounding. To be sure, across the centuries prayerful invocations have been addressed to the earth goddess under such appellations as Dharā, Dharanī, or Dhārtri,[31] and her memory has found some eloquent tributes in myths and legends, as in the Rāmayāna, which, by her very name, Sītā, the Furrow, identifies the hero's bride as her mundane equivalent.[32] Some of the female deity's specializations, such as Annapūrnā, also inferentially recall their associations with the cult of terrestrial fertility; and in many villages the local divinity is still worshiped

Fig. 118. Vrikṣa devatā. Shiva temple, Khiching, Orissa.

in this very aspect. Even so, in their aggregate these surviving traditions may seem by comparison rather inconsiderable, particularly as they appear unsupported by any substantial body of iconographic projections. However, a more careful evaluation of the goddess in her telluric aspect must reverse any initial illusion of her virtual demise, and reveal her as the cultically and iconographically dominant presence she is.

To start with, the worship of stones and rocks is every bit as conspicuous and general as that of hallowed trees and groves and plants. It increases proportionally with the remoteness of the rural countryside, and proves particularly prevalent in the still largely tribal backwoods precincts of central India. The powers imputed to these fragments of telluric matter are obviously those of the goddess, whose immanence is indicated by their markings with the red pigment primordially—and even to this day—identified with her specific magic,[33] and whose presence is further affirmed by their frequent placement in association with sacred trees, as well as those composing the panchavati groves. This presence, too, transforms crevices in large rocks into the mystical abodes of the earth goddess. As one example among many, the natural fissure of the giant boulder into which the shrine of Sītābhinji has been wedged appears to have derived its sanctity from a primeval, yet still lingering, esoteric equation of cleft and vulva, which finds evidential substantiation throughout the most disparate areas of the globe. The ancient perception of the cave as the womb of earth, and by cogent extension as the womb of the earth goddess, accounts for the preeminence everywhere of grottoes as the early tabernacles of the female divinity, and even in far later days as the favored staging grounds of her mystery cults.[34] Undoubtedly, India's partiality toward cave shrines has been founded on this analogy of cave and yoni. While a number of practical considerations may have been contributory, their persistent selection suggests that the tradition originated in the worship of the lotus goddess in her telluric aspect. This fact is in no way contradicted by the circumstance that most of these cave sanctuaries have come to be dedicated to the great Hindu gods, the Jaina tīrthankaras, or the Buddha.[35] Exploited by

II xvi

Fig. 119. Kankālinī. Bhagavatī temple, Banpur, Orissa.

each new creed which utilized the great emotional momentum and cultic prestige for the benefit of its own deity, they yet drew on an inspiration far antedating the ascendancy of their ostensible tenants. Their mystique rests on their perhaps no longer conscious but persevering perception as lithic equivalents of the divine yoni; a perception circumstantially corroborated by the popular reverence accorded to so many caverns which, though but dark and empty hollows in a mountainside, unoccupied by any altar or even idol, and serving no ritual celebrations, remain the abodes of the earth goddess, the indestructible heralds of her presence.

This inclusive equation of nature and lotus essence proved of itself sufficient to raise the sacred flower to a symbol of divinity *per se*. Thus, the evolution that turned this esoteric emblem into a preeminent attribute of the Great Tradition's male deities drew additional impetus from the indigenous prestige of the Divine Feminine. Their need for popular legitimation of their divine status compelled their acquisition of this token of female exaltation.

As might be expected, it is the male deities primarily involved in the generative or the sustaining and preserving life processes, those physiologically and psychologically identified with the female essence, who appear most conspicuously linked to the lotus symbol. Thus Shiva, among all the Hindu gods most prototypally the personification of dynamism, is found least frequently and least emphatically associated with it. It is Brahma, the "Creator," and Vishnu, the "Preserver," who are inextricably bound up with its mystique. The former, addressed by such epithets as *padmayoni* and *padmasambhava*, "the lotus-produced," *padmasadman*, "the one seated on the lotus," or *kamalabhavana*, "the one dwelling in the lotus," is mythically as well as iconographically most closely related to it. The latter finds his entire cosmic and cosmogonic activity identified with that life-engendering power, as indicated by the legends[36] which have earned him such titles as *padmanābha* and *kamalanābha*, "having the lotus in his navel," or *padmagarbha*, "the lotus-produced." The derivation of these symbologies from the indigenous tradition has long been recognized. The

Fig. 120. The Goddess rising from the lotus. Mahāmāyā-Siddhīshvarī temple, Shivpuri, M.P.

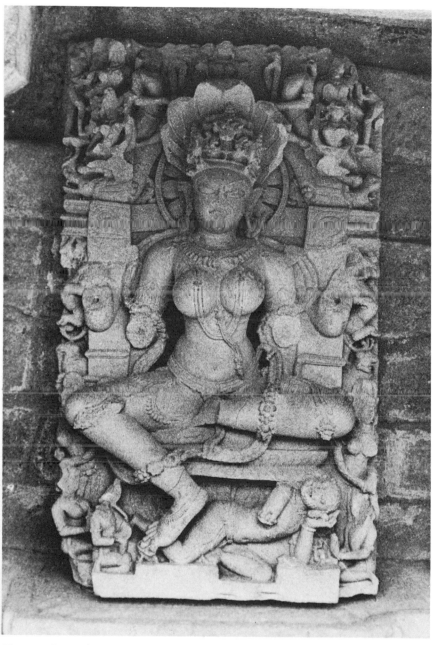

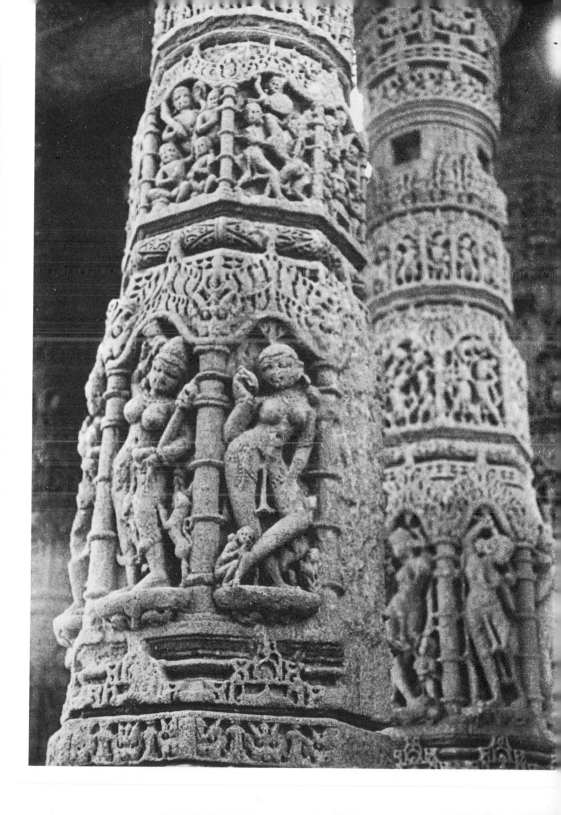

Fig. 121. *Serpentine Yoginī (Manasā). Chaunsath Yoginī temple, Bheraghat, M.P.*

Fig. 122. *Surasundarīs. Pillar: Kāmeshvara temple, Modhera, Gujarat.*

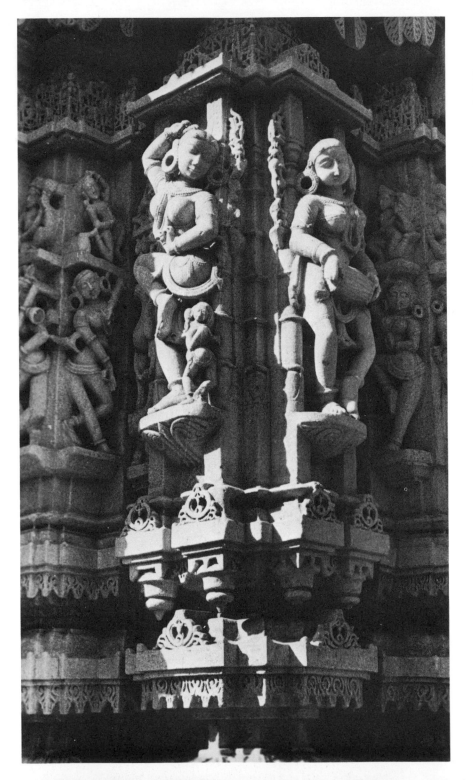

general appreciation that the lotus associations of the Hindu gods signify the actual presence of the lotus goddess herself is most succinctly formulated by Zimmer's unequivocal statement that "this radiant lotus of the world [which grows from Vishnu's navel] is the goddess Padmā."[37] This lotus is her floral epiphany whose vision energizes Vishnu to initiate another cycle of cosmic regeneration.

The even more explicit lotus associations of the Buddha and the later Mahāyāna Bodhisattvas must be viewed in precise analogy: the Enlightened One has not accidentally been proclaimed Vishnu's ninth incarnation. His throne with its lotus base or backdrop or canopy[38] parallels the Preserver's iconography, as do the likenesses of the Bodhisattva Avalokiteshvara-Padmapāni, the "All-observing Lord with the lotus in his hand."[39]

If the native tradition of the Feminine's preeminence could so vigorously impart itself to the male deities of the canonical creeds, its even more intensive impact on their female counterparts seems cogent. After all, the lotus nature is intrinsic to all manifestations of the Goddess. Nomenclature itself implies as much: Sarasvatī, the canonical designation of the lotus goddess, is an appellation assumed also by the ostensibly dissimilar aspect of the female deity as Durgā;[40] and many of the prevalent epithets are shared by Lakshmī, Durgā, and Pārvatī. Iconography offers salient corroboration: throughout central India the representations of the Goddess, however seemingly disparate in their conceptions of the Feminine, show her defined by the lotus symbol. The frightful figure of Kālī exhibits the sacred flower as in triumphant dance she tramples on a conquered demon. 107 Māla Devī; guarding the fields with sword in a merciless hand, occupies 58 a lotus pedestal, as does the grim skeletal Kankālinī. The black countenance 119 of Kālī-Siddīshvarī seems to rise from the double calyxes of twelve-petaled lotuses; while the serpentine manifestation of the Goddess as Manasā is 120 seated against the backdrop of a mandala formed of lotus petals. Even 121 Mahishasura-mārdinī (Durgā), the slayer of the buffalo demon, appears to draw her supernal strength from the eternal font of mystic power provided by the lotus base on which she stands.

96

Fig. 123. Apsarases. Jain temple, Ranakpur, Rajasthan.

Fig. 124. *Apsaras, gandharva, and vyali. Boramdeo temple, Chhapri, M.P.*

This power, animating the supernal revelations of the female deity, this yoni power of the archetypal Feminine also permeates her minor manifestations and defines their extramundane character. Its presence has molded the imageries of exalted femininity which in their aggregate vastly outnumber all other representations of the Transcendent combined. For, however their true character has been obscured or minimized, the celestial females

Fig. 125. Apsaras. Mahādeo temple, Satgaon, Maharashtra.

who in infinite profusion crowd every Indian sanctuary are impersonations of the Divine; each of them wears the countenance of the lotus goddess in her aspect as mistress of the waters or of vegetation, and in that as earth goddess. After all, they had once been her local manifestations, divinities reigning in their own right. They had been yakshīs, the primal guardians of life and prosperity, the magical focuses of popular devotion. Now assuming the familiar guise of the *surasundarī* or *apsaras*, *devikā* or *mohinī*,[41] their individual identities and properties have, as intended, been submerged in the anonymity of the collective. Thus reduced to depersonalized emanations of the supernatural, they have become part of the Hindu heavens as servants and entertainers of the canonical deities.

Shorn of their specific attributes and powers, and generally stereotyped in pose and gesture as they appear in their new roles, nonetheless these yakshīs retain and, by the cumulative effect of their proliferations, even intensify the ancient accents of erotic femininity and fascination that are the heritage of their lotus nature. These accents seem as integral to the mystique of the sanctuaries as the hosts of celestial females prove indispensable to their designs. Those dancing or music-making, frolicking or self-displaying, discreetly insinuating or frankly provocative figures appear to provide the very frame of reference against which the likenesses of the divine protagonists define their presence. They conjure that aura of magic enchantment and beatitude which makes the contemplation of any Indian house of worship a uniquely engrossing experience. Their presence opens a vista of the essential inspiration of Indian religion.

The most magnificent temple and the most inconspicuous village shrine do not differ in their emphasis of the Feminine, but merely in the numerical and artistic elaboration of its depictions. The same intensity that has molded the otherworldly mood and suggestion of the celebrated sanctuaries of Khajuraho, Konārak, and Bhubaneshwar[42] equally dominates their less familiar counterparts everywhere. Whether as companion of a canonical deity, or as a member of a merrymaking group of supernaturals; whether as a lonely dancer or musician disclosing her charms, or as the gracefully

60 66
123 12
125
XVIII x
XX

Fig. 127. Apsaras. Gussai Baba temple, Udaipur, Rajasthan.

sinuous guardian of the gate; whether voluptuously enlivening a pillar, or upholding its capital; whether enchanting the beholder from rows of recessed niches along a temple's circumference, or from circles of high reliefs surrounding its lofty cupola, the countenance of the earlier yakshī wields her inescapable magic. The individual figure may be called surasundarī or apsaras, devikā or mohinī, yoginī or nāyikā;[43] it is always an embodiment of the Feminine, in its sensuous loveliness perpetuating the immemorial nature of the lotus goddess, giving contour to the physical fertility and psychic desire that are the promise of eternal regeneration.

Not always, though, has the countenance of the yakshī preserved its authentic character. Sometimes there remains but a glimmer of its old magic, faint beneath the superficial glamour of the often skillfully executed but coldly stylized, openly suggestive yet lifelessly frozen female forms, produced by a sophisticated but decadent court art which, catering to the jaded tastes of princely patrons and their coteries, substituted titillation where the ardent experience of the erotic was failing. Analogous to the treatises on the art of love which had been gaining more and more audience, art would tend to satisfy the prevalent fashion of the times. As the literati would emphasize the techniques of lovemaking over the spontaneous expressions of loving, so some artists would sacrifice the psychical power of

the feminine essence to the esthetic perfection of the physical form. Even at Khajuraho many likenesses of the surasundarī and apsaras and nāyikā, for all the excellence of their designs and plasticity, seem to serve the quest, not for a glimpse of the Divine, but for a chimera of worldly pleasure. Not rarely their contours and poses appear to have been modeled on the dancers and courtesans of the princely households, whom they glorified in terms of the current ideal of beauty. This trend becomes progressively more marked, especially in the Jaina sanctuaries adorned to suit the proclivities of the wealthy traders who financed their construction; but also in some of the later Hindu temples, as that of Gussai Baba at Udaipur, where the Feminine is reduced to rows of garish masks, almost self-parodying in the grotesque accents of their patternized and unpersuasive sex appeal.

Yet, even when such specimens of inspirational debilitation exhibit their indifferent sexuality, they cannot completely conceal the enabling vision whose corrupted creatures they are. Even these stiff and vapid mannequins of stone still manage to retain a memory of their model: the yakshī, divine mistress of old, whose local primacy could hardly find more eloquent affirmation than that implicit in her perpetual role as the guardian of the temple gate.

Whether as part of a mixed or exclusively female group, or again as an

Fig. 128. Apsarases. Jagannātha temple, Ranpur, Orissa.

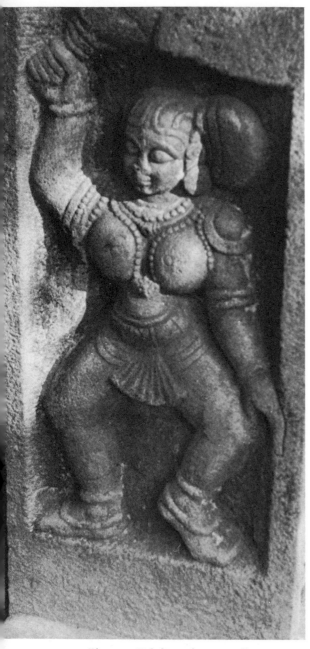

Fig. 129. Yakshī as door guardian.
Balaji temple, Dichpali, Andhra.

individual, forcefully dominant figure, in this function her presence seems practically indispensable; so much so that, apparently taken for granted as but an incidental peculiarity of Indian temple design, it has been ignored as a subject of extended attention. Yet, clearly, while the figure of the *dvarapālikā*, the female gate-guardian, had undoubtedly been conventionalized, its continuing prominence presents a phenomenon of indicative significance, bespeaking as it does the compelling import of the Feminine in popular tradition. For, unless the yakshī continued to be envisioned as the actual, almighty mistress and protectress of the locality, her guardianship over the temples of the canonical gods would seem inconceivable. Her position in front of the entrance is not merely apotropaic. While she is the one who safeguards the sanctity of the shrine, she is also the one who first greets the worshiper, whose suggestion accompanies his steps to the altar, and thus sets the tenor and accent of his devotion. Tutelary mistress of the sanctuary, at the same time she is the one who endows it with the magic of the sacrosanct ostensibly embodied by the deity within it. She is the power behind his throne, the repository of popular adoration which

Fig. 130. *Local goddess identified with Kālī, as dvarapālī. Shankara temple, Wakri, Andhra.*

Fig. 131. *Local goddess with wolflike animal, Mahālakshmī temple, Chandol, Maharashtra.*

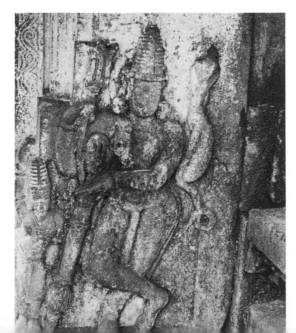

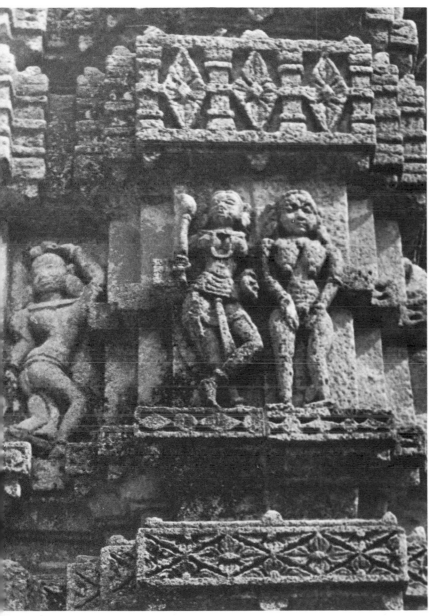

Fig. 132. Local goddess in exhibitionistic pose. Boramdeo temple, Chhapri, M.P.

has been chaneled onto him as its sanctioned object. Her inspirational actuality, blanketed by centuries of orthodox observances, may have long gone unrealized. Her multifold likenesses about the gate, the tower, the walls may have been taken by the worshiper, even as later they would be by the scholars, for merely incidental, if delightful and esthetically rewarding routines of decor. Indeed, it may have been difficult for him to perceive the traces of her transcendence in some of the more extreme products of a progressively secularizing sophistication. Yet for all their lifeless stylization, even the surasundarīs of Chanasma and Udaipur, and their only 96 127 somewhat less implausible counterparts elsewhere, nonetheless remain the 101 123 direct offspring of the yakshī, part of a heritage that has never lapsed. However emotionally enfeebled, however vitiated and devitalized, they are, quite as the wondrous door guardians and dancers of Malhar and Chhapri, 126 68 Sātgaon and Ranpur, Udayapur and Modhera, the legitimate daughters of 125 128 the primeval goddess who, ultimate dispenser of nature's creative abun- 108 122 dance, dominates the temples and shrines of the central Indian countryside.

Fig. 133. Local goddess in exhibitionistic pose. Gaurī temple, Bhubaneshwar, Orissa.

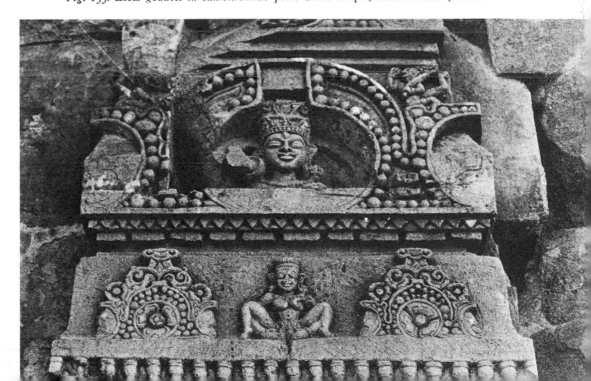

It is she who displays herself, ineffably anonymous, in Shiva-Mahādeo's own strongholds, as though to proclaim her presence as the primal source of the Great Lord's authority; whose entranced countenances in the temples of Shiva-Someshvara recall that she had been the mistress of the soma and its lunar font long before he became its master;[44] who imparts to the sanc-

Fig. 134. Local goddess in exhibitionistic pose. Jagannātha temple, Sonepur, Orissa.

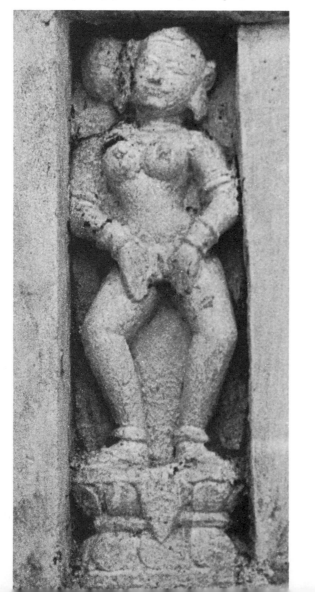

126

tuaries of Vishnu-Jagannātha their mystical grandeur. It is her dancing shape, wielding the lotus, that claims a place of prominence in the Balaji temple at Dichpalli and, in a triplicity of more primitive aspects, assumes it in the sanctuary at Gopalpur; her tranquil contour that presides over the Jaina shrine at Talanpur and, in a crude yet strangely enthralling contour of female mystique, over that of Shankara at Gatora. Here her enigmatic figure, central among a frolicking host of singular and unaccountable creatures, carries the unmistakable accent of her noncanonical inception and identity, to encourage a presumption that this might well be the likeness of Thakuranī, the great tribal goddess of the Baiga.[45] Nor would it seem too extravagant to recognize this deity as the one whose personations, in varied nuances of posture and expression, throng Boramdeo's shrine at Chhapri, and assert their preeminence in other sanctuaries in the same vicinity.

The Baiga's Thakuranī would not be the only tribal goddess to find a place in the shrines of the Hindu gods. Throughout the central regions her parochial counterparts have found consistent depiction.[46] As often as not this female divinity may be known by a generic appellation only; her given name might be lost to memory, or preserved as a sacred secret by the initiate members of the community. Still, her influence remains undiminished; few shrines, indeed, would not honor her presence. Frequently bizarre of aspect, her likeness emerges amid the imageries of the sanctioned deities, specifically unidentifiable, yet often essentially identified by the allegorical display of her genitals, the source of generation and regeneration, of life itself. The gesture of the Baiga goddess is repeated by the yet more unrestrained postures of her counterparts at Bhubaneshwar and Sonepur; and in more muted accents it reappears a thousandfold in the sensuous insinuations of her universalized replicas, the surasundarīs and apsarases, the devikās under whatever designation. Flagrantly advertised or subtly implied, it is the prototypal gesture of the Feminine. In these figures the mundane yoni finds its equation with the cosmic yoni, and every woman her transcendent archetype in the Goddess.

129

III

22

xv 11

130 13

132

133

134 x>

66 118

122 12

123 12

NINE

THE GODDESS
AS SHAKTI

The exhibitionistic gesture extends the generative and regenerative character of the female divinity. The emphasis of the yoni as the symbol of essential female capacity adds a new dimension to her manifestation. In this image of the Goddess, the latent capacities of her lotus nature strive for realization, potential energies for dynamic expression. Female sexuality no longer remains in abeyance, waiting to be awakened to its function. The display of its vehicle implies an invocation of the experience. The creative essence of the Feminine achieves actuation.

Thus the self-display of the Baiga goddess, typical of so many of her counterparts, is one not of narcissistic exhibition but of profound symbolism: the exposure of her sex signifies the impulse that will transform female potentiality into creative function. Repeated in countless aspects of varying intensity and overtness, this symbolism inspires the enchanted eroticism of her myriad kin. Offspring of the lotus goddess, the devikās also encompass the alternative, dynamic aspect of the Divine Feminine; a circumstance that

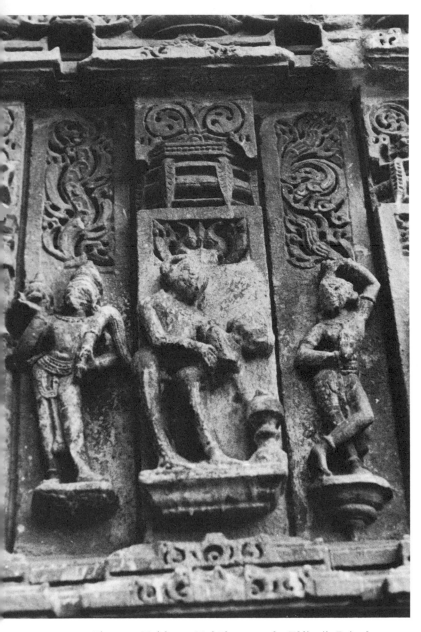

Fig. 135. Maithuna. Mahādeva temple, Eklingji, Rajasthan.

Fig. 136. Maithuna. Jain temple, Ranakpur, Rajasthan. (below)

Fig. 137. Maithuna. Jagannātha temple, Keonjhar, Orissa. (right)

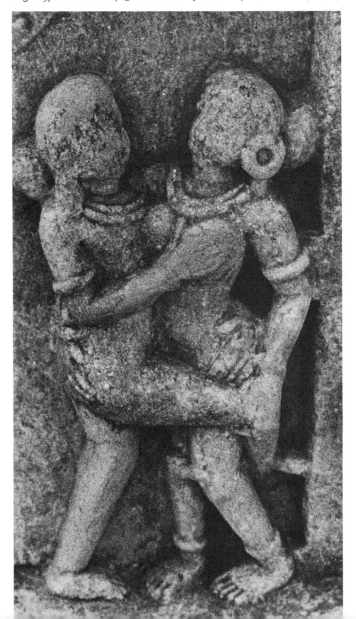

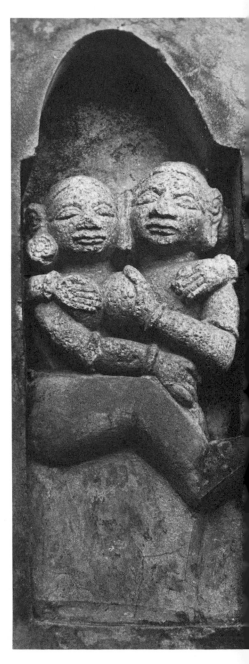

24 125
27 128
35 136
137
66 67
68 126

may well contain the reason for their preponderant depiction in some state of actual or implied motion. For only a minority of the celestial females are presented in static postures. Most of them are shown dancing, or frolicking, or engaged in erotic interplay. Others, not so obviously active, may seem to be beckoning to, or again stepping toward, the beholder. Even when ostensibly immobilized as dvarapālīs, they intimate their impulsion by a twist of the body or a shift of the feet. It is this intrinsic motility which accounts for much of their complexity and of their fascination.

The devikā's dynamic countenance is that of the Goddess herself, inherent in her primal vision as Nature embodied. It is the countenance of her who no longer waits, but reaches out; whose energies are no longer passively contained, but actively engaged; to whom existence is passionate involvement, and consummation its relentless experience. It is the countenance of her who has realized the power she has stored within her self, the power that bestows and deprives, builds and destroys, that engenders life and reabsorbs it, controls its rhythms and at will defies them.

This countenance represents not a renunciation of the Goddess' lotus nature, but its complementation. It is impartibly comprised in the symbol of the lotus: the very concept of the yoni as the vehicle of the feminine essence includes both womb and vulva as the interacting and interdependent integrants of its function. The dynamic aspect of the Divine Feminine reflects the libidinous-erotic element of her nature which, joined to the reproductive-protective one, initiates and enables her task of cosmic regeneration, as it enables the act of mundane renewal in the human female. The female deity who displays her sex is no less "Lakshmī," the Revealer, than her quiescent introspective counterpart of the lotus. It is her power which she once more reveals, but power now extroverted. Her alternative countenance, then, is the visualization of what psychology might term the Feminine's phallic energies.

From time immemorial dynamism has been recognized as fundamental and integral to female nature. In fact, its manifestations have been perceived as not merely *female* power but power *per se*. Indeed, power and femaleness emerge as virtual synonyms in the early metaphysical concepts of people everywhere. Always the truest mirror of man's uncensored realizations, language has reflected this primal equation. In all Indo-European idioms—and not in them alone—the term for "power" assumes the feminine gender.[1] So, also, the Sanskrit vocable, *shakti*, defines power as inherently and existentially female. A word of feminine gender, it signifies not merely "power" or "energy" but "active power" and "female energy" specifically. Of Indo-European root derivation, this term's grammatical form presumably reflects the pre-Vedic Aryans' own perception which, being too profoundly entrenched in universal tradition, would not yield to the male-oriented bias of their later viewpoint. Yet the specific usage and connotation of the term *shakti* in the metaphysics of India's Great Traditions hardly point to a reinterpretation of that original Aryan thought, or to the revival of a vision discarded in the distant past. All indications suggest that, instead, they must be traced to the indigenous perspective which had all along preserved the idea of feminine transcendence.

The native origin of the shakti concept rests also on the most palpable iconographic evidence. In their compelling dynamism the images of Hinduism's Great Goddess singularly and finally counterpoint the static impassiveness characterizing the depictions of the Vedic "shakti" and her canonical upshots and, by this contrast, implicitly negate any plausible notion of that concept's descent from Aryan tradition. For, as implied by the term's grammatical gender and confirmed by universal analogies, "shakti" stands defined as female power; that is, power identified not only with but *of* the female, kinetic, active energy which mobilizes her potentialities for the creative act. Creativeness thus was perceived as an intrinsic property of the Feminine. In man's image of the Divine, the Creatrix came long before the Creator. The actuality of this primal perspective is reflected by many myths and corroborated by the plethora of prehistoric female figurines everywhere, especially when compared to the relative paucity of male ones. Multitudes of such female likenesses, especially among the remains of the Amri-Nal and Kulli cultures of Baluchistan and southern Afghanistan,

challenge the anticipation of similar finds throughout India, where archaeological exploration has scarcely penetrated the surface of the country's buried past.

By its very definition, then, "shakti" was identified with the creative aspect of the transcendent female, the Goddess. Emanating from her essence, this power might materialize in any form, including that of a divine male who would join her lonely preexistence as the requisite partner in her cosmic function, in the complementary role of her consort and lover. This genesis of the male divinity has been confirmed by India's folkloric traditions and even by some accounts which have survived unpurged in the canonical texts. In language sometimes overtly suggestive, sometimes cryptically mystical, these passages concur in their indication that it is from the power of the Goddess that the God was created.

The reinterpretation advanced by Vedic and later Hindu exegeses, proclaiming shakti as the "female power of the male deity" and defining the god's female consort as the materialization of *his* energies, presents a threadbare and obviously spurious inversion of the elementary condition.[2] Clearly, the shakti goddess of the Great Tradition is the creature of a male-centered perspective which, in defiance of both historical and metaphysical verity, would postulate the masculine as the transcendent origin of all things. Brāhmī and Indranī and Varunī are "shaktis" by fiat, not in essence, embodiments of male self-glorification, not of female energy; the same is true of Sarasvatī when she appears in her formalized aspect as Vishnu's Brahmanical wife. It is not true, however, of the one most prominently and consistently celebrated among all the "shakti" consorts, Pārvatī, Shiva's lover and spouse. Though occasionally also depicted, analogous to Vishnu's Sarasvatī, as a subservient miniature shape attendant on her supernal lord, generally she appears conjoined with him in varying poses of intimate conversation, vital with the glow of erotic communion. Especially favored by the representations of the countryside, but characteristic also of more conventional imagery, this accent promotes the argument for the indigenous inception of the shakti concept. A visualization of Shakti so radically at variance with that of her canonical version could not be attributed to a fortuitous deviation from the established norm. It premises an essentially different perception of her nature and function and a fundamentally diverse history of her origin and evolution.

Though scripturally proclaimed and popularly acknowledged as the embodiment of Shiva's "female power," Pārvatī evidently commands substantial evocative capacities in her own right. Shrines in her express and exclusive dedication[3] affirm her independent cultic role. None of the other shaktis has experienced any comparable recognition, except Sarasvatī who, however, was so honored not in her role as Vishnu's shakti but in her specific identity as lotus goddess and alter-ego aspect of Lakshmī. Even Pārvatī's name pinpoints her autonomy. Unlike that of Brāhmī or Indranī, Varunī or Agnāyī—not derived from spouse's designation but emphasizing her own identity, it describes her as the Daughter of the Mountain, a designation further elaborated by her epithets of Girijā, the Mountain-born, and Himasutā, the Daughter of the Snows.[4] But these same appellations are assumed also by Gangā, mistress of the great sacred river that, springing from the snowy Himālāyas, is indeed "girija" and "himasuta." Pārvatī thus represents another aspect of Gangā who, in turn, is but a specialization of Nature Personified, the primal identity of the lotus goddess.

Shiva's spouse, then, is the primordial Goddess. She is not the creature of his power, but herself Power incorporated; not *his* shakti, but Shakti in self-manifestation. In fact, it is Shiva whose essence is the materialization of *her* energies, a circumstance still conveyed by some persevering epithets of the god, such as Mridīkānta, "Lover and Husband of the Gracious and Compassionate One," or as Kālīvilāsin, "Lover and Husband of the Black Goddess,"[5] which define his divinity through her primary being, bespeaking a condition inverse to that proclaimed by the canonical interpretation of shakti.

Such a genesis from the essence of the Goddess may well account also for Shiva's continued preeminence in the Hindu pantheon in spite of his

32 35 36 37

aboriginal character and his flagrant, and mythically documented, opposition to the society and ethos of the Vedic deities.[6] For, unlike Vishnu who, for all the accretions of native Indian deities to his image, had proceeded from sanctioned Vedic antecedents, Shiva's divinity roots in the ancient pre-Aryan past. Though later attributions certainly have elaborated his character too, basically his nature and symbolism remain determined by the world in which he had originated as the male consort of the female deity, materialized by her power. Most of his predominant aspects, and especially his cosmic and metaphysical functions, are directly traceable to equivalent ones of the Goddess.[7] In time assumed unto himself, some of these traits appear in the pashupati of Mohenjo-Daro, whose recognition as an earlier form of Shiva is obvious and uncontested. But, patently a projection of well-advanced and complex religious ideations, the figure of the pashupati must imply a greatly antedating inception of Proto-Shiva in a world that identified female power as the focus and source of all existence, and in which an independent appearance of the male deity might still have been waiting at the threshold of a long evolution.

The intimate, because intrinsic, relationship of Proto-Shiva and the Goddess, and its direct perpetuation in the latter-day analogue of Shiva and Pārvatī, seem once more confirmed by the testimonies of nomenclature. Among her multifold epithets, Pārvatī still carries the one of Rudrānī, evidently a feminine modification of the name Rudra, authoritatively identified as an older appellation of Shiva. Formed in the pattern of the Vedic shakti's names as a derivative of the male deity's name, the designation Rudrānī must be ascribed to post-Vedic times. By inference it defines Rudrānī as the emanation of the male deity's power, subordinate to his supernality. At the same time, however, it establishes the existence of a female divinity associated with Shiva-Rudra in an age well preceding the advent of Pārvatī.

But that female divinity was defined quite differently. Her perennial primacy is circumstantially attested by the scriptural preservation of Rudrānī's alternative name, Rodasī, an appellation of singular significance as it is not derived from that of the male deity. In thus implying the independent essence of Rudra's goddess, it suggests that Rodasī, like the Pārvatī of a subsequent era, represents an embodiment of the preexistent female power which finds in Rudra, as eventually in Shiva, its temporal materialization in masculine shape.

The connotations of the name Rodasī not only further reinforce this suggestion, but also epitomize her very nature. Without apparent root connections in the Sanskrit, and therefore not improbably a foreign borrowing, this name has been interpreted as a personalization of a dual form, rodasī, itself of feminine gender, meaning "heaven and earth." Applied as an appellation of the Goddess, this meaning might be plausibly extended to "She Who Commands Heaven and Earth," describing not only her encompassing power but, with heaven and earth signifying the enclosing boundaries of man's physically perceptible world, also addressing her as the ultimate mistress of the phenomenal universe. The name Rodasī may well have denoted not only she who commanded, but, quite as plausibly also, she who created heaven and earth. It would echo a perception of the phenomenal universe as energy materialized; as the creature of shakti, the power of the Feminine, personified by the Goddess in her dynamic aspect.

Rudra's "wife," then, emerges, as the primordial goddess in whom he had his beginning, and "Rodasī" as an allegorical designation for her dynamic manifestation as Shakti, most specifically in her role as Māyā, the creatrix of the world of sense-perceived reality. This equation with Māyā has by no means been singular to Rodasī; it must be presumed to have been typical of the primordial identities of the female deity, and it has continued to characterize her more recent ones. To this day Durgā, herself but another aspect of Shiva's consort, answers to the byname of Māyā, even though the use of this appellation has been discouraged and its memory ignored as completely as possible by the canonical religion.

This seems hardly surprising. The texts of the Great Tradition have been at best disparaging, more commonly repudiative, in their treatment of Māyā as the creatrix of a phenomenal reality which a dualistic idealism, contrast-

ing it to the absolute of pretermundane Reality, rejected as "illusion" and even "fraud."[8] However, this attitude has not enjoyed widespread emulation. The source and mistress of all this-worldly life may have been exiled, even exorcised, from the devotions of the orthodox, but she has never been divorced from the experience or the adoration of the multitudes. Throughout central India the many shrines specifically dedicated to her, and the many more in which she shares the pūjā with their nominal patron deities, attest the unbroken force of her tradition. Significantly, her popularity appears to achieve its widest range wherever folk religion has retained its strongest hold. The backwoods are the true fortresses of her cult. Though she presides over an appreciable number of larger sanctuaries, it is particularly the humble village shrine that is consecrated to her, often celebrating her as Mahāmāyā, the Great Māyā, to convey the grandeur in which she appears to her communicants. Sometimes this title of exaltation is further elaborated. She may be worshiped as Mahāmāyā-Siddhīshvarī, the Mistress of Magical Powers, or addressed by the name Yogeshvarī, a nearly synonymous appellation which similarly interprets the essence of Mahāmāyā.

The attribution of magic and mystic powers to her whose energies materialized as the phenomenal world was cogent. Māyā's mundane creation was the only reality within man's palpable experience, the only one he could identify with and respond to. Yet the specific phases of its operation, and their interactions, remained mysterious, subject to wonderment but impervious to explication. Nonetheless, the miracles the goddess Nature was producing every moment seemed controlled by an internal logic, a grand design which man realized even while he could neither define nor fathom it. Influences, intangible, indeed inaccessible to his comprehension, perpetually intruded upon and into the world of his perception. Some aroused his anxieties, others kindled his gratification, but all were experienced as integral to Māyā's manifestation, as the work of the Female Power which could assume an endless variety of aspects. Māyā-Shakti could, and continually did, transform the elements of her own creation, the very premises of man's existence, by powers infinitely beyond his grasp, by powers

in their origin secret and hidden—mystic—and in their exercise suprasensible and preternatural—magic. Simultaneously with the concept of Māyā her aspects as Siddhīshvarī and Yogeshvarī were born. They were, in essence, specific characterizations of the great mistress of this-worldly reality, who was the embodiment of the arch mystery of Being, the divine equation of the ontological arcanum. To whatever godhead men may address their entreaties, their emotional allegiance, articulated or not, still belongs to Mahāmāyā in her innate aspects as Siddhīshvarī and Yogeshvarī.

Throughout central India this condition is attested not alone by the abundance of shrines and altars bespeaking Māyā's continued worship; the perpetuation of her symbolism presents evidence of more subtle, but no less forceful eloquence. This symbolism is manifold; here only the most significant of its vehicles is recalled, the sacred panchavati grove, that cluster of trees hallowed with the immanence of the divine presence. It is its arrangement in a fivesome that indicates the grove's mystic powers as specifically those of Māyā. Regarded everywhere as the numeral symbol of the terrestrial sphere and its this-worldly pursuits,[9] the pentad identifies her who had brought forth this sense-perceived sphere of human activity, whose magic controls the phenomena of temporal nature. The panchavati grove announces, in hylic equation, the presence of Mahāmāyā-Siddhīshvarī and man's dedication to the female divinity in this specific aspect. Regardless of superimposed exegeses and reinterpretations, it in fact constitutes an open-air temple of Māyā, the more appropriate to her as it is set up as an integral part of nature herself, produced of her own essence rather than by the hands of men.

Always an implicit tribute to Māyā's presence, the pentad symbol also assumes iconic form. But perhaps because of its specific reference to the Feminine's dynamism, its personified appearances prove to be associated less frequently with her own image than with that of Shiva, her materialization in male aspect. Nevertheless, there could be little doubt that the panchamūrti countenance of Shiva had not been original with the god, but had been transferred to him from the Goddess, most likely during the era

of the male deity's ascendancy over the female, to betoken his own super-nality as the creator of the material universe. Such a presumption seems well suggested by the preponderance of five-headed images which, though often identified with Shiva, in fact depict the male deity in his unassimilated folk-traditional aspect. A typical instance is offered at Arang by a "Balaji" figure that, with its five snoutlike faces so strongly recalling the physiognomy of Maroti, hints at a genesis as a likeness of Rudra,[10] the ancient creature and mate of Rodasī-Māyā, who has assumed her symbol as his manifest attribute to bequeath it to his Great Tradition identity as Shiva.

Still, the original and intrinsic association of the pentad symbol with the female divinity remains unforgotten. It is the great goddess, Kālī-Durgā herself, who, by her concurrent appellation of Panchānanī, the "Five-faced One," stands identified as the Hindu countenance of Maya. The same identification evidently underlies the account of the fivefold appearance of Brahma's divine woman, "created from his immaculate substance,"[11] representing another attempt to ascribe to the canonical deity Māyā's specific creative powers. Even though Brahma's own decline as an inspirational and cultic focus has reduced this legend to a purely literary, and at that rather obscure, piece of mythopoeism, the definition of his divine woman by the pentad symbol points once more to the compelling influence of the native tradition on scriptural formulations. More importantly still, it identifies the object of Brahma's erotic desire as Nature herself. Sarasvatī, her lotus countenance, reveals her potentialities. Sāvitrī, her energizer's likeness, presents her actuated energies. Sātarupa is her all-bestowing form, Gāyatrī her material,[12] Brahmanī her phenomenal aspect. Collectively this fivesome encompasses the total vision of Māyā, the divine equation of the physical universe. Even in its inversion of shakti as a power of the male deity, then, this legend restates her paramountcy: but for its direct involvement with the sensual realities of māyā, godhead would remain unrealized, indeed be nonexistent. Brahma *must* produce the fivefold goddess as his lover and consort, for only her existence enables his own. It seems most likely that in this archetypal interrelationship of the supernatural and the mundane the notion of the *hieros gamos*[13] found its early inception.

Intent, as always, on discouraging any suggestion of the male deity's dependence on the female presence, scriptural lore has treated the legend of Māyā-Shakti's fivefold materialization from Brahma's energy almost as an adventitious, no more than anecdotic, incident. Its sequel, implying the sacred union of the god and his female self-manifestation as the source of all living things, was so carefully deemphasized that it soon fell into virtual oblivion, to be replaced by the canonical cosmology that professed Brahma as the sole author of creation, unaided by any form of female intervention.

Yet gradually the ancient tradition seems to have gained new persuasiveness. At length the acknowledgment of the Female Power became inescapable. Yet for sociopolitical reasons it remained unacceptable. Therefore, if Shakti could no longer be effectively effaced, at least she could be debased. If Māyā could not be denied recognition, at least her concrete reality might be judged as essentially inferior to the male god's abstract reality. If the Goddess would not relinquish man's allegiance, her countenance could yet be judged as essentially inferior to the male god's abstract Reality. If the fear-born obeisance. If her presence could not be exorcised, it certainly could be demonized.

The vision of Māyā-Shakti proved most vulnerable to such exploitation. The Goddess knew many expressions, many gestures. Embodiment of dynamism, she was inherently also the vehicle of change, of uncertainty, of anxiety. Her all-controlling, all-transforming magic was unpredictable in its manifestations, awe-inspiring as well as wondrous in its effects. The phenomenal universe she had produced seemed alarmingly precarious in its arbitrary alternations of abundance and privation, joy and suffering, gratification and frustration, growth and destruction. Every hope was dogged by the shadow of danger, every moment of security haunted with a foreboding of catastrophe. The elements and the weather, every particle of matter, the earth itself might reveal themselves as man's friends and providers, or again his enemies and tormenters. The horizons of his existence

would change their accents, often without warning, in accordance with Māyā-Shakti's will, omnipotent alike in its benevolence and its malevolence, as fickle as the phenomena of the reality she had conjured. Man was the plaything of this will, of an eternal mystery, at once exalting and frightening because it remained impenetrable. Instantly his Goddess's smile might turn into a frown, her affability into rage. Her gesture might proffer aid and comfort, or again decree despair. If she was the one who engendered and nurtured the crops of subsistence, she was also the one who would devastate them with storms and draughts, floods and earthquakes. If she was the healer, she also was the dispenser of disease. If she could cause life, she also could take it.

By her very nature, then, in her manifestation as Shakti, the Goddess was of indeterminate aspect, encompassing within her self the total spectrum of worldly existence in all its apparent contrasts and contradictions. As Māyā she presided over a reality, at once palpable and incomprehensible, which attracted man yet at the same time eluded him. As Siddhīshvarī she was the mistress of beneficial as well as injurious, white as well as black magic; as Yogeshvarī she embodied the mystique of life as well as death, of growth as well as decay, of the hidden origins and the inscrutable prospects of his being. Her presence was immanent in every fragment of nature, irresistible and ineluctable. Man would experience it with hope and with fear, with enchantment and with terror, in paroxysms of ecstasy and in excesses of self-abasement. Thus the very terms of man's conception and experience of her powers would of themselves provide a ready basis for her demonization. Her fearsome aspects merely needed to be placed in bolder relief, her destructive activities only to be emphasized while her salutary ones would be minimized. Before long she would emerge as the incarnation of all the evils, miseries, imperfections, and calamities incident to the this-world of her creation, as the personification of an "illusory and fraudulent" reality which in its degradation and corruption would only the more sharply contrast with the perfect Reality of Brahma's other-world. Man would soon come to see her as his bane, an antihuman as well as antigodly

Fig. 138. Paneled bronze door, Mahāmāyā temple, Pandaria, M.P.

force. From habit or tradition, he might persevere in his supplications and sacrifices to her. No matter, as long as these were prompted not by his adoration but by his need to placate her fiendish cruelties, propitiate her hostile tempers. Māyā-Shakti might continue her ancient domination, her supernatural powers virtually undiminished. This would be not merely tolerable, but indeed desirable. Noxious and terrifying now, these attributes would by their antithesis not only further exalt the wholesome ones of the sanctioned deities, but by establishing a debased archetype of the Feminine also provide the metaphysical justification for the orthodox presumption of innate female inferiority.

In its design and execution, Māyā-Shakti's demonization followed the basic pattern adopted by male-centered societies everywhere in their struggle against the Goddess. In India, however, the effort assumed proportions unparalleled elsewhere. The iconographies of both the Great and the Little Traditions abound with its impact. It is not the extreme, often grotesque hideousness of the female deity's portrayals as such that is so singular,[14] but the frequency and persistence, the cumulative effect of their appearance.

This pictorial denigration of the Goddess has produced such images as 119 that of Kankālinī, the "she-skeleton," of Chāmundā, the "Annihilating 107 One," showing her in a spectral dance with a victim's severed head swinging from her hand. It has shaped many of her aspects, endowing them with XIV 39 the rampant violence of gesture or the potential one of expression, to in-8 139 sinuate into them the frightening and threatening nature of the Feminine, not rarely adding the starkness of color and contrast to further accent the ɔ XXIV undefinable but immediate terror of a demoniac presence. Often the vilification of feminine power has been attempted by way of the subtler, but scarcely less effective debilitation of feminine attractiveness. Thus, in her ɪo 107 appearances as Mariāmmai, the Mistress of Death, or Chāmundā, or 93 Bhairavī, the Goddess is cast in ultimate antithesis to all conceptions of female beauty, as an emaciated or shapeless hag with withered, flopping 141 breasts. Again, her folk-style likenesses as Durgā mahishāsura-mardinī or 99 Modeshvarī are typical of so many others which, by rendering her sexually

nondescript, would seek to prevent the worshiper from equating such an esthetic monstrosity with his image of the Divine.

In a hundred grim variants the images of the Terrible Goddess look from the temples and altars of India. They crowd especially the back country, perhaps because its more profound and more stubborn dedication to the female divinity may have challenged even more rigorous countermeasures which, while meeting with more determined resistance, rural traditionalism would eventually tend to perpetuate. The result is evidenced throughout the central India countryside by the ubiquitous imageries portraying the "demonic" Feminine in her typical likenesses as Chāmundā or Mariāmmai, Kankālinī, or Bhairavī; or as Kālī Mā, Shakti as Supreme Authority, dis- 142 playing the skull as a reminder of mundane evanescence and eternal transformation; or, again, as the snake goddess Mahāmmai-Manasā, whose dy- XV namic fierceness is so hauntingly conveyed by the aggressive garishness of color and the hypnotic stare of her glittering, depthless eyes.

The aspects of the demonized goddess are as diverse as man's imaginings,

Fig. 139. Durgā. Subaranameru temple, Sonepur, Orissa.

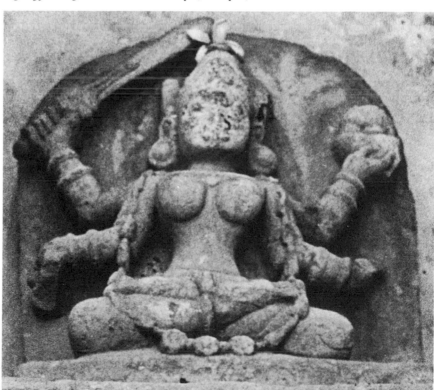

born of his natural anxieties and nurtured by artificially induced fears, have been capable of envisioning them. Yet, beyond the grimaces of violence, beyond the masks of destructive fury, beyond the odiousness of Bhairavī, the Dancer of the Cremation Grounds; of Kālī, trampling on the lifeless body of her lover and spouse; of Durgā, the implacable slayer of the buffalo demon; beyond them all, transcending the ephemeralities of aspect, there is the countenance of Māyā-Shakti, the indelible presence of her authentic nature, the archetypal contour, mocking the terrors of her canonical disguises.

A few moments' contemplation reveals the true character of Bhairavī, 93 the Dancer of the Cremation Grounds. Enthralled by an ecstasy that seems to transfigure her skeletal grimness with a mystic exaltation, she performs not a funeral dirge but the gyrations of a supernatural vitality. Possessed with their magic, the cremation grounds are no longer an abode of death but a threshold of new life. This dance speaks not of annihilation but transformation; the end of one mode of existence is merely the beginning of another; life goes on, only its form changes. The dance describes the round of perpetual regeneration. That in its performance the goddess is imagined to be joined by her consort further affirms this meaning. His presence defines the dance as an act of sexual consummation and infinite procreation. It is from Bhairavī-Shakti that Shiva-Bhairava has learned this dance of eternal life, from her that he has assumed his nritya-mūrti, his transcendent countenance as the Cosmic Dancer. This is why, as Bhairava, the god is so like Bhairavī in aspect and gesture, and why, in his manifestation as Natarāja, his figure duplicates the beauty and grace of the Divine Feminine's authentic vision.[15]

138 Kālī, dancing on the dead form of her mate, once again incorporates the idea of vital energy in eternal transformation, in a variant mode of symbolization which has often been interpretatively discussed, most extensively and perhaps too extravagantly by Heinrich Zimmer.[16] Here the Black Goddess seems to personify not so much the "all-producing and all annihilating principle"[17] as the fathomless depth of infinity into which even the gods are absorbed, to rise again in other forms, on another level of experience. The god beneath her relentless tread is himself a creature of the mundane reality that must surrender its temporal spell to cosmic renewal. Shiva's prostrate contour reveals godhead as but an incident of the evanescent, man-apprehended phenomenality that, issued from the womb of the Goddess as Māyā, must return into the womb of the Goddess as Kālī, Timeless Time, one day to be remanifested. It is thus not idly that Kālī-Chāmundā, "Time Who Causes To Vanish," so consistently displays the lotus even as 107 she destroys the god who has been her mate in this ephemeral phase of her incessant creations. This lotus betokens the cosmic process: after its span of phenomenal actuation, Power reverts to her potential state. This symbolism avers of itself the aboriginal vision of Māyā-Shakti's vision as Great Time, Mahankālī; a vision that in its implicit promise of life eternal depreciated the terrors of death and yet undoubtedly has always been fraught with anxiety and awe. For Kālī, Time, is also Kālī, the Black One. Forever impenetrable, her promise remains inscrutable; if death is but a threshold, no one may recognize, or even presume, that which lies beyond. Thus it seems likely that the Shakti nature of the Goddess had always been bound up with man's fear of the unknown, the preterphenomenal; but a fear assuaged by the concurrent reassurance of her lotus nature, substantively incommensurable with the unmitigated horror of its eventual iconic embodiments. The likenesses of Kālī as a hideous hag whose insatiable greed for the lifeblood of ever new victims is typified by her enormously exposed tongue,[18] represent the final denouement of Māyā-Shakti's demonic perversion in which degradation and abomination have become synonyms for femaleness.

Yet this Brahmanical propaganda spent itself against the pervasive commitment of the Indian people to a more authentic image of female divinity. The orthodoxy could impose the demonic countenance of feminine power in manifestation, but, no matter how it might magnify the fearsome aspects of the Goddess, it never succeeded in denuding her of her promise. Even such appalling likenesses as that of Kālī-Chāmundā continue, as has been

Plate XXIII. Goddess in exhibitionistic pose.
Shikhara, Samlai temple, Sonepur, Orissa.

Plate XXII. Surasundarīs circling cupola of
Neminātha temple, Ranakpur, Rajasthan.

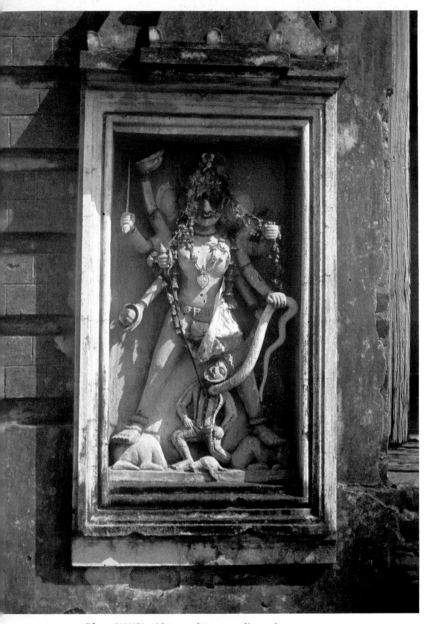

Plate XXIV. Chāmundā strangling demon.
Rāmesha temple, Sonepur, Orissa.

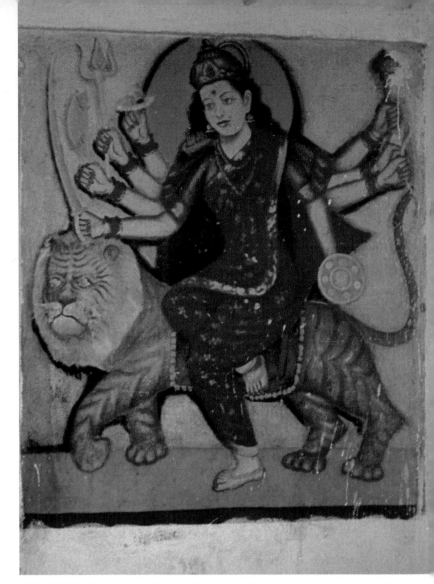

Plate XXV. Kālī on her lion. Wall painting, Shrine
of Durgā, Dharshiwa, M. P.

Plate XXVI. The lion of the Goddess. Māhāmāyā temple, Arang, M.P.

Plate XXVII. Maheshvarī-yoginī. Chaunsath Yoginī temple, Bheraghat, M.P.

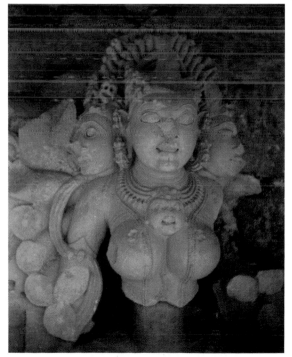

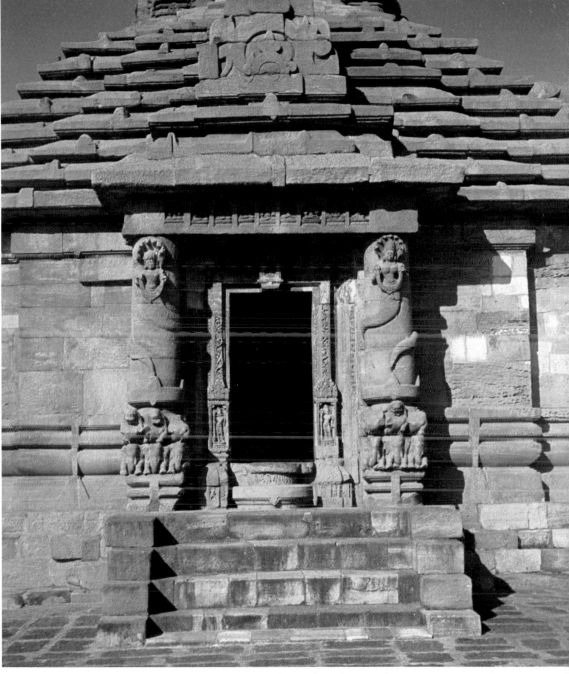

Plate XXVIII. Nāginīs as door-guardians. Rājrāni temple, Bhubaneshwar, Orissa.

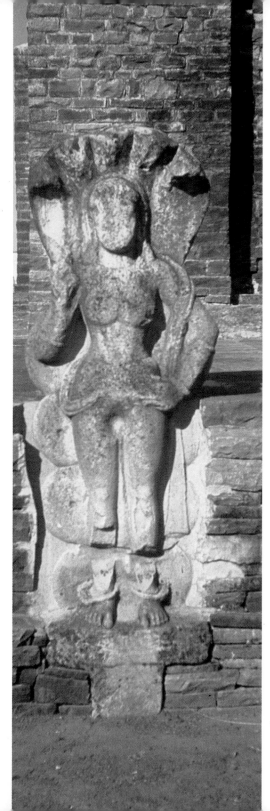

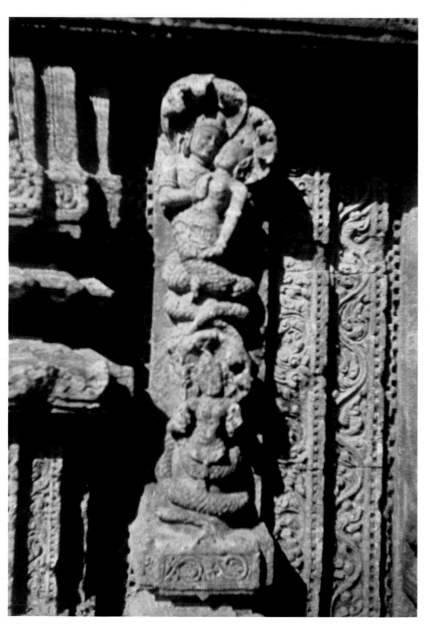

Plate XXX. Nāga and nāginī in maithuna. Sūrya temple, Konārak, Orissa.

Plate XXIX. Nāginī. Stele, Sanchi, M.P.

107 seen, to display the emblematic lotus; others, like that of Mahāmāyā-Siddhīshvarī, stark in the threat of their virulent mystery, rise from the
120 very calyx of the sacred flower. Destructiveness thus is countermanded by protectiveness, the imminence of annihilation by the prospect of regeneration, the dread of death by the certainty of eternal life. However, it is not the lotus symbol alone which contrasts the divine nature of the Goddess to her demonic appearance. Only in some of her manifestations as Kālī does she make Shiva the victim of her "terrible" nature. Most often she is shown conquering antigodly creatures, personalizations of life-opposing and life-oppressing forces that imperil terrestrial and cosmic existence alike. In this
XXIV 93 function she may assume the aspect of Chāmundā or Bhairavī, of Mari-
121 āmmai or Manasā; or again, that of some anonymous supernatural female who, mounted on a rearing horse or vyali,[19] gives battle to those hostile elements. The latter, it should be noted, are uniformly and exclusively male.[20] Here, then, the ethos and vision of the native tradition counterpose themselves, with the vengeance of sublime irony, to the Brahmanical ideology to expose the illusion of its apparent triumph: it is the *female* Power that protects and defends the world of gods and men against the onslaught of *male* destructiveness.

This elementary proposition of folk religion everywhere is in India most drastically rendered by the ubiquitous likeness of Durgā mahishāsura-mārdinī, the Goddess as the slayer of the Titan-buffalo. Whether depicted
90 in the accents of high artistry or in the less refined ones of popular craft;
95 96 whether masklike, the atrophied product of sterile stylization, or the crude
141 but vivid creature of folk imagery; once again the antigod is male. Moreover, by inference of mythic analogies, his prodigious magical capacities seem to have been bestowed on him by Brahma himself.[21] Of still greater eloquence is the account of her origin in the myth describing Durgā's struggle with Mahisha—the name means, significantly, "The Great Lord" —which offers the most extraordinary acknowledgment of the Divine Feminine's supremacy over the secondary and subordinate natures of the male deities.

The story told in the "Text of the Wondrous Essence of the Goddess"[22] discloses the final impotence of the gods, including Vishnu and Shiva and even Brahma himself. Helpless before the demon's might, their only remaining recourse is to fuse their respective energies in one integrated actuation of superlative cosmic power. This composite dynamic manifestation materializes in the shape of Tripura-sundarī, "The Loveliest Maiden of the Threefold Universe," who, under the name of Durgā, the Unconquerable, confronts and defeats the titan monster. In this account the indigenous tradition achieves its ultimate formulation. For here, as Zimmer has discerned, "in the perennial, primal Female, all the particularized and limited forces [of the gods] . . . by a gesture of perfect surrender and . . . self-abdication . . . had returned their energies to the primeval Shakti, the One Force, the fountain head, whence originally all had stemmed."[23] Zimmer's interpretation, though, of this self-abdication as "fully willed" must, from this very context, seem rather precarious; for, their energies being clearly derivative, the canonical gods appear to have no option except that of evoking the "One Force" of the "primeval Shakti," the elemental power of the Feminine Essence.

Durgā, then, stands defined as the Hindu version of this "primeval Shakti," Mahamaya. This identity is still further emphasized by images, particularly frequent in the shrines of the central Indian back country, 93 depicting her with five pairs of arms, an aspect which suggests itself as a *pars pro toto* reminder of her original panchamūrti countenance. The creatrix of the phenomenal universe is similarly recalled by the ten-armed portrayals of Kālī, which seem to preponderate even though some images 138 showing her as eight-armed and four-armed simplifications of her aspect XXV 96 are not unusual. 141

This analogous panchamūrti symbolism is joined by the legendary in denoting the essential identity of Kālī and Durgā as merely specialized countenances of Māyā-Shakti. For, as Durgā frees the world of Mahisha's demonic power, so Kālī matches her role as defender of universal existence by smashing Raktavija, king of the demonic host; and, though Kālī's myth

makes no mention of her genesis as Tripura-Sundarī, her encompassing, supernal power is equivalently indicated by the cosmic lion, her theriomorphic aspect and companion in battle,[24] who, containing within his body the gods of the canonical pantheon,[25] incorporates the sum total of their combined energies.

Kālī and Durgā, like all of Hinduism's female deities, are but the incidental forms of the One Force of the Feminine. This fundamental premise, essentially monotheistic in its cognition, has never been lost to folk religion and has imprinted itself on India's imagery. The cosmic lion, zoic manifestation of Māyā-Shakti's inclusive power, not only witnesses Durgā in her combat with Mahisha and supports Kālī in her struggle with Raktavija; he appears at the feet of Gaurī, the Brilliant and Exalted, and of the lotus-surrounded Bharanī, the Bearing and Fruitful. He accompanies Pārvati even in her intimate communion with her divine spouse, just as he joins Umā and Bhairavī, Shītalā and Yogeshvarī in their specific functions. The lion's presence at the goddess' side, transcending the externalities of her appellations and aspects, testifies to the unity of the female divinity as the embodiment of cosmic dynamism. It subtly discredits the "demonic" imposture of Shakti; the most grotesquely horrible contour of the Goddess seems to dissipate its terror once it is perceived as but another mask of the loving and devoted Parvātī, the benevolently protective Bharanī, the beautiful and luminous Gaurī, the passionate and tender Kāmākshī. The dance of Bhairavī would be experienced as a sacred ritual of transformation, rather than a paroxysmal whirl of unbridled destruction; Kankālinī's skeletal presence, as mundane evanescence rather than irretrievable decay; the black mystery of Kālī-Siddhīshvarī, as the intangible secret of the open lotus from which she rises. Even the lethal violence of Chāmundā would be perceived as the ferocity of the guardian against detrimental forces rather than as the fury of the aggressor against life.

This image of the Feminine Essence has always prevailed in folk religion. While conscious of the violence and destructiveness always potential in her dynamic manifestation, it has to this day consistently emphasized her salu-

tary attributes. If Mariāmmai and Shītalā propagate epidemics, they also cure them, and it is primarily in this function that they are celebrated in their many backwoods shrines, just as Manasā, mistress of the deadly snakes, is revered as the protectress from snakebite. The ambiguities of Shakti's nature have also found their occasional analogies in the semantic ambiguities of her appellations. Thus that of Shītalā is authoritatively rendered the "Cold, Frigid One," suggesting her utter dispassion and deadliness; but it also means the "Gentle, Mild One," and it is in this character that she is adored, a calm and calming figure with an affable inward smile. Similarly, her designation as Chandī, "The One Burning with Passion," has, by interpreting passion as the expression of a "wrathful, fierce, cruel" temper, favored her official appreciation as the "grim goddess;"[26] but passion also connotes the sensuous and emotive, ardent and empathic disposition that, so persuasively mirrored by the gentle grandeur of her boon-bestowing gesture, has continued to define her character to the worshiper.

The name Chandī permits still further semantic inferences. If passion, in the term's most inclusive meaning, defines the emotional aspect of dynamism, the connotation of "burning" evokes associations of "flame" and "redness," the more readily so as flame and redness have everywhere been related to passion, especially in its sensual mode. Indian metaphysics, in particular, has regarded red as the chromatic equivalent of dynamism and of the specifically phallic energy perceived as shakti. Thus defined by her very designation, "Burning with Passion," Chandī is Shakti, the primeval Goddess, in Hindu guise.

The equation of the color red with the psychologically passionate, physically sensuous, energetically kinetic modes seems to belong to man's oldest, elementary appreciations. It finds numerous linguistic expressions, as in the Sanskrit term *rakta*, for which the dictionary lists the following cognate meanings: "Colored, red; charming, lovely; enraged, impassioned." The root-related term, *rajas*, descended from the verb *raj*, "to grow [red], or be red," in Hindu and Jaina esoterics designates the fiery, active, masculine quality,[27] the dynamic and phallic aspect of female power. In later

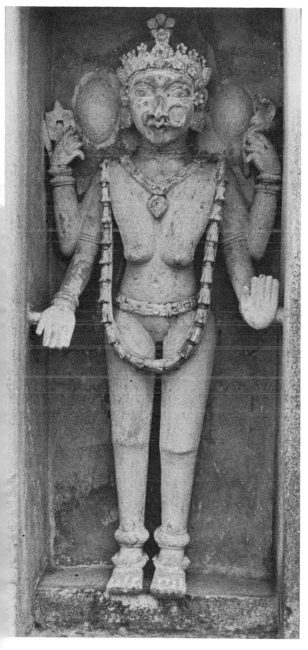

Fig. 140. Mariāmmai. Samlai temple, Sonepur, Orissa.

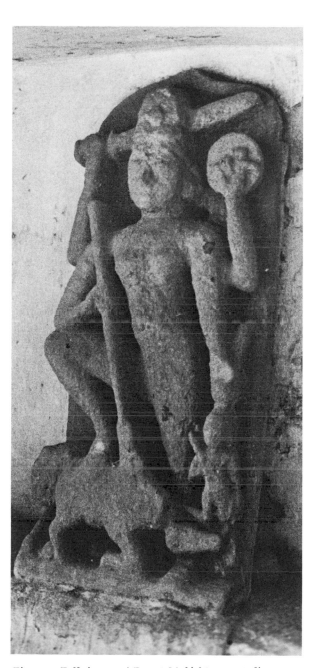

Fig. 141. Folk image of Durgā Mahishāsura-mārdinī.
Kālikā Mātā temple, Dabhoi, Gujarat.

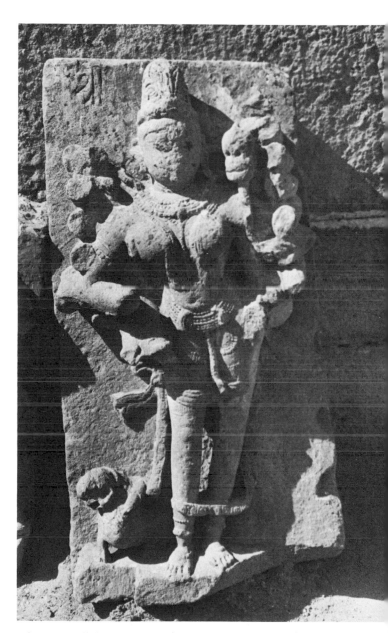

Fig. 142. Kālikā Bhāvanī. Kālikā Mātā temple, Dabhoi, Gujarat.

139

canonical texts this *rajas* quality is frequently found associated with the antigodly, demonic elements and with those who favor the worship of yakshas and yakshīs rather than gods,[28] in this way linking them with the indigenous forms of the Divine and their cults.

This connection is, of course, most appropriate. All creatures of her dynamic manifestation, these local particularizations of Māyā-Shakti would naturally assume her elementary symbol and attribute. The iconography of central India offers itself as one enormous compendium of this condition. Everywhere altars of the Goddess, worshiped in whatever parochial aspect under whatever name, are daubed with *sindoor*, the vermilion lead paint, to announce her Shakti-identity in the brightest, most poignant, and aggressive shade of her own color. As often as not, even where she has been accorded official recognition by the orthodoxy, her very likenesses are tinted with sindoor. The images of Samarī Devī at Kharod and Mahāmmai-Manasā at Mahamadpur, of Kālikā Bhāvanī at Dabhoi and the serpent goddess at Bhilganj provide a few characteristic examples, just as the anonymous goddess appearing on the altar built into the root of a Banyan tree typifies many similar Yakshī idols. One might recall, too, the bizarre face of Dugdhaharī at Raipur, carved entirely in red, or the Goddess' zoic equivalent, the lion, in the temple of Arang.

It seems cogent that Rudra-Shiva and his local equivalents, some still revered as yaksha-Balajis, others perceived as specific aspects of the Great God, Mahādeo, should have adopted this chromatic attribute from the Goddess. Is he not himself the theomorphic embodiment of her shakti, of the phallic dynamism, that very rajas quality symbolized by the passionate hue? In the course of his ascendance to divine preeminence, the color red has become specifically identified as Shiva's symbol and inseparably integrated into his cult and that of the Balaji representing him locally. The testimony of such all-sindoor-coated effigies as those of Mahādeo-Balaji at Ratanpur, his analogue at Chhapri, or of Maroti at Bhilganj is rivaled by the more modest but apparently indispensable applications of vermilion wherever the Shaivite deity is worshiped, be it in the form of an elaborate altar or a crude stone heap announcing his presence, of a red and white striped enclosure circumscribing his sanctuaries, or the red pigment adorning the devotees' bodies and, in powdered or liquid form, spattered over the celebrants of the Holī festival.[29] Most of the countless lingas, archetypal emblems of the deity's phallic dynamism, are in some way or other marked with the symbolic color, streaking the object vertically, circling its base, or simply poured over its top; or, again, coating the prongs of a conjoined trident. Shaivite roadside hagioliths display it routinely; and items of such special cultic significance as "Shiva's footprints" invariably feature it. In its fundamental, unconsciously preserved symbolism, this everpresent vermilion glorifies, through the medium of the male divinity who is her creature, the indigenous vision of Māyā-Shakti.

XVI

XV 142

II

XI

VII

XXVI

V

IV II

VIII

XII

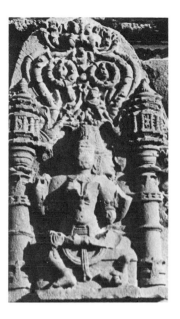

TEN

THE GODDESS AS MAHESHVARĪ

A counterpoise to that of the Lotus Goddess, the vision of Māyā-Shakti opposes manifest to latent energy, operative to potential creativity, transformatory capability to reproductive capacity, erotic self-realization to unawakened expectancy Māyā-Shakti and Padmā-Lakshmī emerge as the twin aspects, inextricably interdependent and interacting, contrasting and complementing, of the Feminine Essence. Yet, in perceiving this polarity as essential to the proper balance of all existence, early mankind seems to have recognized also that, if the vital process were to be realized, the primordial tension would have to be resolved. Both countenances, both temperaments, both selves of the Goddess had to function in synergy to sustain the universe in being.

This imperative has shaped the countenance of the female divinity as the Sublime Mistress, Maheshvarī, in which the apparent opposites would find and manifest their unity; which, at once smiling and frowning, placating and threatening, condoning and raging, bestowing and depriving, comprising in itself the ostensible ambiguities of her nature,

would reflect the ambiguities of man's phenomenal existence. His vision of the Mistress of Life as Triple Goddess, theomorphic incorporation of the concurrent potential, dynamic, and balancing conditions of the female power, seems to be archetypal. Her portrayals in threefold aspect appear to have been universal.[1]

The tradition of the Triple Goddess has to date been curiously disregarded by the interpreters of India's religion and arts. Neither have the iconic representations of Maheshvarī, though by no means rare, found as much as a mention; nor has her ostensible symbol, the trishūla, appearing everywhere, been accorded any measure of critical appreciation.

It may not seem unreasonable to attribute this silence to a successful design which, in diverting the worshiper's devotion from Maheshvarī to Maheshvara, Shiva's triple aspect, obscured the fact that the male god has assumed this transcendent identity from the female divinity. On the other hand, the lack of attention given to Maheshvarī may well have been due to unfamiliarity: her representations occur mostly in the relatively unknown and unvisited sanctuaries of the central Indian back country. Here the

143 144 images of the Triple Goddess outnumber those of Shiva Maheshvara, significantly recalling the original constellation. For the most part, only the

XXVII 40 local population is acquainted with such depictions, be they explicit or modified to portray her single-headed but with three pairs of arms. In them once again the persevering memory of folk tradition preserves a more ancient and authentic vision of the Divine and, incidentally, reveals the source of Shiva's Maheshvara image: the latter's most familiar and most accomplished specimen, in the cave temple of Elephanta,[2] proves in its composition and conception so strikingly analogous to such countenances of

143 XXVII Maheshvarī as those at Khiching or Bheraghat that any accidental parallelism must be ruled out. The circumstance that the Elephanta sculpture predates the Khiching and Bheraghat figures hardly invalidates this contention. Obviously products of a highly advanced, sophisticated tradition, such portrayals of the Triple Goddess must have evolved for many centuries from more ancient models long since lost. Moreover, the emergence

of the Shiva Maheshvara figure has been recognized as engendered by abstract speculation and cultic consideration rather than by spontaneous inspiration. It was induced by a need for a more effective substitute for the Brahmanical trimūrti configuration that, developed in early Gupta times, had largely failed in its devotional appeal.[3] Purely cerebral, mystifying rather than mystical, esoterically invalid in its effort to replace the triune deity with a configuration of three distinct deities, the scheme of the Brahma-Vishnu-Shiva triad remained inherently unpersuasive. Incapable of eliciting any degree of popular response, it proved to be abortive. However, the fact that the introduction of a divine trinity had been deemed desirable would of itself tend to bespeak the force of native India's dedication to the triple countenance of the Divine, though other circumstances may well have been contributory to its canonical promotion. Thus the universality of the tradition might allow for the possibility that memories of a triune godhead in the pre-Vedic Aryan past had been rekindled. The concept of Agni's triple manifestation, though apparently the product of late speculative elaboration, may trace back to such a residual recollection.

In any event, the indigenous tradition had itself already provided a *male* incorporation of the Threefold Power. Though remaining a singular find, the familiar icon of the pashupati of Mohenjo-Daro suggests the existence of counterpart images which have either not survived or are still to be unearthed. Such a preexistent divine prototype would no doubt be instrumental in encouraging the eventual promulgation of the Brahmanical trimūrti. Given such a powerful impulse, the latter's lack of permanent success must, then, seem the more astounding. Perhaps its cause must be sought in the pashupati model's own insufficiency as an embodiment of but reflected divinity. In its modification of the trident the symbolism of the Indus Valley god's three-pronged headgear immediately proclaimed his genesis as the masculine shape of female transcendence.

The trident seems to have been one of the oldest and most universal attributes of the female deity, translating into visual terms the triune nature of her encompassing power. Its spontaneous appearance in the most widely

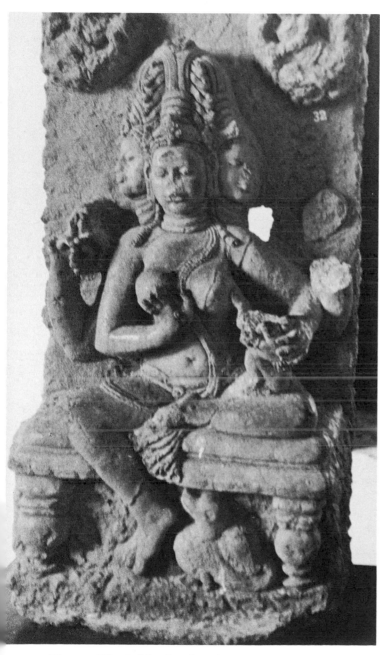

separated areas and cultures testifies to the fundamentality of its symbolism, whose primal reference to the Triple Goddess is suggested by mythological, iconographic, and semantic evidence. Here it must suffice to recall the famous trident of Poseidon-Neptune which, entirely unrelated to his function as the Lord of the Seas,[4] had been inherited, or perhaps usurped, from the Mediterranean Triple Goddess.[5] All evidence seems to point to her original ownership of this emblem as a token of her ultimate supernality. Analogously, the trishūla must have been the characteristic attribute of the Indian Goddess in her identity as Maheshvarī, the Great Mistress, embodiment of the Threefold Power. Her native appellation is today beyond surmise, but its meaning might not have been too unlike that of Rodasī, "Heaven and Earth," epitomizing her universe-encompassing nature.

Even if the archaeologists' efforts should never reveal an identifiable likeness of that primeval goddess, her presence remains incontestable, its

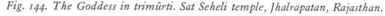

Fig. 144. The Goddess in trimūrti. Sat Seheli temple, Jhalrapatan, Rajasthan.

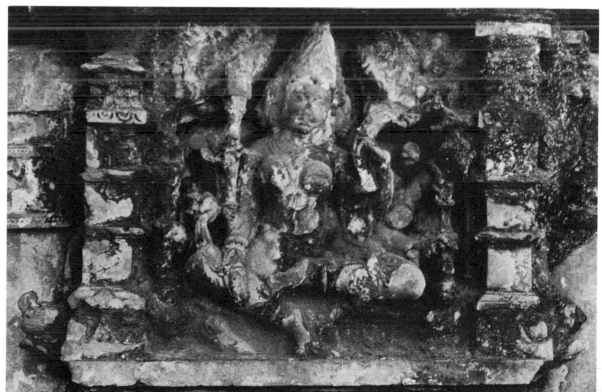

Fig. 143. The Goddess in trimūrti. Stele, Khiching, Orissa.

imprints indelible. Millennia later there still is her countenance in tri-mūrti, radiating her mystique from the walls and altars of the Indian sanctuaries. There, still, are the effigies of Shiva Maheshvara, descendant of the pashupati and of Rudra, the male materialization of her shakti. And there, ever present, is the trishūla. Wielded by Shiva and his local yaksha counterparts and carried as the *vajra*, the "thunderbolt," emblem of Mahāyāna's supreme Bodhisattva,[6] as it once had been displayed by the pashupati and no doubt by Rudra, it yet recalls the triune powers of the Divine Feminine.

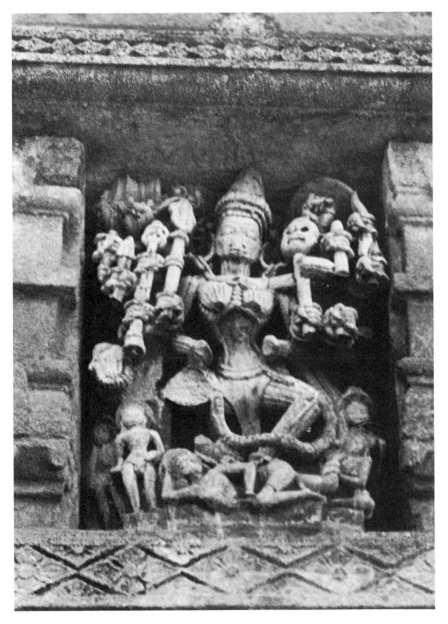

Even a later age's preponderant attribution of the trishūla to the male deity has not succeeded in obliterating this original association. Especially in the imageries of the back country, Shakti still retains her authentic symbol. In whatever aspect she may appear, the emblem asserts her inclusive divinity. Thus the trishūla accompanies her identities as Chandi and Bhīmā, Yogeshvarī, and Kankalini; and, most significantly, often it is exhibited by Pārvatī rather than Shiva as the divine couple share their eternal moment of loving intimacy. It is likewise displayed by her noncanonical, locally worshiped aspects; and, regularly, in that of Durgā mahishāsura-mārdinī, who wields the trishūla as the weapon that slays the cosmic fiend to restore the universe to divine control.

Perhaps even more indicative is the conjunction, throughout central India, of the trishūla with the shrines of the village goddess. Sometimes assuming the form of the *mātā dewala*, a small inconspicuous hut containing a crude effigy, or just an unhewn rock representing the deity, but more often consisting of no more than a heap of stones or a single rock or slab, frequently mounted on a *chabutra*, a low, rectangular platform serving as altar base, these sindoor-marked shrines evidently derive much of their sacredness and mystic efficacy from the attending three-pronged emblems that announce the presence of the divine mistress.

Whatever the incidental aspect, whatever the specific function of the female deity, they seem envisioned as but the ad hoc emphases of her power; symbolized by the trishūla, she always remains identified as the

Fig. 145. Kālī-Bhīmā. Boramdeo temple, Chhapri, M.P.

144

transcendent extension of Archetypal Woman in whose image each human female encounters the supramundane model of her own nature, expression, and conduct. In this sense, Rodasī-Maheshvarī may well be regarded as the prototypal predecessor of later Hindu legend's Satī, immortalized by Purānic literature.[7] The concept and specifics of this legend unarguably indicate that this countenance of the female deity could not have had its genesis in any authentic mythic or cultic tradition within the Brahmanical religion's own compass. To start with, Satī is described as the "daughter of Daksha." Her descent from that mysterious, primeval, precanonical, and thus noncanonical creator divinity, who had been proclaimed the father of so many "demonic" and "antigodly"—that is, non-Vedic—goddesses, inherently postulates her extra-Vedic origin. Moreover, this affiliation implicitly characterizes the great antiquity of her tradition, of which, however, there seems to be no mention whatever before the Gupta era. Ostensibly, the Satī legend was accreted to the Purānic text from a source outside the canonical lore. Its obvious inspiration must have been an indigenous account involving the Goddess in her role as the embodiment of inclusive feminine character and capacity. Powerful in its hold on popular imagination, it may have promised the added asset of being easily susceptible to reformulations which could serve the didactic purposes of the orthodox religion. The self-serving aims were both dissimulated and enhanced by the poeticism, imagery, and symbolism of the text. In the guise of Satī, the immemorial focus of native Indian veneration, Rodasī-Maheshvarī reemerges as the "good, virtuous, faithful wife," as "Womanly Perfection" defined in the explicit terms of Brahmanical ideology. Thus reinterpreted, the prestige of the Goddess herself was exploited to provide scriptural authority and the force of a divine injunction to the already practiced ritual of the widow's self-immolation, the "suttee," the prototypal act of Satī.[8]

The obvious likelihood that this wifely "duty" might have enjoyed substantially less popularity among the women than among their men would explain the need for its religious authentication, particularly as, not having been part of the original canonical rules, it had been made incumbent only by a more recent unfolding of extreme patriarchalism.[9] Masculine self-inflation now not only postulated woman's role as one of inclusive and absolute subjection to her husband, but also denied her any valid existence independent of his own. Her life was defined by his presence, sustained by his vital spark. With the latter's extinction, it thus ceased to have any further function, except that its self-surrender might give the most palpable recognition to the premise of male exaltation and female insignificance. Any noble and pious husband seemed innately entitled to this ultimate tribute from any "good, virtuous, faithful" wife. Her self-immolation would provide the due monument to her husband's grandeur and her own inconsequence. This supposedly innate distinction is often graphically demonstrated by the drastic, if unconsciously self-caricaturing, disproportions of the protagonists on the memorial satī stones.

If the cogency and rationality of this doctrine seemed less persuasive to the wife, its purported acceptance by her divine equivalent would prove most difficult to disregard. Its supramundane enactment would endow it with unarguable validity, and more than just subtle coercion. Satī's sacrifice would establish the effective model. In performing her widow's duty, the mundane satī would be emulating her transcedent archetype. Had the latter not chosen self-annihilation even when her mate had suffered, not death, but merely a diminishment of his grandeur through some calculated slight?[10] If the divine female could not survive this temporary eclipse of her lord and master, how could the human female dare outlive the final demise of hers, the destruction of his vital power which alone had made her own existence viable?

But the fiercely explosive ending of the purānic Satī story carries the marks of superimposed contrivance. It does not evolve as an inevitable or even reasonable sequel to the events of the narrative. The divine bride's self-destruction seems incongruous with her described character which, drawn in the passionate and tender accents of the indigenous vision, proves incompatible with orthodoxy's female paragon. The incidents and symbolisms of the account make it obvious that the canonical Satī bears scant

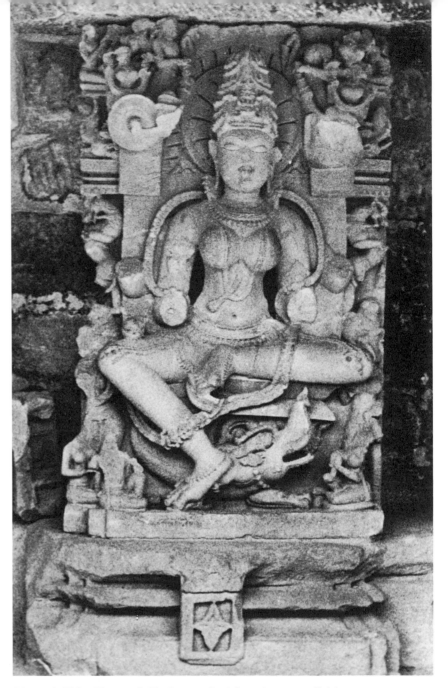

Fig. 146. Kālī. Chaunsath Yoginī temple, Bheraghat, M.P. (left)

Fig. 147. Yoginī with makara. Chaunsath Yoginī temple, Bheraghat, M.P. (above)

similarity to the goddess of the native legend, whose authentic identity is most clearly revealed by her very name. Its renderings of "good, virtuous, faithful" are patently secondary elaborations, extensions not projected by the radical import of the term "Satī," a feminine version of the word *sat*, whose meanings, "existing, existent, present; lasting, enduring; actual, real," in fact enumerate the attributes of the Feminine Essence.

The protagonist of the original Satī story, then, was Maheshvarī, Feminine Essence in divine personalization, and its subject one of the episodes in the chain of her infinite manifestations, which belong to the fundamental legendary of the Goddess, shared in variant versions by many cultures. The original contour of this account still shines through the willful alterations of the Purānic narrative; and it is raised into even bolder relief by such mythological analogies as, for instance, the Greek story recounting Demeter's rage in the wake of Hades' rape of Kore-Persephone. Precisely as the latter, as her daughter, stands identified as the materialization of Demeter's creative power, so too is Shiva, as Satī's husband, defined as the incarnate manifestation of her shakti. And just as the offense perpetrated against her creature evokes an extreme reaction from the Greek Mother of the Gods, so the insult to Shiva triggers an equivalent response from India's Transcendent Feminine.

These situational parallelisms would seem to postulate also parallel endings. The authentic conclusion of the Indian legend may reasonably be inferred from that of the Greek. There Demeter does not engage in self-destruction; rather, she vents her wrath by withdrawing her life-giving powers into herself. Dynamic energy is made to revert to its preexistent, potential state, and the world withers away until the goddess is finally reconciled. A similar result, the suspension of vital continuity, seems implicit in the Indian version. Just as Demeter permits her powers to become creative once more, so, in the original legend, Satī's action could not have entailed self-destruction but merely the imposition of a hiatus in cosmic life. The powers of the Feminine Essence are imperishable and eternal. Even orthodox antagonism had to compromise with this primal thesis.

Thus, contradicting its own postulate of the goddess' self-extinction, the Kālikā Purāna has Brahma himself acknowledge that "the goddess will be Shiva's spouse again."[11] As Pārvatī, she will once more draw him into her life-engendering embrace, and the creative process will resume.

Brahma's prediction merely pronounces in mythic formulation what the emblem of the trishūla had long conveyed symbolically: Pārvatī is but another canonically approved countenance, another Great Tradition identity of the ancient Rodasī-Maheshvarī, another temporal aspect of the Mistress of the Threefold Powers whom the Purānic legend had simply but most pertinently designated Satī, "Feminine Essence." For she is Feminine Essence, one specialization among the many, manifesting one aspect of her complex tempers and functions, yet, like them all, an embodiment of her inclusive nature. For, though typifying one specific accent, each of her incorporations represents the whole divine gestalt.[12]

This circumstance finds its most palpable illustration in the Temple of the Sixty-four Yoginīs at Bheraghat,[13] remarkable not only for its religious implications but singular in that it rises in the center of a sizable courtyard circumscribed by a circular wall, in contrast to the unexceptionally rectangular enclosures of India's sacred precincts. The inside of this wall, facing the sanctuary of the Goddess, is divided into a sequence of closely abutting niches, each containing the likeness of one of the yoginīs who are in attendance on the presiding godhead. Most of these images have long ago crumbled into fragments, and many of the niches are now unoccupied. Only a minority of the original sixty-four female forms remain in a state of viable preservation, yet they permit a perception of this monument's erstwhile magnificence and still persevering import.

Once these remnants, together with their now vanished counterparts, collectively duplicated the all-encompassing presence of the Great Goddess to whom the shrine is dedicated. This conclusion inescapably emerges from any examination of the extant figures, whose conceptions corroborate neither the meanings nor the status and function officially associated with the designation "yoginī." Evidently, their iconic aspects define them as sub-

Fig. 148. Bhairavī. Chaunsath Yoginī temple, Bheraghat, M.P.

Fig. 149. Mariāmmai. Chaunsath Yoginī temple, Bheraghat, M.P.

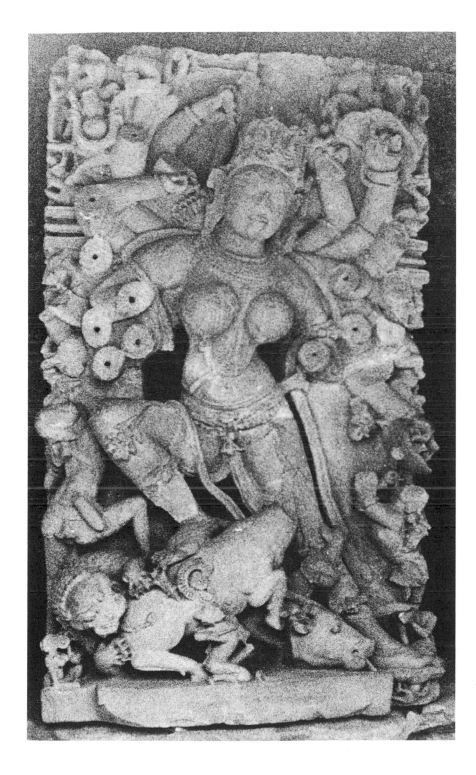

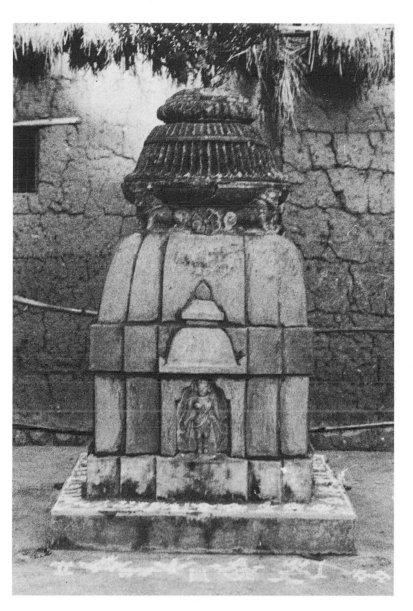

Fig. 150. Durgā Mahishāsura-mārdinī. Chaunsath Yoginī temple, Bheraghat, M.P. (left)

Fig. 151. Revelation of the Goddess in the linga. Street altar, Ranpur, Orissa. (above)

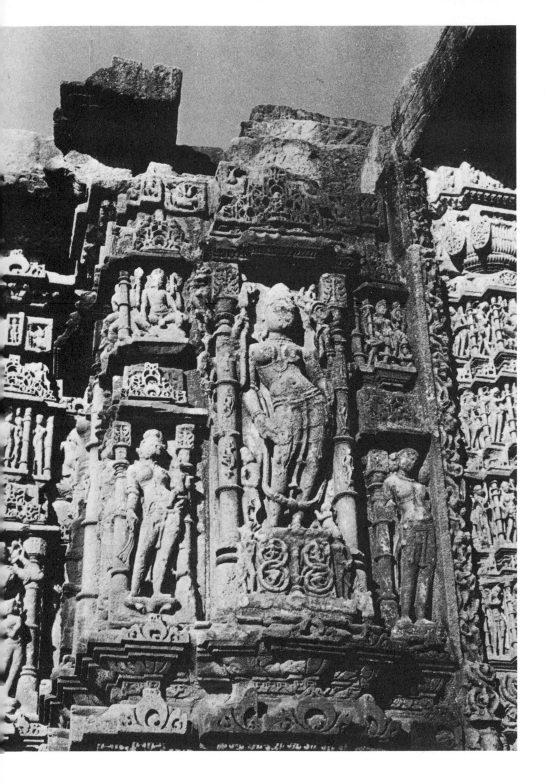

jects of a far greater exaltation than that of "sorceresses, witches, fairies," which the term yoginī is purported to denote; of a sublimity incompatible with the status of "servants of the goddess," which describes their generally presumed role.[14] These images wear the countenances of the lotus goddess and the serpent goddess; of Chandī and of Kalī; of Yamunā, the guardian of the sacred stream; of the ancient boar goddess of the Vindhyas, whose spouse had been Nārāyana before he was made one with Vishnu; of Bhairavī and Gaurī and Mariāmmai; of Durgā, the slayer of the titan buffalo, and of Maheshvarī, the triple goddess. They portray the yoginī not as a servant but as a function of the Goddess, an embodied particularization of her being, possessed of the yoga, the transformatory magic that determines and controls the life of the universe. Here, then, through the collective likenesses of these yoginīs, the Goddess discloses the totality of her power; discloses herself as she had been perceived, from the days of the distant past, in the devotions of India's native religion. It is as Maheshvarī that she presides at Bheraghat: as Satī, the feminine archetype.

And it is she again who stands revealed in the linga-shaped street altar at Ranpur,[15] characterized by the concurrent symbolism of the lotus and the lions[16] as the divine shape of inclusive feminity. Whatever her canonical or local designation, her authentic identity is that of Satī; as is, apparently, that of the goddess at Modhera, who seems to be the integer of all the surrounding female forms, incorporations of her manifold powers.

102
121 146
147 78

148 106
149 150
XXVII

151

152

Fig. 152. The Goddess in her various aspects. Kāmeshvara temple, Modhera, Gujarat.

ZOOMORPHIC MASKS OF THE GODDESS

Inevitably, the powers of the Goddess also found their zoomorphic embodiments. Though many of them are still vivid in folk tradition, in earlier times many more may have been prevalent. The interculturally analogous pattern presented by the primal worship of the female divinity would indicate that her Indian model must have been celebrated by therio-theistic cults of impressive intensity, scope, and variegation. Yet, often indistinct in their contours and recondite in their meaning, of all the aspects of the indigenous religious heritage the zoic manifestations of the Goddess seem to have been favored least by critical consideration, or even interested comment.

Still, the iconography of central India remains a living memorial to their persevering prominence. However, a survey of the female divinity's explicit animal shapes alone would offer poor reward: the examination must comprise those fantastic masks that, bizarre products of the demonization process, conceal their original inspiration beyond immediate recognition.

Of these masks the numerically as well as significatively most important by far is the vyali, that abstruse creature of composite beastliness whose hideous and virulent shape haunts every temple wall and every ornate gate to a medieval citadel. Assuming diverse contours of the monstrous, with a preponderance of leonine, elephantine, birdlike, and what has been inappropriately interpreted as equine, features,[1] the vyali prototypally appears as the epitome of supernatural violence, rearing with implacable fierceness above some diminutive foe of humanoid or zoic aspect, set to smash its hapless body, crush it, or tear it to shreds with its giant claws. Though, the vyali is not always the aggressor. In fact, preponderantly its snarl proves to be defiance, its fury self-defense, its viciousness a grimace of writhing agony, as some puny hero thrusts his sword or lance into its underbelly. These battles seem eternal and inconclusive. As attacker or attacked, the vyali appears possessed of inexhaustible vitality. Moreover, frequently its fight is supported, perhaps directed, by some superhuman rider on its back, as often as not a female one, whose powers might yet reinforce its own prodigious strength.

67 124 153 154 155 156

153

These postures and constellations are highly significant for any understanding of the vyali's original nature, one substantively different from its superimposed, ostensible character and role.[2] However the former may vary from place to place, and even within the same sacred precinct's depictive pattern, the latter remain unchanged. Theriomorphic incorporation of dynamism in its sheerest form, the bizarre creature is cast in the role of the antigodly principle, the prototype of all the noxious, destructive, life-threatening forces that Brahmanical orthodoxy had identified with female power in manifestation. The reigning persuasion's repugnance of theriotheistic cults may have still further exacerbated its radical antagonism toward the worship of the female deity, to invest the vyali with its especial monstrousness, with a sense of supernatural terror befitting its function as the zoic mask of Shakti's demonized countenance.

The vyali's identification as the teratoid equivalent of Māyā-Shakti's demonic aspect seems well suggested by the analogy of processes commonly

Fig. 153. Vyali trampling demon. Stele, Sanchi, M.P.

operative in other cultures, processes that have produced zoic shapes of the Goddess in comparable accents of fiendishness. Nomenclature may offer additional substantiation. Deriving from the Sanskrit *vyala,* "vicious," the designation's present form, *vyal-i,* shows a suffix apparently unknown to the Sanskrit vocabulary. Might not this modification[9] constitute a secondary evolution of the term, in which the current idiomatic ending on the short *i* replaces an earlier one featuring the long *ī,* the grammatical indicant of the feminine gender and, inferentially, of the vyali's original female character? However conjectural, this possibility seems quite real, especially as the iconographic particulars appear to supply some most effective corroboration. For, whatever the vyali figure's specific combination of zoic elements, its one prerequisite is the leonine ingredient. Variously evidenced by the furious snarl of the maned head, the claw-studded hind legs, or the characteristic shape of the torso, its presence is unmistakable. Moreover, as though to reemphasize this implicit reference to the female divinity,[4] there often is an intimation of quaint grace about the brute form, producing, for all its exhibited ferocity, a curious lack of typically masculine accent. Most significant, however, is the unexceptional absence of the instrument of male sexuality, the more notable in the light of Indian iconography's characteristic frankness in its depiction. While this omission might of itself seem sufficiently conclusive, other factors reinforce the persuasiveness of its point; for instance, the actual nature of what, with more fancy than accuracy, has been interpreted as an equine element in the vyali's compound likeness. On closer scrutiny the stubby compactness of its body, the heaviness of its short legs, and their equipment with claws rather than hoofs prove at variance with the horse's attributes; while its head, when it does not assume leonine or elephantine or avian aspect, is singularly reminiscent of the dragon's countenance, a cast so familiar from other cultures as the demonized counterpart of the divine serpent, the primal zoic equivalent of the female godhead.[5] This interpretation seems further supported by the iconic confrontation of the vyali with a male assailant who, however apparently insignificant in his comparative size and physical endowments, char-

acteristically represents the semidivine hero, that perennial protagonist, defender, and conquering apostle of the partriarchal religion and ideology. The import of this design closely parallels that of the frequent south-Indian portrayals of an analogous hero slaying the Goddess' prototypal theriomorphic manifestation, the lion.[6] Perhaps the most significant variant of this theme, featuring a role reversal of astounding implication, is offered by the common constellation of the vyali smashing a miniature elephant. Here once more the battle to annihilation is joined between the two opposing ideologies; for, in the elephant, the heraldic animal of Indra, the Vedic god-king, and of Vishnu, the exponent of the Brahmanical ethos, the reigning orthodoxy itself is being symbolized. This contraposition of the contending supernatural forces, belying the ostensible shape of the zoic monster, inherently identifies the conqueror.

Once this bizarre figure is recognized as the demonically perverted mask of the female deity, its cryptic everpresence becomes plausible as a witness to the perennial collision of high religion and folk religion in India, even though the awareness of this original significance may have been largely lost. This obliviousness to its role as a vehicle of Shakti may explain why, for all the frequent excellence of workmanship, the vyali image so often displays the anonymous tedium of the stereotype. Lacking conscious association,[7] the sculptors adapted their efforts to sanctioned patterns of design, including those that would, in disregard of the monster's authentic character, present it in the role of the Brahmanical order's defender and champion, no longer trampling Indra's or Vishnu's elephant, but now destroying gana-like "demons" or hopelessly outclassed *makaras,* creatures identified with the indigenous tradition.[8]

Imageries of this type reflect the always attempted and often successful exploitation of the vyali's effigy for the benefit of the orthodox religion: even demonized, it carried the charisma of the Goddess. Like those Christian saints who are but the baptized divinities of the old religion, the zoic icon now exercised its magic powers on behalf of a belief never its own, or even truly its communicants'; powers that, still credited with apotropaic

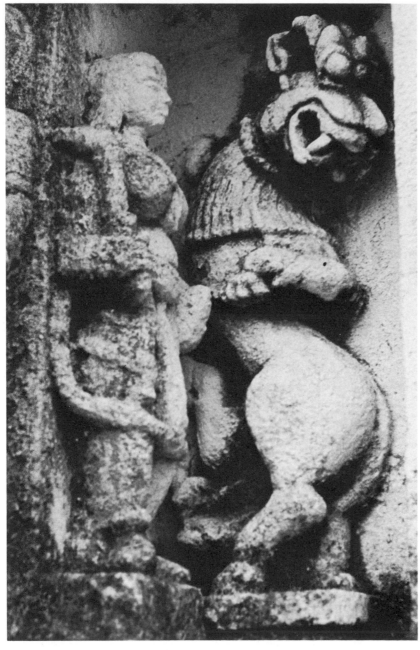

Fig. 154. Surasundarī and vyali. Someshvara temple, Rajura, Maharashtra.

efficacy, accrued as an endowment of, not its new-faith, but its old-faith associations. This canonical assimilation is not exclusive to the vyali. Neither is its apotropaic capacity unique. It is an inherent attribute of all zoic masks of the Divine, among them most conspicuously of the *makara*, another surviving shape of the theriotheistic past whose depictions prove integral to Indian temple decor.

Defined as a "marine monster," the makara has remained enigmatic. Neither has its zoic identity ever been definitively established nor its nature conclusively interpreted. Its mythogenetic and iconographic evolution has not been assessed. Its old-tradition antecedents can therefore only be hypothesized, its import as a zoomorphic manifestation of the female deity only inferred from scattered particulars of its present-day appearance and legendary allusions. But its insistent and ubiquitous presence, especially in the strongholds of folk religion, tend to encourage just such an inference.

In the main the makara is encountered in two iconic variants corresponding to its respective functions as a mask and as a vehicle of the Divine.

The former aspect,-the one most frequent yet least enlightening, features this curious creature in a preeminently apotropaic role. As a stone-sculpted head and neck only, seeming larger in its grotesque ungainliness, it protrudes from the temple walls much like an oriental version of the gargoyle. In their forbidding combination, the brutally massive skull, the bulging eyes with their paralyzing gaze, the giant mouth gaping ready to devour, defy any positive zoological definition. Certainly here the makara's prevalent designation as a crocodile is not at all self-evident. This bizarre countenance seems generically ambiguous, like some animal-shaped offspring of nightmarish fantasy. Yet, perhaps its precise zoic identity is meant to be irrelevant; perhaps again it has been kept deliberately equivocal to ensure an anonymity which, still further enhanced by the unvarying sameness of design, would characterize it as a symbol rather than an embodiment of the Divine.

More revealing are the figurations in which this zoic shape serves as a vehicle of the divinity, as, now depicted in its full aspect, it appears in the

somewhat stylized and anatomically dubious, yet indeed identifiable, like-
114 ness of a crocodile. This iconographic explicitness assumes special signifi-
cance when considered in the light of the makara's official definition as a
sea monster. Since, as a most familiar member of their country's fauna, the
crocodile must have been known by Indians to be exclusively a river animal,
might this designation not suggest a substitution of the crocodilian form
for an earlier one of a sea beast?

Such a substitution appears plausible enough as a consequence of the
Indo-Aryans' advance which carried into the inland territories of the sub-
continent while by and large bypassing the coastal regions. Cut off from the
ocean and its creatures, they would thus find any tradition of a marine
monster unrelated to their experience, and interpret it in terms of their
own environmental phenomenality as some fierce and dangerous animal
connected with the water. Infesting the rivers along which the Aryans
sought their sustenance, the crocodile well answered this description. The
transfer to it of the sea beast's imputed supernatural attributes and sacred
traditions seemed cogent.

The worship of the sea beast as a vehicle of the Divine was common to
early peoples in intimate contact with the sea, and was perpetuated by their
descendants far into the historical age. The substantial body of non-Indian
analogies may supply a clue to the makara's antecedents. While its original
model might have assumed any of a variety of physical aspects ascribed to
the marine monster in legend and iconography elsewhere, its character
seems much more firmly contoured. As concordantly attested by all manner
of referent lore, the sea beast's most salient feature was its intrinsic associa-
tion with the worship of the female divinity. Mythically, cultically, and
iconographically it is linked to the Pelasgian Deo-Demeter; the Aegean-
African Amphitrite;[9] the Babylonian Tiamat; the Syrian Astarte and Ca-
naanite Rahab; to the Goddess everywhere, under whatever name; and pre-
eminently to the ecstatic and orgiastic aspects of her celebrations.[10]

Further accenting this relationship, it also appears as the forbidding
guardian of assorted fabulous "princesses," the female deity's mundane

Fig. 155. Vyali trampling demon. Sūrya temple, Konārak, Orissa.

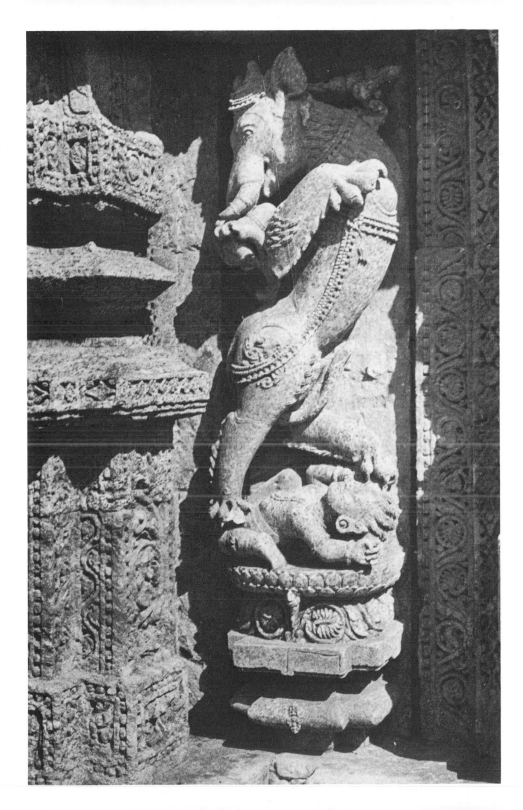

equivalents, whose "liberations"—that is, transfers to the jurisdiction of a different authority—are part and parcel of the legendary hero's tasks. This prototypal constellation necessarily casts the sea beast as an opponent of the new divine order, and implicitly as an exponent of the old, presided over by the Goddess.

Evidently, the religious and cultic patterns of ancient India's coastal dwellers had shared this prevalent conception and passed it on to a later era's recollection. For extant iconography presents the makara, this marine monster of the inland environment, as the vāhana, the identifying vehicle, of the female deities personifying the life-giving properties of the country's great streams. Just as Indra is riding on the elephant, Shiva on his bull, or Kārttikeya on the peacock, so Gaṅgā and Yamunā, the divine embodiments of the sacred rivers watering the oldest Indo-Aryan heartland, are being carried on the backs of those crocodilian shapes. So, too, are their counterparts presiding over other great streams, like the goddess of the Mahānadī. At Bheraghat the presence of the makara at her feet designates one of the yoginīs as the deity's manifestation in the role of a river goddess, apparently Yamunā. Below her seat, an oramentally stylized lotus emblem conveys its message; as does, rather more conspicuously, the halolike lotus circle framing the head of the Mahanadi goddess at Rājim, as though to ensure proper recognition of their identities as specializations of the Mistress of Nature who indwells all the waters. At the same time this emblematic abstraction of female eroticism, reinforced by the alluring stances and intriguing smiles of the divine likenesses, recalls the orgiastic rites so characteristic everywhere of the primordial sea-beast cult.

In spite of the attempt at demonization meant to obliterate the memory of its ancient sacredness, legend and language alike have corroborated and preserved the makara's authentic role as a zoic mask of indigenous India's female divinity. Among the manifold evidences, the makara emblem's curious assignation to the god Kāma offers one of the more involved but also more indicative illustrations.

Duplicating a universally familiar pattern, in India too the transfer of worship from the female to the male deity carried with it the transfer of her symbols to the new celestial masters.[11] Thus, as elsewhere the emblem of the sea beast was acquired by such deities as the Mediterranean Apollo and Triton, or the Canaanite Dagon, so in India it was assumed by the Hindu Kāma. The Kālikā Purāna describes how it appears as his heraldic sign when, generated by Brahma's "inner search," he springs forth wielding "a banner emblazoned with a fish."[12] From the evidence the designation of "fish" must here be considered as misreading for "makara," for not only is the latter regarded as the official emblem of Kāma,[13] but imageries of this god occasionally still configure him with the converted "marine monster." Moreover, the legend itself contributes some revealing allusions in describing him, not as the initial product of Brahma's psychic concentra-

Fig. 156. Vyali destroying elephant. Pārshvanātha temple, Khajuraho, M.P.

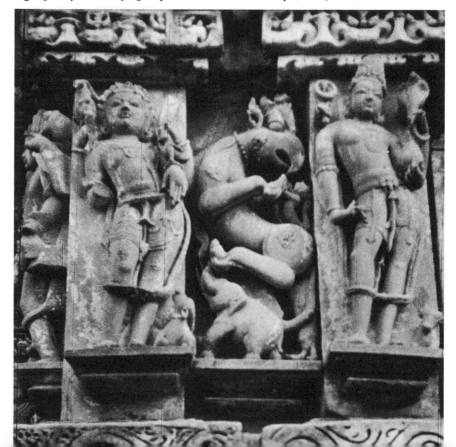

156

tion, but the creator's afterthought prompted by the need to provide a mate for the firstborn of his mind, the goddess Dawn.[14] If this mythical detail is notable for its acknowledgment, within the frame of a canonical text, of the female divinity's primacy, it is equally significant for its incidental identification of Kāma as a *secondary* materialization of the divine energy, complementing the Goddess's preexisting nature. His erotic propensity discloses itself as a mere reflection of her own nature, and his identifying emblem as the replica of what must have originally been her own zoic equivalent. The latter's makara form seems implied by the Purānic characterization of the goddess Dawn as an aspect of the lotus goddess, the more particularly so in view of the fact that the *makarī*, the female version of the sea beast, appears as a "mark on the face of Lakshmī."[15]

The makara's original identity as a zoic mask of pre-Aryan India's female divinity is further credited by the determined effort at its demonization, always a sure indication of the subject's prominent involvement with heterodox and particularly female-focused cult. The obvious purpose of obliterating another memory of the Divine Feminine's power and preeminence is echoed also in the innuendo of nomenclature. For, though the Sanskrit itself confirms the inherent femaleness of the ancient sea beast by way of the grammatical form *makarī*, which must be presumed to be the authentic one, the masculine designation, *makara*, has prevailed. This semantic artifice has succeeded in confounding the interpretations of that mysterious "marine monster," and in diverting attention from its sacred role in the primal cult of the Goddess. Yet, ultimately all assaults on the long memory of folk tradition have proved their failure: Gangā and Yamunā, the goddess of the Mahānadī and her manifold sister figures, all retain the ancient monster as their vehicle; Kāma still carries it as his emblem; throughout India its countenances appear in the temples to recall the rites of a dormant past.

However prominent once, the cult of the sacred sea beast was merely one variant of indigenous India's theriotheistic worship, merely one of the female deity's many zoic aspects. Some of them seem to have faded from recollection for good. Others have left their traces in myth and cult. Only a relatively few have achieved iconic perpetuation. But in some instances the ostensible lack of imagery may prove deceptive. The most conspicuous example is offered by the cow aspect of the Goddess. Surely, its total absence from India's iconography must, on first consideration, seem incongruous, particularly in the light of that country's proverbial veneration of this animal; the more so as its cult had left marks of its preeminence in so many cultures.[16] The nearly universal celebration of the cow goddess as the specific embodiment of lunar powers and magic, with rituals of distinctly erotic accent, would seem to postulate an analogous pattern of worship for early India, sufficiently cogent to become part of her religious heritage.

Closer examination indeed suggests that the cow countenance of the Indian Goddess may be still presenting itself in the familiar guise of the bull Nandi, Shiva's everpresent companion. This conversion from cow goddess to bull god merely repeats a common process of religious evolution, except that in India the process may have been completed earlier than in some other areas. The persistent depictions on Indus Valley seals of the bull rather than the cow, in accents intimating the animal's sacred importance, would indicate that here, at least, the Goddess must have surrendered her bovine mask to her shakti-born mate at an early date. Rodasī's cow became Rudra's bull; and, with that god's country-wide ascendancy in the identity of Shiva, this constellation continued as a fixture of Indian religious and cultic life.

Even so, the memories of the female deity's primal cow-aspect have not been completely obscured. Myth still preserves them in the figure of Surabhī, the celestial cow, inexhaustible source and dispenser of nourishment. This appellation has been rendered as "affecting pleasantly," but its further semantic consideration would propose a primary meaning of "The Beneficially Producing One," marking it as just another of the various synonyms by which a bountiful Mistress of Nature was invoked; as another epithet of the lotus goddess applied to her specific manifestation in cow-aspect. This seems the more likely as legend has identified Surabhī, too, as a

"daughter of Daksha and wife of Kashyapa," thus emphasizing an association that has been recognized as characterizing the non-Vedic, primeval female divinity. This genealogy, in fact, defines the celestial cow as a sister—that is, another aspect—of such as Danu, "The Bestower," and Diti, "Finiteness," whom their very names reveal as doubles of Annapūrnā and Māyā.[17] Surabhī may indeed have served as an alternative designation for Nandi: not only does this name, the "Gladdening One," duplicate the connotation of *surabhī*, "affecting pleasantly," but its feminine version, *nandinī*, also appears as an epithet of Durgā, and as the "name of a fabulous cow." This prompts a conclusion that, even though that fabulous cow has come to play a minor legendary role, originally she may have been identical with Durgā, presumably as the Goddess's zoomorphic embodiment. And just as the female divinity preceded the male, so the cow Nandinī, or Surabhī, must have antedated the bull Nandi, who evolved as her secondary, masculinized identity. The very designation of Shiva's bull may perpetuate the memory and perhaps imply the character of the Goddess' cult as cosmic cow: being modifications of the term *nanda*, "joy," the forms *nandinī* and *nandi* might suggest that the worship of the Indian cow-goddess emulated the ecstatic, often orgiastic rites of her Egyptian and Canaanite counterparts.

Behind the image of the bull Nandi, then, hides the countenance of the cow-goddess. The abundant proliferation of this icon testifies to the vitality of her primal cult. The absence of any direct representations proves irrelevant and misleading. The same applies to many more of the female deity's zoic manifestations. However clouded and disfigured, their memories live on. India's legends treat of the most diverse animals whose specific involvements, and not rarely names, suggest their authentic past. Though their closer study would yield much enlightening information, present consideration must confine itself to only a few that have left their traces also in iconography.

One of the more familiar is the swanlike, originally perhaps dovelike, bird that, commonly sacred to the female divinity, especially in her role as goddess of love, had eventually been usurped from her by Brahma, to serve, in the form of the *hamsa*, as his vehicle.[18] Its continuing attribution to the female deity, reinforced by analogies from other cultures, suggests the prominence of such birds also in the cult of the Indian Goddess.

No less specifically recalled is the worship of the sacred sow, similarly attested by non-Indian parallels, as one of the Goddess's principal zoic embodiments.[19] The importance of her cult in India is circumstantially indicated by the evident need for its assimilation into the new canonical scheme. Now properly sanctioned in her masculinized guise, the sow-goddess enters the mythology and iconography of the Great Tradition as the boar avatār of Vishnu. But her authentic antecedents assert themselves in the image of the yoginī of Bheraghat, whose usual identification as "boar-headed" rests on casual habit rather than an appraisal of the actual design. Significantly depicted without tusks, this animal head on the human female body in fact suggests a sow's likeness rather than a boar's.

The still surviving configurations of she-wolf and female deity recall another theriotheistic cult which, analogous to its obvious prominence in many parts of the non-Indian world,[20] may have been of considerable importance to indigenous India. The persistence of these associations in folk imagery may be prompted by a residual proclivity to the orgiastic accent of the rites that, documented for the worship of the wolf-goddess everywhere, appears to have prevailed in India also. The designation of the wolf-riding goddess as Modeshvarī, "Mistress of Joy and Delight," may well allude to such a pattern. Though today unidentified, the wolf-associated goddess at Chandol and her counterparts elsewhere may once have been known by similar appellations.

Yet, among the persevering memories of indigenous India's theriotheistic cults, none can quite approach that of the Goddess in her leonine aspect. Prominent throughout the subcontinent, especially in the back country of its central regions, the equation of lion and female divinity, whether expressed in terms of mutual configuration or of the former's substitution for the latter's presence, constitutes a near constant of imagery. Though universal throughout the tropics and semitropics, wherever the lion would

find his habitat,[21] in India the cult of the lion-shaped goddess seems to have attained to a ritual and esoteric role of singular scope. This extraordinary emphasis was, evidently, implicit in the circumstance that here the lion had been directly identified as the theriomorphic embodiment of the Divine Feminine's dynamic manifestation, as the zoic countenance of Māyā-Shakti.

This fundamental equation finds its poignant mythic formulation in the Kālikā Purāna. Here the description of the goddess Māyā as she appears before Daksha, "upon a lion, very dark of body, and with mighty breasts,"[22] capsules non-Aryan India's vision of the Female Power. The reference to her complexion affirms her indigenous origin: she is, in fact, Kālī, the Black One. The allusion to her physical luxuriousness accentuates the erotic and sexual aspects of her nature,[23] while her appearance on the lion epitomizes this animal's role as her principal zoic mask.

This image of Māyā-Shakti must have been molded by an ageless ritual tradition, to prompt generations upon generations to its artistic reproduction. Now identified with the canonical names of Durgā and Kālī, it perseveres, substantially as Daksha had beheld it, in countless sculpted, carved, and painted replicas. But not always does it require full representation. Internalized, and perpetually accessible to the consciousness of its worshipers, it is readily evoked by the suggestion of the symbolizing contour. Whatever Māyā-Shakti's incidental guise, as her zoic attribute the leonine likeness would disclose her authentic identity; as substitute icon it would announce her supernal presence. In the former function the lion appears as the constant companion of the Goddess: crouching beneath the seat of Gaurī, or at the feet of Pārvati and Shiva as they delight in their intimacy; in quiescent pose as the vehicle of gate-guarding yakshīs, to reveal them as the local equivalent of the Goddess; in aggressive stance as the fierce ally of Durgā in her battles with the titan buffalo; as a stylized mask affirming the inherent Māyā-nature of the lotus goddess; or, often rearing with untamed power, juxtaposed to surasundarīs or yakshīs, to define their fundamental characters. In their substitute roles the leonine effigies are en-

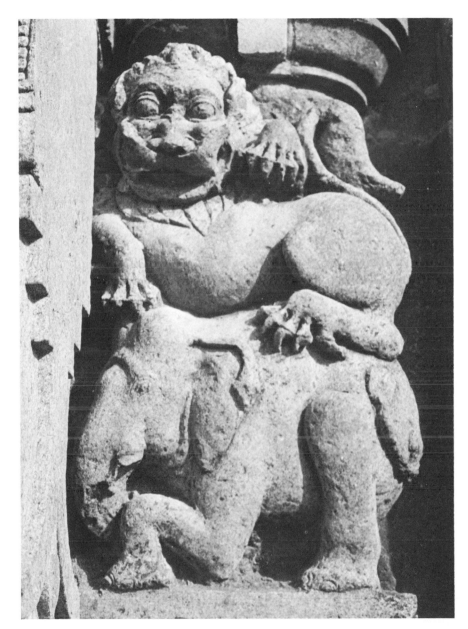

Fig. 157. Lion attacking elephant. Panel, Shiva temple, Khiching, Orissa.

countered with particularly impressive frequency throughout central India. Often depicted in the strange accents of folk imagery, they emerge as the apparent heralds of the female power, as though to assert, irrespective of the sanctuary's nominal or official dedication, her authentic and effective sovereignty. Quite commonly, too, they are constellated as identical pairs, to assume the capacity of dvārapālas. Replacing the anthropomorphic casts of the guardian divinity, such dyads may similarly flank street tabernacles as protectors of the image within; while on many occasions the divine presence is indicated by a single lion figure, placed prominently amid the icons composing the altar, to attest its ultimate consecration to Māyā-Shakti.

The lion's function as Māyā-Shakti's zoic alter ego is semantically corroborated by the animal's designation as *panchānana*, "the five-faced one," which identifies it with Panchānanī, Durgā the five-faced goddess, herself a latter-day form of Māyā. This synonymity finds representational reflection in the not uncommon configurations of five lion heads, most often on festival chariots, meant to spell symbolically the presence of the mistress of

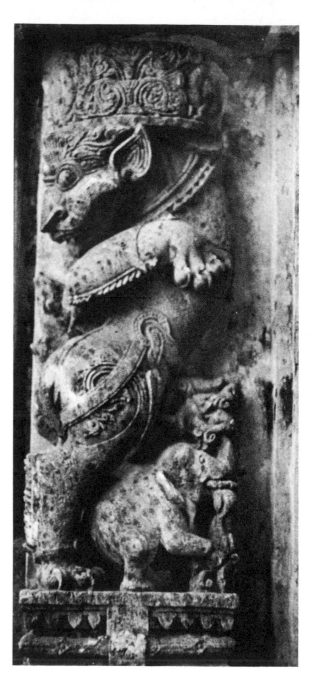

Fig. 159. Crowned lion attacking elephant. Jagannātha temple, Ranpur, Orissa. (right)

Fig. 158. Lion attacking elephant. Panel, Mahādeo temple, Bhojpur, M.P. (below)

the material universe. Myth, too, recalls this leonine alter ego of the female power in proclaiming Simhikā, "The Lion-like," as a "daughter of Daksha."[24] The fact that all the daughters of Daksha have proved to be embodiments of Shakti seems to infer Simhikā's analogous identity in lion aspect.

The iconography especially of central India lends particular emphasis to this equation of lion and female power by constellating the former as the allegorical substitute of the latter in her struggle against the encroachments of the hostile, male-oriented religious establishment. Again and again the lion appears contraposed to the elephant, attacking that vehicle of the Brahmanical deity, and ostensibly in the process of prevailing over it. So strikingly does this repetitive configuration correspond to that of so many vyali figures, such indeed are the analogies of juxtaposition, expression, and implication, that a common conceptual origin must be postulated. Thus, considering the vyali's predominant leonine characteristics, perhaps this creature might be perceived as, not a composite monster, but a basic lion-likeness to which bizarre features of savagery have been incongruously added to multiply the terrors of the demonic mask in which the old-religion god-head continues her presence.

This primal identity of the leonine, the vyali, and the divine countenances seems to achieve its ultimate graphic exposition in the imageries of the human-faced lion-vyali. Comparatively rare but incomparably significative, these effigies may fuse the divinity's fully anthropomorphic visage with the body's leonine attributes and the vyali's prototypal posture, as this strange shape towers over a sword-armed male foe to crush him into oblivion; or it may convey the same idea by applying distinctly human accents to the elephant-destroying divinity's lion head whose crown might well emblematize her transcendent presence.

It is this transcendent presence that the image at Arang incorporates in the solitary grandeur of the zoic countenance. Glowing in brilliant red as though lit with the dynamism of her essence, this lion is Shakti manifesting herself in her favored zoic guise.

Yet, for all its ancient preeminence, this zoic mask must yield its claim of primacy to another, even more ageless and universal; one which, indeed, has so pervasively affected human worship that it demands special consideration: the serpent mask of the Divine.

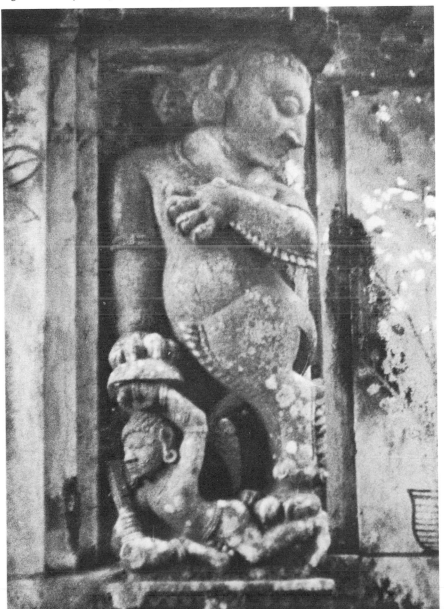

Fig. 160. Man-faced vyali, crushing foe. Charchikā Chāmundā temple, Banki, Orissa.

TWELVE

THE SERPENT MASK OF THE DIVINE

Universal in its scope and import, the serpent countenance of the Divine appears to have attained its widest recognition and most intense reverence in India. Unquestionably, it is here that it has left its most prodigious evidence. Yet, for all the eloquence of its local aspects and emphases, its impact on the Indian scene cannot be fully assessed except against the background of ophiolatry as an intercultural religious phenomenon.

References to the practices of serpent worship the world over have been commonplace in anthropological studies. However fragmentary in their specific treatment, their very persistence must of itself suggest the preeminence of this aspect of religious culture. Any comprehensive exploration of serpent lore and serpent cult, their meanings and ramifications, compels recognition of ophiolatry as an irreducible constant of religion. However, though essential to the understanding and critique of religious thought and expression, such an exploration in depth remains for the future. Within the scope of this book examination must confine itself to a survey only of the fundamental characteristics of serpent worship and of its salient, peculiarly Indian manifestations.

If the beginnings of serpent adoration seem lost in the mists of ages beyond human memory, its vestiges affirm its timeless evolution. Wherever and whenever man's organized encounter with the supernatural crosses the threshold of historical perception, the serpent's special relationship to transcendental power seems inalienably established. The ophidian shape appears as attribute or emblem, as vehicle or zoic mask, immediately configured with the divine image or substituting for it in mystical solitude. Even where such direct association is minimized, a countless array of myths and legends, occult traditions and magic formulas connect it with the biographies and functions, mysteries and rituals of the gods.

Everywhere the serpent emerges as the subject of veneration and celebration as a physical equivalent of a metaphysical essence. The reasons for this sanctification must depend on deductive speculation until the obscurities of primal man's experiential and conceptual realizations are more effectively penetrated. But, perhaps, one may indulge a surmise that to early humanity, living in closer contact with nature and therefore more immediately attuned to its impulses, the snake might have exhibited capacities of a subtlety no longer apprehended by later generations. Certain peculiarities of its condition, in time scientifically explained, may then have seemed magical and supernatural. For, however abundant and conspicuous, its mere presence within a given environment could of itself hardly account for such a singular exaltation among all the prevalent animal forms. On the other hand, the environmental factor is necessarily instrumental to man's preoccupation with the serpent and to his selection of a specific genus of snake as his cultic object. Even a cursory review establishes the tropical and subtropical zones, which provide the habitat for the larger and more spectacular ophidians, as the original heartland and continuing center of ophiolatry. It is in the sultry jungles and blistering deserts of the equatorial belt that this worship was born, attained its greatest fervor, and preserved its prominence most persistently. Though eventually widely practiced elsewhere, unmistakably it is from those areas that it spread to more temperate climes, sometimes introduced by immigrant tribes, more often adopted from

neighboring peoples. Such imitation was prompted as much by the cult's intrinsic appeal as by its paramountcy as a religious expression. Its mystique seemed to impart itself spontaneously and irresistibly to men everywhere, apparently evoking associations of cosmic communion and eternal regeneration. Wherever the serpent went, it seems to have carried with it a sense of impalpable magic and metaphysical eroticism, of profound awe and transcendental sublimity. Of all the theriomorphic masks of the Divine it has captured man's imagination most completely and enduringly.

This singular exaltation could not be ascribed solely to the suggestions of the snake's actual or apparent attributes, however persuasive they may have proved to the sensibilities of early man. The decisive impulse was provided by its essential identification with the female divinity. If this unqualified assertion is at variance with much learned opinion and traditional presumption, given the uncontestable evidence in its support, it should cause less surprise than the wide disregard of the primal equation of serpent and feminine essence or its incongruous interpretations by those who have given cognizance to it. This failure to exploit such an obvious and productive point of departure for any religiocultural exploration must suggest calculated misdirection, once again motivated by the constellation of the new religion in its struggle against the old, and incidental to the attempted exorcism of the female divinity and her worship.

Countless particulars of myth and iconography testify to the universality of the serpent's identification with the primordial female divinity. In Mexico the goddess Coatlicue, "She Whose Skirt Is Woven of Snakes," revered as the Mother of the Gods, apparently long preceded the great Plumed Serpent, Quetzalcoatl. In China, P'an-ku, "Coiled-up Antiquity," embodying the undifferentiated all-inclusive state of a pristine cosmos, is perceived as a female of apparently ophidian contour. In Babylonia the primitive Tiamat, later identified with the dragon monsters,[1] Rahab and Leviathan, reveals her original nature by her role as the mother of the world-serpents, Lakhmu and Lakhamu. In Teutonic lore, Jormungand, the serpent of Midgard, similarly identified as female, encircles the world ash

that supports cosmic life and cosmic order. In Greece the divine priestess, presiding over the Delphic sanctuary untold ages before its usurpation by the Olympian gods, listened to the name of Pythia, the Serpentlike or Serpent-possessed. The monstrous Echidna and the terrible Gorgons, evidently demonized goddesses of pre-Achaean antiquity, preserve their serpentine character, the former being described as a giant snake crowned by a beautiful woman's head, the latter as serpent-haired and serpent-engirdled harridans. Like Echidna, the ancient Scythian goddess Tabiti too is envisaged in an aspect half woman, half snake, while the mistress of the Etruscan underworld, Tuchulcha, is represented with two serpents twined around her head and a third around her arm. Her Teutonic counterpart, the formidable Hel, is accompanied by her theriomorphic double, the "evil serpent" Nidhoegg, and the ceiling of her subterranean abode is crawling with poisonous snakes, ostensibly the zoic embodiments of her manifold magic powers.

The serpent's identification with the Divine Feminine is, however, demonstrated not only explicitly by such direct descriptions and symbolizations, but also implicity by the characteristic mythic constellation. Dramatizing the historic conflict, everywhere the ophidian creature, whether appearing in authentic or demonized dragon aspect, is contraposed to the male godhead of the new religion, or to the superhuman protagonist of its uncompromising ethos. A few random items of lore suffice to exemplify the endless recurrences of this generic confrontation. By their very sovereignty over the realms of death and suffering, such serpent-defined goddesses as Hel and Tuchulcha are antithesized to the deathless and lusty celestials of the new orthodoxies. More drastically still, in Egypt the primeval mistress of the moon, Isis, "fashioned a poisonous snake . . . [which] wounded the sun-god with its bite."[2] In the Greek accounts the aboriginal goddess, who is eventually canonized as the Olympian queen Hera, sends two serpents to attack and destroy Herakles to forestall his future exploits in the service of the new order. Unfailingly victorious as the champion of the establishment must always prove, the infant hero instead strangles the ophidian manifestations of the female power, paralleling the feat of Brah-

manical legend's canonized boy-hero Krishna as he conquers the serpent king Kālīya, whom the attending "swarms of red serpent warriors"[3] and the "serpent queeens and serpent maidens"[4] identify as a male disguise of the ancient serpent goddess herself. In Assyro-Babylonian myth the snake steals the magic herb of immortality from Gilgamesh, the representative of the sky god Anu, frustrating his quest on behalf of a mankind whose disloyalty to its primal mistress the hero himself illustrates by his rejection of Ishtar's passionate advances and Siduri-Sabitu's amorous promises.[5] Greek legend symbolizes this eternal conflict by the struggle on the plain of Ilion between the serpent of the Asian goddess, protectress of Troy, and the eagle, the zoic mask of the Olympian Zeus. India preserves the analogous tradition, in word and image, of the implacable persecution of the snake by Vishnu's zoic double, the solar bird Garuda, as inescapably triumphant over the equivalent of the female deity as his counterpart at Troy. This constellation may well be a variant of a preexistent myth treating of the great encounter of the god-king Indra with the serpentine monster Ahi-Vritra, whom he must slay to preserve his own might and sovereign sway. In the romanticized, fairy tale accents of a later era, Celtic lore recalls the battles of heroes such as Owain against the dragon; while in the Near East the identical antagonism is solemnly formalized by the archetypal confrontation of Jehovah and the Edenic serpent.

Myth and legend are not alone in affirming the primal association of serpent and female deity. Iconography, too, has provided palpable corroboration of its essential and universal character. Throughout the ages the ophidian shape remains conjoined to the image of the Goddess. Wherever it appears as an attribute of the male deity, its presence is derivative, invariably traceable to a preexistent female divinity from whom it had been usurped, so that its symbolic import, magical efficacy, and cultic prestige might serve to legitimate the new celestial master. The great Sabazius of the eastern Mediterranean appropriates the serpent emblem from the Cretan and Cyprian and Thracian goddess whom he succeeds with the advent of the new male-centered order; the Greek Asklepios, his from the native

Fig. 161. Krishna conquering Kālīyā. Panel, Bhagavatī temple, Banpur, Orissa.

goddess of Eleusis who eventually is known as Demeter, the Mother of the Gods. Fu Hsi, China's legendary Heavenly Emperor, inherits his serpent body from the primordial P'an-ku, just as his successor Shen Nung, the Earthly Emperor, exploits the tradition of his miraculous conception through the intercession of a dragon, P'an-ku's demonic variant, to authenticate his supernatural authority. The serpentine ornaments worn for the identical purpose by the Norse god Frey,[6] are directly descended from the snake attributes of the far older Celtic goddess. The Brazen Serpent, Nehushtan, which is carried before the Hebrews of the exodus, ostensibly as a symbol of their Lord Jehovah, is the serpentine emblem of the Egyptian goddess heralding her supernal magic, now transferred to the new tribal deity to credit his still uncertain protective powers.[7] Again, it is the snake of the Near East's primeval female deity, so consistently in attendance on her most ancient icons, that figures so prominently in the cults of the Iranian Zarvana Akarana, of Mithra, the Orphics, and the Ophite Gnostics; precisely as the serpent of India's indigenous Goddess is assumed by Shiva as 44 45 46 an attribute of his own supernality.

Everywhere it was originally the Divine Feminine that was beheld in ophidian aspect; hers was the primal claim and only authentic title to the serpent emblem. The memory of this intrinsic identification has been well preserved by the imageries of the ages. The configuration on a Babylonian gem[8] revealing the Goddess flanked by a pair of her zoic equivalents is still duplicated two millennia later by the effigies of Isis on an Egyptian coin,[9] and of Hekate on a Roman gem.[10] The coiling ophidian form, schematically abstracted, marks the genital region of the neolithic goddess of Thrace[11] quite as its fully zoic shape does in the late Roman copy of the Eleusinian goddess' likeness.[12] An eighth-century B.C. Egyptian bronze presents Isis-Hathor enthroned, with nine snake heads encircling her crown.[13] This token of her vital, transformative powers appears in the simplified version of the uraeus, the sacred asp, which persists as the indispensable feature of the Egyptian goddesses' headgear.[14] This symbolism, anticipated by the earlier magic stela juxtaposing the huge snake at the

base and the central image of the naked goddess,[15] is paralleled by the countenance of the anonymous Celtic goddess on the hydra from Bern,[16] shown with snakes emanating laterally from her head. In Greece some images of Nemesis still recall her pre-Grecian past as the "Universal Goddess," Panthea, by presenting her with a snake rising from her hand. But, then, Panthea appears to have been merely an inclusive designation of the great female divinity who in her eventual identity as Demeter is depicted with a serpent coiling from her lap toward an initiate of her mysteries[17] to suggest the transference of her mystic power to the new adept.

These examples represent but a fractional selection from the countless heritage of serpent adoration throughout the ancient world; a heritage whose endowments have, if not consciously, at least subliminally persisted far beyond the eras of antiquity. Thus a thirteenth-century Italian portrayal of the Tree of Vice perpetuates the immemorial tradition in configuring the snake as the zoic equivalent and defining attendant of the female archetypes of "Luxuria" and the "Babylonian Harlot."[18] This design, one of many analogous contemporary symbolizations, assumes even broader significance when it is recalled that the serpent appears as the ever-present companion of the witch, that maligned and persecuted initiate of a heterodox and ageless persuasion, and indeed was considered a favorite shape into which she might transform herself.

In this awe-born and doctrinally fostered superstition of not so long ago, the pristine vision is revived in its authentic form: the magic faculties of the supernatural female are no longer merely symbolized by the ophidian attribute, but fully embodied in her ophidian incarnation. In the zoic transformation of the witch the serpentine countenance of the primeval goddess continues, now demonically perverted.

In India the presence of this primordial countenance has been encompassing. Here serpent worship has maintained itself as a tradition of pervasive force and has left evidence unequaled elsewhere in bulk or eloquence. Here, too, its fundamental association with the cult of the female divinity contours itself with especial clarity. Its inspiration perseveres as a primary motive of folk religion to impart to the iconography a singular and vital aspect. All indications suggest that Indian ophiolatry evolved early into a theriomorphically specialized but broadly based perception of the Divine, whose distinctive esoteric ramifications and independent cultic tradition encourage its consideration and exploration as a religious phenomenon in its own right.

Though the evidence of iconography is unequivocal in attesting the extent to which the sanctification of the snake has persisted as a living impulse of popular faith, the true magnitude of India's commitment to this vision of godhead cannot be gauged by the sheer prodigiousness of topical imagery alone. Even more revealing are the specific roles in which this zoic mask of the deity is cast and the ritual reverence which continues to be offered to it. Throughout the back country of central India a significant number of the open-air altars, so conspicuously the targets of the villagers' worship, include symbolic or embodied representations of the serpent divinity, frequently in positions of central predominance. Often such icons, though encountered within the precincts of sanctuaries, remain the objects of separate and peculiar homage evidenced by the flower buds still clinging to them as heralds of a devotion unrelated to the sanctuary's ostensible dedication. Such monuments are common everywhere in the vastness of the semitribal countryside, where serpent worship has left the most massive traces of its ancient paramountcy.

The indigenous genesis of this worship has long been recognized. Basham's flat assertion that "legendary serpents, such as Shesha and Vāsuki, gave the snake prestige, but the cult no doubt sprang from very primitive levels,"[19] has been variously substantiated by a consensus of authorities. Though the phrase "primitive levels," referring as always to the non-Aryan cultural complex, identifies the origin of India's ophiolatry with her native religion, the context in which it appears perpetuates a common misevaluation of actual cause and effect. For it is not the Brahmanical myths involving cosmic serpents like Shesha and Vāsuki that "gave the snake prestige"; rather it is the preexistent religious prestige of the snake that endowed

Fig. 162. Nāginī with infant in arm. (see also Plate II). Field altar, Bhilganj, M.P.

these late accretions to the canonical legendary with their eventual import. The supranatural serpent is conspicuously absent from the Aryan tradition. Its rare earlier appearances in literature, in such forms as the aforementioned Ahi-Vritra, present it in the terms of monstrous aspect and antigodly nature which clearly identify it as the exponent of the opposing, heterodox ethos of native India. This characterization is, of course, cogent. Indigenous to the tropics, serpent worship seems hardly plausible as a feature of the Aryan past; and, given the male-centered preconceptions of the Aryan present, its primary association with the female divinity would preclude its connection with the Brahmanical tradition. Certainly, the actual prevalence of serpentine imagery and cult throughout the back country strongholds of age-old beliefs and modes of devotion must of itself suggest ophiolatry's autochthonous Indian inception and evolution. Mutually reinforcing each other toward the identical conclusion, these considerations gain still further support from the evidence of language. Here reference to the two most impressive of the several elements should suffice. The term Kādraveya, "Descendant of Kadrū," is one of the more frequent Sanskrit designations for serpent. Of primarily poetic application, its usage is owed to a mythological tradition of notable ramifications. For Kadrū, known as the "Mother of the Serpents," is earth apotheosized, the goddess Earth, an elemental specialization of the goddess Nature. Her affiliation with Kashyapa, the primodial Tortoise Man, as one of his many "wives" implicitly attests the antiquity of her antecedents as a noncanonical personalization of the Feminine Essence. Her "descendant," the serpent, is thus immediately identified as an aspect of the female divinity. The indigenous provenance of its veneration in this role finds confirmation by another, equally pointed witness of language. The Indian vernaculars know many locally preferred or otherwise variant words for snake, but the most generally used is *nāga*, which in its masculine and feminine grammatical forms also commonly designates the serpent divinity. The preponderance of probability argues for this term's non-Sanskritic origin, for Sanskrit has its own vocable for snake, *sarpa*. Cognate with the Latin *serpens* and the Greek

Fig. 163. Nāga divinity. Stele, Pātāleshvara temple, Malhar, M.P.

Fig. 164. Nāga divinity. Stele, Boramdeo temple, Chhapri, M.P.

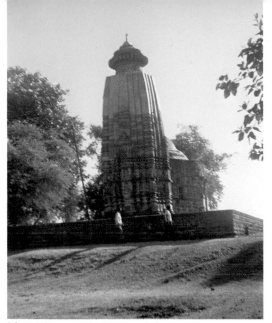

Plate XXXI. Mahādeo temple, Pāli, M.P.

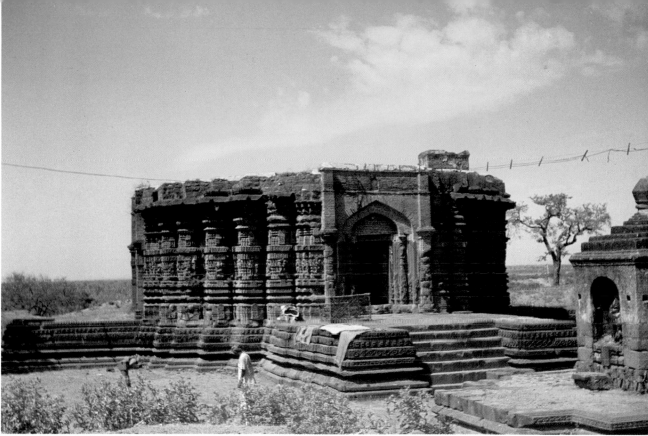

Plate XXXIII. Daitya Sudana, Lonar, Maharashtra

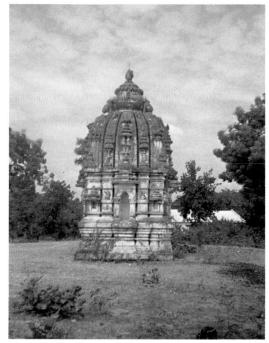

Plate XXXII. Lakshmī temple, Sonepur, Orissa.

Plate XXXIV. Maithuna.
Vishnu temple, Janjgir, M.P.

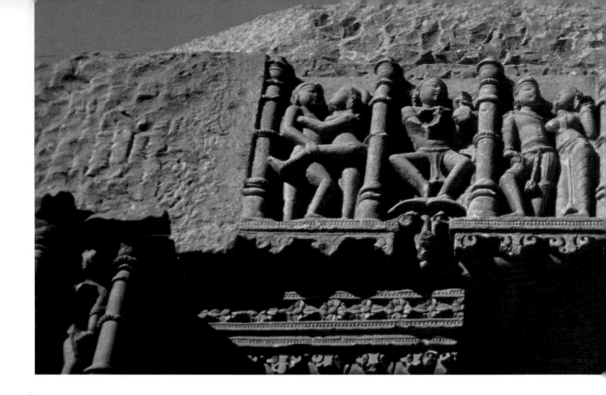

Plate XXXV. Shiva temple. Nemawar, M.P.

Plate XXXVI. Mahādeo temple. Nohta, M.P.

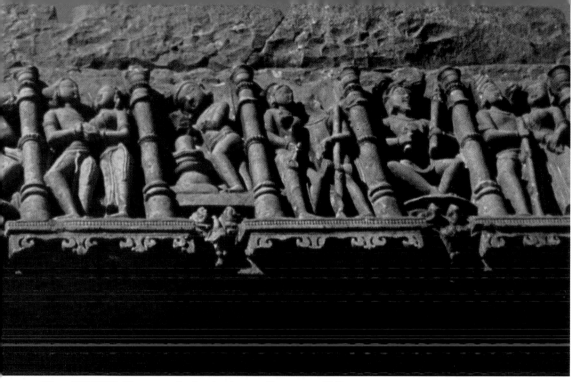

Plate XXXVIII. Transversal of ruined gate. Gyaraspur, M.P.

Plate XXXIX. Boramdeo temple, Chhapri, M.P.

Plate XXXVII. Mangalādevī temple. Gahakpur, M.P.

Plate XL. Ruins of Jain temples. Nagda, Rajasthan.

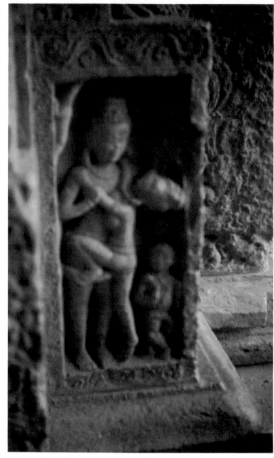

Plate XLII. Maithuna. Lakshmana temple, Sirpur, M.P.

Plate XLI. Jagatsvāmin temple, Jagatpur, Orissa.

herpes, and thus of proven Indo-European root, it defines its animal subject as simply the "crawling, creeping one." In contrast, the form *nāga* shows no Indo-European affinities and thus suggests itself as a borrowing from the native idiom of the people among whom the snake achieved such singular distinction and exaltation. Possibly at first it may have specified a particular variety, the one physically most conspicuous and cultically preeminent throughout India, the cobra. Its extension to more general usage might well belong to a later era. Its adoption into the Aryan vocabulary and subsequent integration into the everyday language may have been favored by the particulars of India's religiohistorical evolution.

In the central regions of the subcontinent a prevalence of place names such as Nāgpur, Nāgbhir, Nāgore, and Nāgjhari, to mention but a few, tends to indicate such localities as the settlements of a people identified as Nāgas.[20] The early presence of large aboriginal populations throughout these central and north-central domains has been affirmed by many authorities, and divers legends recall their gradual assimilation, extinction, or expulsion from the more accessible areas by advancing invaders. But these legends also infer that long before this these people had created their own peculiar culture, one that may well explain their identification as Nāgas. For, while they may have referred to themselves by different idiomatic appellations, they may have been so designated by their conquerors because of their characteristic worship of the *nāga,* the divine serpent. Alternatively, they may indeed have called themselves Nāgas, and the snake may have derived its generic title in consequence of its cultic prominence among them.[21] In either event the significant synonymity of *nāga,* the serpent, and Nāga, the people, tends to characterize the latter as serpent worshipers, whose pre-Aryan presence[22] once more points to the indigenous inspiration and inception of Indian ophiolatry.

Penetrating and encompassing its Great and Little Traditions alike, this inspiration has imparted a unique accent to the countenance of Indian religion and has irreversibly modified its contours. It has permeated the entire spectrum of folkloric beliefs and interwoven the very fabric of the Brahmanical creed. The serpent mask of the Divine has become mystic everpresence.

The vitality of this mystique could find no demonstration more convincing than its impact on the supernatural realm of the canonical faith, an impact that has permanently modulated the iconography of the Great-Tradition deities. Quite possibly because their palpable association with the peculiarly ophidian powers proved to be required to attest, perhaps even legitimate, their special exaltation, the serpent emblem has emerged as one of the principal attributes of the cardinal figures presiding over the Hindu as well as the Buddhist and Jaina otherworlds. Yet, though the snake-connected likeness of the divinity has become so dominant and even conventional a characteristic of orthodox imagery, the familiarity of its occurrence must not obscure its origin, or its continued role as but a sanctioned disguise of the ancient serpentine godhead.

Shiva's prominent assumption of the emblematically betokened identities as Nāgarāja, Nāganatha, or Nāgeshvara, Lord of the Serpents, is, as noted before, incidental to his nature as the masculine self-manifestation of the primordial Goddess, and his consequent endowment with her characteristic powers. In contrast, Vishnu's identification with the serpent essence seems to have been impelled by the need for assimilating the immemorially entrenched nāga worship to his own cult, so that it might make his godly stature popularly credible, or perhaps even initially acceptable. As has been seen, analogous processes have produced his boar and lion incarnations. Here, however, the integration of the indigenous tradition carried with it a further dimension of import: impartibly, the god's cosmic transcendence came to be bound to his serpentine aspect and defined by it. His role and function as Creator, the very core of his being, are dependent on, indeed enabled by, the ophidian energies now attributed to him. This circumstance seems ultimately symbolized by his familiar portrayals as Anantasayin,[23] presenting him in various poses of recumbency as, captive to his transfiguring dream, he slumbers on the giant coils of the cosmic snake Ananta-Shesha, "Endless Residue," embodiment of the elementary forces from 165 166

which life eternally springs.[24] The preeminent exploit of his divine career, the recovery of the elixir of eternal life from the bottom of the ocean, finds him indebted to the same powers. Only by harnessing these in the embodied form of the giant snake Vāsuki is he able to possess himself of an effective tool for his task. Not the sovereign will of the solar lord proves decisive, but the mystic capacity assumed to himself from a divine source of an elementally different order. The iconic rendition of this episode conveys this in most graphic terms: twined around the sacred mountain, Mandara, which, born on the back of the tortoise-shaped Vishnu, functions as the axial churning stick, Vāsuki is the living cord that imparts the motion to the cosmic churner. In their prodigious unfoldment those coils seem to duplicate Ananta-Shesha's, as though to suggest that Vāsuki was but a variant version of the latter, another incarnation of the mysterious energy that provides the agent for all cosmic activities.

88

Even as both high gods of Hinduism perpetuate the heritage of the serpent religion, they again demonstrate the fundamental contrast of their natures and geneses. Whereas Shiva's antecedents as a divinity of indigenous formulation has allowed him to manifest his ophidian aspect as an intrinsic property requiring neither doctrinal explanation nor speculative elaboration, Vishnu's inception as a Vedic solar lord has necessitated an intricate superstructure of exegetic legend to cope with the accretion of the heterodox tradition to his image. These esoteric ruminations, designed to obscure the true roots of his serpentine aspect and at the same time provide an ostensible justification for its canonical sanction, have contributed greatly to both the fascination and the equivoque of Vishnu's divinity.

This need for contrived "scriptural" substantiation did not apply to Vishnu alone; it extended, quite as cogently, to the snake associations of other Great-Tradition deities, producing a multitude of mythopoeic fabrications that, for all the diversities of specific constellation and detail, served the identical purpose. Thus the story of the divine boy-child's battle with the mighty Kālīya[25] supplies ostensible textual authentication to the depictions of Krishna's snake-connected appearances. Again, the tale relating

161

170

the role of the serpent king Muchalinda as the Buddha's supernatural protector[26] undertakes to "explain" the icons presenting the Enlightened One enfolded by seven cobra heads;[27] just as the similarly apocryphal legend describing Parshvanātha's encounter with the snake immediately prior to his own "liberation" attempts to furnish the "reason" for that Jaina savior's own, characteristically analogous, sevenfold serpent crown.[28]

No such mythopoeic constructs were called on to rationalize the serpentine countenances of the female deity. Her snake-symbolized, mystic faculties seem to have been taken for granted as intrinsic, perhaps from a

Fig. 165. Vishnu Anantasayīn. Mandaleshvara temple, Mandleshwar, M.P.

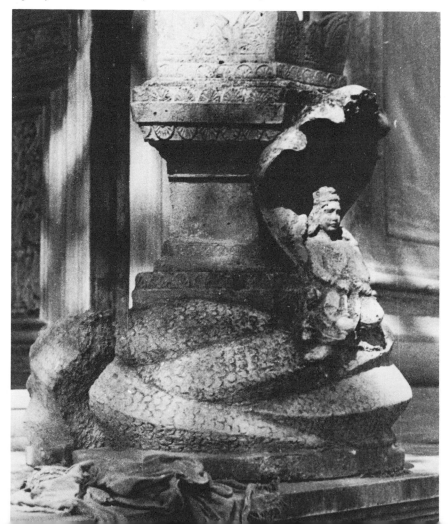

subliminally lingering realization that her Great-Tradition manifestations represented but specialized masks of her Little-Tradition countenance. Thus, regardless of the specific canonical identity she might assume, or by what official appellations she might be known, her serpent attribute would require no further authentication. Token of the magic, transformative, life-renewing powers that are essential to her nature, its emblematic display seemed as relevant to the likeness of Kālī as to that of her local counterpart at Wakri; as apposite to her aspect as Homīya Mātā or Mahāmāyā-Siddhīshvarī as to that as Manasā, the most widely worshiped of her several serpentine characterizations which have maintained themselves at the fringes of the orthodox pantheon, never officially accepted yet tacitly recognized as effective subjects of popular cult.

Quite as commonly as in conjunction with the effigy of the female deity, the snake is encountered unassociated, as her zoic equivalent. As already noted, such icons are found prominently configured on open-air altars, and sometimes even as their solitary occupants, not rarely within the precincts of Brahmanical sanctuaries. Though perhaps originally designed as ophidian representations of some local female deity, in most cases they

Fig. 166. *Vishnu Anantasayīn, and nāga divinities intertwined. Lintel frieze, Rājivalochana temple, Rājim, M.P.*

Fig. 167. *Kālī. Jagadambi temple, Chitorgarh, Rajasthan.*

have come to persevere as harbingers of an anonymous, transcendent essence, mementos of an ageless vision. Still, in the back country the vitality of folk religion has occasionally preserved, or possibly revived, the recollection of their divine associations. Thus, according to the officiating elder, the stela in the main arcade of the temple at Annigeri not merely represents, but indeed is Manasā, or, as she is more familiarly known in that area, Bhogavatī.

The true significance of such monuments, whether their divine identity is known or not, is their paramountcy as objects of devotion, particularly but by no means exclusively in the countryside. Thus, though the sanctuary at Annigeri is dedicated to Shiva-Amriteshvara, the Lord of the Immortals, the image of Bhogavatī, by the pentad of cobra hoods defined as the serpentine countenance of Māyā, seems to be dominant, not only preoccupying the elder's interest but evidently providing the focus of popular reverence. Certainly the same central role is played by the analogous icon in Boramdeo's temple at Chhapri. Though here anonymous, it too might well represent Manasā, who remains so insistently worshiped throughout central India.

But, then, the precise name of its divine model seems of small account: local or regional, such identifications are incidental. Each serpent image is another tribute to the primordial Māyā, another monument to her magic and enchantment. Impressively, at Boidyanath, her serpentine shape winds its giant coils upward on the façade of Kushaleshvarī's temple as though to announce the true source of its inspiration and its mystique.

Wherever met, in whatever aspect or constellation, the serpent is Māyā's zoic manifestation, the primary embodiment of her regenerative and creative energies. This fact has been amply recognized; as, for instance, by Jung, who asserts that "the significance of the snake as an instrument of regeneration is unmistakable;" or by Campbell, who calls the Serpent Power "the mysterious Creative Energy of God."[29] Unfortunately, in referring to "God," the latter statement uses the conventional Western terminology which, equating the idea of the Divine with the image of the Judeo-Christian creator deity, is irrelevant to India's metaphysical perception of those "mysterious creative energies" as inalienably the attribute of the transcendent Feminine in her specific function as Māyā.[30]

This perception finds manifold illustrations, but none more persuasive than the illumination in a Brahmanical text showing the serpent coiling about the "web of Māyā,"[31] the ideogram of material creation and this-worldly existence. Here, the thread of which this "web of Māyā" is spun is shown actually issuing from the snake's mouth: it is the Goddess' serpentine energies that, pouring forth, produce the microcosm of human reality.

In this sense, too, the serpent's presence in so many icons of the countryside's female divinity must be considered; namely, as an indicant of her māyā nature, her māyā function, her essential māyā identity. As has been seen, this conclusion applies just as fully to her Hindu countenance; and it equally pertains to her Buddhist and Jaina aspects. One need only recall, for instance, the Mahāyāna Buddhist image with its stylized ophidian dyad rising up on the throne of the Green Tārā[32] to identify her as a specialization of Māyā who, joined to the transcendent Avalokiteshvara as his female counterpart and consort, by her mundane nature counterbalances the Bodhisattva's pretermundane spirituality to render his divinity once more accessible to human sensibilities. Or, again, the Jaina design illustrating the celebrated legendary episode[33] in which the Golden Goddess, analogously defined by the winged serpent that draws her chariot, comes to "do homage to Pārshvanātha," emulating the Green Tārā's role of reconciling the Tīrthankara's other-worldly rejection of life with his this-worldly obligation to the human materiality that is her own creation.

Whether appearing as Tārā or Golden Goddess, as Kālī or Homīya Mātā, as Manasā or Bhogeshvarī; whether locally identified or, more often, anonymous, the Great Tradition's goddess with the serpent emerges as the Little Tradition's primordial Māyā in canonical disguise. She may, as so frequently she is, be apposed now to a male deity, and regarded as subordinate to his sublimity; yet, from the unanimous testimony of iconography and myth

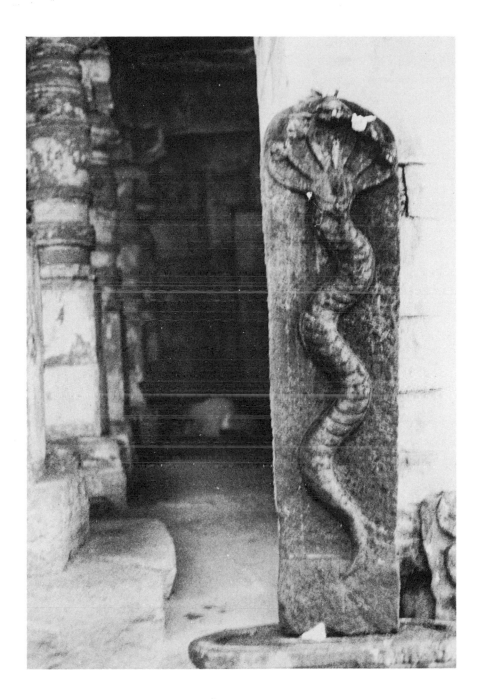

alike, it is she who imparts to so many of his altars their occult capacities and endows him with the mysterious creative powers that define his very divinity. The contours of her countenance may have been redrawn and her character redefined to conform with the preconceptions and purposes of the new creeds. But these efforts have been unavailing. They have obliterated neither her essential aspect nor her authoritative properties. The canonical masks of the serpent goddess fail to dissimulate her authentic antecedents. Behind their ostensible contours looms an inescapable shadow, the memory of the ophiolatrous cults of native India and, ultimately, the zoic countenance of Māyā.

As though to substantiate the aboriginal, noncanonical past of the ophidian godhead, the incidence of even those specimens of serpentine imagery and symbology that have been reconditioned by orthodox conceptions proves most preponderant in the back-country strongholds of folk tradition. Yet the vast proliferation of likenesses celebrating the snake divinities of folk religion throughout the Great-Tradition sanctuaries of central India must implicitly assume even more persuasive significance. Particularly in Orissa and eastern Madhya Pradesh, such imageries constitute an integral, often prominent feature of the sacred precincts, regardless of the latter's incidental dedication. Often products of impressive artistic refinement, collectively they may well rank with the most accomplished and beautiful creations of India's plastic art. Though long patternized in their contours and poses, these half-human, half-serpentine countenances of the Divine yet retain their fascination and mystery, vitality and suggestive impact; sometimes blending into the temple's depictive configurations, sometimes again dominating them, they impart to the stone a strange vibrancy. Side by side with the countryside's fully zoic representations of the serpent deity, another iconic tradition, perhaps previously preponderant, appears to have furnished the models for the elaborate and polished figures of the *nāga* and *nāginī* so prominently displayed in the precincts of the canonical creed.

The antiquity and native inspiration of this tradition has long been generally appreciated. By their very character, the imageries of those male and

xxviii

Fig. 168. Serpent divinity. Stele, Mahādeo Temple, Annigeri, Mysore.

Fig. 169. Giant serpent coiling on façade of the Kushaleshvarī temple, Boidyanath, Orissa.

female snake divinities have compelled the realization that they must have descended from immemorial prototypes. Certainly, their appearances on the oldest preserved monuments and as independent sculpted idols of even more ancient genesis would of themselves argue for such a conclusion; the fully evolved, depictive pattern, the artistically accomplished execution of these earliest extant portrayals, must render it finally indisputable. Only a most extensive period of germination, only a tradition powerfully anchored in time and space, such as could hardly be imputed to the Aryans, could have produced these effigies.

The preoccupation of Buddhist and Jaina art with this tradition implies further substantiation. Indebted to the indigenous heritage, both these reformist creeds drew heavily on indigenous serpent lore for their own conceptions and expressions. Their iconic tributes to the divine nāga must therefore be read accordingly. Zimmer, for instance, in commenting on the second-century sandstone likeness of a Jaina Tīrthankara, explicitly emphasizes that "this particular pattern for the representation of Pārshvanātha was evolved from the well-known nāga-type already current and popular in the early Buddhist art of the era B.C. and familiar to us from the railing figures of the stupa of Bharhut, as well as from Mohenjo-Daro."[34]

The Mohenjo-Daro icons, dating to at least 1500 B.C. and most probably evolved from much earlier models, find a typical illustration in the faience seal showing a deity seated in yogic posture, flanked by adoring worshipers and the towering shapes of upward-coiling snakes[35] in an ostensible depiction of a cultic scene. The religiohistorical importance of this design could hardly be overrated, particularly as its basic constellation returns nearly two millennia later on the stupa of Amarāvatī. Here the snakes and the worshipers, separately depicted on the Mohenjo-Daro seal, have been combined into the humanoid, serpent-crowned likenesses of the "well-known nāga-type," as they flank the object of their devotion, the miniature replica of a stupa, symbolic herald of the divine presence.[36] Closer inspection of this configuration suggests that the divine presence revered by those nāgas is not the Buddha's. Rather, as manifested by the unmistakable serpent

174

shapes which in an emblematic sequence circle the miniature stupa, it is the immanence of the primeval snake divinity, now associated with the Buddha nature, which receives their homage.

From the Mohenjo-Daro seal, then, a direct and unbroken line of religious perception appears to lead to the Amarāvatī image. The changes have been formal only; the conceptual content has remained untouched. Though now conveniently identified with the current embodiment of metaphysical realization, just as it was identified with Pārshvanātha and subsequently with Vishnu and Krishna and other denizens of the Hindu pantheon, the serpent mask of the Divine has retained its inspirational and, under a new guise, even its cultic preeminence from the time of the Indus Valley culture and, one must surmise, from days well prior.

This continuity has left its imprint on the early monuments as it has on those of succeeding ages. At Sanchi the numerous and repetitive medallions featuring the fully zoic snake shapes[37] are no mere exercises in ornamentation but tokens of an ancient and never dead devotion which also produced such semigodly effigies as the Chakravāka Nāga at Bharhut,[38] the nāginī at Sanchi, like the former crowned by a pentad of serpent hoods, or the "Naga-king and queen" at Ajanta.[39]

While in these older Buddhist shrines the emblematic, fully zoomorphic depictions seem to be favored, they become less and less conspicuous in the Jaina and, especially, the Hindu sanctuaries of later centuries, in time to yield their prominence to the theomorphic aspects of the serpentine divinity. This shift of accent, especially marked in central India, seems incidental to the resurgence and mounting self-assertion of the old religion in the precincts of the orthodox creeds. It may have been dictated by the need for emphasizing the transcendental nature of the serpent in terms of a more explicit and immediately recognizable likeness. Progressively, the images of nāga and nāginī replace the more abstract and symbolic designs of the earlier monuments.

The authentic character of these figures appears to be implicitly suggested by the configuration of the Chakravāka Nāga at Bharhut. Sharing the stupa's railing with a succession of yakshas and yakshīs, he is clearly included in their group and belongs to it. Nāgas and nāginīs, then, must be regarded as yakshas and yakshīs worshiped in their specific serpentine aspects. Approaching this subject from diverse points of departure, a number of scholars have reached the same conclusion, one most explicitly formulated by Coomaraswamy[40] and borne out by the imageries of the central Indian sanctuary. Here the identities of the snake divinities as the zoic specializations of yaksha and yakshī become evident from their recurrent and prominent assumption of the latter's favorite function, that of the dvārapāla. The equation of these two classes of supernaturals is yet more poignantly conveyed by the frequently mixed yaksha-nāga groups, more often than not with the serpentine figure placed closest to the entrance, as though to indicate its superior protective magic. Thus, at Surwāya such a triad is headed by a nāginī of atypical aspect in that she holds a coiling serpent in her hand rather than being crowned by the usual cobra hoods. The depiction of the female likeness in this ostensibly dominant position is no more accidental than the analogous disposition of the yakshī, whether appearing in her own identity or in the guise of the surasundarī or apsaras. The implicit significance of this pattern emerges even more impressively in the nāginī's assignment as the sole keeper of the temple gate. Though her male counterpart's appearance in this role is by no means exceptional, it is preponderantly and characteristically she who is featured in this capacity.

Naga and nāginī, then, are specializations of native India's primeval godhead in a function as focuses of the ophidian cult. Given the nature of that godhead, the nāginī must be presumed to be primary to the nāga in origin as well as in import; though, as the embodiment of the feminine essence's dynamism, the male serpent deity too may have emerged very early as a center of popular dedication.

While neither the undefined sexual identity of the snake-associated deity of Mohenjo-Daro[41] nor any other products of early iconography now known offer any substantiation, the figure of Shiva Nāgarāja effectively credits this

XXIX

170

XXVIII

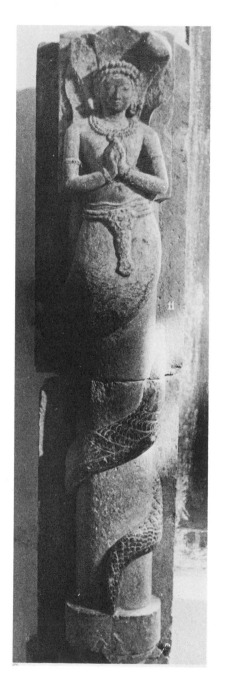

Fig. 170. Dvarapāla group. Pātāleshvara temple, Surwāya, M.P.

presumption. For, an identification of god and serpent as intrinsic and characteristic as that exhibited by Shiva's Nāgarāja manifestation must have been predicated on an extremely extended tradition. The serpentine Shiva may well trace back to his antecedent preeminence as Rudra and quite probably beyond, to the days of the male divinity's very origination. Indeed, the serpentine properties may have been fundamental to the primeval god's advent; the nāga countenance may have been an elementary aspect of the yaksha.

The primeval existence of Shiva Nāgarāja and his local nāga counterparts would, however, in no way contradict or even minimize the conceptual and historical primacy of the nāginī. Flowing from the archetypal constellation of female and male divinity, and thus inherent in it, this primacy has found its perennial reflection not only in the imageries of the back country whose shrines and altars preponderantly feature the nāginī effigy, but also in those of the Hindu and Jaina temples where, reversing the pattern of the Buddhist sanctuaries, her depictions are conspicuously favored. Even more tellingly than by its superior incidence, this representational predominance of the female serpent deity expresses itself in the more intense and meaningful, one might say loving, execution of each individual XXVIII 17 image. Many nāga figures, certainly, carry the imprint of consummate skill 172 and application. Yet they never quite approach the embodied mystique of the nāginī image, its suggestiveness, its persuasiveness. Even where alternations of nāga and nāginī likenesses appear, as at Malhar, this differential 173 persists; a differential, however subtle, yet characteristic not of workmanship but of inspirational depth, of emotional commitment, endowing the female contour with a dimension of magic enchantment.

At its most intense in the single effigy of the nāginī, this enchantment transfigures the Indian temple with an intangible accent of inward ecstasy and supernatural sensuousness. Placid with otherworldly beatitude, or again 171 vivid with the consciousness of feminine allure, the nāginī likeness con- 172 XXV jures an aura of extrasensory exaltation that seems to encompass the sacred precinct like the disembodied yet inextricable coils of an immense serpent.

Fig. 171. Nāginī. Stele, Khiching, Orissa.

Enthralled before its presence, strangely stirred, even the casual pilgrim seems to tarry.

Nowhere is this spell quite as compelling as in the sanctuaries of Bhubaneshwar and Konārak. Here the vision of the nāginī has achieved its surpassing materialization. Some of her portrayals at Ranakpur may seem more impressive in their polished perfection, some at Khajuraho more dazzling in their worldly elegance, but nowhere does her appearance command similar intrinsic beauty or comparable suggestiveness. Nowhere does it quite as clearly disclose its indigenous inspiration and origin or the underlying ethos which has found its mystic abstraction in the serpentine symbol. Though conveyed by the erotic intrinsicality of mien and pose of every nāginī everywhere, nowhere has the dynamism of the feminine essence been rendered so explicitly or so uncompromisingly.

Evidently archetypal in character, this association of the serpent with female eroticism and sexuality is an extension of a symbolic equation of far more inclusive scope. It represents the reduction of a macrocosmic concept to its microcosmic analogue, of a metaphysical abstraction to its physically tangible and thus humanly accessible cipher. By no means singular to India, it constitutes a common denominator of religious symbolism among ancient peoples everywhere, part of the heritage bequeathed to them by their gynocentric pasts. Paralleling the sinuous intimations of their Indian counterpart, the Syrian, Egyptian, Cretan, and Anatolian serpent goddesses affirm their analogous nature. The nāginīs of Konārak and Bhubaneshwar are distinguished only by their more demonstrative display of the external attributes shared by the snake-defined female divinity elsewhere, by the greater candor of their challenging suggestion and libidinous expectancy. But the metaphysical equation embodied by the ophidian symbol remains identical in all systems of belief. In India it appears to have endured longer as a cultic reality and, in consequence, its impact has affected religious evolution more profoundly and lastingly.

This equation seems fundamental to, and may well have been cognate with, the very perception of the female divinity. In its essence it identifies female dynamism with the principle of infinite and continual transformation, which, in the realm of māyā, assumes the aspect of eternal regeneration. It is this principle of which the serpent became the archetypal symbol, connoting the mystery of life itself and the magic of its formal mutations.[42]

Just as this elementary identification has carried in itself the ultimate reason for the snake's sacred exaltation and cultic prestige, so it has determined its role as the significator of sexual desire and expression. The nāginīs' eroticism, mirrored in more subdued but no less characteristic accents by the serpent goddess everywhere, is immanent and integral. A visual concretization of an ontological abstraction, it interprets the life process in terms of continual transformation, explicitly predicated on the fusion of opposites, controlled not by some preexisting law or external decree but by the polarities' self-motivation, their desire to be one; by the erotic impulse, as it were, that very force which, divinely personalized in the mysterious figures of the pre-Vedic Aryans' proto-Kāma and the pre-Olympian Greeks' proto-Eros, was deemed responsible for initiating the eternal chain of regeneration that, alone capable of sustaining universal life, had changed cosmic chaos into cosmic order.

Transformative power and erotic impulse thus evolve as the Siamese twins of female dynamism in operation. Symbolizing the one, the serpent could not but symbolize the other also, to emerge as the archetypal embodiment of that transcendent, life-affirming urge which, on the mundane plane of physical experience, manifests itself in the desire and quest for *maithuna*, the union of the sexual opposites. Within the phenomenal confines of Māyā's realm, then, the ophidian shape connotes the mysterious afflatus that impels male and female toward sexual expression and fulfilment, toward a communion which, however transitory, provides their unique chance for self-realization and self-perpetuation. Its presence, whether in fully zoic or semitheomorphic aspect, objectifies the total spectrum of erotic need and expression and consummation. In the sensual suggestion of the nāginī's countenance, the Indian sculptor has rendered the glorified externalization of his own and the race's libido. In it, women find the supernatural sanction

for their instinctual imperative, men the divine approbation of their carnal impulse, and mankind its truest, most profoundly human self-image.

Yet, however deductively cogent and iconographically self-evident, the primacy of the serpent divinity's erotic nature has been minimized, if not indeed ignored, in favor of her role as the special patroness of fertility and procreation, a role consistently dramatized and frequently presented as exclusive. Yet, while this function is undeniably prominent, it must be understood as a concomitant but secondary aspect, a collateral extension of a fundamental conception which regarded fertility and procreation as consequential to the erotic impulse, not as its precondition or motivation. The serpentine godhead has indeed been intimately identified with the perpetuation of physical existence. From earliest times her intervention has been directly invoked in matters of virility and sexual efficacy, conception and pregnancy. But these specific functions had been descended from her primary character as the personification of life's erotic and transformative imperative.

Even though the memory of the nāginī's authentic role has been increasingly obscured by the advancing emphasis, cultically and ideationally, on her procreative and fecundating powers, it has never been lost to popular tradition. It is still the erotic, not the progenitive, accent of her nature that is dramatized by her iconic appearances. Even the figurations of the *nāga-kals*, those votive slabs[43] set up by women to commemorate her effective intercession in delivering them from their barrenness, are often graphic in their reference to the sexual communion rather than its prayed-for result, to the gratification of eros rather than of parenthood. A majority of these monuments depict a pair of divine serpents united in a clearly coital embrace. This constellation may appear in schematic, fully zoic projection, or again may present the sexually differentiated, semitheomorphic likenesses of nāga and nāginī equally eloquent in the intertwining fusion of their bodies.[44] Sometimes quite beautifully sculpted, more often showing the cruder skills of local untutored hands, it finds its more elaborate but connotatively identical counterparts in the great temples of central India.

Fig. 172. Nāginī. Sūrya temple, Konārak, Orissa.

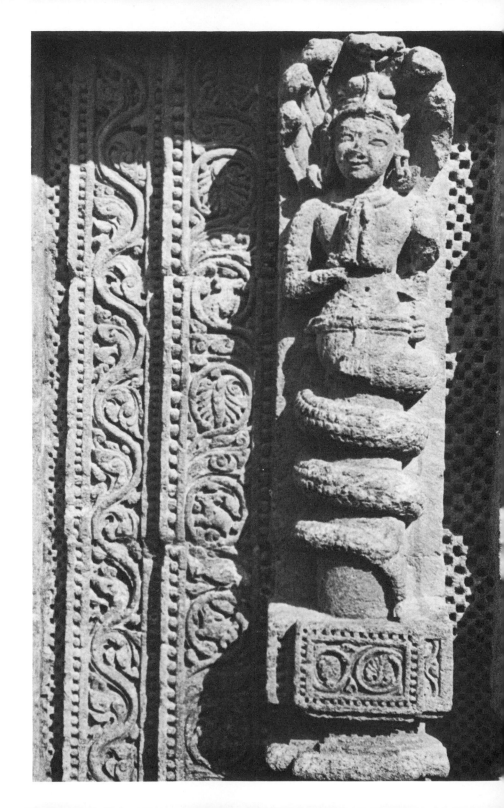

Especially in Orissa the maithuna of the serpent divinities becomes a frequent motive of iconography, reaching a peak of artistic achievement in its portrayals at Bhubaneshwar and Konārak.

To ascribe the excellence of these imageries to the sculptors' virtuosity alone would prove inadequate. Their perfection is not one of design and formal detail; it is one of a different dimension. The magic aliveness, the glow of otherworldliness, the transfiguring ecstasy can be accounted for only by the artist's unique dedication, by his abandon to the experience of divinity, his nonconceptual comprehension of its essence; in short, his mystic realization of the Eternal Presence hiding behind the serpent mask.[45]

In the light of its identification with that Eternal Presence, the serpent's preeminence as a perennial object of India's homage would seem no more than cogent; nor, perhaps, might its symbolizing prominence even in the systems of the Great Tradition seem too surprising. However, its canonical exaltation may not have been primarily due to the pressures of indigenous tradition and popular religion alone. It may have been incidental to, and inherent in, the acceptance of the doctrine of reincarnation into the metaphysics of the orthodox faiths.

Ultimately evolving from the complex speculations on the nature of Existence, this hypothesis eventuates as a logical exaltation of the idea of transformation. Its non-Vedic root and impulse have been recognized by, among others, Hutten[46] and Basham,[47] and circumstantially confirmed by its intrinsic association with the world of māyā,[48] the manifested realm of the Goddess. However qualified subsequently by orthodox formulations, it was originally defined by that "chief concern of aboriginal, pre-Aryan India,"[49] the belief in the cyclical infinity of life, a belief proceeding from the concept of transformation and thus implicitly symbolized by the serpent. It seems likely that doctrine and symbol entered into the Great Tradition simultaneously.

Perhaps this early and spontaneous integration of ophidian symbolism and divinity into the mainstream of the dominant religious perspective accounts for the marked paucity of their appearance in demonized aspect.

Certainly, the divine serpent might have been expected to arouse the irreconcilable antagonism of the socioreligious establishment. Its antithetic identification with the feminine essence and repugnant theriotheistic association, and particularly its erotic character, in its appeal to humanity so sharply contrasting to the extrahuman spirituality of the orthodox godhead, offered a ready target for debasement and demonization. By its very nature it seemed to be destined to produce an abundance of terrifying images, of monstrous shapes announcing imminent destruction and catastrophe, presenting the snake goddess as a nightmarish menace to man and an eternal foe of the true gods, and the serpent symbol as an emblem of black magic and detriment. Yet, in India the process that might have effected the conversion of the nāga deity from a divine benefactor into a vicious fiend never quite materialized.

On the other hand, the memories of the ideological collision could never be entirely expunged. A clash of such scope and impact was bound to leave its references in the mythological and iconographic heritage. Predominantly, these references emphasize the fundamental polarity in two prototypal aspects, one confronting the subordinate nature of the serpent deity with the transcendent one of the canonical deity; the other constellating not the demonic but the antagonistic character of the ophidian power. The numerous and familiar designs portraying the nāga in piously worshiping pose as he offers his homage to Vishnu or Buddha or Krishna[50] present eloquent renditions of the former alternative; the latter is typified by the frequent depictions, previously referred to, of Garuda destroying the snake. Here, in terms of a struggle between the principles of good and evil, is the dramatization of the historical contest between the antithetic socioreligious conceptions and systems, impersonated by their traditional protagonists, the eagle and snake, those zoic embodiments of solar male and lunar female divinity. The same conflict is constellated by the modified configurations in which an anthropomorphic supernatural hero replaces Garuda in the role of the snake's slayer.

The divinity of the serpent-embodied power against which Garuda and

174

85

175

his counterparts are pitted finds implicit recognition in the canonical legends which, recalling the conflict of the rival ideologies, express it in their own archetypes. The most familiar of these legends, that of Indra's battle with Ahi-Vritra, proves also the most graphic of all. Here the antagonist's assumption of the ophidian mask never diminishes the obviousness of his original exaltation. On the contrary, his divine nature has been accentuated. The snake monster is identified as a brahman and, in destroying him, Indra himself "had become guilty of the most heinous of all possible crimes, the slaying of a brahmin." Even more pointedly, by their acquiescence in its perpetration, this deed is deemed all "the gods' original sin," which they could never expiate. Such ultimate condemnation implies the ultimate sacredness of the transgression's victim. This supernal status is further clarified by the specific choice of Ahi-Vritra's avenger, that "implacable ogress" who pursues the god-hero.[51] Evidently a double of Ahi-Vritra himself, a metamorphosis of his immortal essence, this ogress is a manifestation of the Feminine Power in wrathful demonomorphic aspect, replacing her now slain theriomorphic embodiment. Indra's foe, then, is the primal Goddess in serpent shape. It is her destruction that constitutes the sacrilege which defines "the gods' original sin." Thus the story not only chronicles the historical confrontation but also, if circuitously, its eventual denouement. For the god-king's triumph is empty. Though ostensibly he wins his battle on behalf of the Brahmanical establishment, it is the divine mistress of the indigenous vision who perseveres as the quintessence of the sacred.

The legend of Rāhu, a monster believed to personify the eclipse of the moon, proves hardly less transparent. The serpentine character of this fiend is established by his epithet, *Phanin*. Literally denoting "serpent," and quite possibly of native derivation, this designation may still preserve the recollection of an ophidian manifestation of the Divine cognate with the vision of the primeval moon goddess.[52] Anciently, the noncanonical, and surely nondemonic tradition of Rāhu must have been of profound significance; and, while casting him as the vicious challenger and impious oppo-

nent of both Vishnu and Shiva, the Purānic reformulation of his legend broadly alludes to his authentic prominence: it is Shiva himself who, after defeating Phanin-Rāhu, restores him to a new sacred exaltation, and to the full possession of his primal power and magic. Nor does the antagonist's original identity remain altogether inscrutable: Shiva's solemn declaration, "Whoever neglects to worship you shall never win my grace,"[53] would seem implausible unless it referred to Rāhu's role as the serpent mask of the Divine Feminine for whom, as her masculine alter ego, the great god demands due reverence.

If such authoritative efforts have proved ineffectual in dissimulating the sacred nature of the snake, secondary attempts in this direction, often but regional in scope, could hardly promise any greater success. Especially in the precincts of the native tradition, the salutary image of the divine serpent has never been discredited. Certainly its iconography manifests neither the aspects nor the attributes of the terrible godhead. If occasionally the authoritative canonical identification of its local embodiments as "demons" has impressed some practitioners of the orthodox creeds, among the communicants of the old religion it has turned out to be an exercise in futility. The nāga and the nāginī have remained their friends and benefactors, the recipients of their affection and reverence, of their confidences and gratitude, of their continued and unfaltering homage. The brahman or the sādhu may abominate the serpent divinities and call them demons, but even their own texts refute them, for the numerous "snake-demons" who appear in their tales carry names like Pūrnabhadra, "The One Full of Blessings," or Vasunemi, "The One of Encompassing Beneficence," names that have retained their authentic connotation of affability and graciousness. The back-countryman knows nothing of those texts or their legends, but those appellations would have a most familiar ring to him. The same connotations have always fashioned his own designations for the local, folkloric presences of the divine serpent.

These presences are all about him. Even though more often than not they remain anonymous, undefined in their specific contours, elusive in

their identities, their influence is experienced no less keenly or decisively, their intervention invoked no less hopefully or credited no less reverently. Here and there they may still retain some individual distinction and association; but for the most part they are perceived and worshiped generically, as serpentine manifestations of the supernatural, otherworldly forces of an impalpable yet intense reality, as they have been perceived and worshiped for untold generations, living among the people as their familiars and faithful tutelaries.

This objectification of supramundane power in terms of generic serpentine forces represents one of aboriginal India's most enduring attempts to allegorize the mysterious interactions of nature and man, of extrasensory impact and sensory experience, of physical and emotional reality. Inextricably part of the Little Tradition, and essentially alien to Aryan Vedic conception, the lore of serpentine spirit hosts has proved of sufficient moment to compel its integration into canonical literature. References abound, describing the nāgas as collectives of supernatural ophidian beings, most often

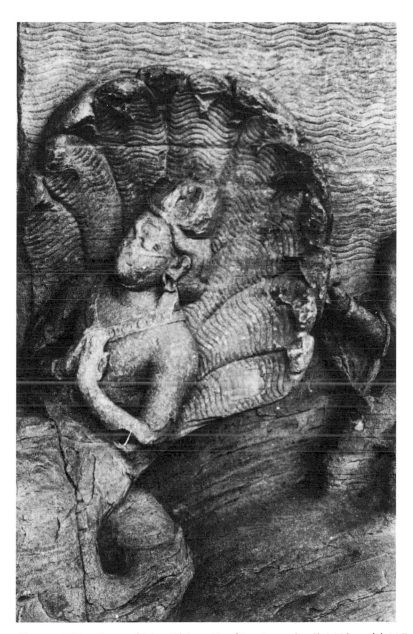

Fig. 174. Nāgarāja worshiping Vishnu. Varahāvatāra rock relief, Udayagiri, M.P.

Fig. 173. Serpent divinities. Frieze, Pātāleshvara temple, Malhar, M.P.

as a "tribe" of "fabulous serpents with human faces inhabiting the city of Bhogavatī in the infernal regions."[54] Frequently mentioned also are groups of obviously related types, such as *sarpas*, whose sacred character has remained acknowledged by the continued pursuit of *sarpabali*, the Offering to Serpents, likewise recalled in the textual accounts as a semi-official ritual practice. Other legends treat of the *uragas*, a class of similarly exalted snake spirits who attend Shiva's evening dance before the Goddess.

The imageries of the temples, particularly in eastern Madhya Pradesh, have preserved the memory of these presences with equal emphasis. Serpent-tailed creatures, such as those attending Vishnu matsyāvatāra or ringing the base of the Malhar sanctuary, are commonly encountered. Their precise designation as sarpas, uragas, or nāgas, or members of some other group, may have been a matter of indifference even to those who, translating the supernatural into the palpability of the physical form, carved their contours in stone.

The scriptural references to the serpentine forces have, however, done more than merely perpetuate their tradition or extend to it the seal of canonical sanction. They have involved mythopoeic elaborations which, evidently echoing indigenous formulations, reveal the original nature of these spirit hosts. The description, for example, of the sarpas as "dwelling on earth, in the air, heaven, and the lower regions,"[55] that is, throughout the threefold divisions which define the entirety of the Hindu universe, bespeaks their perception as all-pervasive metaphysical energies, manifestations of an inclusive Serpent Power which, rather than the sarpas themselves, appears to have been the actual object of the sarpabali devotions. Analogously, the legend of their attendance at the great god's evening dance characterizes the uragas as materializations of that same Power, as personified equivalents of Shiva's symbolic ornaments, the "bracelets, arm bands, ankle rings, and brahmanical thread, [that] are living serpents."[56]

As these emblematic attributes and their embodied counterparts combine to convey, it is the Serpent Power that animates Shiva's enchanted gyrations, and in them achieves its culminant expression. The god's ecstasy reveals the cosmic character of this Power, while his performance before the Goddess signifies its essential nature. His evening dance is a nuptial dance, courting, wooing, impassioning; a lover's prelude to erotic consummation, epitomizing the metaphysical as well as physical urge for *sambhava*, the "being together" which finds its ultimate experience in "sexual union, cohabitation."[57] It is couched in terms of superhuman exaltation, a projection of the most elementary of human impulses, that toward erotic realization. In Shiva, the performer of the evening dance, man has personified eros as an imperative of universal as well as individual existence. Inevitably, the Serpent Power, so prominently associated with the dancing god, stands defined as the zoomorphic allegory of this imperative. By inference, then, the generic groups of serpentine spirits might perhaps be best understood as objectifications of man's id forces, supernaturally exalted to mirror the mysterious but ineluctable impact of the yearning and desire, the innate urge toward the redeeming communion, which control every phase of his being.

Legend, language, and iconography all substantiate such an interpretation. Preeminent amid the abundance of examples are the semantic equivalence, fully accepted in the Sanskrit, of the word *bhogavat*, signifying both "possessed of coils" and "affording enjoyment"; and the analogous synonymity of the related term *mahābhoga*, with its cognate meanings of "serpent" and "great delight." The word *bhogavatī* indicates at once "female serpent" and "female vehicle of sexual enjoyment." Thus the famed mythical abode of the snake spirits, Bhogavatī, is not only the "City of Serpents" but also, and perhaps primarily, the City of Sensual Pleasure. As, certainly, the equivalence of serpentine nature and erotic experience was essentially alien and implausible to Vedic conception, only the presumption of a preexistent equation, anchored in popular imagination and tradition, can explain the scriptural perpetuation of these ostensibly incommensurable double meanings. On its part, the iconographic evidence leaves no doubt that it is in their specifically erotic connotation that the terms "enjoyment," "pleasure," "delight," have found their textual usage. Throughout India

this interpretation is rendered in stone. In temples and village shrines, the anonymous denizens of Bhogavatī exult in their intercoiling embraces, emulating the enchanted sambhavas of the nāga-nāginī couples of Bhubaneshwar and Konārak. Frequently this constellation appears restated in abstract formulation, with reference not to serpent beings but to Serpent Power. At once symbols of physical and metaphysical communion, the interlocking bodies of fully zooidal snake pairs circle pillars, look from sculpted niches, enliven carved panels.

Though conceptually the mystic equation presented by the double meanings of *mahābhoga* seems nearly universal, its conspicuous representations are singular to India. Many other regions have, to varying extents of prominence, seen the evolution of snake-centered cults. But nowhere else has the identification of serpentine essence with erotic quest and gratification,[58] of Serpent Power with self-realization through communion with the Divine,[59] achieved comparable subtlety and grandeur to engender a new perception and interpretation of the human individual's relationship with the Transcendent.[60]

Nowhere else has the serpent mask of the deity so closely coincided with the countenance of the godhead or served man so directly as guide to its revelation.

Fig. 175. Hero conquering serpent. Kāmeshvara temple, Modhera, Gujarat.

HINDUISM'S TANTRIC HERITAGE

The mystique of the Serpent Power has pervaded every aspect of Indian religion. Folk iconography reveals it as vital to the perception of the Little Tradition's numina; the canonical imageries of more conventional design attest its instrumentality in the evolution of those of the Great Tradition. Always latent as a shaper of metaphysical notions, periodically it had surfaced in explicit cults. In historical times it has attained its consummate expression in the speculations, symbolism, and rituals of the Tantric sects.

This singular surge into occult and ritual prominence was consequential to the Serpent Power's identification as a specialized aspect of Feminine Power. The rise of Tantrism was concomitant with the Goddess's reenthronement as the embodiment of ultimate divinity. For the equation of Feminine Essence and godhead was fundamental to all denominational divisions of the Tantric persuasion,[1] dominating with only minor variations of emphasis their interpretations of cosmic and mundane existence.

The flowering of cults traceable to the fourth-century A.D. texts known as Tantras can

hardly be considered, as some sources seem to maintain, as a mere proliferation of some special ritual practices, eclectic and sometimes even deviative in their accents, yet still founded in the broad compass of Brahmanical teaching. Nor can Tantrism's basic doctrine be fairly described as "a creative synthesis of the Aryan and native Indian philosophies."[2] It may well be that the Tantric groups' continued usage of canonical terminology, and particularly their ostensible dedication to the canonical divinities, diverted general attention from the essentially obverse infrastructure of their own viewpoint, and obscured the true nature of their creed. However, all indications point to their exercises as the outward manifestation of a rival faith flowing from a revival of indigenous traditions and beliefs; of premises that, gradually expanding their attention from small and intimate circles of devotees to ever broader segments of Indian society, created a religious perspective not in supplementation of, but in opposition to, orthodox Hinduism. Evidently, not a few of the latter's functionaries and scholars realized this. As their disparagement of Tantric teachings and practices suggests, to them Tantrism represented not merely a modification or even reformation, but a refutation of the established religion. Keenly aware of the perils of a conflict which pitted mystical revelation against formal theism, theopathy against theology, they foresaw that the outcome could not possibly favor their own power and prestige. Their own scripturalism could not hope to compete with the promises of the *participation mystique*. Any recrudescence in force of indigenous traditions and preconceptions, undiminished as they were in their hold even on many of those professing the reigning persuasion, was bound to triumph over a largely abstract creed whose appeal had proved so limited.[3]

Tantrism must be seen as the last of native India's periodic counter-offensives against the creedal and social perspective of an alien establishment and the doctrinal props that supported it. But, far more uncompromising in its reassertion of indigenous tradition, and far more radical in its departure from the canonical frame of reference, its impact proved more decisive and enduring in the long run. One millennium and a half after its initiation, Tantrism still "governs the mind and heart, worship and ritual of modern India."[4] Indeed, in its determination not merely to reform but reformulate India's religious vision, it may well have been the principal agent in the decline of the once dominant Buddhist and Jaina estates. For, what has often been regarded as a Brahmanical success in restoring Hinduism to supremacy, might be far more appropriately recognized as a Tantrist success in restoring the old religion behind a facade of Hinduism. In fact, the emotional climate of the early post-Christian centuries would never have favored, much less sustained, a Brahmanical revival. It demanded a spiritual reorientation which neither traditional Hinduism nor the more cautious innovations of the earlier heterodoxies could satisfy. Tantrism's responsiveness to the time's needs and aspirations fashioned its appeal to ever broadening sectors of the population. During the latter part of the Gupta era it moved toward a prevalence which it was to maintain throughout the Indian Middle Ages, to flower in the parallel cults of Mahāyāna Buddhism and Hindu Shaktism. Its new, exuberant image of man in his relationship to the Divine, the ecstatic accent of the new religiosity, found in India's genius for the plastic arts the characteristic vehicle of expression. Its mystic fervor translated itself into a veritable avalanche of architectural and sculptural creations that have permanently molded the subcontinent's cultural countenance.

Though the intensity of Tantric inspiration may vary, there is hardly a temple, a village chapel, a sacred monument that does not feature its unmistakable traces. Obvious even in regions distant from its source in Bengal, its impact is proportionally more marked throughout the adjoining central areas directly in the path of the cult's expansion. The great shrines of Orissa and of eastern and central Madhya Pradesh are the capital creatures and symbols of the new faith, the famous edifices of Bhubaneshwar, and Konārak, Rājim, and Khajuraho being prototypal for the plethora of less familiar ones, such as those at Pali and Sonepur, Lonar, Janjgir, and XXXI *to* Nemawar; and of such practically unknown ones as those at Nohta and XLI Gahakpur, Gyaraspur and Chhapri, Nagda and Jagatpur. Everywhere,

however simple in structure and artistic elaboration, the sanctuaries betray, no less eloquently if less conspicuously, the Tantric accent by the subject choice of their imageries and their mode of representation.

The dimension of the religious reorientation which swept the country in the name, and under the auspices, of Tantrism may seem the more astounding as, unlike its Buddhist and Jaina precursors, it had not derived its impetus from the commanding presence and example of a charismatic leader. The Tantras were claimed to have been revealed to mankind directly by Shiva himself. Surely there were advocates of these new gospels, interpreters of their messages, initiates of their secrets. There were gurus, teachers of the doctrines, presiding over the sectarian gatherings and conducting their rituals, but their influence rarely spread beyond the confines of their individual congregations. Distinguished by no special sanctity but only a superior experience, actual or alleged, in matters of the occult, for the most part they remained anonymous members of the various mystic fellowships. It may well have been just this communally based rather than personality-centered structure, encouraging the worshiper's reference to the immediacy of the divine source rather than to the jurisdiction of an intermediary in the flesh, that proved a significant factor of the cult's prodigious conquest. For Tantrism's essential impetus derived from the mystical and aboriginal character of its teachings; the one offering a new, vital experience to men disenchanted with the petrified and meaningless formalism of the theological creed; the other reasserting the long dammed up but never forsaken heritage of the native past over the superimposed injunctions of an alien, basically incompatible interpretation of Being.

While no detailed examination of Tantric doctrine can be attempted within the present context, a brief synopsis of its salient principles should suffice to explain its peculiar fascination. Certainly the reactuation of the indigenous traditions which had never ceased to dominate the emotional, and even the notional, proclivities of most of India's people gave Tantrism its primary impulse. The spiritual revolution it ushered in was one defined not by its inauguration of a future, but by its resurrection of a past, perspective of existence. Unlike many similar episodes in the history of man, it did not substitute a new godhead for the one that had outlived its utility, but reenthroned the old one that had never failed the believer. This debt to the past has been consistently emphasized by most authorities. Thus, in commenting on certain cultic and iconographic aspects of the Indus Valley civilization, Mukerjee avers that they present "prototypes and traditions that still live in Tantrism."[5] Zimmer concurs in speaking of Tantric symbols and rituals as "something that had emerged from the depth of an agelong popular tradition going back to primitive times," and in elaborating that "the Tantra may have its roots in the non-Aryan, pre-Aryan, Dravidian soil."[6]

However the specific pertinence of these statements may be affected by their precarious references to the Indus Valley and Dravidian cultures,[7] the essential validity of their conclusion, their identification of the Tantric inspiration with the "non-Aryan, pre-Aryan" perspective remains undiminished. All major aspects of Tantric doctrine and practice converge, usually complementing and corroborating each other, to prove this conclusion. The remarkable accord of their testimonies can but imply their cognation from one fundamental, central, and all-inclusive premise.

This premise is the transcendence of the Feminine Power. It is her embodiment that assumes the focus of Tantric worship, her nature that becomes the leitmotif of Tantric speculation and metaphysics; the modes of her manifestations that induce the ecstatic accents of Tantric cult; the symbols of her cosmic actuality that dominate the mysteries of Tantric ritual. Most specifically, it is her identification with Māyā-Shakti, "the perpetual dynamism of the transitory, contingent realms of becoming and dissolving," that defines the Tantric world-view in its "new, audacious, Dionysian affirmation"[8] of life and human self-realization. It is the conscious vision of the Feminine Principle that, reemerging from the distance of an immemorial past, determines Tantric cosmology and ontology, to forge what Mukerjee calls "the last profound Indian interpretation of the

world;"[9] but which, in fact, is a reformulation of what must have been the earliest one.

The reenthronement of India's primordial Goddess presents the most conspicuous symptom of this world interpretation. Shakti served as the popularly accessible cipher for a complex conception, as a medium through which abstraction would gain intelligible contour. She presided over the Tantric religion as the symbolic personalization of the Feminine Principle that was its ultimate godhead. Femininity apotheosized, in her all the magic, regenerative life-affirming forces found their incorporation. She was perceived as the macrocosmic extension of each woman; and each woman, in turn, was deemed her microcosmic equivalent, possessed of the same potentialities in as yet unrealized but eventually realizable form. Each, a mundane Shakti, within herself contained the substance of the Divine

It would thus seem but cogent that, as living Shakti in the flesh, woman should be central to the rites of Shakti. Her participation would be indispensable to the liturgies of the Tantric cults. Though she would assume in them neither the title nor the function of priestess, her exaltation was implicit.[10] Only her presence could induce the mystic experience; only through her could the mystery of the transcendental communion achieve consummation.

The temples of India, especially throughout her central regions, give exuberant expression to this exaltation. The likenesses of the Divine Woman, each an aspect of Shakti, dominate the sacred precincts. Yet it is not their sheer numerical abundance but their reverent and glorifying conceptions that impart to these imageries the unmistakable accent of the Tantric vision. The esthetic delight in the beauty and fascination of the female countenance, always a characteristic of Indian sensibility, here attains a new and different dimension. External contour becomes the vehicle of internal reality; physique, the interpreter of essence. Each female likeness is another visual interpretation of the female principle. For this reason the argumentative differentiations between divine, semidivine, and nondivine effigies seem ultimately irrelevant, and any authoritative distinction between the various identities of Devī or the various classes of her minor manifestations proves ultimately meaningless. Creatures all of māyā, they are equally replicas of Woman Divine, stand-ins for Shakti within the sphere of mundane phenomenality. Their aggregate presence transforms the medieval sanctuaries into figural chronicles of Tantrism's basic thrust, the redefinition of existence in terms of mystic experience rather than theological rationalization; of the divine potential within man rather than a transcendental deity inaccessibly beyond him; of emotional rather than intellectual realization. On those temple walls unfolds a reborn world actuated by magical forces and governed by a universal mystery, equated with feminine nature and function, subsumed in the vision of the archetypal woman and incarnated in the innumerable diversities of the female presence.

The Tantric quest was neither original in its direction nor unique in its aim. It had been anticipated by a trend that had exerted ever mounting pressure for some centuries past, to emerge occasionally in the Upanishads and impress itself tentatively on the Purānic texts, in which the figure of the Goddess comes into ever greater prominence.[11] The religious and ideological traditions of indigenous India had long been urging toward reassertion. Tantrism represented another step along an ascending road, but a step far bolder, far more decisive than the earlier ones, the one giant stride that carried the propensities of ages past to their denouement. It would not merely amend the premises of the canonical creed, but postulate its own; not contrapose only a different image of the godhead, but also a different image of man's own being; not alone formulate different goals, but also different disciplines to achieve them. Thus, though in their very emphases some aspects of the new cult—particularly the explicit sanctioning of the "five forbidden things"[12]—seem deliberate in their repudiation of Brahmanical injunctions, basically it was the indigenous tradition's occult presumptions regarding the nature of man that dictated Tantrism's liturgy and substructured it. Its ritual gestures endeavored to affirm man's innate divine nature which, realized in the sacramental act, would transport the devotee beyond and above all ephemeralities. They announced that man

the god would not, and could not, be subject to the restrictions of mundanity. In the ecstasy of experiencing his own being in terms of *Shivo'ham*, "I am Shiva," the celebrant was not defying any theological prohibitions; they simply no longer applied to him. The doctrine of the Divine Within must of itself make them irrelevant. It seems obvious that, fundamentally antithetic to the Brahmanical postulate of a transcendent deity, this doctrine must trace back to India's native mysteries, to premises as elementary and crucial to them as they prove to have been to mystery cults the world over. The devotee's partaking of the five forbidden things, then, constituted a token of his participation in what must have once been sacramental routines, an act recreating the incidentals of a liturgy that finds its revival and reformulation in Tantric worship.[13]

Tantrism's symbology proves singularly eloquent in attesting the doctrine's indigenous source. It is remarkable not so much for its introduction of new elements as for its elaboration and reinterpretation of those pristine ciphers of female divinity, the serpent and the lotus.

Tantrism's reinstatement of the divine serpent to new preeminence has already been noted. It seems but cogent that any revival of the native traditions would seize upon the equation of Serpent Power and Female Power, one that, as has been seen, had continued uninterruptedly as an essential of India's religious conception and as a leitmotif of her devotional and iconographic expression. However, the new esotericism expanded the dimension of its primal import. As developed especially in the *Sat-chakra-nirūpana* and the *Padukāpanchaka*,[14] symbolic abstraction is transformed into mystic actuality. Kundalinī, the Serpent Power, emerges as the cardinal vehicle of man's communion with the Divine.

A thorough exploration of the psychological and physiological, occult and practical ramifications of the Tantric interpretation of the Serpent Power, particularly as expounded in the doctrine of Kundalinī Yoga, "the magic control of the serpent power," would provide much insight both into the fundamentals of ancient man's religious experience and his knowledge of the dynamics of human existence. Zimmer's exposition[15] may offer a valuable starting point for its pursuit. Within the scope of the present book, even the principal notions can find only cursory consideration.

Kundalinī Yoga no longer perceives the interrelation of Feminine Power and Serpent Power in terms of an archetypal equation, but of an absolute identification. Kundalinī, the "female serpent," is often described as the "Inner Woman." Shakti becomes synonymous with Kundalinī Shakti. The divine afflatus assumes the form and aspect of the "Coiled One" which, aroused, progressively prompts the worshiper's consciousness of his own divinity toward his ultimate realization in the ecstasy of his communion with Shakti, the Feminine Power that is the primum mobile of all Being. It is in this communion that the act of self-transformation comes to pass; that the identity of microcosm and macrocosm, of self and universe, of subjective reality and objective Reality is experienced; that individual differentiation dissolves, and the ego is reintegrated with the All.[16] This communion is envisioned as the ultimate physical as well as metaphysical event. The devotee, now as an aspect of Shiva, embraces Shakti, to perform the divine connubium, the *hieros gamos*, which is the mystical fountainhead of all creation.

Kundalinī, the serpent countenance of the Divine Feminine, is the source, the impetus, the catalyst of that transcendent consummation. No longer a symbol or cipher of the godhead, the serpent is now the contour of her manifested presence. As in the Gnostic scheme Ophis *is* the Cosmic Goddess, so in the Tantric interpretation Kundalinī *is* Shakti. Perhaps this conception of the Serpent Power had indeed been the original, primal one which, latent in the native tradition, was now reactuated in the flowering of the Tantric renewal. At the same time the authentic symbolism of the lotus also was recaptured from the depth of the past. As Kundalinī is identified with Shakti, Feminine Power, so the mystic flower is identified with Satī, Feminine Essence, to signify the complementary mode of the Divine Within. This archetypal juxtaposition is most expressly conveyed by the designation of the energetic centers which Kundalinī in her passage must stimulate to achieve ever higher levels of consciousness, as *padmās*, "lo-

tuses."[17] In these centers of potential power, man's divine nature lies in abeyance, inchoate, waiting for Kundalinī to uncoil and touch it into self-realization. Only as the energies of serpent and lotus combine will the Divine Within gain shape. Shakti and Satī will reveal their identity in the one, eternal form of the Feminine. In this timeless moment of transcendent experience, man becomes one with the universe: Shiva consummates his union with the Goddess.

The doctrine of the Serpent Power is only one of the many elements of Tantric teaching, but one of central import in that it defines the ultimate goal of the religious quest and charts the path to its attainment. It thus seems inevitable that this doctrine should have been instrumental in molding the aspect of the Indian temple and its iconic configurations for many centuries. Responding to its impetus, India's medieval imageries recreate the performances of the Tantric ritual which thus achieve their glorified transposition and exuberant interpretation through art. Indeed, in the subcontinent's shrines the vision of Kundalinī has found its repositories and illustrative chronicles.

No doubt much of its esoteric and ritual prominence accrued to the doctrine of the Serpent Power from the expressly sexual terms of reference in which the equation of serpent power, female power, and divine power was postulated. The indigenous tradition, of course, had always intimately interrelated these concepts. But now they were envisioned as virtually synonymous. This final identification seems most conspicuously symbolized by the putative function of the first padmā touched by Kundalinī on her upward path through the worshiper's body. Designated *svādhisṭāna*, "the goddess' own abode," this center's peculiar energies are characterized by its location at the level of the sex organs. Only after its successful stimulation, that is, only after the arousal of sexual desire, urge, and quest, and the assimilation of those impulses to herself, can Kundalinī proceed toward her unfoldment on further, more differentiated levels of experience. It is in the "goddess' own domicile," defined as the receptacle of sexual potency and function, that she acquires her essential impetus. The very perception

of the svādhistāna padmā thus implies the actual identity of female divinity, serpent power, and sexuality. Kundalinī *is* the Goddess, and her progress equals the evolution of sexual experience through the variant phases of sublimation toward its eventual realization in the physical as well as metaphysical consummation of the divine connubium. Shiva embraces Shakti, and Shakti receives Shiva into herself. In the maithuna, this act of "copulation, sexual union," the phenomenal differentiations of the Divine, god and goddess, return to the original and elementary state of oneness from which all creation, macrocosmic and microcosmic, ensues.

Allegorically, this communion of god and goddess is reenacted by the devotees as the culminant ritual. The human shakti, terrestrial replica of the Divine Feminine, receives her mate as the mundane equivalent of the Great Lord. Celebrating the eternal cosmic drama of regeneration, and anticipated by all the other liturgical gestures and incidentals, their maithuna constitutes the solemn, crowning, all-redeeming moment of the Tantric sacrament. Though, in releasing the forces of physical and emotional desire in a trancelike ecstasy of gratification, it may assume orgiastic overtones, the terms of its performance preclude any diversion into wantonness; for this connubium transcends self-directedness, to transform the bodily urge into the other-directedness of complete union. Sexual need is absorbed, dissolved, and transfigured by the erotic imperative of which it is but a sense-defined specialization. The maithuna of the Tantric mysteries reaches beyond the mundanity of "copulation, sexual union." Coition and all its cultic preliminaries serve as merely the most apposite instruments of an erotic self-realization that belongs to the dimension of the sacred.

For this identification of the spheres of the Divine and the erotic, the twin meanings of the term *mahābhoga* offer internal evidence. Concurrently signifying "serpent" and "great enjoyment," its connotations make it a synonym for Kundalinī, Shakti's serpentine self, and mahāsukha, the principle of the "great delight." Semantically, then, erotic enchantment and divine worship are defined as equivalent and concomitant. Philosophically, the same concept finds expression in the celebrated formula, "bhoga

is yoga," which Zimmer renders as "delight is religion,"[18] but which might be more precisely transcribed as "delight is religious exercise." This equation is of fundamental implication not only for the evolution of Indian art,[19] but also for the understanding of the impulse that throughout the ages has shaped so much of man's cultic activities. For, in no way unique to India but a shared viewpoint of early cultures, the same appreciation of the erotic as an intrinsically sacred exercise appears to have catalyzed the "orgies" of the ancient and later mysteries elsewhere. A conceptual analogue of "bhoga is yoga" may have supplied the premise for such practices as the worshipers' sexual congress with the priestesses of the Babylonian Ishtar, or the Canaanite Astaroth, the "promiscuous" carnalities of the Dionysian celebrations in Greece, or originally even the procedures in the Roman rites of Priapus. In the Tantric ceremonies it achieved its consummate expression, the final event of cohabitation being considered and experienced as an act of sacramental obligation, and the physical endearments as its exalted prologue. Paired impersonally, the participants in the maithuna would engage in the embrace not as emotionally or even corporally defined individuals but, their egoities stripped to irrelevance, as ciphers of the Divine.[20]

With sex recognized as the vehicle of metaphysical realization, and erotic stimulation as the instrumentality of its achievement, the lovers' activities paralleled the progressive unfoldment of kundalinī. Delight became indeed a function of devotional exercise. Hence the depictions of maithuna, in all its multiform stages of anticipation and consummation, that crowd the shrines of India. Illustrations of the pursuit of the sacred, could there be a more fitting place for their exhibition than the abode of the sacred? Key to the ultimate religious experience, the liturgic connubium would impel its iconic portrayal in the precincts of the Divine.

The erotic imageries of the medieval temples are pictorial interpretations of the formula "bhoga is yoga," graphic renderings of Tantrism's mystic vision. The maithuna couples project supernatural essence in mundane contour, metaphysical experience in the concrete of physical sensation, the regenerative synthesis of the cosmic opposites in the shape of its terrestrial analogue. Their exuberant everpresence is a paean to transcendental Eros, translated into the language of human reference.

During the last few centuries this paean has lacked an appreciative audience. The fanatical iconoclasm of conquering Islam abominated its joyful tunes. The militant Hindu movements, pointed toward a return to Brahmanical puritanism and ritualism, rejected its heterodox inspiration. And missionary Christianity, steeped in its equation of sex and sin, turned a deaf ear, frightened by its message of a richer life. Only the current century has, if gingerly and with slowly abating misgivings, accorded new attention to the creations of the Tantric faith. The iconographies of some of the larger and famous sanctuaries, as those of Konārak and Khajuraho, have been explored and commented on, and some of their art has been reproduced. Though these efforts have not done full justice to their subject, they have stimulated an ever-expanding interest. However, their concentration on but a few conspicuous and famous shrines for their illustrative material has encouraged an inaccurate assessment of Tantrism's impact on India and her art. Their partiality to the designs of Khajuraho, Konārak, and Bhubaneshwar are of course understandable; the cumulative superabundance and artistic perfection of those temples' maithuna scenes must place them naturally in the focus of consideration.[21] On the other hand, this overemphasis has tended to suggest that such erotic imageries are peculiar to a few singular, Tantrically oriented sanctuaries, and to obscure the actual compass of their incidence. For these renderings of the Tantric vision are common to the shrines throughout the subcontinent. They may vary in boldness, incisiveness, depictive directness, or in the artistic merits of their execution; as a rule, they will find more forceful as well as numerous exhibition in the sanctuaries dedicated to Shiva, the Goddess, or their local equivalents, rather than in those consecrated to Vishnu. But, embracing all diversities of expression and display, the erotic nature of the religious experience has engendered its figural paraphrases in all of them. It was not merely the predominance of the *kaula-kapila* cultists at the Chan-

della court of Khajuraho, nor that of similar sects at other seats of princely power, that produced sacred edifices in the image of their mystic vision. While in such places superior resources of material wealth and trained craftsmen would produce structures of superior size and splendor, and imageries of superior polish and finesse, the prompting inspiration proved in no way unique. Tantric religion has left its monuments everywhere, many less sumptuous or accomplished, many again rivaling even their most famous counterparts.

XXXIX
176 This seems well exemplified by the Boramdeo temple near Chhapri. Though practically unknown, its architecture compares well with the edifices of Khajuraho, and its maithuna figures, though less refined in their individual execution, concede nothing in abundance or expressiveness to those of the Chandella sanctuaries, of Bhubaneshwar and Konārak, or the great temples of the South. Yet this shrine proves typical rather than singular. Similarly unnoticed and unfamiliar, its counterparts dot the Indian landscape. Memorials to a profound reorientation of man's image of existence, they attest that the Tantric creed was not the esoteric property of some heterodox sectarians but indeed a mass movement of religious renewal especially attractive to the non-Hindu, or but nominally Hindu, people of the back country, from whose traditions it had drawn its conceptions and its impetus. It may not be mere fortuity that precisely in the vast, preponderantly aboriginal countryside of India's central areas art and iconography acknowledge most consistently and vigorously their cardinal debt to the Tantric influence. Here, from Orissa to Gujarat, the temples are strung out in countless sequence, each a verse of a poem in stone celebrating the sacred delight. Many, modest in structure and sparing in their imageries, may spell their message in a single maithuna figuration. Others, competing with the Boramdeo temple in tectonic magnificence and artistic bounty, may transcribe theirs in depictive variations that run the gamut of the erotic in all its manifestations.

Collectively, the temples of central India blend into one immense choir in glorification of the maxim, "bhoga is yoga." The theme is common to

Fig. 176. Section of wall. Boramdeo temple, Chhapri, M.P.

all, but the individual voices come through in different registers, ranging from the sexual expectancy of the supernatural females of Khiching and Pāli to the embraces that unite the lovers of Sirpur and Konārak, of Modhera and Rajim; from the challenging exhibitionism of the goddesses of Sonepur and Chhapri to the passionate consummation of the maithunas of Ranpur and Eklingji and Konārak; from the expressions of delicate intimacy to those of enchanted fulfillment; from the gestures of erotic interplay to the pantomimes of orgiastic abandon portrayed on the shrines of Khajuraho.[22]

118
66 XLII
177 *to* 180
132 XXIII
134 181
135 182
56 XXXVIII
183 XXXIV
184 *to* 187
137 188

Most of the larger temples announce the gospel of the Great Delight in all its stages and aspects, as though each were designed as a pictorial chronicle of Kundalinī's unfoldment from her first arousal to her ultimate apotheosis. Scores of typical examples might be cited, but the aforementioned sanctuary of Boramdeo and the nearby wedding chapel (mālava mahal) may serve as one of the most inclusive illustrations.

The main temple rises near a sizable, lotus-dotted pond in the midst of a jungle. In structural conception closely akin to the style of the principal Khajuraho group, it perseveres in a state of excellent preservation as a monument to a past when its grandeur must have been the focus of a large and prosperous, perhaps even politically prominent, community. For whatever reasons the site may have been abandoned, it seems to have become prey to the wilderness long ago. The debris of dwellings remain strewn about among the trees and bushes; more relics most likely are buried beneath the soft forest soil. The original dedication of the shrine was, as the principally featured effigies suggest, to Shiva-Mahādeo, but eventually it had been identified with the worship of Boramdeo, the chief divinity of the Gonds, who have controlled the district for centuries. Earlier it might have been associated with the deity of the Baigas.[23] Many of the imageries, particularly some likenesses of the Goddess, intimate their debt to indigenous tribal tradition, which emerges even more obviously as the dominant factor in the designs enlivening the smaller, now partly ruined wedding temple. Half a mile distant, this shrine is not part of the sacred

XXXIX

35 43

Fig. 177. Maithuna. Sūrya temple, Konārak, Orissa.

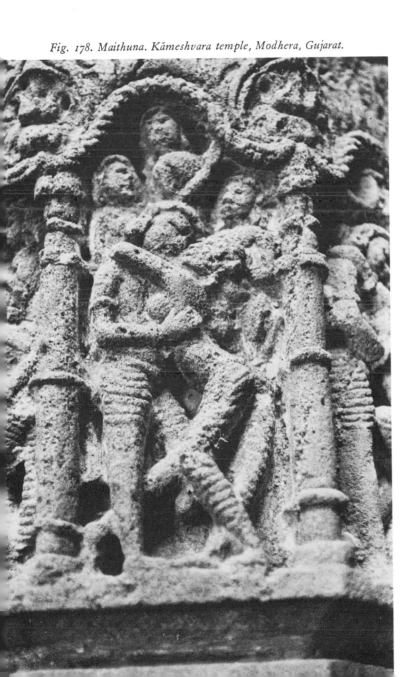

Fig. 178. Maithuna. Kāmeshvara temple, Modhera, Gujarat.

Fig. 179. Maithuna. Rājīvalochana temple, Rajim, M.P.

Fig. 180. Local goddess. Boramdeo temple, Chhapri, M.P.

Fig. 181. Maithuna. Jagannātha temple, Ranpur, Orissa. (left)

Fig. 182. Maithuna. Sūrya temple, Konārak, Orissa.

Fig. 183. Maithuna. Shankara temple, Wakri, Andhra.

Fig. 184. Maithuna. Bhagavatī temple, Banpur, Orissa.

Fig. 185. Maithuna. Shiva-Bharu temple, Mungeli, M.P.

Fig. 187. Maithunas. Mahādeo temple, Nohta, M.P.

Fig. 186. Maithunas. Frieze on gate to the Fort at Kalinjar, M.P.

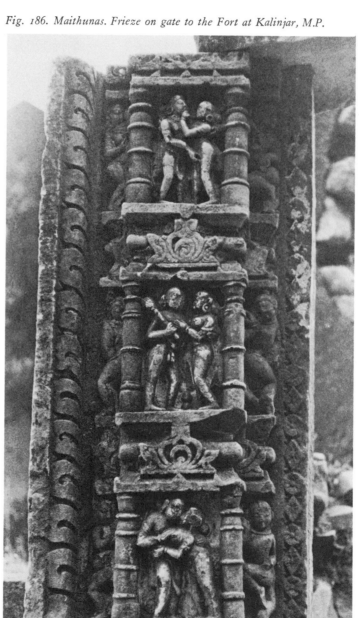

compound. Its relative location and different style indicate that it may have been erected by different people at a different time in consecration to a local divinity presiding over the rites of marriage. In any case, both these temples share the explicit Tantric commitment of their builders, and of the community for which they had been built. The iconic preeminence of the female deity in all the gradations of her human, supernatural, and transcendent revelation speaks for itself; and the exuberance of the erotic 189 figurations, encompassing all the varieties of maithuna, all the aspects of mahābhoga evolving toward its surpassing realization, combine into a panegyric of Tantric worship and its central ritual. Their sequences unfold, stage by stage, like a visual account of the mystic experience that is its most treasured mystery.

The Goddess herself, so transpicuous in her sensual self-display, appears 132 180 in numerous, similarly suggestive replicas circling the walls of Boramdeo's 190 temple. Her counterpart on the façade of the wedding shrine is even more overt in her invitation. Human contour of Shakti, she is still alone, but

anticipating, demanding her sacred due. Other panels portray her with her mate-to-be, her consort in the *hieros gamos*, in constellations of mutual exhibition and eventual manifest arousal. As kundalinī rises from padmā 191 192 to padmā, the preliminaries of mahābhoga become progressively intense, with all the facets of emotional and physical stimulation, all the modes of lovemaking, including fellatio and cunnilingus, finding their passionate 176 189 exercises. And, as kundalinī has reached the *sahasrāra*, the final lotus of power, as ecstasy has achieved its culmination, in a hundred stone-carved 193 *to* variations of sensual experience and gratification, goddess and consort 199 celebrate the divine connubium.

All across central India, in unfamiliar towns and forgotten villages, in the middle of endless fields and on the summits of steep hills, crumbled to ruin or defying the inroads of time, the counterparts of the Chhapri temples paraphrase the Tantric message, each in its own distinctive accents of style and expression. In Boramdeo's sanctuary in the jungle near Chhapri, these accents converge to reflect the accession of that message,

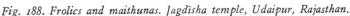

Fig. 188. Frolics and maithunas. Jagdīsha temple, Udaipur, Rajasthan.

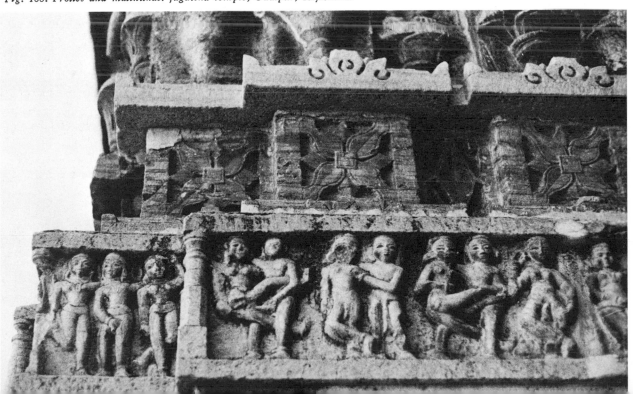

within the framework of orthodox reference, in a mirror of especial force and clarity. Oddly apposite to its actual situation just halfway between the two focuses of Tantric expression, Boramdeo's shrine merges the characteristics of the preeminent structures of Khajuraho and Konārak. While, as noted, its tectonic features closely follow the former, its representational pattern, favoring the portrayals of intimately personalized maithuna couples rather than of schematized orgiastic groups, more nearly corresponds to the latter. This synthesis may well trace to the presumptive history of the sanctuary's origination. Apparently it had been built on the initiative of temporary overlords, most likely of the Kalachuri dynasty, who had introduced their own religious and cultural partialities to the areas of their expanding dominion. The dedication of their house of worship accorded with their still formal, if evidently Tantric oriented, Shaivite persuasion.

But these were the rugged and secluded backlands of the Maikal Range. Preeminently settled by tribal peoples, distant from the highways of cultural interchange and of difficult access, their penetration by the preconceptions of the Great Tradition would remain no more than peripheral, their devotion to the canonical gods no more than nominal. Here the divinities of old still reigned paramount; here thought and emotion, lore and worship, were, as largely they have continued to this day, captive to the immemorial notions of the native religion. Inevitably these percepts would impress themselves on the aspects of the sacred precinct, irrespective of the creedal proclivities of its alien founders; the more surely so, as much of its imagery appears to have been produced by local artisans, themselves beholden to the regional traditions.[24] Consecrated to the celestial lord of the ruling prince and his coterie, designed to celebrate their vistas of the

Fig. 189. Section of wall. Mālava mahal, Chhapri, M.P.

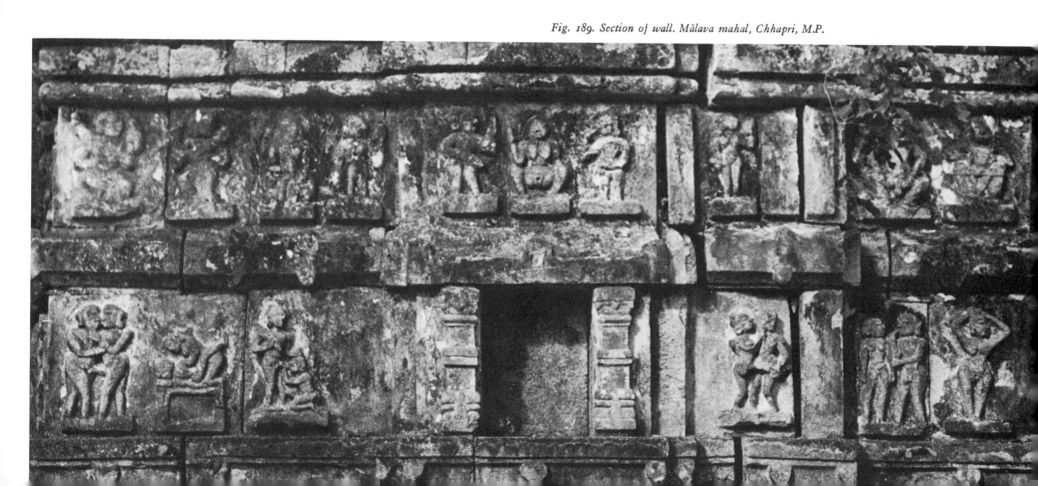

Fig. 190. Exhibitionistic nāyikā. Mālava mahal, Chhapri, M.P.

Fig. 191. Section of wall. Boramdeo temple, Chhapri, M.P.

199

here and the beyond, the temple might provide the Brahmanical frame for worship and religious exercise; but the stone carvers and sculptors would impart to it their own contents of belief and reverence, would give form to them after the familiar models of their environment. They would, as they must, speak of their own people and their own world. In consequence, it is the characteristic physiognomies of the region's inhabitants that reappear in so many of the supernatural countenances crowding the walls of Boramdeo's shrine and those of mālava mahal; that leave their traits even on the effigies of the Natarāja and on Shaivism's divine couple, and accent some of the human portraitures on the satī stones. Likewise, it is the characteristic perspective of the native world that, transcribed by the collective imageries, defines the mood and meaning of the sacred precincts. For contained within them persevere enigmatic shapes from the depth of time, the icons of tribal and folkloric deities; the emblematic figure of the five-hooded snake, zoic double of Māyā, or perhaps, a representation of Kun-

132 180
190 191
43 35
53

IV
164

Fig. 192. Maithuna. Mālava mahal, Chhapri, M.P.

Fig. 193. Maithuna. Boramdeo temple, Chhapri, M.P.

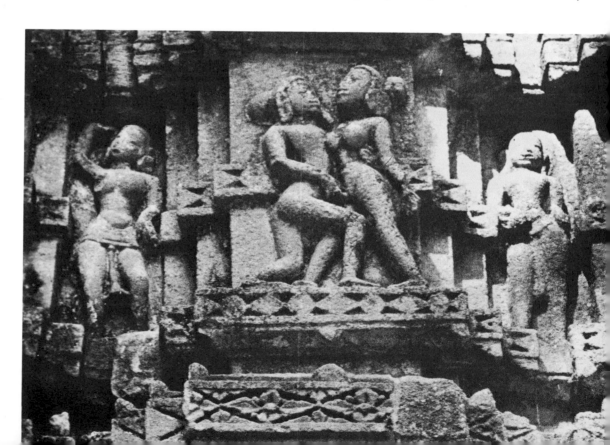

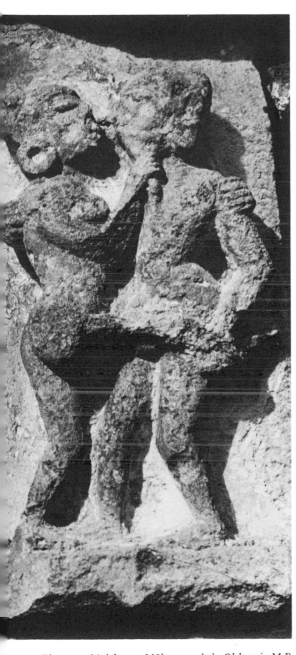

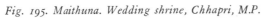

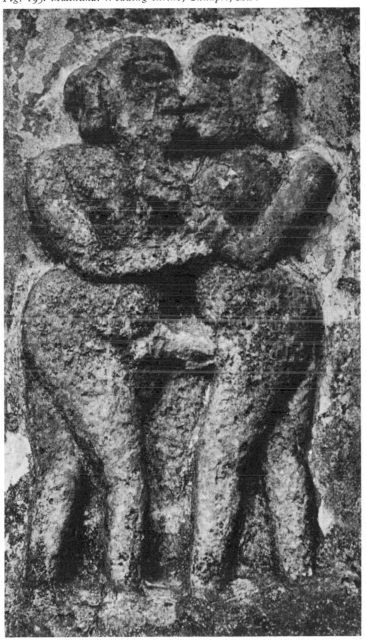

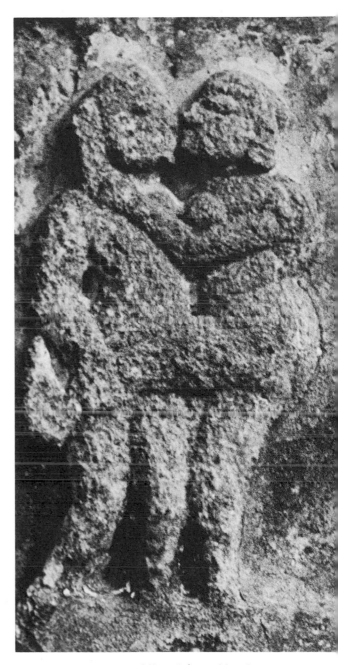

Fig. 194. *Maithuna. Mālava mahal, Chhapri, M.P.*

Fig. 195. Maithuna. Wedding shrine, Chhapri, M.P.

Fig. 196. Maithuna. Wedding shrine, Chhapri, M.P.

201

Fig. 197. Maithuna. Wedding shrine, Chhapri, M.P.

Fig. 198. Maithuna. Wedding shrine, Chhapri, M.P.

dalinī herself; and, permeating the sanctuary's very dimensions, the effigies of maithuna, not merely ciphers of remembered cult but projections of a living experience. Above all, there is an encompassing presence, the primordial source of this experience, the Feminine Essence in her numberless manifestations: theomorphically presented in the endless pageant of supramundane females, theriomorphically embodied in the fanciful contours of lion vyalis, and supernally impersonated in the canonical disguise of Kālī, whom the people of the district revere as Bhīmā, the Terrible One.[25] Placed centrally among the iconic configurations, ostensibly in a presiding role, it is she who stands identified as the paramount power and effective godhead of the hallowed realm.

Prototypal of India's medieval shrines, those of Chhapri are one with them all in the substance, if more vivid than most of them in the exhibition, of the religious renewal. However, some of the sanctuaries of that period may not have owed their origination directly to the impetus of Tantric teaching and practice. Their distinctive character may have evolved spontaneously as the indigenous traditions were emerging from the depth of a timeless commitment when the spirit of revival had removed the barriers from their expression and extended official sanction to their display. The medieval temples, then, were as much the producers as the products of their age. While many had obviously been designed as harbingers and illustrations of Tantrism's doctrine and ritual, not a few of them may have themselves provided a stimulus to its perceptions and cultic formulations.

Where the fervor of this renascence has translated itself into egregious design, its exhibitions have often been roundly condemned for their "excesses." The symbolic and implicit references to maithuna might meet with silent dismay and studied disregard, but its explicit portrayals have long served as primary targets of antagonism, disparagement, and outraged denunciation. Fostered by a later era's Brahmanical puritanism and the sex-associated anxieties of missionary Christianity, such responses have affirmed only the critics' own insufficiency of historical and psychological understanding, and their insensibility to the profoundly religious reverence

Fig. 199. Maithuna. Wedding shrine, Chhapri, M.P.

behind the passionate exuberance that celebrated the liberation of human aspiration from a long, impoverishing captivity.

Mocking man's ignorant dogmatism and biased intolerance, time has preserved these monuments to a richer, more beatifying perception of life in the yesterday; preserved it, perhaps, as a possible promise in the tomorrow. Like all ideological movements, that of the Tantric renewal, rising in a great crescendo to its climax and then gradually degenerating, proved to be but temporary. Yet, while for the most part its doctrinal precepts and ritual exercises have faded,[26] its subtler impact has persevered. Behind the conventional outward forms of canonical Hinduism, the ethos of the native tradition has remained a dominant force in India's life. The realities of her people's daily existence and worship continue largely defined by the non-Aryan, non-Vedic heritage. Tantric teaching and cult have fulfilled their function as the effective vehicles of its resurrection and the guarantors of its preservation.

INDIA'S GREAT TRADITION

The slumber of a scorching midday has descended upon the precincts of the sacred. The shikharas of the great temples, their upward sweep distantly contoured against the blue brilliance of the sky, guard the somnolence of deserted courtyards, of pillared halls and tenebrous tabernacles. The tattered pennants, limp in the still air, bespeak the idleness of artless purāna mandirs and lonely chabutras. Untouched by human presence, the images of the countryside altars are swallowed up in the quietude of a vast horizon.

Yet, rapidly wilting, there are the blossoms of the pūjā; faint now, the dark spots of moisture recall the reverence of the morning's early visitors.

They are gone now, to their fields, their looms, their stalls in the bazaar; to the diverse chores of a uniformly arduous everyday. Yet, perhaps, their toils and privations, their penury and sorrows seem less bleak, somehow lightened and sustained by an undefinable certainty, an impalpable hope. They have had their dialogue with the Divine.

It matters not whether they have found solace and promise in the splendorous abodes

of Vishnu or Shiva-Mahādeo, or in the humble ones of their local counterparts; before the likeness of their own favorite among the guardian powers, some yaksha or yakshī, the immemorial familiar of their hamlet; or, again, before but the symbol of divinity, a sindoor-daubed rock or tree, a trishūla, a flag-topped heap of stones, a snake's lonely image. They may have found their encouragement from the grace-bestowing gesture of Devī, the supernal mistress of the infinite manifestations, whether they acknowledged her as Lakshmī or Durgā, Chandī or Mahāmāyā-Siddhīshvarī, Mahāmmai or Shītalā. The mysterious smile of a nāginī may have bestowed new reassurance to them. Or they may have derived their moment of unfathomable, wondrous transport from a glimpse at the processions of the supernatural hosts, the frolicking of the gandharvas, the drolleries of the ganas, the beauteous charms of the surasundarīs and apsarases; at a world beyond yet inalienably within their selves. Unconsciously, though no less profoundly, they may have been moved by the blissful ecstasies of the maithunas.

It matters not where they performed their worship, or what might have been its specific object. To those that seek it, the Divine reveals itself everywhere and in all things. The deities and their emblems are but its ciphers, the ephemeral masks that hide its countenance.

It is this countenance whose features this study has attempted to envision beyond the inroads of creedal and interpretative projections, whose perpetual reality it has sought to trace from the passing pageant of its disguises. To this end, India's art and iconography, especially in their abundance and variegation throughout her central regions, have seemed to offer the most immediate and effective guide. For, whether spontaneously evolved to characterize, in terms of mundane sensibility, some aspect of the extramundane essence, or, again, superimposed to conceal or pervert its identity, even in their dissimulations the masks of the Divine remain powerful tools of insight. The specific choices and peculiar attributes of its disguises testify to the character of the model.

On the most elementary level this model proves to be a universal constant. India's pre-Aryan and non-Aryan conception of the Divine not merely parallels but, modified only by the incidental variances of the diverse ecologies, defines the fundamental pattern common to prehistoric and early historical cultures. Created by man in his own image, the countenance of the godhead is predetermined by the generic identity of human nature. Its universal analogies are inherent in its origination. Thus the Indian cast of this countenance is by no means singular, but, favored by a combination of local conditions, it is singularly vivid. The jungle-encompassed seclusion of so much of the country, permitting only the most perfunctory penetration by alien ideas; the inherent unattractiveness of the Vedic, and the evident unpersuasiveness of the Hindu doctrines, incapable of minimizing the appeal of the popular traditions; the peculiar propensity toward representational expression, apparently native to most ancient India, allowing, even beneath the veneer of a later creed's superimpositions, perpetual paraphrases of the old beliefs; all these factors must have contributed to the superior distinctness of this divine silhouette and, in the process, to a more encompassing view of man's image of the supernatural, its impact on his history and culture in general, and on the Indian scene in particular. Certainly the disquisitions of this study have fully indicated the extent to which the current attitudinal and cultic propensities of the countryside, and, even more incisively, its extant figural and symbolic imageries, have enhanced this especial intelligibility. Collectively they chronicle India's past, the shifting balance of unresolved antagonisms and incidental adaptations that, inherent in the juxtaposition of Aryan-Vedic and folkloric elements, outline the path of her cultural history. Its trail seems well traced by their testimonies. So, too, the vicissitudes of her indigenous traditions, from their prehistoric beginnings through their long centuries of forced obscurity and even longer ones of gradual recovery, to their eventual reassertion as the principal and effective vehicles of India's religiocultural heritage.

Yet, within the context of this study, such clues to India's historical evolution have been accessory rather than integral to its endeavors, the byproduct rather than the purpose of its explorations. The quest of this

inquiry has been for a new appreciation of the origins of Hinduism, for a clearer vista of the model of the Divine that appears to have been its primary instrumentality.

Relying on extant iconography as its best evidence, the conclusions of this study do not merely sustain and elaborate Coomaraswamy's assertion, "In India it becomes more than ever clear that thought and culture are due at least in equal measure both to Aryan and indigenous genius";[1] they suggest that, indeed, this evaluation may have considerably understated the case for the native tradition. The testimony of the imageries simply does not seem to validate any such near balance of the interlocking influences. India's vision of the Divine emerges as essentially the vision beheld by her indigenous culture complex,[2] a vision antedating the advent of the Aryan, surviving it to persevere as the chief element of her religiocultural experience and the principal architect of Hinduism.

Beyond its temporal masks, the authentic countenance of India's godhead still reveals itself as the one apprehended by her native peoples well before the dawn of history. Psychological, no less than chronological, remoteness has inevitably dimmed its full aspect. But, preserved by the vigor of indigenous India's profound commitment, its contour at least has remained intelligible. Many of its lineaments will, it is hoped, in time be drawn more firmly by further inquiries. Whether by expanding the material presented in this initial work or by proceeding from diverse premises to areas of research not included in it, any contribution to a more complete, more integrated comprehension of its Indian cast will prove most valuable, not merely on its own account but equally for its implications concerning the religious actualities of mankind as a whole.

For, as emphasized before, native India's model of the Divine is ancient humanity's universal model, born of men's identical intrinsic needs, shaped by their equivalent extrinsic perceptions, endowed with analogous attributes defined by their analogous interpretation of their own existence and that of the world about them. Iconography and cultic tradition have seemed concordant in pointing to this model's origination as the archetypal incorporation of the Feminine Principle, the supernal objectification of a perspective that perceived all life-sustaining power as essentially female, and implicitly equated Nature and its processes with the vehicle of that very power. All closer inspection of the imageries has led to the conclusion that behind the ostensible figures of India's deities rises, however distant and obscure, the shadow of that model. Beyond the putative faculties and activities of these celestials persists, a constant of inspiration, the presence of Devī, the great mistress presiding over the Indian segment of the Realm of the Goddess.[3]

Devī's character should require no further description here. Reflected by the multiformities of her extant likenesses, and epitomized by the symbols of serpent and lotus, it has sufficiently emerged from the explorations of this study. Nor need the liturgical diversities of her cult be considered in detail. Its basic, ecstatic, and erotic tenor has been recalled by the joyous frolics of ganas and gandharvas and kimnaras, the suggestive sinuosity of dancing apsarases and self-displaying surasundarīs; and its ultimate sacrament has found its iconic transcriptions in the delights of the maithuna couples.

On the other hand, the implications which Devī's character and her attendant cult present for the societal structure and religious conceptions of a faraway age may warrant a brief summary, not alone because of their specific reference to the Indian past but because of their extended reference to the full orbit of the Realm of the Goddess.

Clearly, the mistress of that realm's Indian province was perceived as the prototype of the young, physically attractive and psychically challenging, emotionally and erotically active female. On this point the testimony of central India's iconography seems incontrovertible. As has been seen and emphasized, the countless images of the Divine Feminine, whether depicting their subject in her supernal or her secondary identities, perpetuate the vision of woman as lover rather than mother, as bride rather than matron. Being, like all images of godhead, the given community's idealized self-image, this image of godhead inherently determines the cast and structure

of the social scene. It postulates not only the preeminence of the female group within the body social but, more specifically, the predominance of such of its members as would most closely conform with the divine archetype. Thus it is to those who manifested Devī's characteristic aspects that the age's leadership must have fallen, certainly in the religious sphere, and quite probably in the political arena as well. It is the young, nubile woman who, as the Goddess' mundane replica, presides as priestess and as queen, most likely in both functions concurrently, thus defining her dominion as structurally a gynocracy rather than a matriarchy. The actuality of woman-ruled societies of this type has never faded from man's memory. The Greek stories about the fabled Amazons are but the most familiar among many similar allusions; and, significantly, the several Amazonian priestess-queens cited in them are without exception described as young and beautiful, in fact as specimens of female perfection. India herself, too, has preserved such legends, as that of *strīrājya*, the Empire of Women.[4]

Given the specific conception of the Goddess, the essentialities and even the elementary liturgical ramifications of her cult would seem self-defining. The very nature of the female divinity and the prevalence of the feminine viewpoint within the devotional group must predicate a pattern of worship most expressive of, and responsive to, women's psychic needs. The unequivocally emotional, directly experiential, ecstatic, and erotic character of this worship is not a matter of presumption or of speculation and deduction. Beyond its obvious recall by the imageries of a later age, it is evidenced by the visions and perceptions, the doctrines and rituals of Tantrism, in which the ancient religion achieved its revival, quite as elsewhere it would achieve some measure of restatement in the various mystery cults.

But Tantrism, for all its instrumentality as an architect of India's ethos, merely reemphasized, reformulated, reactuated the predilections of the indigenous tradition, refocused the elements of a religious and ideological heritage that had been scattered but never squandered. As so many aspects of cult and iconography reveal, the countenance of Devī, the divine lover and beloved, the dispenser of mundane joy and human fulfillment, has always remained the object of India's adoration. Among the most typical witnesses of this is the circumstance that it is Rādhā, Krishna's paramour and subject of his erotic imperative, Rādhā, his lover and beloved, not Rukminī, his lawful spouse and mother of his children, who has continued as the recipient of both popular affection and official worship: for it is she who presents, not merely a palpable manifestation of Devī, but the very incarnation of her fundamental ethos; whose intimacies with Krishna evoke in the communicant the mystique of mahāsukha, of redemption through erotic realization. It is within the setting of unfettered Nature, imbued with the Goddess' presence, that their moments of passionate abandon elicit an instant of his *participation mystique*.

In telling contrast, Rukminī, the archetypal exponent of the patriarchal ethos and its model of female role and function, has remained a canonical cipher, quite like so many deities, major and minor, introduced into Hinduism by its Aryan-Vedic components. She retains the reverence of the Brahmanical texts; but it is Rādhā whose likenesses grace altars and temple walls, whose memories have preempted the offerings of pūjā.

In the broadest sense, the juxtaposition of Rādhā and Rukminī symbolizes the genesis and history of Hinduism, the syncretism that produced the ostensible fusion of the heterogeneous elements of India's indigenous and orthodox traditions. As they are joined to him, the one by the imperative of human nature, the other by the dictate of priestly injunction, Krishna's two female companions constellate the intrinsically oppugnant conceptions of the Divine, confront each other as the archetypal personifications and exponents of the resultant, ultimately incompatible religious ideologies and systems which are represented by the indigenous and the Aryan-Vedic traditions, but trace back to the characteristic perspectives evolved in the era of the Goddess's dominion, and the succeeding one of the Divine Patriarch's reign.

The figures of Rādhā and Rukminī, then, epitomize the two fundamental types of religion, defined in their antithesis by their godheads, apotheoses, respectively, of the Id and the Superego; the one cosmic and mystic in its

accents, the other social and pragmatic; the one relying on the internal experience as man's guide, the other on the external Law; the one perceiving divine power as immanent in nature, the other deeming it nature's transcendent creator and overlord; the one emphasizing the joys of life in the here and now, the other those of an afterlife in a chimerical beyond; the one essentially anthropocentric, holding out the prospect of human fulfillment through actuation of the Divine Within, the other uncompromisingly theocentric, conceding no possibility of such realization, save through the will and grace of the Deity Above; the one seeing existence as continually self-creating, as eternal Becoming, the other regarding it as finally created, as categorically defined Being.

Hinduism, of course, has not been singular in its attempt to syncretize these diametrical opposites. All religions, including those that have arrogated to themselves the attribute "great," have been the products of a similar conceptual and cultic integration of the heterogeneous traditions, which alone could promote their popular acceptance and their consequent viability. But Hinduism's attempt constitutes the most spectacular and elaborate, most encompassing and obvious of them all; and, at least in its apparent aspects, the most successful and enduring one. Perhaps this strength and resilience have been due to its comparative lack of dogmatism and its ensuing capacity, unmatched by other religious systems, for tolerant accommodation of heterodox viewpoints, interpretations, and even cultic activities within its creedal structure.

In fact, Hinduism has evolved through a continual progression of such accommodations, tacitly acceding to the shifting balance of its component inspirations in favor of the indigenous viewpoint. Its concurrent canonical as well as practical recognition of both Rādhā and Rukminī offers one of the most typical among the abundant examples. Incompatible exponents of the indigenous and Aryan-Vedic viewpoints, they yet have come to coexist as complementary aspects of female ideality.

Complementary, but unequal. For, whatever their relative creedal or cultic prominence may have been in the early days of this accommodation, for many centuries past Rādhā has enjoyed undisputed preeminence.

Yet, for all its ramifications, Rādhā's ascendancy over Rukminī gains significance less as a phenomenon in its own right than as a particularly distinct, persuasively eloquent symbol of Hinduism's evolution, of which, after all, it is but another incidental manifestation. Delineating the relative balance of the syncretized elements, it capsules the repetitive and concordant testimonies of the countless imageries, and finally affirms the prevalence of the indigenous tradition in the mosaic of India's religious life.

Inevitably extending its import to the very fabric of Indian culture and ethos, this prevalence is the central fact emerging from the considerations of the present study. Its total impact on the Indian scene reveals that, for the preponderance of its elements, what has been designated India's Great Tradition is indebted to her indigenous, pre-Aryan, non-Vedic heritage. As documented by the iconic arts of the sacred sites, corroborated by the idiosyncrasies of popular cult, and confirmed by the innuendos of myth and legend and the pointed suggestions of etymology, it is the preservation of this heritage that has made India's Great Tradition a truly great tradition.

NOTES

INTRODUCTION

1. See particularly Redfield, *Peasant Society and Culture,* Chapter Three. In the process of universalization in India "the little traditions of the folk exercise their influence on the authors of the Hindu great tradition," and in the process of parochialization "some Sanskritic element is learned about and then reformed by the villagers" [pp. 54–55]. See also Leslie, *Anthropology of Folk Religion.* Anthropologists are, of course, concerned with both directions of cultural communication; this study, by definition, concentrates its investigation on the evidences of universalization.

2. In the use and interpretation of semantic material, the renderings of Sanskrit terms in English, when appearing within quotation marks, are literal quotations from Macdonell, *A Practical Sanskrit Dictionary.*

CHAPTER TWO
ANTHROPOMORPHIC MASKS OF THE GOD

1. Pūjāri: the priestly initiate who performs the ritual sacrifices. Though most often officially bound to the cult of one of the sanctioned divinities, in the countryside he is, sometimes quite unconsciously, the chief repository of folk religion's lore.

2. The use and symbolism of red lead (sindoor) is discussed in a subsequent context.

3. Throughout Eastern Madhya Pradesh the designation "Mahābir" replaces that of "Balaji." Literally, "Mahābir" means "Great Hero"; but this connotation is extended to that of "Great Being", and is employed in a sense identical with that of "Balaji."

4. The pūjāri's identification of this image as Balaji, however, was erroneous. It did not consider the sexual identity of the divinity, indicated by the crown that is almost exclusively the emblem of the female godhead. See discussion of this icon in a subsequent context.

5. The figure of Maroti, his genesis and significance, are considered in detail subsequently.

6. A discussion of Shankara, is found in Chapter Three; the symbols of trident and bull, are considered in Chapters Four and Five, respectively.

7. The trimūrti aspect of Shiva is explored in Chapter Ten.

8. This may account also for the inconsistency of this constellation, which has Krishna, who belongs to the Vaishnavite cycle of myth and cult, sharing the altar with Shiva and Durgā. If these icons represented the likenesses of folk divinities, their incongruous configuration would be of no moment.

9. The design and significance of the kīrti-mukha are explored in Chapter Four.

10. The concept of māyā and its non-Aryan origin are explored in Chapter Nine.

11. See, for instance, Basham, *The Wonder That Was India,* p. 317.

12. See Coomaraswamy, "Yakshas," p. 36.

13. Zimmer, *The Art of Indian Asia,* p. 35.

14. Basham, p. 317.

15. See Coomaraswamy, "Yakshas," p. 37.

16. It may be noted here that for the purposes of this study the designation "yaksha" is used not only in the narrowly circumscribed sense, but also in its inclusive application, extending to all the divinities of the old religion that still dominate the beliefs of the countryside. These divinities, some of benign, others, again, of demonic character, are known by a variety of regional and local designations. Many of them, like the *bhūtas* and *pretas,* represent the embodied spirits of the dead; others, like the *rakshasas,* the ancient guardians of the villages. In fact, the appellation of the latter divinities derives from the verb *raksh,* "to guard, protect," and thus identifies their original function; while the term *bhūta* signifies at once "having been, past," and "existing, present," indicating that those that have been and have passed away are still existing; the term *preta,* derived from *pra-ita,* "gone forward," signifies the "departed, dead," and at the same time "ghost, spirit." The subsumption of these and similar types of supernatural beings in the collective designation "yaksha" seems amply justified since the distinctions reflect functional specializations and subtleties of nomenclature rather than differentiations of

essence; this also seems indicated by the circumstance that the aboriginal Veddas of Ceylon revere the *yakkas* (obvious counterparts of the yakshas of India), who are indeed the spirits of the dead.

17. This phenomenon is discussed more fully in Chapters Six to Eleven.

18. See Chapter Six.

19. Harihara: this designation indicates the nature of the image. *Hari* is an epithet of Vishnu, *Hara* one of Shiva.

20. Trivikrama: literally, "of the three steps," referring to a legendary incident in Vishnu's *vámanávatára,* his incarnation as a dwarf.

21. The non-Hindu inspiration of this myth has been recognized. It is suggested by Basham, who remarks that "the three steps of Vishnu are as old as the Rig Veda, but other popular elements were incorporated into the story" [p. 303]. It would appear that the three steps count among these elements.

22. For the reason for this, see Chapters Three and Nine.

23. Shakti: literally, "power, energy," and generally applied in the meaning of a god's female energy. The concept of female energy is fully discussed in Chapter Nine.

CHAPTER THREE
THE CANONICAL GOD

1. See Zimmer, *The Art of Indian Asia,* Plate 372.

2. See Basham, p. 235.

3. This role is still recalled by his epithet, *jagaddhátri,* "creator of the world."

4. The Macdonell *Dictionary* officially ren-

ders this term as "Son of Man," but a more perceptive examination might suggest an equally literal rendering of "the human vehicle (of the Divine)," which accords far more closely with the actual meaning of this aspect as well as with the old-religion outlook generally.

5. Only the anthropomorphic avatārs are considered here. The zoomorphic ones are discussed in Chapter Five.

6. Basham, p. 298.

7. This process is not wholly dissimilar from that operative in the composition of King Arthur's Round Table, where the persons and stories of many local legendary figures have been loosely related to a central personage who provides the now desirable framework for the new Christian ideology.

8. This conjecture is based not only on the geographical implications of Rāma's mythical exploits, but also on the observation that the cult of this avatār seems proportionately more important and widespread throughout these areas than in the rest of the country.

9. The description of Rāma's allies as "monkeys" must be evaluated in its historical and cultural perspective. "Monkey" represents one of the usual derogatory descriptions applied to the aborigine, particularly if he is dark-skinned and forest-dwelling, by a racist-oriented conqueror people which considers itself the only human type of being.

10. Vasudeva is clearly a Sanskrit title for a native divinity of a character appropriate to the meaning of "the beneficent god."

11. See, for instance, Zimmer, *The Art of Indian Asia,* Plate 307.

12. See Zimmer's rendering of the story from the Sanskrit text in *The King and the Corpse,* pp. 289–91.

13. Evidence for this is the circumstance that throughout India there is but a negligible number of temples in Brahma's specific dedication. The best known of these is at Pushkar, Rajasthan, near Ajmer. In Khajuraho, too, there is a "Brahma" temple, but it appears that this may have been a misnomer inspired by the four-faced idol inside the shrine, the four-faced (*chaturmukha*) aspect being primarily identified with Brahma. But as here this chaturmukha is associated with a linga, it would appear to indicate rather the four-faced Shiva and thus identify the temple as a Shiva shrine.

14. See Zimmer, *The Art of Indian Asia,* Plate 2a.

15. It is for this reason that this figure has been designated as pashupati, commonly rendered as "Lord of the Beasts," but more correctly to be read as "Lord of Living Beings."

16. Especially throughout eastern and northern Maharashtra and the adjoining sections of Madhya Pradesh, Shiva is often known and worshiped as Shankara, and quite a few of the shrines in that area are dedicated to Shankar or Shankarji.

17. Dakshinamūrti has the meaning of both "in southward-looking aspect" and "in amiable or obliging aspect." Typically in this manifestation Shiva has four hands. The animal is generally held to represent a horse but consistently appears rather like a doe, an animal of the forest.

18. The preeminent role of the erotic in the old religion, and its underlying conceptions, are discussed in Chapters Eight, Nine, and Thirteen.

19. These various aspects of the linga are discussed in Chapter Four.

20. See Zimmer, *The Art of Indian Asia,* p. 27.

21. Evaluation and interpretation of this symbolism are attempted in Chapter Ten.

22. See, for instance, Kramrisch, *The Art of India,* Plate 100.

23. See Chapter Ten, where this subject is considered in full and its supporting illustrations are presented.

24. See Zimmer, *Myths and Symbols in Indian Art and Civilization,* p. 90n.

25. The figure and character of Maheshvarī are considered in Chapter Ten.

26. Interpretations of Shiva's dance in its cosmic and esoteric significance have been offered by many authorities, for instance by Coomaraswamy in *The Dance of Shiva,* pp. 66–84. Their discussion here would prove repetitious and not suitable in the present context. However, the conceptions underlying this ecstatic image of the godhead are explored in Chapters Nine, Ten, and Thirteen.

27. This is likely in view of the prominent bull cult in Mesopotamia and the documented intercourse between that land and at least the area of the lower Indus, known to the Sumerians as Meluhha.

28. See Chapter Twelve.

29. This proto-Kāma must not be confused with the later Hindu Kāma, the god of love, who, in character and function totally different, has no tradition in Aryan lore.

30. This story offers a mythopoeic rendition of the early struggle between the Aryan and the native deity, and of the latter's success, achieved perhaps by something less than peaceable means, in asserting the claims of the old religion against those of the rival system.

31. As noted before, Brahma's prestige and cult were in a decline acutely proportional to the ascendancy of Shiva's; thus the latter's assumption of the fifth head would merely symbolize the accomplished fact of his superiority.

32. This subject finds more detailed consideration in Chapter Nine.

CHAPTER FOUR
THE SYMBOLIC PRESENCE OF THE GOD

1. Zimmer, *The Art of Indian Asia,* p. 22.

2. See Basham, p. 24.

3. See Chapter Eight.

4. "Compared with it the other representations are regarded as secondary," remarks Zimmer in *Myths and Symbols in Indian Art and Civilization,* p. 126.

5. Zimmer, *ibid.,* p. 129.

6. Zimmer, *ibid.,* has probed into many of them, but much more needs to be done in this respect.

7. See Chapter Ten.

8. For Ganesha's cult, character, and function, see Chapter Five.

9. See Chapter Eight.

10. See Zimmer, *Myths and Symbols,* pp. 181–184.

11. Zimmer, *ibid.,* p. 184.

CHAPTER FIVE
ZOOMORPHIC MASKS
OF THE GOD

1. See, for instance, Neumann, *The Great Mother*, p. 12.

2. There is no apparent reference to Ganesha, literary or iconographic, earlier than the fifth century A.D.

3. The vehicle of the rat, is considered subsequently in this chapter.

4. See Basham, p. 315.

5. See *ibid.*, pp. 314–15.

6. See Zimmer, *Myths and Symbols*, passsim.

7. See Piggott, *Prehistoric India*, Fig. 22; and Zimmer, *The Art of Indian Asia*, Plate 2c.

8. Gaja-Lakshmī: literally, "Lakshmī of the Elephants." A discussion of this icon may be found in Zimmer, *Myths and Symbols*, pp. 90ff. It is given further consideration in Chapter Eight.

9. The ritual appearance of the priest in animal mask has been documented as a common feature of ancient cult everywhere, with roots reaching back into furthest prehistory.

10. See, for instance, Basham, p. 308.

11. Tantric cults: mystically oriented heterodoxies emphasizing the ecstatic as well as erotic element in their liturgies. They are considered fully in Chapter Thirteen.

12. Most scholars have not even attempted an explanation. Those who have, like Zimmer (see *Myths and Symbols*, p. 183; *The Art of Indian Asia*, p. 46), seem to have lost themselves in tortuous, entirely unpersuasive arguments.

13. Also variantly called Hanūmat and Hanūmant. The former version is held to be the authoritative one. However, as the more familiar and more widely used one, the form Hanūman is referred to here.

14. Their "divine" or "demonic" character depends in part on their identifications with natural phenomena, experienced by man as beneficial or noxious, but more largely on the local influence of the canonical creed which would implicitly define all old-religion deities as antigodly and therefore demonic.

15. See Chapter Eleven.

16. This number is significant. Its meaning is made apparent by considerations presented in Chapter Nine.

17. Vāhana: literally, "vehicle." A designation applied to emblematic forms, often zooidal, assigned to specific deities as their identifying attributes. Generally the vāhana appears below the divine effigy. The rat of Ganesha, the bull of Shiva, the elephant of Vishnu, the hamsa (gander) of Brahma are some of the familiar examples.

18. It might also be considered that the Sanskrit term for peacock is *nīlakantha*, the very designation that has been encountered as an epithet of Shiva. Perhaps this circumstance points to the absorption of an ancient peacock god cult into the more general one of the all-encompassing aboriginal deity, Shiva.

The aboriginal importance of the peacock may be reflected by the veneration of the peacock even today in some tribal societies, for instance, the Saoras. See Elwin, *The Tribal Art of Middle India*, pp. 151–55.

19. See Chapter Twelve.

20. See Basham, p. 303.

21. To argue that the lion cult may have been imported into this area would be to assume the unlikely. All evidence suggests that, for their divine subjects, theriotheistic cults have drawn on the familiar fauna of their immediate environment.

22. See Basham, p. 298. Malwa was an ancient kingdom situated in the western part of present-day Madhya Pradesh, and until recently constituted the heartland of the former province of Madhya Bharat.

23. Yoginī: generally designated "servant of the goddess." A manifestation of the Divine Feminine, her identity is explored in Chapter Nine.

24. The designations of these incarnations are matsyāvatāra and kūrmāvatāra, "fish incarnation" and "tortoise incarnation," respectively.

25. The Tritons of Greek legend are associated with Amphitrite, wife of Poseidon and sea goddess. Pluralizations of the god Triton, a masculine form of the primal Libyan goddess Trito, they are thus closely affiliated with the cult of the female deity.

26. See Chapter Twelve.

27. Basham, p. 302.

28. For further reference to this myth, generally designated The Churning of the Sea, see Chapter Eight and Twelve.

29. For the character and role of Sarasvatī see Chapter Eight.

30. As expounded in Chapter Twelve, the serpent represents the foremost cultic and emblematic animal equivalent of the Goddess. The life-and-death enmity of solar bird and

serpent therefore reflects the antagonism of the opposing religious systems.

31. It is often supposed that this elemental antithesis of the drying heat of the sun and the all-penetrating moisture of the waters has been symbolized by the conflict of the solar bird and the serpent. Though indeed the serpent figures as the archetypal zoomorphic representative of the water, and its elemental antithesis to the heat-dispensing sun may well be a contributing facet of solar bird-serpent struggle, it appears that in the latter a more pragmatic constellation has found its symbolization. See Chapter Twelve.

32. See Basham, p. 317; Zimmer, *Myths and Symbols*, p. 120.

33. It might be noted that one of these beings is obviously female, yet nowhere has the existence of a female kimnara been acknowledged.

CHAPTER SIX
THE REALM OF THE GODDESS

1. Von Cles-Reden refers this designation to the Mediterranean and Western European areas only, since these delimit the subject of her studies. However, examination of other parts of the world prove that it is applicable everywhere.

2. See Chapter Thirteen.

3. See Chapter Eleven.

4. Here examples have been selected from the central areas of India only. Similar ones may, however, be found throughout the subcontinent. Thus, to mention only two of the most prominent, at Aihole, Mysore, the largest and most beautiful of the many temples is dedicated to Durgā; and at Madurai, one of the principal centers of southern Shiva worship, the main sanctuary is that of Mīnākshī-Sundareshvara, that is, the Goddess as Shiva's paramour and Shiva as the lord and spouse of the Lovely One. (See Zimmer, *The Art of Indian Asia*, Plates 116 and 448, respectively.)

5. This interdependence of the two aspects of the female divinity is considered in Chapters Eight and Nine.

6. Mangalādevī: another eponym of Umā, Shiva's spouse.

7. The larger, adjoining sanctuary is dedicated to Shiva.

8. See Chapter Eight.

CHAPTER SEVEN
THE VEDIC GODDESS

1. Danu appears as a great goddess throughout the Indo-European sphere of occupation, emerging in such identities as the Celtic and Teutonic Danu, the gentle Dennitsa of the Slavs, and the voluptuous Danae of the Greeks.

2. See Chapter Nine.

3. Basham, p. 233.

4. Etymologically the name Ushas is cognate with the Greek Eos and the Latin Aurora, both goddesses of the dawn, originally conceived as personifications of ever new beginnings.

5. These, of course, are merely a few random examples. There were more such female personifications of aspects of nature, since nature herself—as Chapter Eight makes evident—was envisioned as Woman Divine.

6. The original femaleness of the fire deity is evident from the mythologies of many peoples. For the prepatriarchal Indo-Europeans it is confirmed by the cognate terms for "fire" in Sanskrit and Latin, *agni* and *ignis*, respectively, the Latin *ignis* being, most significantly, of feminine gender, pointing to the fire's original personification by a female divinity. This female character is inferentially recalled by the god Agni's epithet, "lotus-born," which identifies him with the principal and fundamental symbol of the Goddess. (See Chapter Eight; for Agni's lotus association, see Zimmer, *Myths and Symbols*, p. 90n.) Other indication of Agni's original female character is offered by his appearance in tri-mūrti (see Frederic, *The Art of India*, Plate 324) which, as shown in Chapter Ten, inherently refers to the female aspect of the Divine.

7. Sāvitrī is she who disposes of the *sava*, the juice of *soma*, the elixir of the lunar power, personified by the god Soma. The term is a cognate of the Germanic root which has produced our own "sap" and the German *saft*.

8. See Basham's reference (p. 316) to Vāch as a "hypostatic" goddess.

9. Originally this divine voice may have been embodied by a prophetic priestess who eventually was apotheosized. It may well be that this aspect of the revealing divinity contributed to the selection of the lotus goddess as the equivalent of Vāch. See the discussion of Lakshmī in Chapter Eight.

10. Bog: the great Slavonic god, conceived as masculine. The meaning of the Slavonic designation has come to be simply "god."

11. Vohu-mano: most commonly translated as "Spirit of Wisdom," but the original meaning may have been "Voice (or Revelation) of the Intellect."

12. The relative insignificance of the goddess Vacuna in Roman times is deceptive. Her far greater ancient prominence seems indicated by her eventual designation as a companion of the most Roman of gods, Mars. Originally her role may have been that of the "Voice of the Great Mars," god of the battlefields.

13. In later times she would, in accordance with the general resurgence of goddess worship, regain some measure of independent status and cult.

14. This fivefold appearance of Brahma's mind-born goddess has its genesis in a symbolism examined in Chapter Nine.

15. This concept is reviewed in Chapter Nine.

16. See Zimmer, *The Art of Indian Asia*, Plate 243.

17. Among other indications, the probability of Sūryā's original identity as an archaic Indo-European sun goddess seems reinforced by Slavonic mythology which knows the three goddesses of Morning, Noon, and Evening—the phases of the sun's daily path—by the name of Zoryas, an appellation evidently cognate with that of Sūryā.

18. See, for instance, Kramrisch, *The Art of India*, Plates 11 (pillar on the right) and 137.

19. In its Indian form of the hamsa this ubiquitous bird is not clearly defined zoologically, being variously identified as a swan, a goose, or a gander. Though assigned to Brahma as his vāhana, originally it may have been the avian attribute of the lotus goddess, and was assumed by Brahma from her when she became his "wife." Abundant analogies point to this probability: variations of this bird have been associated with the cult of the Goddess elsewhere, including the sacred dove of the Greek Demeter and the Syrian Astart (later reappearing as the symbolic attribute of the Virgin Mary); the sacred swan of the Celtic Brigit and the Aetolian Leda, daughter (i.e., aspect) of the moon goddess Leucippe.

20. The symbolism of the lotus is discussed in Chapter Eight.

CHAPTER EIGHT
THE LOTUS GODDESS

1. See Macdonell's *Dictionary*. The diversity of meanings conveyed by the term Lakshmī is commented on subsequently.

2. The name of this celebration is Dasharah (from Sanskrit Dasharātra, "tenth day").

3. See "Sarasvatī" in Macdonnell's *Dictionary*.

4. Padminī, "possessed of the lotus"; Padmasambhavā," lotus-born"; Padmākshī, "lotus-eyed"; Padmānanā, "lotus-faced"; Padma-ūrū, "of lotus-like thighs"; Padmeshthitā, "standing on the lotus"; Padmahastā, "carrying a lotus in the hand."

5. Designations such as Padmahastā or Padmeshthitā, evidently descriptive of a particular posture or appearance, bespeak the antiquity of the lotus goddess as a subject of India's iconography.

6. As noted previously, the lotus, which is not native to the regions whence the Indo-Aryans had proceeded, could not have been identified in terms of their own language. The diverse appellations of the lotus goddess must therefore be assumed to have echoed indigenous, perhaps regional idiomatic designations of the flower and its several subspecies.

7. Macdonell's *Dictionary* renders as the most important definitions "Good Fortune, Dignity, Glory; Wealth, Beauty, Splendor."

8. "Lakshmī" also has the meaning of "Auspicious Sign, Mark, Token." (Macdonell's *Dictionary*)

9. *Chala,* in nonpersonified, adjectival form, denotes "unsteady, wavering, fickle." Personified, then, Chalā is the Fickle One, Dame Luck.

10. This parallel is even more appropriate in that Fortuna, too, evolved from pre-Roman beginnings as the great goddess, Fors, into the comparatively trifling figure of the Goddess of Fortune.

11. See Zimmer, *The Art of Indian Asia*, p. 160.

12. The connections of the lotus symbol with other divinities is considered subsequently.

13. See Chapter Thirteen.

14. This seems well indicated by the official double name of the goddess, Shrī-Lakshmī.

15. Sarasvatī may well be presumed to have been the lotus goddess' indentity in the region of Brahmāvarta, the nuclear Indian domicile of the Aryans before their eventual expansion, for it is in this region that the sacred river

Sarasvatī, especially dedicated to the Goddess, ran its course.

16. These contrasting poses of Lakshmī and Sarasvatī may often serve to distinguish these two aspects of the lotus goddess, when conjoined with Vishnu; particularly, as often no symbolic attributes aid their identification.

17. Mahālakshmī: the Great Lakshmī. Her relationship to Nārāyana is affirmed also by Macdonell's *Dictionary*. See article, "Mahālakshmī."

18. Depictions of the lotus goddess in her ostensibly maternal role are, though not exceptional, infrequent compared to the prodigious recurrences of her portrayals in primarily erotic accents or suggesting her magical character. The actual incidence of her depictions as mother contrasts significantly with the repetitive dedication of sanctuaries to the goddess as mother (Mātā, Ambā, Ambikā, Ammai, etc.). The assumption that shrines so named are presided over by a "mother goddess" would prove fallacious. Most of these dedications are addressed, rather than to specific physical motherhood, to a cosmic metaphysical maternal principle and to the sustaining, life-affirming properties commonly associated with it.

In fact, the iconography of India demonstrates the undue emphasis which so many authors have placed on this archetype of the Divine Female. The contradiction presented by the comparative paucity of "mother goddess" figures even in temples which, by their very designation, are ostensibly consecrated to the goddess as mother, may have its origin in the superimposition of a male-centered ethos on indigenous India's perspective. Woman's erotic role, in the expression of which the give-and-take of the interrelationship would implicitly establish her as man's equal, was implicitly rejected by the Aryans in favor of her maternal role, which tended to relegate her to a special, narrowly circumscribed sphere of application subordinate to masculine direction and leadership. As Woman Transcendent, the goddess would necessarily assume this aspect, her functions and powers now promulgated in terms defined by sociopolitical ideology rather than religious experience.

This ideology was, however, no more than partially, and often but nominally, assimilated by the subject population; though, imposed by the powers that be, it elicited compliance. The description of the goddess as mother became one of the gestures of conformity; but her perception in all the concurrent meanings of her yoni-lotus personification would continue as the effective focus of the subject population's religious experience. Accordingly, her effigies have persisted in portraying her in terms of her authentic nature, while at the same time affecting the authoritative if empty title of "mother."

19. It is not improbable that these two stories represent divergent versions of the same original legend.

20. As, for instance, the Latin *natura*, which derives from the root connoting the process of birth and birth-giving.

21. Her stellar aspect is still recalled by the divine Tārā, "Star," who appears as the consort of Mahāyāna Bodhisattvas. Occasionally she is recalled in Hindu and popular worship as Tārini, "the Star-like One," but in this identity she receives no special worship or iconographic attention.

22. *Pushkara* is one of the many designations of the lotus.

23. See Basham, Plate IXd.

24. A more likely interpretation of this configuration is suggested in Chapter Nine.

25. Analogous depictions of the mistress of the plants in other areas, many stemming from prehistoric times, tend to encourage this presumption even in the absence of any substantiating material from India herself.

26. See Zimmer, *The Art of Indian Asia*, Plate B-3b.

27. *Ibid.*, Plates 33-B, 24-B.

28. *Ibid.*, Plate 15.

29. *Ibid.*, Plates 33-B, 34-B.

30. The myths and legends involving the Greek dryads clearly seem to point to the original character of these semidivinities as local mistresses of the plants. The analogy of vrikshakā and dryad, as implied by the synonymous rendering, seems therefore quite appropriate.

31. Dharā, Dharani, "earth"; Dharti, "Sustainer, Preserver," used synonymously with "Earth."

32. It may be recalled that Sītā was eventually recognized and reelevated as a divinity, a process certainly not only facilitated by, but also premised on, her original identity as an earth goddess.

33. See Chapter Nine.

34. Cf. the intimate mythical association of such divinities as Cybele, Dictynna, Circe, Eurynome, and Thetis with the cave or grotto.

35. Among the most famous of these cave temples are those of Badami and Bagh, Elephanta and Udayagiri, M.P. (Hindu); Nasik, Karli, and Khandagiri (Jaina); Ajanta and Barabar Hills (Buddhist); the caves of Ellora divide their dedication among all three creeds.

36. Cf., for instance, Zimmer, *The Art of Indian Asia*, pp. 165, 166.

37. *Ibid.*, p. 166.

38. *Ibid.*, Plates 64a, 80, and others.

39. *Ibid.*, Plates 151, 378.

40. See, for instance, Macdonell's *Dictionary*, article "Sarasvatī."

41. The respective dictionary meanings are given as "Divine Beauty," "Celestial Nymph," "Minor Goddess," and "Infatuating One," but these terms are not clearly distinguished from each other and may be used interchangeably. Obviously, all of them are subsumed in the term "Devikā," "Minor Goddess." As every image reveals, all possess the "infatuating" quality of the mohinī, and certainly all may be identified as "celestial nymphs." Possibly one differentiation may be tentatively proposed: in contradistinction to those in static postures, the dancing figures of the celestial female may be designated "apsarases."

42. See Zimmer, *The Art of Indian Asia*, Plates 312, 337, 338-39, 352-53.

43. *Yoginī*: "sorceress"; *nāyikā*: "heroine."

44. As indicated by his title, and aspect, as Someshvara.

45. The Baiga are a tribe of central India, with a considerable concentration also in the Bilaspur area which includes Gatora. Thakuranī is their chief female deity, who has been canonically identified with Kālī-Durgā wherever Hindu orthodoxy has been able to impose itself on the tribal religion. For details see Elwin, *The Baiga*, p. 55.

46. In reference to the prehistoric antiquity of India's female deity, it is instructive to observe how her conception and vision have been preserved with little change since those early days. The striking similarity of the Baiga goddess of Gatora and the goddess of Charsada (see Wheeler, *Early India and Pakistan*, Plate 55) and even the Indus Valley goddess (see Zimmer, *The Art of Indian Asia*, Plate A8), the former of the third century B.C., the latter of about 2500 B.C., points to an almost unbroken line of religious apprehension. Also it may be noted that the Charsada goddess is wearing a lotus in her hair. Though this attribute is not duplicated by the Baiga goddess, we need scarcely doubt the analogy of their characters and roles.

CHAPTER NINE
THE GODDESS AS SHAKTI

1. A few examples may suffice: the Greek *energeia*; the Latin *vis*; the German *die Kraft*; and, outside the Indo-European language family, the Hebrew *Shekinah*, signifying the active power of God.

2. Aryanized India has by no means been alone in this superimposed inversion. The emanation, from the head of Zeus, of Pallas Athena who demonstrably had reigned long before his coming, is but one of many equivalent stories, all serving the same sociopolitical purpose as the specific variant of Eve's creation from Adam's rib.

3. One of the most famous and elaborate of these stands at Khajuraho.

4. These epithets are paralleled by a considerable number of synonymous ones.

5. Mridī is an epithet of Pārvatī; Kālī is another, more dynamic aspect of her.

6. See especially the Kālikā Purāna account of Shiva's quarrel with the gods, and his exclusion from the Great Sacrifice, as retold in Zimmer, *The King and the Corpse*, pp. 278ff.

7. See also discussions later in this Chapter and in Chapter Ten.

8. See Macdonnel's *Dictionary*, article "Māyā."

9. The conceptual and esoteric ramifications of the pentad symbol cannot be considered in the context of this study. It must suffice to recall its significance as the equivalent of the mundane sphere, in contrast to the hexad symbol which serves as the equivalent of the extramundane plane. This symbolism can be traced in so many cultures that a presumption of its near-universality appears warranted. In Judeo-Christian symbology the antithetic meanings of the pentagram and hexagram present the most familiar example, typical of its analogues elsewhere. These two designs oppose, respectively, the physical world to the metaphysical, the material to the spiritual, the microcosmic to the macrocosmic, the human to the divine, the nature-defined to the transcendent plane.

10. See Chapter Five for the relationship of Rudra and Maroti.

11. Mason-Oursel, in *Encyclopedia of Mythology*, p. 359.

12. According to canonical exegesis, Gāya-

trī is the personification of a sacred hymn in praise of the Vedic deity. However, the root derivation of this designation suggests a quite different original meaning. Gāyatrī is a feminine form of *gāyatra,* a term that also carries the second meaning of "striding," evidently being derived from the verbal form *ga,* to "go, come, move," which is in fact cognate with our own verb "go" and the German "gehen," and which apparently underlies the appellation of the ancient Greek earth goddess, Gaea. The latter, like Gāyatrī, seems thus to be a personification of the solid ground on which man moves, "goes," the very ground that is the earth.

13. The Sacred Marriage, which appears prominent as a cultic and symbolic incident in all religions. For further reference see Chapter Thirteen.

14. There are comparable depictions elsewhere, such as the Greek Gorgon or the Egyptian Taurt, but their appearances are occasional and relatively inconspicuous.

15. See, for instance, Kramrisch, Plate 124, or Zimmer, *The Art of Indian Asia,* Plates 124 and 411.

16. Zimmer, *Myths and Symbols,* pp. 197–216. However, though much of this interpretation remains pertinent, some of its value is seriously diminished as it proceeds from the Brahmanically biased presumption of the female deity's secondary nature as a reflection of the preexistent male deity's power.

17. *Ibid.,* p. 211.

18. *Ibid.,* Plates 68, 69.

19. For a discussion of the vyali figure see Chapter Eleven.

20. As are, also, the antigodly forces destroyed by Shiva and Vishnu, as for instance Apasmāra, Hiranyāksha, and Hiranyakashipu.

21. Cf. Mason-Oursel, in *Encyclopedia of Mythology,* p. 352 and passim.

22. *Devī-māhātmya,* in *Markandeya Purāna,* 81–93.

23. Zimmer, *Myths and Symbols,* p. 191.

24. See *ibid.,* Plate 57. For a discussion of the goddess' lion see Chapter Eleven.

25. See Neumann, *The Great Mother*, Plate 130.

26. See Macdonell's *Dictionary,* "Chandī."

27. See Zimmer, *Philosophies of India,* pp. 229, 230.

28. See *ibid.,* p. 296.

29. Ostensibly and officially this holiday, Holī, is associated with the god of love, Kāma. However, for reasons to which consideration cannot be given in the present context, as well as by the token of the liberal use of sindoor, Holī suggests itself as originally a Shaivite celebration. Kāma himself, a deity of late genesis, might well be regarded as a specialization of Shiva's own sensual aspect.

CHAPTER TEN

THE GODDESS AS MAHESHVARĪ

1. Evidence of this universality is plentiful. For an extensive compilation of it, with particular reference to the Mediterranean and Western European areas, see Graves, *The White Goddess.*

2. See Zimmer, *The Art of Indian Asia,* Plate 253.

3. See Basham, *The Wonder That Was India,* pp. 310, 311.

4. This basic unrelatedness of the trident to the aquatic deity is shown by the appearance of this emblem in the hand of the Hittite storm god (*Encyclopedia of Mythology,* ill. p. 83); in the White Demon of Iranian legend (*ibid.,* ill. p. 232) who, living in a cave, is a mountain deity; and on a Babylonian cylinder seal (Neumann, *The Great Mother,* Plate 54b). conjoined to the goddess, most likely Ishtar, who again has no aquatic connection. It may also be recalled that the pitchfork of the medieval Satan, another non-aquatic being, is a latter-day version of the trident; invariably this pitchfork is depicted as three-pronged.

5. This development seems indicated by the trident's association with Triton, presumably a regional and perhaps not originally aquatic deity; as well as with the Tritons, the subaltern embodiments of his energies. It is that god's appellation, Triton, which is so revealing in that it presents a masculine variant of the name carried by the primal Mediterranean goddess who seems to have had her cultic center in Libya (as suggested by the lake that traditionally has carried her name). Evidently Indo-European immigrants to this area had, in recognition of her character, designated her by the appropriate term of their own idiom, Trito, the Threefold One, whose powers were symbolized by the trident. It is from her that Triton must have derived the emblem; from her, again, that Poseidon-Neptune assumed it by way of his "marriage" to Amphi-trite, a goddess whose name patently identifies her as a double of the ancient Trito.

6. For a discussion of the vajra, see Zimmer, *The Art of Indian Asia*, passim.

7. Most extensively and importantly in the Kālikā Purāna.

8. The British, coming upon this ritual, transcribed its designation, satī, as suttee, and this form has since been familiar usage.

9. This Brahmanical revival had its incipience in the "elite" groups. Gradually many of its attendant attitudes and cultic features, among them the rite of suttee, spread to, or were aped by, aspiring segments of society.

10. See Zimmer, *The King and the Corpse*, pp. 278ff.

11. *Ibid.*, p. 305.

12. This is why Sarasvatī, the lotus goddess, could be identified with Durgā, the express theomorphic manifestation of shakti. For Durgā's shakti character amounts to no more than an incidental emphasis: representing the whole gestalt of the Divine Feminine, she preserves within herself Sarasvatī's lotus nature.

13. There are also temples dedicated to the Sixty-four Yoginīs elsewhere, notably those near Bhubaneshwar and on the outskirts of Khajuraho. Only that at Bheraghat, however, has, in spite of the considerable depredations of time and weather, been sufficiently preserved to permit an assessment of its iconography.

14. The individual names inscribed on the pedestals of these images to identify their respective subjects, appellations by and large corresponding to a canonical list of yoginīs, must be read as those of local female divinities whose continued prominence had prompted their adoption, if in this minor role, into the orthodox pantheon.

15. Though somewhat more frequent outside India, particularly in Cambodia, the icon of the revelation of the goddess in the linga is an extremely rare specimen of imagery within India herself.

16. See Chapter Eleven.

CHAPTER ELEVEN
ZOOMORPHIC MASKS
OF THE GODDESS

1. See below for a discussion of the presumed equine attribute.

2. See below.

3. Whether semantic or grammatical, changes words undergo are never arbitrary. However obscure or untraceable later, they are prompted by reasons cogent in their own day; reasons sometimes conditioned by the psychic climate of the age and therefore indicative of it.

4. For the association of the lion with the female deity, see below.

5. See the referent discussion in Chapter Twelve.

6. For instance, at Belur (Mysore), where such an image achieves by its size as well as its placement in the Chennakeshava temple a predominant, even focal position.

7. The primary significance of the vyali image today rests with its role as a material projection of man's unconscious, an objectification of an emotional bond which, no longer doctrinally permissible, has been repressed when it could no longer be reconciled with the order in being. It is the persistent, if unrealized, actuality of this bond that made its expression imperative and thus accounts for the abundant and repetitive proliferation of this iconic subject.

8. The original antecedents and role of the gana were discussed in Chapter Five. For those of the makara, see below.

9. Amphitrite, of course, is more generally familiar as a Greek divinity; however, compare note 5, Chapter Ten, describing her earlier identity as a great goddess of the southeastern Mediterranean.

10. For a detailed discussion of this, see Graves, *The White Goddess,* passim.

11. This process has been previously observed, especially in connection with the lotus emblem's transfer to Brahma and Vishnu, Chapter Eight.

12. Zimmer, *The King and the Corpse*, p. 242.

13. See Macdonell's *Dictionary*, "makara."

14. See Zimmer, *The King and the Corpse,* pp. 241ff.

15. See Macdonell's *Dictionary,* "makarī."

16. Among others, the Mesopotamian, Caananite, and Cretan goddesses were worshiped in this aspect. In Egypt, Nut and Hathor appeared cow-headed, and in Greece certain manifestations of Aphrodite assumed similar appearance. Hera herself, as her epithet *boopis,* "cow-eyed," recalls, had once been cow-faced; and the story of the Peloponnesian Io, who in the shape of a white cow was seduced by Zeus, attests for that area a cow cult in honor of the female deity.

17. See Chapter Seven.

18. See Chapter Seven, note 19.

19. This aspect was, for instance, most marked in the rites of the Celtic goddess of ancient Britain, but also in those of several Italic as well as some pre-Achaean Greek goddesses, particularly the archaic Demeter.

20. Here only the Roman myth is recalled as the most familiar example. Its constellation leaves no doubt that the she-wolf who suckles the infant Romulus is the zoic equivalent of Rhea Silvia, the Vestal, herself but a mundane identity of the goddess.

21. Here it must suffice to refer to such as Taucret, Sekhmet, Renetet, and Tefnut in Egypt; Cybele in Anatolia; and the Celtic goddess who is often similarly symbolized and whose magic powers are embodied in the lion that, in a later myth, appears as the inseparable companion of Owain.

22. Zimmer, *The King and the Corpse,* p. 269.

23. Indian esthetics call for a decided emphasis on the female breast. However, in its application to the iconography of the female divinity, this emphasis is designed to symbolize not the maternal but the erotic aspect of the subject; to convey the sensually alluring, sexually affective character of the divine likeness.

24. See Macdonell's *Dictionary,* "Simhikā."

CHAPTER TWELVE
THE SERPENT MASK OF THE DIVINE

1. Wherever he appears, the dragon represents the demonized aspect of the serpent.

2. Jung, *Symbols of Transformation,* p. 235.

3. For the significance of the color red see Chapter Ten.

4. Zimmer, *Myths and Symbols,* p. 84.

5. See F. Guirand, in *Encyclopedia of Mythology,* pp. 69ff.

6. See Jung, *Symbols of Transformation,* Plate 11B.

7. It is in recognition of the Brazen Serpent's original and essential association with the abominated female deity of Egypt that the fanatically Jehovistic king, Hezekiah, "broke it in pieces" (2 Kings 18:4).

8. See Jung, *Symbols of Transformation,* Plate 11B.

9. See Neumann, *The Great Mother,* Fig. 29.

10. See *ibid.,* Fig. 40.

11. See *ibid.,* Plate 6.

12. See *ibid.,* Plate 152.

13. See *ibid.,* Plate 44.

14. See *Encyclopedia of Mythology,* plate on p. 29.

15. See *ibid.,* p. 42.

16. See Jung, *Symbols of Transformation,* Plate LI.

17. See *ibid.,* Plate IVb.

18. See Neumann, *The Great Mother,* Plate 111.

19. Basham, *The Wonder That Was India,* p. 319.

20. Not necessarily related to the tribes who now under the collective name of Nāgas still persist in the jungles of Assam and the hills of neighboring Burma.

21. The Ceylonese aborigines may well have been called Nāgas for the identical reasons, particularly when it is remembered that this designation seems to have been applied to them by the Buddhist missionaries from Ashokan India.

22. See, for instance, Basham, p. 315, or Mukerjee, *The Culture and Art of India,* pp. 51–52.

23. For a variety of subject presentations, see also Zimmer, *The Art of Indian Asia,* Plates 111, 122, 127.

24. Among others, Zimmer recognizes Ananta-Shesha's role as Vishnu's zoic self, in stating, "Ultimately Ananta is identical with Vishnu himself" (*ibid.,* p. 13).

25. See Zimmer, *Myths and Symbols,* pp. 82–88.

26. See *ibid.,* p. 67.

27. See Zimmer, *The Art of Indian Asia,* Plates 557, 559.

28. See *ibid.,* Plate 247.

29. Jung, *Symbols of Transformation,* p. 437; Campbell, *The Hero with a Thousand Faces,* p. 129n.

30. In fact, it is inapposite to Judeo-Christian conception as well. For, if the Serpent Power is the creative energy of the Divine, the latter could scarcely be equated with the Judeo-Christian god, in view of Jehovah's unequivocal contraposition to the Edenic Serpent, the presumptive possessor of that very power.

31. See Neumann, *The Origins and History of Consciousness,* Plate 8.

32. See Neumann, *The Great Mother,* Plate 185.

33. Described in the *Pārshvanātha Charitā* of Brahmadevaduri, published in Benares, 1912.

34. Zimmer, *The Art of Indian Asia,* p. 56; the reference is to illustration Plate B-2b.

35. *Ibid.,* Plate 1b.

36. *Ibid.,* Plate 97.

37. See, for instance, *ibid.,* Plate 28c.

38. *Ibid.,* Plate 35a.

39. *Ibid.,* Plate 181.

40. See Coomaraswamy, "Yakshas," passim.

41. This lack of sexual definition may have been deliberate; but, too, it may be an illusion created by the wear of time. The sexual attribute of the figure may well have been eroded beyond retrieve or recognition.

42. The basic exercise and quest of magic is the effectuation of transformation by supernatural means. This is why the serpent has remained the symbol of magical power, the companion, as noted before, of the sorceress and witch, and the symbolic equivalent of Mahāmāya-Siddhīshvarī as it rises before her image.

43. See Zimmer, *The Art of Indian Asia,* Plate B-2a.

44. Though the configuration of the semi-theomorphic serpent divinities in embrace seems to be uniquely Indian, the design of the fully zoic snake pair in analogous constellation is not. It finds numerous counterparts in diverse cultures, some of the specimens being frank in their representations of the copulative act, many more modified to intimate it by the intertwining twist of their tails. Thus, the snake pair rising about the figure of Isis (see Neumann, *The Great Mother,* Fig. 29, p. 144); the similar configuration on an Ephesian coin (see Jung, *Symbols of Transformation,* Plate LVIIa); or the design of the Lares at Pompeii showing two snakes coiling toward each other from opposite sides of a phallic altar, making the suggestion even more explicit (see *ibid.,* Plate LXLb). The last configuration has been aptly designated "The Serpent Mystery," a title that could be applied with equal appropriateness to all the appearances of the sexually conjoined serpents. It may also be recalled that "the caduceus of Hermes, his wand of office while conducting souls to Hell, was in the form of coupling snakes" (Graves, *The White Goddess,* p. 267). Here the essential condition was not that the god was "conducting souls to Hell" but that he conducted men's passage from life to afterlife, which represents an act of transformation. Hence the symbol of the coupling snakes. Asklepios, the god of Healing, also will be remembered as the possessor of the identical emblem: healing, after all, was divine magic, an act of life renewal.

Whatever the specific design, whether explicit in its depiction or modified, the difference is one of candor, not of connotation; of form, not of inspiration. In fact, the wide distribution and essential similarity of these images, and their unexceptional association everywhere with the realm of the sacred, points to their origination from a common conceptual sphere, antedating the rise of the respective cultures that had preserved the tradition of the design. This would, in turn, imply their analogous signification of transformative, magical power, the preeminent aspect of female dynamism which India identified as Shakti. The actuality of this symbolism is confirmed, in a transpicuous variation, by the esoteric cosmogony of the Orphics, who averred that "the creation of the world . . . resulted from the sexual act performed between the Great Goddess and the World-Snake Ophion. The Great Goddess herself took the form of a snake and coupled with Ophion" (Graves, *The White Goddess,* p. 266). Perhaps, then, India's coupling nāga and nagini represent but a local version of the Great Goddess and Ophion?

45. This mystic realization is concomitant with, and in consequence of, the contemporary artist's involvement with Tantric teaching and cult. See Chapter Thirteen, passim.

46. Hutten, *Caste in India,* pp. 197, 221–22.

47. Basham, p. 242.

48. See, for instance, Zimmer, *Myths and Symbols,* p. 24.

49. Zimmer, *Philosophies of India,* p. 253.

50. Some of the more famous illustrations of this figuration may be found in Zimmer, *The Art of Indian Asia,* Plates 97, 109, 110, 423.

51. See Zimmer, *Myths and Symbols,* p. 189 and footnote.

52. Quite possibly, Rahu originally personified one part of the moon goddess's double nature, her new moon aspect.

53. Zimmer, *Myths and Symbols,* p. 182.

54. See Macdonell's *Dictionary,* "nāga."

55. *Ibid.,* "sarpa."

56. Campbell, *The Hero with a Thousand Faces,* p. 129n.

57. See Chapter Thirteen, passim.

58. This identification may perhaps account

for Vātsyāyana's epithet, *mallanāga*, "the powerful serpent." As the author of the Kāmasūtra, in time invested with the aureole of almost legendary wisdom, Vātsyāyana came to be regarded as the ultimate authority in all matters of erotic quest and activity, matters linked to serpentine inspiration and intervention. The epithet, therefore, seems hardly haphazard or accidental.

59. See Chapter Thirteen.

60. It may well have been his preoccupation with yoga, the road to the Transcendent, that earned Patanjali his epithets Phanin, "Serpent," and Phanindra and Phanipati, "Lord of Serpents." Perhaps even more significant seems the association of Nāgārjuna (whose name itself means "Shining, Splendorous Serpent") with the serpent power. Again, as the formulator of the metaphysical doctrine of Mahāyāna Buddhism, his preoccupation was with the Transcendent. "Adept in all sciences, including those of Magic" (Zimmer, *Philosophies of India*, p. 519), his suprahuman wisdom is supposed to have been gained through the intercession of a nāgarāja (serpent king), who communicated to him matters of occult knowledge

CHAPTER THIRTEEN
HINDUISM'S TANTRIC HERITAGE

1. The essential conceptions of the Tantric creed were adopted by each of the contemporary sectarian groups within Hinduism, which proceeded to associate them with the specific divine identities that had been, and ostensibly remained, the focuses of their respective cults. Thus, though Shakti presided over all Tantric communities, the Ganapatyas continued to pay their nominal reverence to Ganesha; the Bhairavas to Shiva's aspect as Bhairava; the Kapalikas to his aspect as Mahākāla; the Pashupatas to his identity as Pashupati.

2. Zimmer, *Philosophies of India*, p. 62n.

3. Curtailed by the triumph of Tantrism, the power of the Brahmanical priesthood was partially restored only when, eventually, secular corruption of Tantric worship encouraged a puritanical reaction.

4. Mukerjee, *The Culture and Art of India*, p. 37.

5. *Ibid.*, p. 266.

6. See, respectively, Zimmer, *The Art of Indian Asia*, p. 130, and *Philosophies of India*, p. 62n.

7. The actual elements of the Indus Valley's cultural evolution have not been definitively determined beyond the fact that they must have derived from preexistent traditions. The term "Dravidian" as used by Zimmer proves inadequate because it embraces indigenous groups of diverse origins and traditions and therefore presents a catchall rather than a classification.

8. Mukerjee, p. 37.

9. *Idem.*

10. This participation was no doubt instrumental in ushering in the enhanced social status which women were to enjoy during India's medieval period.

11. See the previous references to the Purānic legends treating of Satī and the goddess Dawn, or of Tripura-Sundarī.

12. The so-called "Five M's," representing the formalized sacramental indulgence in the five forbidden things, namely wine, meat, fish, parched grain, and sexual intercourse. For elaboration, see Zimmer, *Philosophies of India*, pp. 572–73, 577–80, 588.

13. As the principal mode of the ancient world's institutionalized worship, mystery cults everywhere precede the rituals of the Great Traditions. Their performance in India may be deduced not only by obvious analogy, but also by traces left in Hindu as well as in local and tribal devotions. In essence, Tantric practice itself represents a resuscitated mystery cult. However varied in their specific expressions, the mystery cults and their latter-day upshots shared certain fundamental concepts and beliefs. Thus it seems by no means accidental that Tantric worship combines the bacchanalian accents of Greece's Dionysian mysteries with the emotional accents of the early Christian love feasts. Apparently the ideas of communal *participation mystique* and erotic ecstasy were among those inherent in and common to the mystery cults everywhere.

14. Translated by Arthur Avalon. See Bibliography.

15. Zimmer, *Philosophies of India*, pp. 560–602 and passim.

16. Exploiting the vocabulary of the Great Tradition, the Tantras define this state of experience as *nirvikalpa samādhi*, "union beyond differentiation," describing it as the realization of the identity of Atman and Brahman in which "both the subject and its highest object are annihilate." (Zimmer, *Philosophies of India*, p. 593). For an explanation of Tantra yoga and the continuing

tradition of Tantric art, see Mookerjee, *Tantra Art.*

17. These energy centers have become more familiar to the West by their alternative designation *chakras,* "circles, wheels."

18. Zimmer, *The Art of Indian Asia,* p. 274.

19. See Mulk Raj Anand, "The Great Delight."

20. This is true also of such instances when, as was not unusual for some Tantric sects, a man and his wife might jointly attend the celebration. They might then be mates in the ritual connubium, or perform the act with other members of the sacramental group. However, in the former case the emphasis would not be on their customary relationship but on their transfigured roles as representatives of the Divine.

21. The current study refrains from reintroducing these valuable but largely familiar illustrations. Convenient examples may be found in Zimmer, *The Art of Indian Asia,* Plates 214, 315, 316, 318, 361; Kramrisch, *The Art of India,* Plates 122, 146; Thomas, *Kāma Kalpa,* Plates 75, 94, 98, 99, 104, 105, 122, 199, 215; Frederic, *The Art of India,* Plate 286; Goetz, *India,* ill. on pp. 153, 156.

22. Illustrations of these scenes are not offered here, as they are included in most works on Indian art; e.g. Frederic, *The Art of India,* Plate 286; Thomas, *Kama Kalpa,* Plates 98, 99; Zimmer, *The Art of Indian Asia,* Plate 315.

23. See Elwin, *The Baiga,* passim, under "Bara Deo," one of the alternative spellings of Boramdeo.

24. It seems not unlikely that the maithuna figures of the mālava mahal may have received some of their impetus from the designs on the once traditional boys' and girls' dormitories of various central Indian tribes. See, for example, Elwin, *Tribal Art of Central India,* pp. 114–17.

25. Some of this effigy's features suggest that originally, perhaps, its model might have been Thakuranī, the great goddess of the tribal peoples of the area, who so regularly had come to be identified with the Hindu Kālī. See, for example, Elwin, *The Baiga,* p. 55.

26. However, to this day a vestigial scattering of Tantric ritual practices, most often performed in secrecy, survives from the cult's glorious days of centuries past. See, for example, Carstairs, *The Twice-Born,* pp. 102–5.

CHAPTER FOURTEEN
INDIA'S GREAT TRADITION

1. Coomaraswamy, "Yakshas," p. 37.
2. This culture complex, created by a conglomeration of subcultures, must be postulated as a historical reality. Though this study has considered only the evidences of India's central areas, its findings prove, with minor variations, applicable to the rest of the country. Such an extent of conceptual, cultic, symbolistic, and iconographic patterns must argue for the existence of beliefs, perhaps originally local, which in the course of universalization produced a common cultural stratum of native tradition.

3. See Chapter Six, passim.

4. The aboriginal genesis of this legend seems indicated by the fact that *strīrājya* was presumed to be located in the north, an area that, inaccessible behind the impassable and awe-inspiring Himalayan ranges, always represented to the native Indian a realm of mystery and wonder and of things extraordinary or miraculous, even supernatural. For the Aryans, themselves coming from the distance beyond the mountains, that region would scarcely have held the same connotation.

Also, it may be noted here that this land of Indian legend bears the designation strīrājya. But *strī* signifies "woman, female, wife," never "mother." Considering the availability of many terms for mother, this nomenclature could not be accidental but must be considered a deliberate attempt to emphasize the gynocentric rather than matriarchal character of that Empire of Women.

BIBLIOGRAPHY

Anand, Mulk Raj. "The Great Delight," *Evergreen Review,* Vol. 3, No. 9 (Summer 1959). New York, Grove Press.

Avalon, Arthur (John Woodroffe). *The Serpent Power (Sat-chakra-nirūpana* and *Padukāpanchaka).* Madras, Ganesh & Co., 1953.

Basham, A. L. *The Wonder That Was India.* New York, Grove Press, 1954.

Brown, W. Norman. *Man in the Universe: Some Continuities in Indian Thought.* Berkeley and Los Angeles, U. of California Press, 1966.

Campbell, Joseph. *The Hero with a Thousand Faces.* New York, Meridian Books, 1956.

——. *The Masks of God: Primitive Mythology.* New York, Viking Press, 1959.

——. *The Masks of God: Oriental Mythology.* New York, Viking Press, 1962.

Carstairs, G. Morris. *The Twice-Born.* Bloomington, Indiana U. Press, 1961.

Childe, V. Gordon. *New Light on the Most Ancient East.* New York, Grove Press, 1957.

Cles-Reden, Sibylle von. *The Realm of the Great Goddess.* Englewood Cliffs, Prentice-Hall, 1962.

Coomaraswamy, A. K. "Yakshas," Smithsonian Miscellaneous Collections, Vol. 80. Washington, 1928–31.

——. *The Dance of Shiva.* New York, Noonday Press, 1957.

Elwin, Verrier. *The Baiga.* London, John Murray, 1939.

——. *The Tribal Art of Middle India.* London, Oxford, 1951.

Frederic, Louis. *The Art of India.* New York, Abrams, 1959.

Goetz, Hermann. *India.* New York, McGraw-Hill, 1959.

Graves, Robert. *The White Goddess.* New York, Vintage Books, 1958.

Hutten, J. C. *Caste in India.* London, Oxford U. Press, 1963.

India, Census of 1961. Madhya Pradesh (Vol. VIII):
Fairs and Festivals (Part VII-B, No. 2)
Village Survey Monographs (Part VI):
 Kulhari, in district Sehore (No. 1)
 Bendri, in district Raipur (No. 2)
 Tilaibhat, in district Bilaspur (No. 3)
 Dikhatpura, in district Morena (No. 4)
 Naharkheda, in district Indore (No. 5)
 Jaitpuri, in district Jabalpur (No. 6)
 Pipalgota, in district Sconi-Malwa (No. 7)
 Richhari, in district Datia (No. 8)
 Kosa, in district Durg (No. 9)

Jung, C. G. *Symbols of Transformation,* tr. by R. F. C. Hull. New York, Pantheon Books, 1956.

Kramrisch, Stella. *The Art of India*. London, Phaidon Press, 1955.

Leisegang, Hans. "The Mystery of the Serpent," in *The Mysteries: Papers from the Eranos Yearbooks*. New York, Pantheon, 1954.

Leslie, Charles, ed. *Anthropology of Folk Religion*. New York, Vintage Books, 1960.

Macdonell, A. A. *A Practical Sanskrit Dictionary*. London, Oxford U. Press, 1929.

Mason-Oursel, P. "Mythology of India," in *Encyclopedia of Mythology* (Larousse). London, Batchworth Press, 1959.

——. "The Indian Theories of Redemption in the Frame of the Religions of Salvation," in *The Mysteries: Papers from the Eranos Yearbooks*. New York, Pantheon, 1954.

Mookerjee, Ajit. *Tantra Art*. New Delhi, R. Kumar, 1967.

Mukerjee, Radhakamal. *The Culture and Art of India*. New York, Praeger, 1959.

Neumann, Erich. *The Great Mother*. New York, Pantheon, 1955.

——. *The Origins and History of Consciousness*. New York, Harper, 1962.

Piggott, Stuart. *Prehistoric India*. Baltimore, Penguin Books, 1950.

Redfield, Robert. *Peasant Society and Culture*. Chicago, Phoenix Books, 1960.

Renou, L. *Religions of Ancient India*. London, 1953.

Seznec, Jean. *The Survival of the Pagan Gods*. New York, Pantheon, 1953.

Thomas, P. *Kāma Kalpa*. Bombay, D. B. Taraporevala Sons, 1959.

Vogel, Jean Phillipe. *Indian Serpent Lore*. London, A. Probsthain, 1926.

Wheeler, Mortimer. *The Indus Civilization*. London, Cambridge U. Press, 1953.

——. *Early India and Pakistan*. New York, Praeger, 1959.

Woodroffe, John. *Shakti and Shakta*. London and Madras, 1929.

Zimmer, Heinrich. *Myths and Symbols in Indian Art and Civilization*. New York, Pantheon, 1946.

——. *The Art of Indian Asia*. New York, Pantheon, 1955.

——. *Philosophies of India*. New York, Meridian Books, 1957.

——. *The King and the Corpse*. New York, Meridian Books, 1960.

LIST OF ILLUSTRATIONS

INDEX